PRAISE FOR
Shockwave

"Dramatic . . . an important page-turner. . . . Walker's admirably even-handed and smoothly written history records the countdown from the explosion of the first atomic bomb at Los Alamos in July 1945 to the incineration of Hiroshima, Japan, three weeks later."
—*Entertainment Weekly* (Grade: A-)

"A meticulous, emotionally devastating portrait of both sides. . . . [Walker] creates an arresting feeling of suspense, but also the structure adds an overwhelming sense of the personal, individual impact the bomb would have." —*Atlanta Journal-Constitution*

"Those who revere John Hersey's *Hiroshima* as a classic piece of reporting about an act unprecedented in human history—the instantaneous annihilation of tens of thousands of civilians by human agency—may approach a new book on the subject with lowered expectations. But in *Shockwave: Countdown to Hiroshima*, Stephen Walker has painted on a larger canvas." —*Washington Post*

"As the sixtieth anniversary of the bombing of Hiroshima approaches, this book offers a fascinating look at a moment in history that for many of us has become distant and unimaginable. The book has the feel of a suspense novel, unfolding with such tension and drama that we must remind ourselves that we know what will happen. . . . Like John Hersey's *Hiroshima*, *Shockwave* brings to life one of history's most profound events. Don't miss it." —*Arizona Republic*

"Electrifying. . . . The tension and concentration of Walker's thriller-like prose elicits a visceral response, but he also raises complicated and urgent questions about our continued harboring and development of nuclear weapons." —*Chicago Tribune*

COUNTDOWN

TO

HIROSHIMA

SHOCKWAVE

STEPHEN WALKER

HARPER PERENNIAL

NEW YORK • LONDON • TORONTO • SYDNEY

HARPER ● PERENNIAL

Permissions appear on p. 352.

A hardcover edition of this book was published in 2005 by HarperCollins Publishers.

P.S.™ is a trademark of HarperCollins Publishers.

HarperCollins books may be purchased for educational, business, or sales promotional use. For information please write: Special Markets Department, HarperCollins Publishers, 10 East 53rd Street, New York, NY 10022.

FIRST HARPER PERENNIAL EDITION PUBLISHED 2006.

Designed by Elliott Beard

Library of Congress Cataloging-in-Publication Data is available upon request.

ISBN: 0-06-074284-4
ISBN-10: 0-06-074285-2 (pbk.)
ISBN-13: 978-0-06-074285-0 (pbk.)

09 10 11 ❖/RRD 10 9 8 7 6 5 4 3 2

For Sally,
whose love, spirit, and indomitable courage
inspired every word

ACKNOWLEDGMENTS

This book would not have been possible without the help, generosity, patience, and kindness of so many people across the world. They have stood behind me, and beside me, sometimes literally, every step of the way. I owe debts of gratitude I can never fully repay.

My first thanks must go to all the men and women who were witnesses to the events I have attempted to describe in the following pages. Any success I might have had in bringing those events to life is, I believe, due to them. To give a whiff of the atmosphere and flavor of a moment—especially such a great moment in history—is a very precious thing. There are so many names on this list, perhaps too many to mention here. I have included all of them in the bibliography at the end of the book. They are all very special, but among them are a few I would like specifically to acknowledge here: Dutch Van Kirk, *Enola Gay*'s navigator, who gave me such a spellbinding interview in his garden one summer's afternoon; Morris Jeppson, *Enola Gay*'s weapons specialist, whose account of the mission has never left my mind; Kenneth Eidnes, a former tail gunner in the

509th, an indefatigable source of information, who also supplied wonderfully evocative images of Tinian island at the time of the atomic missions; Thomas J. Classen, the 509th's former deputy commander, a fount of illuminating detail; Leon Smith, also a weapons specialist on Tinian and another brilliant photographer, some of whose images illustrate this book; former Los Alamos scientists Professors Henry Linschitz, Don and Lilli Hornig, Norman Ramsey and Philip Morrison; and retired Vice Admiral Frederick L. Ashworth Sr., weaponeer on the Nagasaki mission (who allowed me to take many of his books and papers back to England). All of these people have been enormously helpful, not least with the hundreds of e-mails and inquiries I have made of them. Their courtesy has been as unfailing as their efforts, and I thank them all. Among the eyewitnesses in Japan, I am also forever indebted to Dr. Shuntaro Hida, Sunao Tsuboi, Taeko Nakamae, Toshiaki Tanaka, Suzuko Numata, and Yoshito Matsushige, the marvelous cameraman who shot five extraordinary photographs within hours of the explosion in Hiroshima. I was very sad to learn of his death shortly before this book was finished, one of several among the men and women I interviewed over the last fourteen months in the course of my research.

I have been fortunate to tap into vast reservoirs of goodwill from a number of historians and experts in this field, bombarding them with infinite numbers of requests to which they have always generously responded. This book would have been impossible without them: Roger Meade and Linda Sandoval at the Los Alamos National Laboratory Archives; Jim Petersen at Historic Wendover Airfield in Utah; Richard Campbell, Al Christman, Sparky Corradina, John Coster-Mullen, Anderson Giles, Ed Humphreys, Joseph Papalia; Rebecca Collinsworth at the Los Alamos Historical Museum; John Rhoades at the Bradbury Museum in Los Alamos; Kenneth Schlessinger and Dave Giordano at the National Archives in Washington. Their kindness knows no bounds. I also want to thank Don Farrell for resolving many of my questions over a won-

derful evening at his home on Tinian's beautiful island; Larry Meeks for giving me an unforgettable personal tour of the Trinity test site in New Mexico; and Barry Bayorek for giving me an equally unforgettable ride in his Piper Cub airplane over the runways and salt flats of Wendover's air base. The ghosts of the men who flew there lived once again in the air.

My thanks go as well to Dr. Jonathan Porter and Dr. Ferenc M. Szasz at the University of New Mexico, who willingly gave their time to read drafts of the manuscript. Their notes added new dimensions to this book, and their spirited encouragement spurred me on to the finish line.

Very special thanks go to my two extraordinary and wonderful researchers, Romaine Lancaster, in London, and Yukiko Shimahara, in Japan. They have performed miracles beyond any call of duty, responding to every request with grace, humor, and tremendous initiative. They have left their mark on every page of this book. I owe them both more than I can say in words.

I also owe an enormous debt of gratitude to my editors. In the United States Jill Schwartzman has handled the book, often under considerable pressure, with terrific skill and panache, lighting my way in the darkness with her infectious enthusiasm. In addition her colleague Dan Conaway, and Roland Philipps and Rowan Yapp in Great Britain, have all been astonishingly helpful at every stage of this journey. Their tireless encouragement, astuteness, common sense, patience, and valuable insights have been an inspiration to me. They have always responded to my concerns with consummate tact and sensitivity. I thank them all from the bottom of my heart. I must also thank my foreign-language editors, in particular Hiroyuki Chida in Japan and Harald Stadler in Germany, for their meticulous notes, which have helped so much to clarify and refine the narrative in these pages.

I owe an immeasurable debt to my agents. Rachel Calder in London and Henry Dunow in New York have both been veritable saints, holding my hand with infinite tenderness, sympathy, and lu-

minous intelligence as I researched and wrote this book. Despite a battery of almost daily telephone calls, they have never once complained. They have been my rocks. My respect and affection for them both is perhaps higher than they will ever know.

Finally, it remains for me to thank all those people around me, friends and family, who have lived this book every inch of the way: my dear friend Donald Sturrock, who was there from the beginning; another dear friend, Richard Bradley, a true soulmate from my television days, who first lit the fire by encouraging me to make a film about Hiroshima; my sister-in-law Wendy George, who transcribed so many interviews with such marvelous goodwill; my parents, who showed such love as I never knew existed in the world; my beautiful and brilliant daughter Kitty, who inspired me more than she will ever realize; and above all my wife, Sally, the love of my life, without whom none of this would ever have happened at all.

Stephen Walker
LONDON, MAY 2005

INTRODUCTION

Twelve miles north of Santa Fe, New Mexico, Highway 502 breaks westward from Route 285 at a little junction called Pojoaque. Take the turn, and you quickly find yourself climbing into the cool heights of the Pajarito mountains. The road snakes upward, higher and higher, winding past the ancient Indian settlements with their resonant Spanish names: Jaconita, El Rancho, San Ildefonso Pueblo. The air becomes perceptibly brighter and clearer. The heady scent of ponderosa pines permeates through the open car window. The view is utterly, enticingly glorious. To the east lie the distant peaks of the Sangre de Cristo range; to the south a wide basin, rich in yellows and pinks and greens, rolling back toward the haze of Santa Fe; to the west, the high mesa of the Jemez Plateau, and a small town that once harbored one of the world's biggest secrets: Los Alamos, the place where the first atomic bombs were built.

I was there in May 2004, to meet a contributor as part of the research for this book. But halfway up the road I stopped to take in the view. It was midday and despite the altitude—over 7,000 feet—

the sun burned the asphalt, creating shimmering pools of air back along the way I had come. The silence was overwhelming. With a sudden shock, I realized that on this very same stretch of highway, fifty-nine years ago, on a sunny summer's morning just like this one, a closed black truck escorted by seven carloads of security guards crawled down the mountain from Los Alamos, past the old Indian pueblos, past the place where I had now parked my car, down into the plains of Santa Fe. The date was Saturday, July 14, 1945. Inside the black truck, sitting in a sealed lead bucket, was the uranium projectile for an atomic bomb. That afternoon, it was flown from Albuquerque to San Francisco. Two days later it sailed beneath the Golden Gate Bridge in the USS *Indianapolis* on its way across the Pacific. Twenty-three days later it was carried in the bomb bay of the B-29 Superfortress *Enola Gay* to the city of Hiroshima, where it exploded, killing at least 80,000 people. The journey started here, in these beautiful mountains with their limitless horizons. It ended there, at 9:16 A.M. on August 6, 1945, some 6,000 miles away, on the other side of the world. I was standing on a piece of history.

That journey became my journey. Over the following weeks and months, I followed in the bomb's footsteps. I visited extraordinary places, I met extraordinary people. I spoke to men who had flown the mission to Hiroshima, to scientists who had built the bomb, to people who had survived it. I had tea with old ladies in Hiroshima hotels who told me stories of pain, despair, and courage beyond any imagining. I had dinner in a Chinese restaurant in California with the man who navigated the *Enola Gay* and its weapon over 1,500 miles of the Pacific. I sat in a Cambridge, Massachusetts, living room with the nuclear physicist who carried the core of the world's first atomic bomb, tested in New Mexico three weeks earlier, in a suitcase on the backseat of his car.

I traveled from one coast of the United States to the other, to several cities in Japan, and finally to the tiny, remote island of Tinian in the western Pacific from where *Enola Gay* departed one

tropical night on its mission to Hiroshima. On the way I collected odd pieces of physical evidence that sit in my study as I write: a piece of faintly radioactive trinitite, the strange, greenish, bomb-blasted earth that still surrounds the site of the first atomic test in New Mexico; a shard of crushed coral, still gleaming white, from the abandoned, jungle-rotted runway where *Enola Gay* took off six decades ago; a handful of rubble from the Peace Dome in Hiroshima, the one building in the city preserved exactly as it was on the day the bomb fell.

My journey has encompassed moments whose meanings I will always struggle to comprehend. I have been shocked, disturbed, thrilled, appalled, entranced, amazed, and deeply moved. In listening to people's stories, and in the many accounts I also read, I found myself struck again and again by the *confluence* of events: the revelation of experiencing the same episode from so many different points of view. This became the core of my book. In moving between eyewitnesses on various parts of the globe I have tried to present one of the most decisive moments in history as it was experienced by people famous and obscure, powerful and ordinary, who lived it in the moment. We know what happened on that August morning in 1945. They did not.

The first atomic bomb was tested in the New Mexico desert on July 16, 1945—two days after that closed black truck with its lead bucket rode down the twisting highway from Los Alamos on the first leg of its trip across the world. Just three weeks separated the test from the destruction of Hiroshima. Only the resources of the richest and most powerful nation of earth could achieve something so colossal so quickly. Those three weeks, from the bomb's dress rehearsal to its delivery, define the framework of this book. Inevitably any attempt to circumscribe an historical event—especially one as consequential and controversial as this—is bound to be flawed. There are so many roads leading to it. One can start anywhere, even as far back as Leucippus, the Greek philosopher who first proposed the idea of the atom in the fifth century B.C. I chose this brief

period in the summer of 1945 because it seemed to me to contain almost every element which makes the story comprehensible, if not always complete. The world really did change in those three weeks, and forever.

What follows is the narrative of those weeks. As I wrote I tried always to keep to one key rule: that every event, incident, character trait, encounter, even piece of dialogue was, as far as possible, accurate and verifiable. Such errors of fact or judgment as there may be in a subject of this magnitude and complexity are of course entirely my responsibility. But this is not a piece of fiction.

Sixty years afterward, the events of July and August 1945 are slipping from a twilight of memory into history. Some of the people I interviewed have since died. Others will pass from us in the months and years to come. The witness they have left is infinitely precious: as a record, as an example, as a warning. In the kind of world we live in today, perhaps there has never been a better time to unfold the years, and return to the moment when it all began.

A NOTE ON TIME

THE EVENTS in this book take place in a number of different time zones around the world. To avoid repetition and potential confusion, I have removed all time zones from the datelines that head the chapters. All times given are local, with one exception: Japan. In the summer of 1945, Japan War Time was one hour behind Guam War Time—the time used by the crewmembers of the *Enola Gay* on its mission to Hiroshima. For purposes of consistency, I have kept all events in Japan and the western Pacific on Guam War Time.

PROLOGUE

TWELVE HOURS BEFORE ZERO

Sunday, August 5, 1945
Shukkeien Garden, Hiroshima

*F*OR THE REST *of his life, Sunao Tsuboi would never forget how beautiful the garden looked that night. The trees, the lake, the little rainbow bridge, the ancient wooden teahouses dotting the banks, the smell of fresh pine, the white heron sleeping on the rock. The perfect stillness of it all. Outside, beyond the garden walls, the city slept in the darkness. In the blackout, it was almost possible to believe there was no city out there at all, no houses, no army, no war. As if he and Reiko, lying together under the stars, were the only people alive in the world. That is how he remembered it the night before the bomb.*

They had entered the garden at dusk. There were four of them at first, but the other couple soon drifted away, leaving Sunao and Reiko alone. They wandered slowly along the little secret pathways, they sat in green hidden corners and listened to the cicadas and watched the turtles splashing in the water. At this time in summer the garden was full of flowers, and their scent carried on the night air. Even now, in this fifth year of war, when so many cities had been bombed to destruction, it was wonderful how the Shukkeien Garden survived intact. Designed by a seventeenth-century master of tea ceremonies,

its miniaturized landscape idealized a perfect, ordered, peaceful world. The war had simply overlooked it.

As always, they had to be discreet. The authorities, not to mention their own families, disapproved of unmarried couples spending frivolous hours in each other's company. These were times of self-sacrifice and denial. Every day the newspapers in Hiroshima urged its citizens to work harder and longer and faster, to focus all their energies and spirit on the single goal of victory. Japan was facing its greatest test in history. This was no moment for love.

But Reiko was beautiful. Sunao remembered the first moment he had seen her, earlier that summer by the Ota River. She was sitting on a bridge with a party of other girls, and she was laughing. He was very shy. Perhaps there was something about his shyness that appealed to her. Or perhaps she liked him because there were so few healthy young men still left in the city. They talked for hours, and he told her about himself and his life as an engineering student in the city. He was twenty and she was younger, only just out of school. Her movements were full of grace, and years later he would remember there was something in her voice and her smile that was like a breath of summer. They saw each other all through that hot July. They went to the shrine at Miyajima. They picnicked in the hills overlooking the city. They even went to one of the few movie theaters still open in the commercial district, going separately so they would not be spotted. And they went to the Shukkeien Garden. Sometimes she sent him letters with just the faintest whiff of scent, a luxury in those times of war. But they never kissed. They never even touched. Until that final night.

She had cried when he told her. Of course it was inevitable. He was young, and the war wanted him. Time had run out for both of them. He would be in the army by September, only a few short weeks away. She was inconsolable. She was sure he would die, like all the other young men who had been called up. Everybody knew the Americans were planning an invasion. It was only months or even weeks away. Okinawa, the last Japanese bastion before the home islands, had fallen in June. The battles would be fierce and desperate. She was convinced Sunao would be dead before the end of the year.

They lay together on the grass and she cried, and for the very first time they touched hands. He would never forget that. It was the only time they ever touched. After a while she stopped crying. They spoke little. But their hands never left each other. At some point in the evening there was an air raid alert, but still they did not move. There were often alerts these days, as the Americans passed north over the city. They flew high in their silver planes, sometimes so high that in daylight all you could see was a brilliant white trail in the blue sky. But they took their bombs elsewhere.

A little after midnight the lovers parted. They said good-bye at the gate. Reiko walked away down the street. Sunao watched her go, until she disappeared around a corner. She never looked back. Then he turned slowly toward his home, the memory of her touch still fresh in his mind. Afterward, he would remember this as the happiest night of his life.

He looked up at the sky. The stars were clear and brilliant. Tomorrow was going to be a beautiful day.

ACT I

THREE WEEKS EARLIER

DRESS REHEARSAL
JULY 15–16, 1945

Batter my heart, three-personed God, for you
As yet but knock, breathe, shine, and seek to mend;
That I may rise, and stand, o'erthrow me, and bend
Your force to break, blow, burn, and make me new.

JOHN DONNE, "Holy Sonnet XIV"

Now we are all sons of bitches.

KENNETH BAINBRIDGE,
director of the Trinity test, July 16, 1945

ONE

DON HORNIG stared up at the tower. The wind and rain whipped through the steel latticework. The storm that had been building throughout the day had finally erupted in all its fury. Flashes of lightning lit the San Andres mountains to the south, and the desert echoed with the growl of thunder. The tower loomed 103 feet above Hornig's head, a network of black braces and girders reaching upward like a giant electric pylon. By now the clouds were racing so low across the sky, he could barely see the top. Which was just as well, really. He did not want to think about what was at the top.

He began to climb. The wet steel slipped between his fingers and the rain stung his eyes, making it difficult to see. He wore no safety harness. Rung by rung, he pulled himself up the ladder. It was slow going, but he was only twenty-four, and the long Sunday rides over the Pajarito mountain trails near Los Alamos kept him fit. Once or twice he stopped, and he could see the guards below him looking up, like ants on the desert floor. They seemed a long way down.

At the top of the tower, a simple corrugated tin shack rested on a

square wooden platform. It was a flimsy, cheaply made structure, obviously not designed to last. It was not much bigger than a garden shed. One of its walls was open to the elements. Hornig stepped off the ladder beside it, pausing by the entrance. A huge, dimly discernible shape crouched inside. There was a bare sixty-watt bulb hanging from the roof. Hornig switched it on and peered inside.

Hulking on a cradle was a metallic-gray, bloated, four-ton steel drum, and it took up almost every inch of space in the shack. Even by day it would have looked ominous, but it looked especially so now with the wind whipping the tin walls, and the dim bulb swaying from the ceiling, and the lightning and thunder edging nearer. A fantastic complex of cables sprouted from its sides like a spillage of guts or arteries, as if it were somehow not inert at all but actually organic, a growing, living, autonomous embryo, awaiting the moment of its birth. Perhaps in acknowledgment of its essence, its creators had even given it a name. A number of names, in fact. They called it *The Beast, The Gadget, The Thing, The Device.* Sometimes they just called it *It.* The one thing nobody ever called it was what it actually was. The world's first atomic bomb.

Hornig squeezed down beside it. The rain pelted on the tin roof like a thousand hammer blows. The wind rattled the thin walls of the bomb's cage. In a few hours, a fellow scientist named Joe McKibben, standing in a concrete bunker exactly 10,000 yards to the south of this tower, would initiate the final act in what was almost certainly the biggest and most expensive scientific experiment in history. McKibben would press a switch on a panel that in turn would close an automatic timing circuit and begin a forty-five-second countdown. At the end of that time a number of different things could happen. The bomb could fail to go off. Or it could detonate with varying magnitudes of explosion. Or, as one Nobel Prize–winning scientist believed possible, it could set fire to the earth's atmosphere, in the process destroying all life on the planet. The difficulty was that nobody knew.

The only other object in the tin shack, besides an atomic bomb,

was a telephone. It was Hornig's sole means of communication with the outside world. The lines ran down the tower and out through the desert to the control bunker. They were supposed to call him when it was time to come down, and he was supposed to call them if anything went wrong. That was the theory, at any rate. In practice, if anything did go wrong, there might not be much time to start making phone calls.

He had not asked for this job. It was a last-minute decision, made only a couple of hours earlier by the director of the bomb's laboratory, J. Robert Oppenheimer. Oppenheimer was worried about pretty much everything that night, but right then one of his main concerns was security. He wanted somebody to go up there, babysit the bomb, keep a watchful eye on things. Maybe Hornig was unlucky enough to be in the wrong place at the wrong time, but he was an obvious choice. A brilliant Harvard-trained chemist, he had spent the early war years in New England researching underwater explosives. One day in 1943 his boss had called him into the office and told him he was wanted for a job so secret, not even his boss had a clue what it was. Within days, Hornig had sold his beautiful forty-five-foot yacht *Siesta*, bought himself a secondhand 1937 Ford Coupe, and together with his twenty-year-old wife, Lilli, an equally brilliant German Jewish refugee whom he had met in a chemistry course at Harvard, headed out west. Their destination was a place he had never heard of. It was called Los Alamos, a secret laboratory in the high mesas northwest of Santa Fe, where they were building very special bombs.

Over the next two years, Hornig designed a wondrously complex piece of equipment called the X-unit. Essentially the bomb's electric trigger, it would, at the requisite time, send a five-and-a-half-thousand-volt charge to sixty-four detonators arranged in geometric patterns around the bomb's sphere, like cloves stuck in an apple. Of course, if anything went wrong with the X-unit, there would be no firing charge, no detonation, no explosion. With a two-billion-dollar investment underwriting the project, not to

mention the possible fate of the war in the Pacific, this was clearly not an option. Which is why young Don Hornig now found himself sitting all alone on top of a tower in the middle of a violent electrical storm, next to an atomic bomb.

There were clearly ample opportunities here for a little philosophical speculation, but Hornig chose not to indulge. Instead, he started to read a book. It was a cheap paperback thriller called *Desert Island Decameron*. It was not, he remembers, a very good book. Of course, it was hard to read in the dim sixty-watt light. Plus his concentration skills were not quite up to their usual levels. After all, Hornig knew perhaps better than anyone that a well-placed lightning strike could perform precisely the same function as one of his X-units. It could quite easily set off the detonators, in turn igniting the 5,300 pounds of Comp B and Baratol high explosive surrounding the nuclear core of the bomb. Even if the bomb failed to go nuclear, the high explosive alone made it the biggest conventional weapon of the war. It was quite powerful enough to destroy Hornig, his book, the tower, the guards standing at the base, not to mention a sizable lump of New Mexico real estate.

It did not help that a trial X-unit had already been set off by atmospheric disturbance from a passing cloud just two days previously, instantly discharging its five-and-a-half-thousand-volt firing signal. Fortunately, Hornig survived that time because there was no bomb on the end of it. Nor was it helpful to recall the time he and Lilli were once *actually* struck by lightning, out in the plains of eastern New Mexico in a place called Tucumcari, as they traveled out west in their Ford Coupe toward Los Alamos. Now it almost felt like a portent, as if some pernicious spirit were determined to end Hornig's bomb-making career as it had started: with a bang, but the wrong sort of bang. Under the circumstances, he figured it was better to stop thinking of the one-hundred-foot tower standing in the middle of the desert as a giant lightning rod. Far better to think of the rain pouring down the steel frame as an efficient earthing device, carrying any million-volt charge benignly into the ground.

After all, if he was right, there was nothing to worry about. And if he was wrong, he would never know it.

In the meantime, Don Hornig and the bomb remained up there together on the tower, while he tried to read his book and waited for the phone to ring, and the thunder and lightning crashed all around him. And out in the concrete bunkers, 10,000 yards to the north and west and south, the men who had spent the last three years designing and building this bomb prayed for the weather to improve. Radiating out from the steel tower was the most elaborate complex of instruments ever devised for a single scientific experiment. There were crusher gauges, geophones, seismographs, gamma sentinels, peak pressure gauges, piezoelectric gauges, sulfur threshold detectors, impulse meters, ionization chambers, and a hundred other kind of instruments, and they hid in the ground or poked through the sagebrush or peeked from behind the mesquite trees. There were twenty-five miles of newly built blacktopped roads, and hundreds of telephone poles carrying 500 miles of cables in every direction. There were the three concrete bunkers to the north, south, and west of the tower, and lead-lined photographic bunkers housing batteries of cameras, some of them mounted on army air force machine-gun turrets. There was a radar unit to track the fireball and four high-speed Mitchell 35mm motion picture cameras to film it in slow motion and innumerable spectrographs to record its radiation. It was an astonishing array of hardware, and it stretched out over this half-forgotten chunk of ancient Apache territory between the Rio Grande to the west and the Oscura mountains to the east, a vastly intricate spider's web at whose center was that lonely steel tower with its tin shack and its bomb and Don Hornig sitting on top with his paperback.

The tower was the focal point, the hub of man's first attempt to dabble with the very guts of creation, unleashing new, monstrous fires over the earth. Everything led back to it. Everywhere was locked into its destiny. Not only here in this remote New Mexico plain but across the world: to Washington, to the shattered heart of

Europe, to the war-ravaged islands of the Pacific, and finally to two cities in Japan and a young couple touching hands in a tea garden.

Perhaps the bomb makers understood all this when they gave the tower's site its name. They called it Ground Zero.

FIVE AND A HALF thousand miles away, President Truman was just finishing breakfast on a sunlit porch in the sleepy Berlin suburb of Babelsberg. The weather was perfect, a beautiful, still July morning. Dressed in a polka-dotted bow tie and natty two-tone summer shoes, Truman cut an almost holidaylike appearance, a smart American tourist on a European vacation. But he was not a tourist, and this was no vacation. The president was here for the start of one of the most important conferences of the war. Beginning tomorrow, he would drive from the Little White House—in fact a yellow stucco three-story building which served as his headquarters—to join Joseph Stalin and Winston Churchill around a circular table at the Cecilienhof, a cavernous, mock-Tudor, early twentieth-century palace in nearby Potsdam. Together, these three men—the Big Three—would thrash out the shape of the postwar world. They would also determine the fate of Japan.

The war with Germany had already been over for two months, but this final struggle with Japan was proving hugely difficult and costly. Over the past three years American troops had battled their way, island by island, across the Pacific toward the enemy heartland. British and Commonwealth troops had fought bitterly in the dense jungles of Burma in Southeast Asia. The slaughter was horrific on all sides. The Japanese fought tenaciously, bravely, and determinedly. Their culture regarded surrender as a disgrace and death in battle as the ultimate honor. The result was terrible destruction. Only two weeks earlier, on June 30, the island of Okinawa, just 400 miles southwest of Japan, had finally capitulated after three months of vicious, often hand-to-hand combat. The casualty figures spoke brutal truths: at least 12,000 Americans and

107,000 Japanese soldiers killed. The island was defended with fe-
rocious tenacity. Offshore, thousands of kamikaze pilots slammed
their planes into American ships, exploding over their decks: 30
vessels were sent to the bottom of the sea, a further 164 damaged.
And then there were the civilians: perhaps as many as 100,000
Japanese and Okinawans who died, some caught in the crossfire,
some pressed into the fighting, some entombing themselves in the
island's caves. Most of the population had been warned by their
leaders of the atrocities they would suffer if captured. To the horror
of the advancing Americans, whole families preferred to leap off
the cliffs, parents often clutching their children, rather than fall into
enemy hands.

Okinawa was the last Japanese outpost before the home islands.
The battle was still raging when Truman met his Joint Chiefs of
Staff at the White House on June 18 to discuss the invasion of Japan
itself. His decision was to commit U.S. forces to a massive assault on
Kyushu, the southern island of Japan, beginning on November 1,
1945. The operation was code-named Olympic. It was to be fol-
lowed four months later by Coronet, a second invasion, on the
plains near Tokyo. More than three quarters of a million Americans
would be involved in Olympic. They would face at least 350,000
enemy troops. The number of Americans expected to die in the op-
eration was a figure that has caused controversy ever since. At the
White House meeting, General George Marshall, the Chief of Staff,
estimated that 31,000 men would be killed or wounded in the first
thirty days of the assault. The course of casualties after that was
almost impossible to predict. Perhaps the only certainty was that
the Japanese would fight as they had always fought: with everything
they had, right up to the bitter end. Unless, of course, the atomic
bomb stopped them from fighting at all.

Truman understood this perfectly well as he sat at his breakfast
on the Little White House porch. But he understood more. Part of
him was dreading this conference. He saw himself as an unknown
next to world-class leaders like Stalin and Churchill, a second-rater

who had become president only because of Roosevelt's death back in April. But this flat-footed former railroad worker who had spent part of his boyhood castrating pigs on the family farm had also inherited the bomb. He had, as his secretary of war Henry Stimson explicitly pointed out, a master card up his sleeve, even a royal flush. And its potential benefits were massive. The bomb could alter everything. It could offer a way out of the war with Japan, it could offer a handle against Stalin's expanding empire, perhaps most of all it could offer an all-powerful weapon in the new game of atomic diplomacy. It could, in effect, turn the Big Three into the Big One—or perhaps the Big One and a Half, with a grateful Churchill trailing at Truman's apron strings. There was only one question: would it work?

It was a two-billion-dollar gamble. Truman had even deliberately postponed the start of the conference to coincide with the Trinity test. The shot *had* to go ahead now, today, while Stalin, who was afraid of flying, slowly made his way in his heavily armored train toward Berlin. The president of the United States himself had set the deadline, and time was running out.

SINCE THE MOMENT he had said good-bye to his wife, Kitty, three days earlier, J. Robert Oppenheimer had become an increasingly nervous wreck. His weight was down to a mere 114 pounds, and his crumpled suit hung limply on his tall, cadaverous frame. His face was equally gaunt, and heavy bags weighed down his blue eyes. Despite doping himself up to the gills on Seconal, he had barely slept for days. A sizable portion of his time was now spent downing gallons of black coffee and smoking endless cigarettes with short, sharp, almost manic puffs. He coughed almost continuously, a thick, heavy, nicotine-filled cough. He was just forty-one years old, but he looked a decade older, an exhausted, fragile, brilliant man facing the greatest challenge of his life.

The pressure he faced was hideous. As the director of the Los Alamos laboratory, he was personally responsible for the test actu-

ally succeeding. And so far, despite the most rigorous rehearsal schedule imaginable, plenty had already gone wrong. Even before this mother of all storms hit the ground.

Kitty's last gesture had been to give him a four-leaf clover, but she might as well have given him a thornbush for all the help it gave. The two of them had also agreed on a special code: if the test were successful, he would send a message telling her she could change the sheets. The likelihood of the sheets ever being changed was now looking remote. A miscellany of cock-ups littered the past forty-eight hours. For instance, there was the case of the bomb's detonators that had very nearly never made it to the test. Four days ago, on July 11, Kenneth Greisen, a young Cornell explosives expert, had packed 200 detonators in the trunk of his car in Los Alamos, driven off toward the test site, and promptly got himself stopped by a traffic cop near Albuquerque for speeding. By grace or good fortune, the cop did not look in the trunk. Had he done so, it is unlikely either Greisen or his 200 detonators would ever have made it in time for the test.

Then there was that problem with Don Hornig's X-unit, gaily firing off its thousands of volts after electrical discharge from a passing cloud. Or the failure in the last twenty-four hours of yet another trial X-unit that simply refused to function, its circuits blown to bits. Oppenheimer really laid into Hornig over that one, until it became clear the unit had been tested over and over again, literally hundreds of times, when it was only ever designed to be used once or twice. That may have temporarily calmed Oppenheimer down, but whichever way you looked at it, the X-unit was almost perniciously unreliable, disgorging its thousands of volts when it was not supposed to and stubbornly refusing to do so when it was. And who knew just how it would behave in a few hours' time?

Nor was that the end of the problems. There was the moment when the bomb was being winched up the tower toward the tin shack and it suddenly slipped, nearly falling fifty feet onto a pile of mattresses beneath. As if *they* would have helped. Perhaps most

worrying of all was the Creutz fiasco, a dress-rehearsal test named after the physicist Edward Creutz in which an exact replica of the test bomb, minus its nuclear core, was exploded in a remote Los Alamos canyon just two days previously. The purpose here was to confirm that the high-explosive assembly surrounding the bomb's core would work properly. Unfortunately the test failed completely, meaning that the four-ton *Gadget* now sitting primly on top of its tower at enormous taxpayers' expense would very likely also fail, thereby damning the entire operation to absolute and predictable meltdown. This sent Oppenheimer into a meltdown of his own, and he poured out all his fear, anger, and venom on Don Hornig's colorful Ukrainian boss, George Kistiakowsky, who had designed the high-explosive assembly in the first place. As a man who had once fought against the Red Army across 2,000 miles of hostile Russian steppe, Kistiakowsky was not the sort to back down under this kind of onslaught. He immediately bet Oppenheimer a month's salary against ten dollars that his explosives would work. It is a sign of Oppenheimer's state of mind that he took the bet.

The next day—less than twenty-four hours before the real test—a physicist called Hans Bethe phoned from Los Alamos to say that the Creutz calculations were erroneous, since the instruments measuring the test were incorrectly set up in the first place. This was something of a mixed blessing. All it meant was that the Creutz experiment was neither a failure nor a success. The bomb might work, but then again it might not. The net result of all this was just the same in that it had Oppenheimer reaching with trembling fingers for yet another of his industrial-strength cigarettes.

And now of course he was facing this terrible storm.

ONE HUNDRED TEN miles north of Ground Zero, Lilli Hornig parked her husband's 1937 Ford Coupe by the roadside and switched off the engine. She gazed through the windshield into the night. In daylight the view up here on Sandia Peak was magnificent, a limitless panorama of desert and mountains. Lilli knew it well.

Sometimes, when the strain at Los Alamos grew too much, she and Don would drive up here and sit in their car 10,000 feet up, with half of southern New Mexico unrolling to the horizon.

But tonight there was almost nothing to see. The lights of a few remote towns spread beneath her, isolated pinpricks in the darkness. Far away in the distance, lightning flashed over the mountains. There was a big storm brewing that way. It was more than a hundred miles off, too far for the sound to reach her. She wondered if Don were anywhere near it.

It was cold up here in the thin evening air. Lilli settled back in her seat and spread a blanket over her knees. She was glad she had brought something to eat. It was going to be a long night. Unlike many of the wives, she knew all about the test. As a highly trained chemist, she was among the privileged in Los Alamos, one of the scientific elect, and she shared in many of its secrets. Her coveted pass gave her access past the armed guards and the electrified wire fences and automatic alarms into the Tech Area, the collection of hastily erected wooden buildings and muddy footpaths that was the laboratory's heart. In one of those buildings she spent her days working on the purification of a strange, newly created element called plutonium. In the evenings she and Don often sat down to dinner with their scientific colleagues and talked into the night. Sometimes on the weekends they went riding, out into the cool poplar trails from which Los Alamos took its name, or up into the Pajarito mountains. And sometimes they would drive here to Sandia Peak where Lilli sat now in her car, looking out into the night.

It was an exciting life. She was only twenty-three, but almost everybody seemed to be about the same age. It felt like being on a university campus, a rather beautiful one nestling on top of a mesa up in the mountains above Santa Fe. A very unusual campus too, with its roster of stellar scientific talent and its Nobel Prize winners, some of them living virtually next door. It was said that this brand-new town of 5,000–odd inhabitants had the highest IQ of any city in the world. To Lilli and Don, as to so many of their colleagues, it was a heady place to be. There was a terrific sense of purpose they

would remember for the rest of their lives. After all, this was where the war would be won! This was where the dream of infinite power would be realized! This was the future! A secret laboratory above the clouds: how could you not feel excited? Especially when you drove down to Santa Fe for drinks in the La Fonda bar and heard people speaking in hushed tones about that strange, secret place up in the hills, like ancient Greeks describing their gods on Olympus.

There were other wives in other cars up there on Sandia staring out into the darkness. Some of them were listening to the radio, some were dozing or eating or trying to keep warm. But they were all waiting. Most had simply been told by their husbands that something very special was going to happen tonight, something extraordinary and unique, just a hundred miles to the south, and that Sandia Peak was the best place to see it. Many of these wives had moved to Los Alamos years ago, never knowing exactly what their husbands did all day. They had given up their homes, their friends, even their families to be there. They lived in a kind of security vacuum, where nobody outside Los Alamos was ever allowed to visit them, where their address was only a P.O. box, where their letters were censored and their phone calls were tapped, where even their babies were sometimes fingerprinted. It was a heavy sacrifice to sever yourself so completely from the world, especially when your own husband was forbidden to tell you what it was all about. Perhaps that was why so many wives were up here now, watching and waiting for whatever it was that was going to happen out there. Perhaps at last they would learn the truth.

Lilli could see the storm down in the desert was growing bigger. Even on Sandia Peak it was beginning to rain. She had driven all this way for nothing; surely they would never fire tonight. It was now nearly midnight. The best thing was to climb into her sleeping bag and try to sleep. She only hoped her husband, Don, was sitting somewhere warmer and more comfortable than she was.

TWO

**Jornada del Muerto Desert,
New Mexico**

IT WAS A strangely appropriate place to test the world's first nuclear bomb. A parched land largely inhabited by jackrabbits and rattlesnakes and turkey vultures and a few forlorn ranchers scraping out a living until the bomb makers finally evicted them. Even its old Spanish name was appropriate: the Jornada del Muerto, it was called. The Dead Man's Journey.

The conquistadores had given the land its name. Four hundred years ago they marched here in search of new pickings in the north. From the surrounding hills, Apache swooped down on them, killing off the stragglers as they trailed, thirsty and exhausted, in the burning sun. In later centuries, the descendants of those same Apache attacked the English-speaking white men who came to deprive them of their territory, torching the wagon trains that rolled down from Santa Fe to El Paso. This was a land that knew violence long before the bomb makers staked their claim to it.

The first detachment of military policemen had moved into the Jornada desert back in September. On horseback and in jeeps, they patrolled the 432-square-mile test site, set up security checkpoints,

hunted pronghorn antelope, played polo, and generally lived a life so cut off from the rest of the civilized world that each of them would one day receive a Good Conduct Medal for the lowest rate of venereal disease in the army. The only towns nearby were Troy and Carthage, old coal-mining communities abandoned years ago, their empty, dilapidated streets wasting in the midday heat. The few ranchers who lived here were paid to leave their homes, but some refused until they found their water tanks mysteriously perforated or their cattle accidentally shot in the night. Nobody was ever able to prove the military police were responsible, but the ranchers soon left, never to return.

By the spring the area was beginning to fill with teams of construction workers, road builders, engineers, and scientists. A base camp was built around one of the old homesteads, a drab, dust-ridden, godforsaken collection of hastily erected barrack huts, where the fire ants ate you alive at night and the brackish water gave you dysentery and the trucks had to be banged with sticks every morning to get the rattlers out. The pace of activity quickened with each day, despite the hundred-degree heat and the dust devils that sprang out of nowhere, not to mention the unpredictable hazards of high-flying bombers, which on two occasions dropped a few practice bombs on the base camp by mistake.

By July 13, two days before Don Hornig climbed up his rain-soaked tower, the operation moved into its highest gear. At three o'clock that afternoon, Philip Morrison, a gifted young nuclear physicist, removed two hemispheres of a strange new metal from a vault in one of the most isolated buildings in Los Alamos. Each hemisphere was nickel-plated and sheathed in glittering gold foil. Accompanied by a guard and a radiologist, Morrison placed them both inside a special two-piece magnesium suitcase fitted with twenty shock-absorbing rubber bumpers. It had taken six months to design that suitcase, an indication of the importance of its contents. Because those golden-wrapped hemispheres of metal were far more valuable than the most precious diamonds on earth. Within

the perimeters of a closely guarded, highly secret 428,000-acre industrial site in Hanford, Washington—half the size of the state of Rhode Island—mammoth processing plants had been built simply to produce the metal they were made of. So far, these two hemispheres represented their entire output. The metal itself did not even exist four years previously. It was not found in nature. It was made by man, in a fantastic latter-day alchemy that created new elements by tampering with the most basic units of matter. It was named plutonium, after the god of the dead, and it was the secret heart of the atomic bomb.

Morrison carefully placed the suitcase on the backseat of an olive-drab army sedan and climbed in beside it. A security car filled with armed guards led the way, and the convoy threaded its way down the vertiginous switchback roads that led from the high mesa of the laboratory down toward Santa Fe. As the two cars sped through the sleepy streets of pink adobe houses, Morrison kept thinking how extraordinary it was to be carrying the core of the world's first atomic bomb, riding next to him in its shock-absorbing suitcase on the backseat of an ordinary car.

It was 150 miles from Los Alamos to the test site, and it took five hours to get there. Two thousand yards southeast of Ground Zero, the cars turned down a dust track toward an undistinguished single-story ranch house. An ancient Chicago Aermotor pump stood forlornly in the yard next to an ugly concrete water tank. A few unkempt outbuildings were scattered nearby, adding to the spent, desolate air of the place. But the views were stupendous, especially now with the lowering sun burning the scalloped contours of the Little Burro mountains and Mockingbird Gap to the south.

Apart from the carbine-carrying guards at the entrance, the ranch was empty. It had recently belonged to a rancher named George McDonald. Nobody told him exactly why he and his family had to give up the home where he had lived for half his life. Neither did they tell him to what use his blue-walled, beige-ceilinged front room was about to be put.

Together, Morrison and a colleague carried the suitcase inside, taking care to obey the summons on the doorstep to PLEASE WIPE YOUR FEET. It was an interestingly domestic touch in an otherwise unsettling scene. Everything else about the room was faintly sinister, as if some secret crime were about to be committed inside. For one thing, all the windows were completely sealed with black masking tape. For another, the room was almost disconcertingly clean, like the inside of a laboratory. Which, in a sense, was exactly what it now was.

The suitcase was placed on a table. There it remained, with its two gold-wrapped hemispheres inside, for the night. An armed sentry stood outside, but neither he nor anybody else was permitted to enter. Nothing disturbed the case or its contents until nine o'clock the following morning, when the curtain was raised on a bizarre and extraordinary scene.

Nine men, including Morrison, stood around the table on which the plutonium hemispheres now rested on sheets of brown paper. All the men were wearing white surgical coats. One of Morrison's colleagues, Robert Bacher, turned to an army general and asked him to sign a receipt for the plutonium, worth at least several millions of dollars. The general, Thomas Farrell, jokingly asked if he could hold it first. He wanted to feel what he was buying. He put on a pair of rubber gloves and picked up one of the hemispheres. It was smooth and heavy, and it felt curiously warm to the touch, as if it were alive.

What Farrell was feeling was radioactivity. The artificially created element was literally breaking down in his hand, the unstable nuclei of its atoms ridding themselves of billions of particles in a bid to regain stability. Some of these particles were able to do something that had once been thought impossible: to smash through the fantastically powerful forces that held the atom's heart—or nucleus—together. And the reason they could do that was because they had no electrical charge themselves. They were called neutrons, and the electrostatic barrier could not keep them out. Like billions of Trojan horses, they slipped at fantastic speeds through the impregnable gate, sundering the nucleus in two, splitting it

apart, *fissioning* it. And when they did that, they released levels of energy hitherto undreamed of in the history of man.

It was science fiction come true. Just forty years earlier, Einstein had offered to the world his revolutionary equation relating energy and matter. The message of that equation was simply this: that matter and energy were not different things but two expressions of the same thing. Matter could be converted into energy and vice versa. Since 99.8 percent of all the matter in the universe was contained in the nucleus of an atom, theoretically the nucleus was a potential source of incredible and unheard-of amounts of energy. A single gram of water could raise a million-ton weight to the top of Mount Everest. A handful of snow could heat a large apartment building for several months. A breath of air could power an airplane continuously for a year. The trick was to get past that barrier and into the nucleus, split it open, convert as much of it as possible into pure energy. Which is where those Trojan horses came in.

The men who now watched General Farrell weigh the plutonium in his rubber-gloved hands had effectively grabbed Einstein's equation and made it flesh. They had discovered that a specific amount of the radioactive plutonium would liberate enough neutrons to smash enough atoms to release yet more neutrons, which in turn would smash still more atoms in an unstoppable, exponential, ever-expanding chain reaction. The minimum amount of plutonium required to do that was called the critical mass. Exceed the critical mass, and the chain reaction starts. Less than one-millionth of a second later, you have an atomic explosion.

Farrell signed the receipt and handed the plutonium to Louis Slotin, a young Canadian physicist. Slotin's job was to assemble the bomb's core. Hunched in rapt concentration over the ranch house table, he set to work. First he nestled a gleaming grape-sized sphere of polonium and beryllium, called the initiator, inside one of the plutonium hemispheres. The initiator's function was to kick-start the chain reaction, pouring billions of extra neutrons into the supercritical mass at the requisite time, like fuel into a raging

furnace. Next, and with infinite care, he placed the second gold-wrapped plutonium hemisphere over the first. Geiger counters clicked away, monitoring the neutron count. Every ear in the room strained for the slightest change in pitch or rate. The operation was extremely delicate. If the plutonium went critical, even for an instant, the result would be lethal. Less than a year later, in May 1946, Slotin himself would experience a massive dose of radiation in a criticality experiment in Los Alamos. It would take him seven days to die. Now he continued: adding the parts one by one like pieces of the world's most expensive jigsaw puzzle. At some point in the morning Oppenheimer came in to see how the work was proceeding. Quietly he was asked to leave. His nervousness was adding to the tension. Outside, the guards waited with their submachine guns in the baking sun. The temperature climbed into the hundreds. And all the while, in the very place where George McDonald and his family had once had their meals or listened to the radio or read or knitted or snoozed, Slotin and his team constructed the core of an atomic bomb.

It looked like an oversized tennis ball when it was finished. A very heavy tennis ball, weighing just over thirteen pounds. Around the core was the tamper, an eighty-pound hollow cylinder of plum-colored uranium. Together, the plutonium core, the initiator, and the tamper formed the bomb's heart. Later that afternoon, the whole assembly was carried from George McDonald's living room in a specially designed, ventilated cage, like some sort of highly dangerous wild animal, before being driven on the backseat of another olive-drab army sedan into the wilderness of sagebrush and Joshua trees to the steel tower. There, it was taken out of its cage and slowly lowered deep into the cool center of a five-foot-wide Duralumin ball of high explosives.

The precise arrangement of those high explosives was so pivotal that some of their secrets remained classified for decades. It had taken a number of the world's most brilliant chemists two years to work it out. In the end, the explosives were packed around the core

in two layers, each containing thirty-two sections. Most of the sections were hexagon-shaped so that the whole assembly fitted together piece by piece like segments of a giant soccer ball. The fit had to be perfect. The slightest air gap could turn the bomb into a dud. To reduce the friction between the explosives they were dusted with the best thing to hand, which happened to be Johnson's Baby Powder. Scotch tape was used to keep them in alignment. Once detonated, they would send a symmetrically converging shockwave down toward the bomb's plutonium core, a shockwave so powerful and so perfectly spherical it would literally crush or *implode* that core, squeezing its billions of atoms into a fantastically dense Ping-Pong ball–sized mass for just long enough to sustain a chain reaction, before the whole thing blew itself apart.

That was the theory, at any rate. Of course, nobody knew if it would actually work. In this titanic bid to outdo nature, perhaps it was nature that would have the last laugh. Or so it began to seem, as the bomb was slowly winched up the one-hundred-foot tower toward the tin shack where, less than thirty-six hours later, Don Hornig would keep his lonely vigil amid the rain and thunder.

THE STORM had been building up in the course of the afternoon, and by sunset the skies west of the test site were heavy and overcast. At first Oppenheimer was philosophical, almost poetic, as he watched the clouds gathering. "Funny," he said to a colleague, "how the mountains always inspire our work." By late evening, the poetry had gone. Oppenheimer's anxiety was now palpable to anyone near him, and his ability to make decisions was beginning to derail. The shot had originally been scheduled for 0400 hours. But this storm brought with it a whole new compendium of difficult decisions. Oppenheimer sat in the base camp canteen, chain-smoking and drinking black coffee and worrying about what to do. Should he fire, should he postpone, or should he scrub? It did not help that half the scientists in the canteen kept offering their own suggestions

until Oppenheimer's head was spinning with paralytic indecision. At the best of times his own nervous constitution was not the strongest. As a young man he was once diagnosed with dementia praecox—a form of schizophrenia—after he tried to strangle his best friend on holiday in France. The cause, it was said, was too much tension.

Nor did it help that Enrico Fermi, one of the world's greatest physicists, was calmly predicting the possibility that the bomb might set fire to the atmosphere and destroy the world. This was not an entirely novel prediction. A couple of years earlier, another physicist at Los Alamos had mathematically predicted a three in one million chance that this would really happen. It was decided that three in one million was a chance worth taking, and the work continued. Of course at that time there was no physical bomb. But now there was, and it was actually sitting out there on top of a tower in the middle of the New Mexico desert, and the shot time was just a few hours away at four o'clock in the morning, and the man who was making these terrifying predictions was not some apocalyptic religious freak but a Nobel Prize–winning scientist who had overseen the design and construction of the world's first chain-reacting atomic pile. Nor was he a lone voice. Others in that canteen took up the theme. Some even took bets: would the bomb simply destroy humanity, or would it actually destroy the entire planet? "We've all had a long and joyful life," said General Farrell, "and maybe we'll all go out in a blaze of glory." "Ah," said another, eyeing the play of thunder and lightning outside the canteen window, "the earth on the eve of its disintegration."

Perhaps nobody in that room was quite in his right mind that night, least of all the man at the center of it all. Oppenheimer was teetering on the edge of exhaustion, and this, combined with the fear of a possible Armageddon, was surely enough to drive anybody a little crazy. There he was, with his coffee and his cigarettes, with forty-eight hours of knife-edge anxiety behind him and the toughest decision of his life just ahead of him and everybody pitching in

with a hundred suggestions about what to do next, when suddenly a big, beefy two-star general abruptly entered the room. He took one look at Oppenheimer, marched over, grasped him by the arm, and rescued him from the crowd.

The general's name was Leslie Richard Groves, and he was Oppenheimer's boss. A commanding, conspicuously overweight figure with a funny little mustache, he was also the most reviled, feared and admired man in the entire atom bomb project, which he ran with ruthless megalomania, like the tyrant of a medieval fiefdom.

THEY COULD NOT have been more different. Oppenheimer was the scion of a wealthy Jewish Manhattan family, a brilliantly precocious, pampered boy who gave his first lecture to the New York Mineralogical Society at the age of twelve and once read all six volumes of Gibbon's *Decline and Fall of the Roman Empire* in a single transcontinental train journey. An almost extreme example of the polymath, he was an outstanding, if not especially original, scientist, fluent in several languages including Sanskrit, a connoisseur of art, haute cuisine, French medieval literature, European capitals, and poetry. It was Oppenheimer who had given the test its code name, Trinity, after a John Donne Holy Sonnet he had been reading one evening. Like almost everything he said, it was apposite, prescient in its association of unearthly power and regeneration.

Groves, a less imaginative man, could not surpass that, but he did give the bomb program its name—the Manhattan Project, after the location of its original offices. The two men were cast in almost opposite molds. Where Oppenheimer was thin, Groves was fat, and his uniform spread tightly over a not very well concealed paunch. His life was an unequal struggle against his weight, and he spent a large portion of his otherwise very well managed time failing to adhere to strict diets. It was rumored he weighed at least 230 pounds, although the actual figure was a secret almost as highly classified as the atomic bomb. He kept two pounds of chocolate

bars in his office safe along with top secret files on the atomic bomb program, and one of his aides was responsible for making sure they were always topped up.

Oppenheimer smoked five packs a day and mixed a famously mean martini. Groves hated smoking and was a virtual teetotaler. Oppenheimer was a scientist, Groves an engineer who loathed scientists, damning them as a bunch of hopelessly impractical left-wing "longhairs" who could not run a faculty meeting efficiently, much less a two-billion-dollar bomb program. He once described Los Alamos as the greatest collection of eggheads ever assembled at enormous expense in one place. Oppenheimer was Jewish, Groves was Presbyterian. One of his army-chaplain father's enduring legacies was to make him a very productive combination of prude and almost inhuman workaholic, able to suppress almost all bodily requirements (apart from chocolate bars) in the energetic pursuit of his goals. Groves lived a life of blameless domesticity with his wife and two children. Oppenheimer had a Communist mistress who later committed suicide and a wife who was on her fourth husband. A cousin of the Nazi field marshal General Keitel (who was later hanged at Nuremburg), Kitty Oppenheimer was a notoriously tough, highly sexed, hard-drinking woman with a well-plumbed vocabulary of swearwords—"not the kind to serve tea," as one of Groves's agents put it.

Oppenheimer was an intellectual who believed in open discussion. Groves was a security freak whose obsession with secrecy reached paranoid levels. He used his position as head of the Manhattan Project to build a private intelligence network so pervasive that not even the FBI could get past the gates of one of his nuclear plants. A senior congressman who tried ended up being interrogated in a windowless room for several hours. Not even Groves's family had the faintest clue what he did in the office all day. The first time they discovered he had spent the last three years running the biggest and most expensive weapons program in history was the day after the bomb was dropped on Hiroshima. And they heard it on the radio. He

set spies on his sister-in-law, and his agents tapped and tailed and bugged Oppenheimer with almost heroic efficiency. He was so charmless, undiplomatic, and uncompromising that even his deputy, Colonel Nichols, described him as "the biggest sonofabitch I've ever met in my life." Nichols also said he was the most capable.

Groves's capability was legendary. That was why he was chosen to run the Manhattan Project. A West Pointer right down to his bones, he had joined the prestigious Corps of Engineers, quickly building a reputation for taking on—and completing—projects massive enough to break ordinary mortals. His most recent task before Manhattan was to oversee construction of the Pentagon, then the largest building in the world, and he did it in just sixteen months. He ruled the bomb project's empire—at one point comprising more than 100,000 men and women—with terrific confidence. He took risks where others quailed, spending enormous amounts of money without hesitation to achieve his ends. An early government committee estimated that the entire bomb-building program would cost $133 million. Groves went through that sum in the first few weeks. And it was not only money he took risks with. Perhaps his choice of Oppenheimer was the best proof of his talents. In brazen defiance of his own security people, he chose to overlook Oppenheimer's open association with almost every Communist front on the West Coast and make him director of his top secret laboratory. And he did it because he knew Oppenheimer was the right man. He understood better than anybody how Oppenheimer's need to shine, his craving for recognition, would ensure he kept all those Nobel Prize–winning eggheads on track toward their single goal. It was an inspired decision, and one that perfectly captures the force of his personality. For Groves was the kind of man who crushed any obstacles in his path, who broke, beat, bullied, and smashed his way to the promised land of a workable, deliverable atomic bomb; and woe betide those stupid or vain or arrogant enough to get in his way while he was doing it.

Groves was utterly, almost endearingly shameless in his efforts to

persuade people to spy on their friends, and he tried to do just that with Oppenheimer's secretary, Anne Wilson. She bluntly refused, and wrote subsequently that Groves was almost certainly in love with Oppenheimer. She remembered Groves saying, "he has the bluest eyes you've ever seen, and they look right through you." It was perhaps the shrewdest insight into this peculiar, unholy, extraordinarily productive, and ultimately world-changing partnership.

Now, as these two men stood outside the base camp canteen watching the approaching storm, they needed each other as never before. It was nearly midnight. Away from the madding crowd of scientists, they made a decision. The planned firing time of 0400 was scrubbed. Instead they agreed to meet at 2 A.M., along with the test's chief meteorologist, Jack Hubbard. A final decision could then be made. And the New Mexico desert might yet see a second sun rising over the mountains.

Groves told Oppenheimer to get some rest. There was nothing to be done until later. The general went off to his tent and fell into a deep sleep. Oppenheimer obediently returned to his own tent. But he did not sleep. He lay wide awake, smoking and coughing his thick, heavy cough, while the lightning lit up the northern horizon and the wind blew dust devils around the camp.

THREE

WHILE GROVES SLEPT and Oppenheimer smoked, Winston Churchill drove over to Truman's villa in Babelsberg to meet the new president. Together with Jimmy Byrnes, Truman's dapper, wily, South Carolinian secretary of state, they sat down in the grand drawing room whose German owners had only recently been evicted by the Russians. Despite Truman's fears, the two men got on immediately. "He is a most charming and clever person," wrote Truman in his diary that night. For his part, Churchill was attracted by Truman's "gay, precise, sparkling manner." He was also impressed by Truman's immense determination. It was clear the new president was a man of decision. The two-tone shoes and natty suit were not mentioned.

There was no set brief for this meeting. But behind the informal, easy tone lay a deeper agenda: Stalin and the war in Japan. Four years ago, the Russians had signed a nonaggression pact with the Japanese. Technically it still had a year to run. But that was about to change. Back in February, at the last Big Three conference in Yalta, Stalin had made a promise. Within three months of the cessation of hostilities in Europe, he would tear up the pact and join in the war

against Japan. On August 8, the three months would be up. In just twenty-three days, time would run out for the Japanese.

It would also run out for the Americans and the British. At this very moment, Stalin was moving more than a million troops toward his southern border with China, ready to pounce on the Japanese who occupied Manchuria. The Soviet leader could soon extend the hammer and sickle deep into China. His promise at Yalta was a harvest just waiting to be reaped. No doubt he would be more than happy to fulfill it.

Back in February, Churchill and Roosevelt had needed the Russians to help win the war against Japan. But the world at Yalta was a very different place from the world today at Potsdam. Back then the atom bomb was still a developing concept. Now it was sitting on a tower in New Mexico, waiting to be detonated in the next few hours. The bomb offered the perfect solution to a very dangerous crisis. It could win the war against Japan and it could win it quickly, before the Russians set so much as a foot inside Japanese territory. Stalin would understand then what a royal flush looked like when it stared him in the face.

As they sat in that sunny drawing room on that Monday morning, Truman and Churchill knew very well what was at stake. This was a dangerous diplomatic game, and it rested on two critical foundations. The first was that Stalin must not be told about the bomb until the last moment. If he knew, he might attack the Japanese even sooner, grabbing what he could before the Americans abruptly ended the war with their very big bang.

The second foundation was perhaps more directly pertinent. The bomb actually had to work.

JACK HUBBARD was running late for his 2 A.M. meeting with General Groves and Oppenheimer. Huddled in a portable hut near Ground Zero, the test's thirty-one-year-old chief meteorologist was busy taking last-minute readings. The hut was packed with the very

latest, state-of-the-art equipment. There were two army air force weather stations, there were radiosondes and pilot balloon wind observing sets. There were fifty years of New Mexico weather reports sitting in Hubbard's desk and fourteen experienced meteorologists to advise him, including the man who had selected the day for the Normandy invasion. And all these highly trained people, with all their wondrous, cutting-edge technology, told exactly the same story. The weather was lousy.

The latest readings made accurate predictions almost impossible. For one thing, the winds were changing course with almost dizzying speed. Over the past twelve hours, they had shifted through an entire 360 degrees. The implications were potentially disastrous. Once the bomb went off—*if* it went off—it would almost certainly suck hundreds of tons of debris and dust into a vast and extremely lethal radioactive cloud that would then travel wherever the winds happened to take it. If the winds were moving east, the cloud would head directly toward the towns of Roswell and Carrizozo. If they were moving northwest, Socorro could be hit. The only chance of this great radioactive ball not unloading its contents on top of the sleeping inhabitants of any sizable conurbation was if the wind was moving northeast. Apart from the odd rancher, a few thousand cattle, plus an unknown number of rattlesnakes, tarantulas, and jackrabbits, there were no towns up that way.

Right now, Hubbard could not predict with any certainty what the winds were going to do in the next few minutes, let alone the next few hours. At 11 P.M., they were going north, threatening Socorro. At 1:15 A.M., they were heading south, directly over the control bunker and base camp. A few weeks earlier, the test's director, Kenneth Bainbridge, had set out by jeep to chart possible escape routes out of the Jornada in case of catastrophe. He found just three: a poor road that ran southwest toward Elephant Butte, a new access road that ran north, and an old Spanish-Indian trail that meandered south through a pass in the mountains called Mockingbird Gap. To the personnel in the control bunker and base camp, Hub-

bard's 1:15 A.M. finding was of more than academic interest. It meant that one of their key escape routes was now closed.

And the winds were only part of the problem. There was the lightning too, which—as Don Hornig knew only too well—could accidentally detonate the bomb. Perhaps most dangerous of all, there was the rain. Only two months earlier, on May 11, Oppenheimer himself had written a highly classified memo to General Groves about the perils of exploding an atomic bomb in what he called "conditions of high humidity." The result, he wrote, might be to create a radioactive downpour in which "most of the active material will be brought down by the rain in the vicinity of the target area." The language may be dry, but the message was brutal. Explode the bomb in these conditions, and the result would almost certainly be a deadly radioactive cocktail just waiting to dump its poison straight back onto the ground. Oppenheimer's words were not lost on Hubbard as he cowered in his portable weather hut. Nor would they be lost on the people of Hiroshima who would experience the exact same phenomenon in just three weeks. Except their language would be more direct. They called it black rain.

To prevent the same catastrophe affecting millions of Americans, teams of fallout monitors were now stationed across the Jornada and beyond. Some of them were driving jeeps so they could chase the radioactive cloud whichever way it happened to go. All of them were in radio contact with one another, using code names borrowed from *The Wizard of Oz*. The chief monitor was the Tin Woodsman, based in Carrizozo, in the northern Jornada. There were monitors as far away as San Antonio and Fort Sumner, as well as in all three concrete bunkers positioned 10,000 yards from the tower. Headquarters were at base camp, where the test's senior medical officer would man a command post. He would also keep an open telephone line to a deputy waiting 160 miles north in a Santa Fe hotel room. If the bomb or the radioactive cloud wiped out base camp, this deputy would automatically take command. He would also direct any major evacuations from towns and cities.

The army was out there too. Twenty security officers were posi-

tioned within a 100-mile radius to coordinate those evacuations should they be necessary. One hundred twenty-five military police-men were detailed to guard the site during the test, blocking off all access routes. Another 160 men, equipped with trucks, jeeps, and extra rations, were now sitting in the rain north of Trinity, ready to rescue any remote farming communities if the fallout cloud hap-pened to go that way. The base commanders at Alamogordo and Kirtland airports were ordered to establish relief shelters, stock-piled with food and hundreds of cots, in case larger evacuations were required. They were never told why. Nor were they told why they were required to halt all civilian and military air traffic throughout the night.

Now, across the state of New Mexico, an entire population of Americans slept through this stormy night, utterly unaware of the potential dangers surrounding them. Unaware, but not entirely un-protected. After all, nobody wanted this American bomb to kill Americans. The purpose, in the end, was to kill Japanese.

FOUR

Monday, July 16
Japanese Embassy, Moscow

NAOTAKE SATO was drinking heavily these days. The Japanese ambassador to the Soviet Union knew every movement he made was watched day and night by the secret police. Technically his country was still at peace with the Soviets, but the warmth that had once existed between the two nations had cooled to freezing point. Japan was losing the war. Its cities were in ruins, its empire was crumbling, its armies were on the run. It was obvious to Sato that the Russians had little to gain from their nonaggression pact with Japan. Two days ago, Stalin and his foreign minister, Vyacheslav Molotov, had departed for Potsdam. The writing was on the wall. As Sato worked in his office near Moscow's Red Square on this humid morning, the conclusion was inescapable: the Soviet leader knew exactly where his future interests lay. And they were not with Japan.

All of which made the growing pile of cables from Tokyo on his desk depressing reading. They had been arriving almost every day, and sometimes more than once. Their author was Shigenori Togo, Japan's foreign minister, a canny, sixty-two-year-old ex-diplomat whom the emperor had brought back from retirement for one pur-

pose: to seek an honorable way out of the war. The key would be the Russians.

Just four days earlier, on July 12, the emperor had received a former prime minister and close political ally in the Imperial Palace. His name was Prince Fumimaro Konoye, and he was quickly ushered into the emperor's private apartments. The prince bowed low to the man worshipped throughout Japan as a god: the Emperor Hirohito, Son of Heaven and descendant of the Sun Goddess Amaterasu, the divinity who had inaugurated his reign in 1926 as the era of Showa, of Enlightened Peace. But the man standing before Prince Konoye did not look like a god now. He looked like what he was: an exhausted, emaciated, frightened forty-four-year-old insomniac with a twitching right cheek, a powerless and reluctant divinity living amid the ruins of his beloved city.

The emperor was unusually direct. He requested Prince Konoye travel to Moscow as his imperial envoy. Konoye's duty was clear: he must do everything possible to persuade the Russians to mediate in the war. The emperor's name would underwrite his efforts, sealing his authority and guaranteeing his plea. The Russians would understand the imperial envoy meant business. Perhaps they would agree to broker a peace from which the emperor and his people could still emerge with their honor intact.

It was a very risky strategy. There were powerful elements in the cabinet who still believed the war should be fought to the bitter end—even if this meant the mass suicide of the Japanese people. To these people, the men who espoused peace were objects of hatred. They were constantly watched by the Kempei, the Japanese secret police. Their lives were in danger. But to the emperor, to his foreign minister Togo, and to Prince Konoye, there had to be an alternative. The search for peace was becoming more desperate with each bomb dropped on a Japanese city. And the bombs were dropping every day.

The cables sitting on Sato's desk in Moscow represented Togo's latest efforts to get the Russians on board. Konoye was still waiting to leave Tokyo. Again and again, Togo urged Sato to persuade the

Russians to grant the prince an audience. But the Russians were stalling. Just three days ago, on July 13, Sato had met Alexander Lozovsky, the Russian deputy foreign minister, in the Kremlin. He had presented Lozovsky with a letter directly from the emperor, requesting consent to Konoye's mission. Lozovsky had responded evasively. The Soviet government, he said, was unclear about the terms of the visit. They needed greater clarification. Moreover, he added, all the key Soviet ministers were leaving that very night for Potsdam. A decision would have to wait.

Sato returned to his office, dejected. Behind Lozovsky's diplomatic niceties lay a stark and simple truth: the Russians were not interested. The sixty-three-year-old diplomat had been in the game too long not to recognize the realities facing his country. He understood the world outside Japan perhaps better than anybody. He had served as ambassador in innumerable European capitals. He was a tiny man, barely five feet tall, but his capacity for plain speaking was both legendary and atypically Japanese. He had never liked this war, and he did not like it now. Togo's cables were a step in the right direction, but they did not go far enough. They were too tentative, and they missed the point. There was only one way to make peace in Sato's mind: unconditional surrender. Sato had already explained this to Togo in his last cable. "The war," he had written, "has brought us to a real extremity. The government should make the great decision." If his government did not make the great decision, the consequences for Japan would be terrible. But not even Sato could imagine just how terrible.

IN HIS apartment across the lake from Truman's villa in Babelsberg, Henry Stimson examined the files on his desk. The American secretary of war was seventy-seven years old and his eyes were not what they used to be, but the message in the files was clear enough. Each one was headed "MAGIC" DIPLOMATIC SUMMARY with a number and a date. Inside each was a sheaf of typewritten papers: a carefully

decoded, meticulously translated copy of every secret cable Shigenori Togo and Naotake Sato were sending to each other across the world.

The Americans had long since broken the Japanese diplomatic codes. They were now following every move of the game. Togo's drive for Russian mediation, Sato's failures with Lozovsky, all the machinations of this desperate telegraphic communication were laid bare and exposed. Every two or three days, the "Magic" summaries were updated and sent to the president and his key advisers, including the secretary of war. The question was, what to make of them?

As he sat at his desk on that summer's morning in July, Stimson cut a curiously incongruous impression for a secretary of war. He looked every inch the old-school gentleman, almost the paradigm of old-fashioned American values, with his carefully combed white hair and fine, aristocratic features. Yet this man, born just two years after Lincoln's assassination in 1865, had spent the war years nursing the most revolutionary weapon in history. The career diplomat who had been secretary of war in 1911 under President Taft was today one of the key architects of the atomic bomb. He was the bridge between the president and General Groves, the critical link in a chain of command that stretched from Potsdam all the way back to the bomb makers now waiting for the rain to stop in New Mexico. As chairman of the innocuously named Interim Committee—inaugurated by Stimson to decide America's atomic policy—he had unhesitatingly recommended using the bomb on the Japanese. A key meeting of the committee had taken place in Stimson's Pentagon office on May 31, just six weeks ago. Its eight core members were drawn from a mix of leading government figures and distinguished scientists—men who had been associated with the bomb project almost since its inception. Included was the president's own special representative, Jimmy Byrnes, the tough, hard-line South Carolinian who would shortly be appointed Truman's secretary of state and would later accompany him to Potsdam. A four-man scientific panel was also invited, one of whose members was Oppenheimer. The military were there, too: General

George Marshall, the chief of staff, perhaps the most powerful figure in the U.S. Army; and of course General Groves. An interesting addition was Arthur Page, head of public relations at AT & T. Even at this stage, the publicity impact of the bomb was a central concern.

The committee's conclusions had been blunt and uncompromising. Stimson, with typical concision, summed them up: Japan, he said, should be bombed without warning. The target should not concentrate on a civilian area, but it should be chosen to "make a profound psychological impression on as many of the inhabitants as possible." Nobody pointed out the possible contradiction inherent in these two statements. Not even when James Conant, the president of Harvard, suggested that "the most desirable target would be a vital war plant employing a large number of workers and closely surrounded by workers' houses." Nothing was said about the families of those workers. The alternative of first demonstrating the bomb to the enemy was discussed just once—over lunch. It was rejected. There was always the danger the Japanese might fail to be impressed, especially if the device turned out to be a dud.

The following day, at the end of another session of the committee, Byrnes reported its conclusions to the president. Truman accepted its findings. "While reluctant to use this weapon," recalled Byrnes later, he "saw no way of avoiding it." A critical step had been taken toward the final order to drop the bomb; and it was Stimson who had helped to make it happen.

But Stimson also hated the bomb. In the notes to his opening speech at the May 31 meeting, he described it as a Frankenstein monster that could devour mankind. Its very existence threatened the civilized values of the world he had grown up in, and loved. With remarkable acuity for a man of his generation, he grasped the essential point about the bomb: that it changed everything, even the very nature of man's relationship to the universe. If there were the remotest chance of not using it, it would be inhuman not to seize it. Perhaps the pile of secret cables now sitting on his desk offered just that chance.

Unlike almost all the politicians and diplomats who surrounded the president, Stimson knew his Orient. As a former governor-general of the Philippines, he had visited Japan twice in the 1920s. He did not belong to the ranks of Americans who saw the Japanese as a monolithic race of half-alien fanatics. He believed there were liberal elements in the country, civilized, decent people like himself who were sickened by the killing and who wanted a way out. The Japa-nese foreign minister's pleas offered a tantalizing glimpse into that possibility. "His Majesty," Togo had cabled Sato four days earlier on July 12, "is deeply reluctant to have any further blood lost on both sides. It is his desire for the welfare of humanity to restore peace with all possible speed." Unconditional surrender was the single obstacle to that peace. Should the Allies continue to demand it, Japan had no alternative but to "fight on with all its strength for the honor and existence of the Motherland."

Even now, hours before the bomb was due to be tested in New Mexico, a window for peace might exist. Everything depended on the terms the Japanese were offered. The key, as Stimson understood very well, was their god. Guarantee them their emperor, he believed, and they would surely give the Americans their victory. Nor was he alone in his thinking. His assistant secretary, John McCloy, pressed the same point: "We should have our heads examined," he said, "if we don't consider a political solution." The undersecretary of the navy, Ralph Bard, had even resigned from the Interim Committee over the issue. "The stakes are so tremendous," he wrote in his resignation note on June 27. "The only way to find out is to try it out."

In the next few days, Truman would issue his ultimatum to the Japanese government. McCloy had already drafted a clause that permitted postwar Japan a "constitutional monarchy under the present dynasty." Stimson now had to persuade the president to accept that clause—and quickly. Let the Japanese keep their emperor, he had urged Truman in a memorandum just two weeks before, and "it would substantially add to the chances of acceptance." No invasion, no bomb, no monster.

Stimson was sleeping badly and he had pains in his chest and he was worried about his wife, Mabel, who had recently had a serious fall. But his duty was clear. The old reluctant secretary of war would pursue the peace he prayed was still possible. Before Frankenstein's monster devoured them all.

FIVE THOUSAND miles away, some of the men who had created that monster were also fighting to destroy it. As the bomb makers in New Mexico waited through the stormy night, a Manhattan Project scientist in the University of Chicago was desperately circulating a petition among his colleagues for signatures. The substance of the petition was a passionately argued appeal to stop atom bombs from ever being used. What made it unusual was that it was addressed directly to the president himself.

Its author was Leo Szilard, a squat, pot-bellied, forceful forty-seven-year-old Hungarian Jewish exile, a brilliant nuclear physicist who lived his life out of suitcases and believed he had a mission to change the world. Szilard's opposition to the bomb was positively messianic, but what made it especially ironic was that on September 12, 1933, just twelve years earlier, he had first conceived the idea of the atomic bomb in the time it took for a traffic light on a London street to change from red to green.

The idea horrified him. What horrified him even more over the following decade was that the Germans might have had the same idea. By 1939, he was instrumental in persuading the United States government to build their own bomb. With Albert Einstein, he drafted a letter to Roosevelt warning of the acute Nazi danger. There was evidence, he wrote, that the Germans were developing an atomic program. Hitler would have no compunction about using nuclear weapons. The only answer to a German bomb was an American bomb. Roosevelt was persuaded. "Pa," he said to his secretary, Brigadier General Edwin "Pa" Watson, "this requires action!" The driving force for what later became the Manhattan Project was in place: it rested, fundamentally, on the possibilities of a German

nuclear threat. Japan, with only a very fledgling atomic program, never entered into it.

By the spring of 1945, all that had changed. The Germans were effectively defeated. It was also clear that they did not have an atomic bomb. Hitler's loathing for what he called "Jewish physics" had blinded him to the temptations of almost unlimited power. The Manhattan Project's own agents had swept into Germany behind the Allied troops: the Nazis, they discovered, were years behind the Americans. At the very moment the scientists in New Mexico were busy preparing for Trinity, the whole *reason* for having nuclear weapons was fast disintegrating. Or so it seemed to Leo Szilard. From being the bomb's greatest apologist—indeed, one of its prime movers—he suddenly became its implacable enemy. He crusaded to stop it altogether. And other scientists joined his crusade.

Most of them were centered at the University of Chicago's Metallurgical Laboratory—MetLab, as it was known—which back in 1942 had built the world's first chain-reacting atomic pile in the university's squash courts. Unlike their peers in Los Alamos, they now had less work to do, and consequently more time to think. As the bomb neared completion, the moral case against its use became increasingly urgent. Szilard drove them on. With two of his MetLab colleagues, he attempted in May to persuade Jimmy Byrnes not to go ahead with the weapon—not even to *test* it. If the Russians knew it worked, he argued, they would throw all their resources into building it themselves. An unlimited arms race would be the result, bringing with it the possible destruction of the human race. Byrnes dismissed his claims. "Rattling the bomb," Szilard remembered him saying quite openly, would make Russia "more manageable." Szilard tried again: in June he sat on a committee chaired by another Chicago scientist, James Franck, to explore the bomb's social and political implications. Their concluding report proposed that—at the very least—the weapon be demonstrated "before the eyes of the representatives of all the United Nations on the desert or a barren island." The report was sent to Stimson's office. His assistant, George Harrison, took care of it. The evidence suggests that Stimson him-

self never saw it. "We waited and waited," said one of its authors, Eugene Rabinowitch, "and we had the feeling we could as well have dropped it into Lake Michigan." So Szilard tried yet another tack: he attempted to persuade Oppenheimer to join his crusade. Oppenheimer turned him down. "The atom bomb is shit," he said. "It will make a bang—a very big bang—but it is not a weapon which is useful in war." It was an astonishing remark. Perhaps Oppenheimer was simply less prophetic than Szilard. Perhaps he was blinded by the intellectual challenge of actually building an atomic bomb— what he once called a "technically sweet problem." Or perhaps he was seduced by the trappings of power and his own ambition. He preferred, in the end, to remain king of his own castle, confirming the recommendations of Stimson's Interim Committee that the bomb be used directly and without demonstration against Japan. Szilard's case was lost before he even started it.

But still he did not stop. Now constantly tailed by Groves's agents—his phones were tapped, his letters read, his every movement watched and recorded—he threw all his energies into one final effort: to make a direct appeal to the president himself. Once again he pleaded that the bomb not be used. His words resonate with frightening prescience. "A nation which sets the precedent of using these newly liberated forces of nature for purposes of destruction," he wrote, "may have to bear the responsibility of opening the door to an era of devastation on an unimaginable scale." He had collected sixty-nine signatures—most of MetLab's leading physicists, and some of its biologists and chemists—when Oppenheimer and Groves were waiting for Jack Hubbard's final weather report in Trinity's base camp. The era of devastation was only a few hours away, but Leo Szilard was by now so distrusted that he was not even allowed to know today was the day.

FIVE

Monday, July 16, 2:08 A.M.
Base Camp, Trinity Test Site

By THE TIME Hubbard arrived at base camp for his 2 A.M. meeting, he was eight minutes late. He was also drenched. The full force of the storm had just hit the camp. Within seconds, the rain had churned the dust into viscous pools of black mud. He was barely out of his jeep before Groves immediately tore into him. "What the hell is wrong with the weather?" were his first words, as if it were all Hubbard's fault. He demanded a specific time when the test could go ahead. Hubbard began to explain the meteorological processes behind the storm. Groves abruptly cut him off. He hadn't asked for explanations, he said; he'd asked for a specific time. Hubbard argued he was trying to give him both. He believed the storm would collapse with the first rays of the sun. The weather should be clear by dawn. By now, Groves's blood was up. Even Oppenheimer—himself hardly a model of philosophic calm—tried to pacify him. Hubbard was convinced Groves was going to call off the test altogether. But he did not. Instead he ordered Hubbard to sign his own forecast. "You'd better be right on this," Groves told him, "or I will hang you."

A few minutes later, Groves phoned the governor of New Mexico,

rousing him from a deep sleep. As always, he was blunt. He told the governor he might have to declare martial law during the night. Forcible evacuations could well be necessary throughout the state. The two men had discussed this possibility a few weeks previously. Then it seemed remote. Now the dangers were all too real. If the shot went ahead, nobody could predict the outcome. Bleary-eyed and half-awake, the governor knew better than to argue. Groves was running this show.

He was, after all, in his element. This was what he did best. Despite the pressures he was under, he did not break. He was able to make decisions when everybody else around him, including the director of his laboratory, was unable to do so. In a curious way, it was almost as if he reveled in this moment—Leslie R. Groves's finest hour, when the fate of the world rested on his shoulders. In this hour, he could bludgeon governors of states and move whole communities from one end of New Mexico to another. Groves was never afraid of power, and just now his power was arguably greater than that of any man alive. His fingers were in every pie—scientific, political, and military—and over the next three weeks they would stretch across the world: from this wilderness in deepest New Mexico, to Potsdam in war-battered Germany, and finally all the way to Japan.

He was powerful, but he was also careful. Perhaps regrettably in Groves's view, America still had a free press. He was acutely aware of the potential public relations disaster now hanging directly over his head. In just a few hours, half of New Mexico might go up in smoke, taking with it a number of the world's leading scientists. Not even Groves could put the lid on *that* story. It was essential to be prepared. And typically, he was. Sitting in his Foggy Bottom safe back in Washington, along with the classified documents and the chocolate bars, were four different press releases covering four different outcomes to the test. A reporter attached to his staff had prepared them as far back as May, two months earlier. Each described an accident in which a remotely located ammunition dump had blown up by mistake. They went all the way from this:

Several inquiries have been received concerning a heavy explosion which occurred on the Alamagordo Air Base reservation this morning. A remotely located ammunition magazine containing a considerable amount of high explosive exploded. The cause is as yet unknown but an official investigation is now proceeding. There was no loss of life nor injury to anyone and the property damage outside of the explosives magazine itself was negligible.

To this:

The premature explosion of material intended for use as an improved war weapon resulted today in the death of several persons on the reservation, including some of the scientists engaged in the test.
Among the dead were:

(Names)

As is normally the case with considerable amounts of high explosive, the effects were noticeable for several miles.

Of course, there was also another possibility: that the bomb failed to go off at all. It was a fear Groves lived with every day of his life. He even joked about it from time to time, in one of those jokes that was not entirely funny. "If the gadget proves to be a dud," he told a colleague in the days running up to Trinity, "I will spend my life so far back in a Fort Leavenworth dungeon they'll have to pump sunlight in."

TWENTY MILES northwest of Ground Zero, up on Compania Hill, the reporter who wrote those press releases sat in a bus and watched the rain dripping down the windows. His name was William L. Laurence, and he was here to write up the biggest story of his career. Just two days ago, on July 14, Laurence had arrived at Los Alamos on the final stage of his journey to Trinity. From there

he mailed a letter to his editor at the *New York Times*. "The story," he wrote, "is much bigger than I could imagine. When it breaks, it will be an eighth-day wonder, a sort of Second Coming of Christ yarn. It will need about twenty columns on the day it breaks."

Laurence was another of Groves's finds. A tough, pugnacious, tirelessly energetic journalist with a thick Slavic accent and a jutting chin, he was virtually a one-man incarnation of the American Dream. He had come to the United States from Lithuania in 1905 as a penniless refugee, worked his way through Harvard Law School by teaching the sons of the rich, and had since become one of the country's most brilliant and successful science reporters. With one Pulitzer Prize already behind him, he turned his attention, in September 1940, to the revolutionary new science of atomic physics. The result was an article for the *Saturday Evening Post* with the innocuous title, "The Atom Gives Up." It was an astonishingly prescient piece. In a few choice paragraphs, it predicted a world in which the almost limitless possibilities of atomic power might be harnessed for man's benefit—or his destruction.

At the time, nobody appeared to pay the article any attention. It simply disappeared into oblivion. Only later did Laurence discover that the FBI had pulled that particular edition of the *Saturday Evening Post* out of every library across the United States. And they did not stop there. They also investigated every individual who asked to see it. The long arm of what was to become the Manhattan Project already ran the length and breadth of the country. It was only a matter of time before its spotlight finally turned on the author. Laurence knew too much. He was far too dangerous to leave outside the nuclear fold. So they brought him inside, to work for them. And the man who made that decision was General Groves.

By then, Bill Laurence was working for the *New York Times* as a science reporter. Groves made an appointment to meet the managing editor, Edwin L. James. For extra clout, he brought his chief of intelligence and counterintelligence along with him. As always, he was direct. He told James the project needed Laurence and it needed him for several months. He also said Laurence would continue on

the *Times* payroll for security reasons and that stories should occasionally appear under his byline to suggest he was still actually writing for the paper. Groves did not state any of this as an offer. There was no appeal. Laurence, in effect, was to be requisitioned.

It was an inspired choice. Laurence's selection suited everybody. He turned out to be the most dedicated apologist of nuclear power the Manhattan Project could ever have wished for. His zeal for atoms was positively messianic. He was never happier than when describing all those cosmic fires that man's genius would spread over the face of the earth. On a more mundane level, he was also perfectly happy to draft as many press releases as Groves could throw at him. Months before the first bomb was dropped on Hiroshima, Laurence had written the draft presidential statement to be released to the press immediately after that event. Almost the only word left blank was the one he did not yet know: the name of the city.

Laurence's choice was also good news for the *New York Times*. They were guaranteed the scoop of the century, even though they had no clue what would be revealed. On May 17, 1945, Laurence had written a top secret three-page memo to General Groves entitled "Plans for Future Articles on Manhattan District Project." All of these would of course be "subject to approval," by which Laurence presumably did not mean the approval of his editors at the *New York Times*. There were twenty-nine articles listed, and they ranged from subjects like the early history of the Manhattan Project to an eyewitness account of the first combat use of a nuclear weapon. This last was a little premature since the first test bomb was still two months away from demonstration, but Groves had agreed in principle. Laurence would certainly get to ride one of the missions to Japan and witness firsthand just what his dream atomic power could do to a real city.

By the time of the test, a significant number of these articles were already written and filed away in Groves's safe. Now, as he sat in the bus on Compania Hill, Laurence began to take notes. It was 2:30 in the morning. To the southeast, twenty miles away, he could

see a single searchlight flashing in the sky. He knew what that was: Ground Zero.

A shortwave radio linked Compania Hill to base camp, but it kept shorting out. One of Los Alamos's most brilliant physicists, Richard Feynman, was trying to fix it with the help of a flashlight. Until or unless he succeeded, none of the scientists up there had any idea when—or if—the bomb would fire. Laurence fumed silently in the shelter of the bus. If only they had allowed him to get closer. Twenty miles—he was too far away. Even if the thing went off, he would never see it properly. He was out of the loop. The thought that he might miss the biggest scoop of his career was enough to drive him mad. After all, hadn't Groves read that memo properly? It was all there, in black and white. Item number 23: "An eyewitness account (in case eyewitness survives) of the first test with bombs." He had even written his own obituary.

SOMETIME IN the night, Don Hornig finally got his telephone call. It was his boss Kistiakowsky, telling Hornig he could come down at last. Gratefully, Hornig shut his unread thriller, stood up, and squeezed past the bomb. He stepped onto the top rung of the ladder. The steel tower dropped beneath him in the rain, its wet girders and cables gleaming in the powerful beams of the searchlight Bill Laurence also saw from his bus window. He looked back at the bomb for the last time. There it sat, inert, cold, quiet, skulking in the darkness of its tin home. Hornig turned away, and began to descend.

At the bottom he climbed into a jeep, huddling under the canvas cover as protection against the rain. Cold and wet, he raced off through the sagebrush, back to the warmth and coffee and companionship of the base camp mess, where Fermi and his fellow-scientists were still taking bets on whether the bomb up there would destroy the earth in the final minutes before dawn.

SIX

TWELVE HUNDRED miles northwest of Ground Zero, in the predawn darkness of one of the United States' largest naval bases, two army trucks drove onto a wharf and pulled up alongside the USS *Indianapolis*, a heavy cruiser. A team of heavily armed marines jumped down and took up position around them, weapons held ready. The flaps at the backs of the trucks were opened. From the decks above, sailors stared down. Loading operations did not normally take place at this time of the night. Whatever was in those trucks was obviously very unusual.

From the first truck, a wooden crate emerged. It was big, perhaps five feet high, five feet wide, and fifteen feet long. A gantry crane on board the *Indianapolis* secured it, then lifted it up into the night sky. Once over the ship's side, it was carefully set down in the hangar ordinarily used for observation planes. Some of the sailors took guesses what was inside it. The running bets were on toilet rolls for General MacArthur. Or maybe Rita Hayworth's underwear.

The crate attracted all the attention. Almost nobody noticed the object that emerged from the second truck. It was hardly worth

comment: just a bucket-shaped cylinder less than two feet high and eighteen inches in diameter. The only odd thing was that two sailors were needed to carry it. It was suspended from a crowbar on their shoulders, and it was obviously very heavy. Two army officers followed them up the gangplank onto the ship. There was something a little odd about them too. They were dressed in artillery uniform, but they appeared to be wearing their insignia upside down.

The two officers followed the sailors and the bucket into the flag lieutenant's cabin, where it was welded to the floor. The sailors then left. One of the officers removed an instrument from his valise and held it next to the bucket. It began clicking slowly and regularly, like a heartbeat.

The ship's captain, Charles Butler McVay, waited on the bridge. In a little over six hours, he was due to depart. Everything about this mission unnerved McVay. Only the day before, he had been abruptly summoned to Admiral William Purnell's headquarters in San Francisco. The admiral had introduced him to a lean, balding navy captain in his forties called William "Deak" Parsons. The two men came straight to the point. They ordered McVay to prepare his ship immediately for a highly secret mission. He was to sail at maximum speed across the Pacific. His destination was Tinian Island, a tiny speck in the ocean 1,500 miles south of Japan. The ship would travel alone and without escort. It would also carry two pieces of very special cargo.

McVay was not told what the cargo was. He was simply informed that it was more important than anything else on his ship, including the lives of its men. If the ship went down, the first lifeboat went to the cargo. He was also told that every day he saved on the trip would cut the length of the war by just that much. Then he was dismissed.

As McVay now waited on the bridge, one of the artillery officers with the upside-down insignia climbed up. He told McVay that the bucket was secure. He also said it was padlocked, and that he would keep the only key. McVay studied him a moment. "I didn't think we were going to use bacteriological weapons in this war," he said. The officer made no reply. Then he left the bridge.

In New Mexico, the time was 3 A.M. General Groves had just threatened to hang Jack Hubbard. Don Hornig was sitting down over coffee and powdered eggs in the base camp canteen. The final pieces were locking into place for the test of the world's first atomic bomb. But in Hunter's Point naval base, a very different drama was taking place. In these quiet, dark hours before dawn, preparations were rapidly moving ahead for the world's second atomic bomb. The one they would drop on a city.

The two men with the upside-down insignia sitting over their bucket in the flag lieutenant's cabin were not artillery officers at all. Their names were James Nolan and Robert Furman, and they were working for Groves. The big wooden crate sitting in the *Indianapolis*'s hangar did not contain toilet rolls or underwear. It contained a key component for that bomb, a specially designed high-velocity cannon weighing half a ton. The lead-lined bucket welded to the deck of the two men's cabin did not contain bacteriological agents. It contained approximately half of the 141 pounds of weapons-grade uranium that would explode over Hiroshima in three weeks' time.

With less than three hours to go before the first bomb was tested, the second bomb was already on its way.

AT 0400 THE WINDS at Ground Zero began to veer in the direction Jack Hubbard had been praying for: to the northeast. The rains also eased, and the thick clouds scudding overhead at last began to break. The weather was not perfect, but for Hubbard it was acceptable. No doubt he could feel General Groves's noose hanging over his head. At 0445 he discussed his findings with Kenneth Bainbridge, the test director. After a hurried telephone conference with Groves and Oppenheimer, the final decision was made. Zero hour was set for 0530, just half an hour away. The test was on.

In the concrete control bunker five and a half miles south of Ground Zero named S10,000, Bainbridge inserted a key into a padlocked metal box. Inside were switches for the bomb's arming and timing circuits. One by one Bainbridge flipped them on. The final

switch controlled the bomb's firing circuit. From here, cables snaked back through the miles of sagebrush to the tower, then up the steel girders to the tin hut until they reached Don Hornig's X-unit bolted to the rear of the bomb. Bainbridge flicked the switch on, closing the circuit. The electrical pathway to the X-unit was now clear. The bomb was armed.

The control bunker at S10,000 was a small room, just twenty feet by twenty feet, but each square foot was crammed with instruments, dials, oscilloscopes, gauges, cables, knobs, boxes, panels, racks of fuses, half-eaten sandwiches, and empty coffee mugs scattered in haphazard confusion on desks, tables, even on the floor. Despite the electrical equipment there were puddles from the rain everywhere. With all this paraphernalia, there was almost no room for the dozen or so scientists. In one corner, Hornig and Bainbridge squeezed together over their apparatus. In another, Kistiakowsky sat hunched at a table over his dials. Oppenheimer stood by the door, a thin, fragile, exhausted figure, looking up at the sky. Although there was still some mist in the west, the skies to the east were now clearing rapidly. The winds were light and gentle. It was even possible to see a few stars.

The time was now 0510. In a tiny cubicle to the side of the bunker, a middle-aged man sat holding a microphone. His name was Sam Allison, and his role was about to become one of the most important in this test. In a moment, he would begin the twenty-minute countdown toward zero. For the last time he checked his watch. Just a few days ago, his wife had collected it from a repair shop in Santa Fe. The watch had sentimental value for Allison. His wife knew he wanted it urgently. He did not tell her why.

Allison switched on the microphone. Outside, the loudspeakers hissed into life. He began to count. Suddenly his voice was drowned by the deafening strains of the "Star-Spangled Banner." Radio KCBA, broadcasting from Delano, California, had just begun its morning Voice of America show. Somehow its wavelength had crossed with Trinity's. It was too late to do anything about it now. As the scientists, guards, and radiation monitors huddled in their

bunkers to the north, west, and south of Ground Zero, Allison's voice and the National Anthem echoed in strange harmony across the lonely desert. Meanwhile in California, KCBA's listeners would spend the next twenty minutes hearing a man counting backward.

AT BASE CAMP, General Groves watched the single searchlight playing on the northern horizon. He and Oppenheimer had already agreed to witness the test from separate positions. The program might survive the death of either one of them. It could not survive both. Not far from Groves was Philip Morrison, the man who had carried the bomb's plutonium core in its shock-absorbing suitcase all the way from Los Alamos. Now he was busy relaying Allison's countdown to base camp from a sound truck. For a moment he stopped, reaching down to pull his socks up and trouser legs down as far as they would go. He wanted to be sure no part of his skin was directly exposed to whatever the bomb out there threw into the sky—or, more precisely, at him. He knew that 360 highly radioactive isotopes of plutonium would be created at the instant of fission. He also knew the potential hazards of ultraviolet light traveling directly toward him at 186,000 miles per second. The trousers and socks may not have been much, but they were better than nothing.

All around Morrison, men were now burrowing themselves into trenches. Most of them had brought along welder's goggles or pieces of strongly tinted glass. Everyone had been advised to lie facedown away from Ground Zero and not look up when the bomb exploded. The light was sure to be brilliant, but nobody could be sure just how brilliant. One man chose to ignore this advice. Enrico Fermi was standing on a mound to get a better view. Now he was rapidly tearing up pieces of paper and making swift calculations on his slide rule. He smiled at Herb Anderson, a fellow scientist. "Just watch," he said. "I'll know the yield before anyone."

Up on Compania Hill, twenty miles northwest of Ground Zero, Bill Laurence watched the Hungarian physicist Edward Teller smear suntan lotion over his face and arms. Others were following his ex-

ample. For the past two years, Teller had been working on what was euphemistically known in Los Alamos as the "Super": the hydrogen bomb. The sight disturbed Laurence. Perhaps Teller knew something the *New York Times* reporter did not. It was eerie to see some of the world's most celebrated scientists wearing sunglasses and rubbing sun cream on themselves in the pitch darkness of the desert night.

Nearby, Richard Feynman had finally managed to get the short-wave radio working for a few minutes. Then it suddenly died again. This time nothing could coax it back into life. But at least everybody up on Compania knew the test was now very close. Laurence was still irritated they had stuck him so far away. From this distance—twenty miles—he would never observe anything useful. He settled himself uncomfortably on the hard ground. One of the project's scientists called him softly from behind: "Don't worry," he said, "you'll see all you need to. We want our chronicler to survive."

To the left and right of Laurence, all along the ridge, men lay facedown and shivered in the predawn cold. Most of them huddled together, as if for comfort. One man, however, remained apart, sitting alone on a small hillock. He was a curious-looking individual, with his thin, owlish, bespectacled face and bulging forehead. He hardly spoke to anyone, and when he did, it was with a distinctly foreign accent. But everybody knew who he was. In fact, throughout Los Alamos he was renowned: as an enthusiastic three-step waltzer, a jazz lover, an extremely reliable babysitter, as well as one of the most brilliant mathematicians on the project. The one thing nobody knew was that he was also a Soviet spy. His name was Klaus Fuchs, and he had already fed the Soviets information about the program seven times, most recently on June 2, just six weeks ago. Truman and Churchill's chat this very morning in that sunny Babelsberg drawing room five and a half thousand miles away rested largely on a fantasy. What they agreed to tell or not tell Stalin about the bomb was irrelevant. Thanks to Fuchs, he knew most of it already.

Now Fuchs fixed his welder's goggles over his eyes and waited to see what he could tell the Russians next.

Five miles above the desert, two B-29 observation planes flew in wide circles, the men on board straining to catch a glimpse of the searchlight at Ground Zero far below. At the height they were flying there was still an overcast, and it was almost impossible to see anything. The lingering aftereffects of the night's storm had also created a bizarre spectacle. A strange blue fire appeared to burn around the two planes, streaming over the wings and past the windows, leaving a luminous wake in the sky. At times it looked as if the bombers were riding incandescent waves of blue light. It was called Saint Elmo's fire, and it occasionally happened after a major storm. But to the men on the planes it was still unsettling, especially now, in the final minutes before zero.

One of the observers staring through the windows at the light was Deak Parsons, the balding naval officer who had interviewed the captain of the *Indianapolis* the day before. An outstanding ballistics expert, he was perhaps the key figure in the development of the bomb as a droppable, deliverable weapon. He was a quiet, serious, technically brilliant man who enjoyed the complete confidence of both Oppenheimer and Groves. So much so that they had entrusted him with a monumental responsibility. In three weeks' time, he would sit in a B-29 just like this except with one difference: the bomb would be in the bomb bay and not on the ground. It would be Parsons's job to babysit it all the way to Japan.

Tonight was the dress rehearsal. Parsons needed to see what an atomic explosion looked like from 25,000 feet. As the B-29 slowly descended toward the clouds, he could hear Allison's countdown over the headphones. It was 0523. The big bomber banked gently to the northeast, still trailing a beautiful blue glow in the sky.

At zero minus five minutes, a short siren blast wailed across the desert. Seconds later, a green rocket flared up into the sky.

Through the loudspeakers, the hollow strains of Tchaikovsky's

Serenade for Strings mingled with Sam Allison's countdown. Voice of America's early morning classical music show was now in full swing.

All over the Jornada, radiation monitors sat at their shelters or in their trucks, listening to the countdown over the radio. Soldiers detailed to supervise possible evacuations smoked last cigarettes as they waited outside the lonely desert towns. Cameramen and photographers made final adjustments to their equipment, polishing lenses, checking exposures with their flashlights. To the east, over the Little Burros, the faintest gleam of light was now discernible. Dawn was not far away.

Outside the control bunker at S10,000, armed guards sat in jeeps, their motors idling, ready to evacuate the scientists at an instant. Inside the bunker, Don Hornig stared at a control panel in front of him. There were four lights on it. Right now they were all blank. Exactly forty-five seconds before zero, his colleague Joe McKibben would throw the switch closing the automatic timing circuits for the bomb. Once Hornig saw his four lights go red, he would know the X-unit was charged, ready to disgorge its five and a half thousand volts to the bomb's sixty-four detonators. After that, if anything went wrong, the only way to stop the bomb from blowing up was to cut the power to the X-unit.

Next to Hornig was a knife switch controlling the power. He figured he had perhaps half a second to react if there was a problem. Half a second to abort the world's first nuclear bomb. It was enough to make anyone a little crazy. He turned to Oppenheimer and made a joke. "What's likely to happen, Oppie," he said, "is that at minus five seconds I'll panic and say—Gentlemen, this can't go on—and then I'll pull the switch."

For a long moment Oppenheimer stared at him. "Are you all right?" he asked.

AT ZERO minus two minutes, the siren wailed again, a slow, stretched howl that seemed to hang forever in the desert air.

At zero minus one minute, a red rocket spat up into the sky. It was 0528.

Philip Morrison, the man who had ferried the bomb's core all the way from Los Alamos, hunkered down on the ground. The camp looked like a place of the dead. Shadowy bodies lay everywhere, immobile and silent. It felt as if everybody was collectively holding his breath, waiting for whatever it was out there by the tower and the sweeping searchlight to do its worst. Morrison wondered what that worst would be. Tonight it was a test, at best a beautiful, brilliantly conceived scientific experiment. In just a few days, perhaps, it would be the real thing. Morrison was not the only scientist who almost wished the bomb would fail. Like many, he was caught in a trap of desire and horror. The physicist in him wanted to see the experiment succeed. The human in him wanted to see it fail. Sometimes, like Leo Szilard, he even questioned whether it was necessary at all. Now that the threat of a Nazi bomb had disappeared, its purpose was uncertain. The only certainty was that the power they were about to unleash in the next minute would change the world forever.

On SANDIA PEAK, 110 miles to the north, Lilli Hornig watched the first rays of the sun touch the mountains to the east. The storm had disappeared. It was going to be a lovely day. The test had obviously been scrubbed, she thought. They would only fire in the dark. She dumped her sleeping bag in the trunk of her car, quite forgetting that up here at 10,000 feet the sun rose earlier than it did down on the wide plains below.

Forty-five seconds before zero, exactly on cue, Joe McKibben pulled the switch triggering the automatic timing sequence. All the circuits to the bomb now closed. Don Hornig stared at his panel, waiting for the four red lights to glow. Right behind stood Kistiakowsky, looking over his shoulder. His entire reputation, not

to mention a month's salary, now rested on whether the troubled X-unit would finally work. Hunched against the racks of equipment to their left was Thomas Farrell, the general who had felt the plutonium core in his rubber gloves two days earlier. A First World War veteran, all he could think of now was how much worse this was than going over the top. Over in base camp, General Groves's very last thought was what would happen if the countdown got down to zero, and nothing happened.

The red lights on Hornig's panel flicked on. The X-unit was energized and ready. His eyes were glued to the panel. His hand still rested on the knife switch, waiting for the word to abort. Allison's countdown passed the ten-second mark. Everybody in the shelter braced himself. Farrell noticed how Oppenheimer scarcely breathed. In the last moment he suddenly grasped a beam, as if to steady himself. Somebody heard him murmur, "Lord, these affairs are hard on the heart."

And then, in the final seconds before zero, a strange new noise filled the air. Only later would the men who were there learn what it was. It was the noise of frogs, hundreds upon hundreds of them, mating in the dawn. They had come up from the surface after the long night of rain, slipping into the cool, sandy puddles. In the instant before the bomb ripped open the sky, the only sound in the desert was the sound of life in the act of creation.

FIFTY MILES north of Ground Zero, an eighteen-year-old girl was traveling in the front seat of a car next to her brother-in-law, Joe Willis. The girl's name was Georgia Green, and Joe was driving her to an early-morning music lesson in Albuquerque. They still had some way to go. As they passed the town of Lemitar along an empty Highway 85, a flash of extraordinary brilliance suddenly filled the landscape. Georgia grabbed her brother-in-law's arm. "What was that?" she cried.

Joe stared at her. Georgia Green was blind.

SEVEN

Monday, July 16, 5:29 A.M.
Ground Zero, New Mexico

It rose from the desert like a second sun, a searing, brilliant, expanding ball of fire, and it struck terror into everyone who saw it. In the first millisecond it resembled something horrifyingly alien, a giant, fleshy, brainlike shape with shooting points of fire, and the skies split before it. In that same millisecond, the very instant of its birth, the temperature at its core was 60 million degrees centigrade, ten thousand times hotter than the surface of the sun, and its blinding flash was far brighter. It bathed the mountains and the desert with a beauty and a clarity that nobody who witnessed it would ever forget. Its impact was monstrous and elemental. Within seconds, the brainlike substance had sucked thousands of tons of sand, dust, sagebrush, juniper bushes, rattlesnakes, jackrabbits, mating frogs, bits of pulverized steel tower, and every kind of organic and inorganic matter from the earth's bowels into a mammoth, rapidly expanding radioactive cloud. It swelled up into the sky, punching through the clouds at 5,000 feet a minute, climbing higher than the highest mountains until it seemed to touch the edge of space. To Bill Laurence, twenty miles away on Compania

Hill, it felt as if he were present at the Creation of the universe, the moment when God said, "Let there be light."

Those who were closer felt the impact of that light much more forcefully. To Isidor Rabi, one of the scientists at base camp thirteen miles away, it blasted, pounced, and bored its way like a drill into the backs of his eyeballs. It was a shocking, painful, visceral sensation he prayed would stop but that seemed to last forever. In fact it lasted two seconds. To Philip Morrison, also at base camp, it felt like a blinding, burning heat, as if somebody had suddenly opened a hot oven inches from his face. To General Farrell, watching even closer from the control bunker, it was stupendous, magnificent, and terrifying, an act of blasphemy in which puny man had dared tamper with the forces of the Almighty. "The long-hairs have let it get away from them," he yelled, as the fireball mushroomed into the sky. And for a moment it really did seem as if Fermi's fears had come true and the world was about to end.

Those first few seconds of the atomic age unrolled in an almost eerie silence. But behind the light came the sound, tearing through the desert at twelve miles a minute, and it arrived, as Farrell would remember for the rest of his life, like the roar of doomsday. A million hammer blows struck the Jornada and the Oscura peaks with a noise that numbed the senses like a physical shock and broke windows 120 miles away. The mountain ranges bounced the sound back and forth across the desert and the ground trembled as in an earthquake. To Bill Laurence it sounded like the first cry of a newborn world. Along with the sound came the shockwave, a hundred billion atmospheres of pressure ripping outward from the core like a hurricane, except this hurricane moved initially at several hundred miles per hour, as fast as a modern passenger jet, battering and blasting everything in its path. Even in the concrete, sandbagged control bunker nearly six miles away several observers were knocked to the ground. One of them was Kistiakowsky. He jumped up and slapped Oppenheimer excitedly on the back. "You owe me ten dollars," he cried. A dazed Oppenheimer pulled out his wallet. "It's empty," he replied, "you'll have to wait."

At base camp, the blast wave arrived forty seconds after zero. Standing on his mound, Fermi tossed his pieces of paper directly into it, measuring the distance they were carried on the wind. He grabbed a slide rule and rapidly calculated the size of the blast: the equivalent, he found, of 10,000 tons of TNT, almost five times the total weight of bombs dropped on Dresden on the night of its destruction. It was a brilliantly virtuoso guess, but it was also wrong. In fact, the yield was twice as great. It would need 5,000 bombers, each carrying a full load of conventional explosives, to match it. And all this awesome, inhuman power came from a piece of plutonium very slightly larger than a tennis ball.

Don Hornig had rushed out of the control bunker the instant Allison's count hit zero. As the flash flooded the desert, he tore up the stairs. Then he looked up. The huge, expanding cloud boiled up into the skies almost directly above him like a mountain growing out of the earth. But the most astonishing spectacle was the colors, a glorious riot of luminescent pinks and blues and greens spilling out of the cloud before themselves unfolding whole spectra of new colors, until the sky became one vast and dazzling fireworks display. It was the most beautiful sight Hornig had ever seen in his life.

All over the Jornada, men cheered and shouted and sang as the pyrotechnic wonders raged above them. Others watched in horror. Henry Linschitz, one of the physicists who had designed the bomb's detonators, stared in disbelief. My God, he said to himself, we're going to drop *that* on a city. Normally sober, rational men were seized by an almost animal passion. On Compania Hill, Bill Laurence observed little groups of scientists suddenly dancing with strange, primitive rhythms, clapping their hands and leaping from the ground as if this were some ancient fire festival or rite of spring. Others elsewhere also reverted to primitive instincts. At base camp, General Groves's first words were, "We must keep this whole thing quiet." An engineering officer stared at him: "Sir," he said, "I think they heard the noise in five states."

In fact all of southern New Mexico, as well as large swaths of Arizona and western Texas, had heard the blast. In Carrizozo, 40 miles

away, several people believed they had just experienced an earthquake, as did a forest ranger near Silver City, 125 miles on the other side of the state to the west. The Smithsonian Observatory on Burro Mountain registered a shock, but something about the vibrations was wrong. They were uniquely and inexplicably different from any other earthquake ever recorded. The brilliant light was witnessed as far as 180 miles away. Lilli Hornig saw it as she switched on the ignition in her car on Sandia Peak. She stared openmouthed through the windshield at the floodlit horizon. Ed Lane, an engineer on the Santa Fe Railroad, saw it as he was approaching El Paso, 70 miles to the south. It looked as if the sun had suddenly risen on the wrong side of the earth. Many others who saw it believed that the end of the world had come. Lewis Ferris, a native of Carrizozo, was terrified for a different reason. He ran up and down the streets yelling that the Japanese had invaded.

ON BOARD the B-29 observation plane, Deak Parsons had slipped on his goggles just before zero, when an intense light suddenly filled the sky. The bomber was twenty-five miles from the tower, heading northeast. Within seconds the seven-tenths cloud cover beneath turned a violent orange-red color, as if lit by a giant bulb from the ground. A red ball of fire burst through the undercast, mushrooming into an enormous multicolored cloud. It raced past the bomber's altitude of 25,000 feet until it reached more than 40,000 feet—eight miles up into the sky. Everybody on board was hollering over the intercom. Parsons, ever the technocrat, began making notes. In the next forty-eight hours he would be leaving for Tinian Island on the other side of the Pacific, the same destination as the USS *Indianapolis* carrying its lethal cargo. Within days, he would have to brief bomber crews about the awesome spectacle outside the window. It was important he remember it right. The next time he saw anything like this, it would be over a Japanese city.

As the cloud topped out in the stratosphere, the air around it ionized, leaving a luminous violet afterglow in the sky. From the ground it looked as if the light were filtered through a purple lens stretching across the sky. It was the final curtain call, and like everything else in this drama, it was both beautiful and frightening. After the elation and the excitement, people were now noticeably quieter. Perhaps it was sheer exhaustion. Or perhaps the realities of what they had just seen were beginning to sink in.

Over the eastern mountains, the real sun now began to rise. It seemed to many a pale imitation of the man-made one. Oppenheimer returned by jeep with General Farrell to base camp. Groves was waiting for him. "I'm proud of you," he said. "Thank you," Oppenheimer replied. Farrell said the war was over. "Yes," said Groves, "after we drop two of these bombs on Japan."

Oppenheimer sent a message to his wife, telling her she could now change the sheets. There would be a party tonight in Los Alamos. His old friend Isidor Rabi watched him as he strode across the camp. Something in Oppenheimer's bearing chilled his flesh. "I'll never forget the way he walked," he said later. "It was like *High Noon*—I think it's the best I could describe it—this kind of strut. He'd done it." Gone was all the fragile self-doubt, replaced by something quite different: the intoxicating certainties of power.

His test director, Kenneth Bainbridge, came up to him, numb and exhausted. He held out his hand. "Oppie," he said, "now we are all sons of bitches."

In potsdam, it was 3:30 in the afternoon. With Stalin not expected until tomorrow, Truman decided to do a little sightseeing. Along with Jimmy Byrnes, his secretary of state, and Admiral Leahy, the White House chief of staff, he climbed into the backseat of an open Chrysler convertible and drove off to see the ruins of Berlin.

On the way, he stopped to review the U.S. Second Armored Division. The troops lined the road toward Berlin. Their nickname

was "Hell on Wheels," and they were the biggest armored division in the world. It took the president's convoy twenty-two minutes to ride from one end to the other. Here was American power at its mightiest and most concrete. "We drove slowly down a mile and a half of good soldiers and some millions of dollars worth of equipment," he wrote, "which had amply paid its way to Berlin." The relationship between cost and effect, between cash and power, was one that Truman would not be slow to recognize again.

The presidential party then drove into Berlin. The spectacle that greeted them was awesome and terrible. For more than five years Allied bombs had rained down on the city. In the last weeks of the war, the Russians had poured a never-ending rain of shells and rockets directly into its heart. Four million people had once lived here, and now there was barely a house or building intact. The destruction was literally everywhere. Every wall was savaged with shellfire, every window a gaping hole, every street a smashed litter of craters and rubble and gnarled metal. Nothing grew or flourished except weeds and disease. Truman's Chrysler slowly edged through a world from which all color had been drained, and with it all hope.

But it was the survivors who affected the president most. From the windows of his car, he gazed at the never-ending processions of broken, dislocated people, refugees in their own city. "We saw old men, old women, young women, children from tots to teens," he wrote in his diary, "carrying packs, pushing carts, pulling carts . . . and carrying what they could of their belongings to nowhere in particular." The spectacle haunted him. This, he said, is what happens when one man overreaches himself. Berlin's ruin was Hitler's folly.

The president's car slowly drove out of the battered city, back to the sunny suburban tranquillity of Babelsberg. The jagged, broken skyline with its hopeless millions receded behind. But the experience hung like a lead weight on Truman's mind. His diary that night is untypically philosophical. "I hope for some sort of peace," he wrote. "But we are only termites on a planet and maybe when we bore too deeply into the planet there'll be a reckoning—who knows?"

He would not have to wait long to find out.

THE FIRST person to enter Ground Zero was a scientist called Herbert Anderson, and he went in a lead-lined Sherman tank weighing twelve tons and carrying its own oxygen supply. It was now 7 A.M., just one and a half hours after the test. As the tank trundled slowly over the desert toward the place where the tower had once stood, the Geiger counters on board went off scale. The tank ground to a halt. Through a heavily shielded periscope, Herbert Anderson stared at the world outside.

A strange, greenish substance glittered in the morning sun on every side. It was smooth and it looked like glass and it stretched out from Ground Zero to a radius of perhaps 400 yards. The sagebrush had entirely vanished. Anderson had never seen anything like it before. He radioed back to base that the area had turned "all green." In fact it was a bizarre chemical mutation. The thousands of tons of sand sucked up into the fireball had fused into glass before being hurled back on the ground. This alien greenish substance was the result. It surrounded Anderson's tank like a petrified green sea. Later it was given a name: Trinitite. Like the fireball from which it was created, it was lethally radioactive.

Slowly Anderson panned the periscope across the site. The one hundred-foot steel tower where Don Hornig had spent the night had completely disappeared. The only trace of its existence was its massive concrete stumps, and these had been slammed seven feet into the earth. Half a mile away, another thirty-two-ton, six-story steel tower lay tossed like a child's plaything on the ground, a smashed and twisted wreck of mangled girders. An enormous crater now surrounded Ground Zero, 1,200 feet in diameter and 25 feet deep. The force of the bomb's blast had literally hammered the earth open.

Within a mile of Zero every living thing was dead. Every animal, every insect, every tree, every blade of grass. Nothing had survived. With an irony so perfect it seemed almost deliberate, a huge number of the instruments set up to measure the blast had also been destroyed by it. Across the desert they lay smashed and scorched and

bent. Most of the cameras that had not been shielded by lead were destroyed. Much of the film had been blackened and fogged by the extreme radiation. And the radiation was everywhere.

Even in Anderson's lead-lined tank, the levels were beginning to rise. He did not stick around too long. At the edge of the crater, he quickly fired off a tethered rocket into the ground, scooping up samples of soil and Trinitite with a specially designed claw. Then he signaled the driver to return to base camp. Clumsily, the tank turned away from the crater, lumbering across the slippery green surface of bomb-blasted glass.

At 7:30 that evening, Secretary of War Henry Stimson was in his villa in Babelsberg when he received a cable from Washington. It came from George Harrison, his assistant at the Pentagon.

> *TOP SECRET*
> *Number WAR 32887*
> *To Humelsine for Colonel Kyle's EYES ONLY from Harrison for Stimson.*
>
> *Operated on this morning. Diagnosis not yet complete but results seem satisfactory and already exceed expectations. Local press release necessary as interest extends great distance. Dr. Groves pleased. He returns tomorrow. I will keep you posted.*

Stimson immediately replied:

> *From: TERMINAL*
> *To: War Department*
> *To Secretary General Staff for Mr. George L. Harrison's EYES ONLY. From Stimson. TOP SECRET*
>
> *I send my warmest congratulations to the Doctor and the consultant.*

Stimson left his villa and crossed over to the Little White House. He found Truman sitting in his drawing room with Jimmy Byrnes swatting mosquitoes. It was a warm summer's evening, and the windows were open to the lake and the gardens. The president scanned Harrison's cable. "I feel fine," he said, "it's taken a great load off my mind." Then he told an old Kansas joke about a girl who said she would drown herself if she discovered she was pregnant. It is not recorded if any of his audience laughed.

LATER THAT EVENING, Stimson returned to his villa. Somewhere still in his office were the "Magic" intercepts he had read earlier that day. They were all there: the Japanese ambassador's hard-headed realism, the Japanese foreign minister's desperate pleas for an honorable surrender. In those carefully translated, typewritten pages lay exposed the latest chapter in Japan's stumbling steps toward some kind of peaceful solution. But now there was a new dimension. Now there was the bomb: no longer a putative threat, but a physical, achieved, brutal actuality.

Perhaps, thought Stimson, there was still a bridge across which the president and the Japanese could meet. Perhaps Truman could yet be persuaded to let the Japanese keep their emperor, to give them the honorable surrender their foreign minister craved. The more moderate, unfanatical parties in Japan might yet be encouraged to deliver a peace before this man-made Frankenstein destroyed them all.

Stimson prepared for bed. The old, tired, aristocratic statesman who had nursed the bomb through the long wilderness years would try once more to prevent it from being actually used. As the secretary of war, he knew better than anybody just how little time was left.

THE USS *Indianapolis* set sail at exactly eight o'clock in the morning, Pacific War Time, just three and a half hours after Trinity blew

its great glass hole in the ground. The crew were at morning colors as the heavy cruiser eased under the Golden Gate Bridge thirty-six minutes later.

In happier times, she had carried President Roosevelt on his tour of Latin America. He had famously dined off fresh venison in her mess and watched Laurel and Hardy movies in her cinema. Now she carried a crate and a bucket and two fake artillery officers who sat in their cabin day and night with a padlock and a key and a Geiger counter.

On the bridge, Captain McVay rang for full speed. The ship's 107,000-horsepower engines turned her four massive screws faster and faster in the water. A boiling white wake of foam marked her path as she cut through the waves, unescorted and alone, out into the open ocean.

The dress rehearsal was over.

ACT II

DECISION

JULY 18–28, 1945

The responsibility taken by Mr. Truman was essentially, I think, the responsibility taken by a surgeon who comes in after the whole patient has been opened up and the appendix is exposed and half cut off and he says, "Yes, I think he ought to have out the appendix—that's my decision."

GENERAL LESLIE GROVES

The atomic bomb was no "great decision." . . . Not any decision you had to worry about.

PRESIDENT HARRY TRUMAN

EIGHT

Wednesday, July 18, Morning
In the Western Pacific, North of Tinian Island, Marianas

Bob caron lit up another cigarette and stared out of the bullet-proof glass at the empty expanse of sea. From here, high up above the ocean, it seemed to go on forever. There was nothing to relieve the endless monotony of the view. Once or twice he picked out the odd volcanic island, one tiny pimple in the middle of the ocean, like the small island they had just practiced bombing. But other-wise it was all sea and sky for a million miles whichever way he looked, and the roar of four Wright R–3350 engines beating in his head, and the hot sun burning a hole through the turret's wind-screen. No wonder Caron smoked his way through a mission. Half the guys did. Back here in the tail, ninety feet behind the flight deck, there was not much else to do.

You had to be small to fit in the turret. Caron was only five foot five and he weighed less than 120 pounds, but even for him it was cramped. This was certainly not a place for claustrophobes, what with the General Electric gun sight and its gyroscopic motors and the five-inch automobile ashtray and the photo of Kay and baby Judy dangling from the oxygen chart on a chain. Some guys got

lonely back there too, especially when they went up to 30,000 feet and had to pressurize. Then you were cut off completely from the rest of the plane, clamped into your tiny pressurized cubicle, holed up all alone for hours on end watching the world go backward until someone up front finally decided it was time to come down again.

But Caron never got lonely. The little turret with all its clutter was home to him. Plus there was always Kay to look at. She was so beautiful, with her jet-black hair and sparkling eyes. He had hand-tinted the picture himself. Sometimes it was hard to think they had been married less than a year. Perhaps even harder to think they now had a baby daughter. Judy looked very cute in Kay's arms. Caron remembered how the crew had celebrated her arrival at the Fontenelle Hotel in Salt Lake City just a couple of months back, chucking empty whiskey bottles out of the eighth-floor window until the management turned them out. That was right near the end of their training. He had only seen Judy once. There was barely time to get to Dodge City where she was born before they left the States to fly 6,000 miles out here to Tinian Island. He often wondered when, and if, he would see her again.

It had taken four days to cross the Pacific, island hopping all the way from their base at Wendover in Utah. The day they left, June 27, their captain, Bob Lewis, had tipped the B-29 on its wing, screaming past the control tower so low you could see the guys running for cover inside. Lewis was always pulling crazy stunts like that. He was a great pilot, but Caron often got the feeling maybe he was trying too hard. Many of the guys disliked him. He was only twenty-six, the same age as Caron, but he could be a little wild sometimes. It was a standing joke how they had flown all the way across the Pacific with a cargo of bootleg whiskey, not to mention the box of condoms or the garter belt picked up from some girl back in Salt Lake.

Still, their B-29—call sign Victor 82—had performed flawlessly all the way. She was a beautiful machine, a gleaming, glittering, brand-new silver bird with the number 82 on her side and a big black arrow on her tail. There was nothing in the world like the '29.

She could fly faster, farther, higher, and she carried a bigger bomb load than any other bomber ever built. She was as tall as a three-story house, an aerodynamically perfect weapon of war, with her four massive engines, her slim, tapered wings, and that great glass greenhouse in her nose. The view up front was glorious. To her pilots, it sometimes felt like riding a magic carpet.

Caron would never forget the day the boss picked out Victor 82. Colonel Paul Tibbets had flown up to the Glenn L. Martin plant in Omaha, twenty-five football fields of B-29s in various stages of assembly, and the foreman had pointed directly at 82. "Trust me," he had said, "that's the one you want. It was built midweek, not on a Monday." Even the screws in the toilet seat had been given an extra turn. A couple of months later, Bob Lewis was sent to collect her. One of the factory girls kissed her for luck. Lewis flew her back to Wendover at zero feet, whooping and laughing and kicking up the dust all the way. But it was Tibbets who had chosen her. She was his baby. There was only one thing she was missing: a name.

The engine note changed pitch as the plane began to descend. They had been in the air nearly five hours. And all they had to show for it was a few 500-pound general-purpose bombs dropped on one volcanic rock. Today it was the island of Guguan, last week it was Marcus and Rota. They all looked the same from six miles up. Caron was beginning to wonder what the point of it all was. For ten months they had trained in the empty salt flats of Utah. They had done all kinds of strange things out there. They had dropped curious bulbous-shaped bombs from 30,000 feet onto targets marked out in concentric rings on the desert floor. They had practiced fantastically steep high-altitude turns, standing the big bombers on their wingtips before diving them to earth at terrific speeds. They had even taken their B-29s down to Cuba, flying endless low-level navigation exercises up and down the Caribbean. They had flown hard for days and weeks and months. And now they were ready. Caron remembered how way back in September when they started training, Colonel Tibbets had stood on a soapbox in front of one of

the hangars at Wendover and told them their mission would end the war. They were forbidden to ask what that mission was. They knew only they had been chosen for something very special and very secret. Yet here they were, halfway around the world in the middle of nowhere, dropping bombs on a few half-starved Japanese hiding on rocks.

The big plane banked low over the sea. Through his prescription sunglasses—he was the only nearsighted gunner in the outfit—Caron could see a patch of green sliding under the wingtip, the lines of breakers rippling against its shores. He had been here just two weeks but this view of Tinian never ceased to amaze him. It looked like a giant aircraft carrier. Its flat, treeless plateaus were scarred with six of the biggest runways Caron had ever seen. Each one stretched 8,500 feet, dead-straight ribbons of crushed coral dazzling in the sun. It was quite a sight. Especially now, as Bob Lewis gently lowered the silver bomber over one of those runways until its wheels kissed the earth.

It was the biggest air base in the world. A dot in the Pacific Ocean, 1,500 miles south of Japan, twelve hours' flying time there and back. One year earlier, in July 1944, the Americans had taken Tinian from the Japanese after seven days of vicious fighting. The enemy troops were pushed back to the southern tip of the island. Some of them surrendered. Others leaped to their deaths off the place the Americans afterward called Suicide Cliff. A few hid in the limestone caves that punctured the island's only hill, Mount Lasso. And from these caves they watched the island undergo an astonishing transformation.

With their diggers and their cranes, the construction battalions—the Seabees—followed hard behind the troops, building roads, camps, warehouses, generators, sewage systems, and fuel depots. They built the docks to which the USS *Indianapolis* was now sailing at full speed with its lead-lined uranium bucket. And they built the

runways. Within a matter of months they had completed all six of them, two on West Field and the other four on North Field, where Bob Caron's plane landed.

North Field was, quite simply, unique. Its parallel runways ran east to west like a giant grid stamped on the bare plateau, linked by miles of taxiways and hundreds of hardstands. Its innumerable fuel dumps, bomb dumps, and support facilities supplied as many as 265 B-29s. And they flew almost every day. Nose to tail they lined up on the taxiways, engines roaring, wings trembling, awaiting their turn to depart from runways Able, Baker, Charlie, or Dog. The ground shook as they took off exactly one minute apart, carrying their loads of jellied gasoline and incendiary bombs to the wooden cities of Japan. Together with other B-29s from nearby Saipan and Guam, they destroyed Tokyo over a single night on March 9, killing an estimated 100,000 people. That was just the beginning. Over the next four months, they went on to incinerate another fifty-seven Japanese cities. Night after night, they slogged up the so-called Hirohito Highway, perfectly fulfilling the objective of their commander, General Curtis "Iron Ass" Le May, to "scorch and boil and bake to death" the cities of Japan. Over a matter of months the little Japanese airfield that had once stood on North Field had swollen into an awesome affirmation of American can-do and raw power.

Every bomber group on Tinian joined in this machine of mass destruction except one: Bob Caron's group. These men never flew with the others. They never even flew to Japan. They had inexplicable powers and privileges: within weeks of arriving they had ejected the Seabees from the best living quarters on the island. They had every comfort, every whim attended to. They had the best showers, the best whiskey, the best caterer who cooked the best steaks. They had five fridges and several washing machines. They even had their own private movie theater, the Pumpkin Playhouse, with seating capacity for a thousand. Whenever they wanted ice cream it was said they simply took one of their B-29s up to 30,000 feet with a tub of the stuff in the bomb bay to freeze it—the $25,000 dessert, it

was called. They also had a very odd name: the 509th Composite Group. Everybody knew what a bomb group was. But what was a *composite* group?

The rumors had started back in May, almost as soon as the group's advance party arrived. By the time their first B-29s with the big black arrows on the tail had made the long haul across the Pacific, the rumors were raging around Tinian like an epidemic. Suddenly everyone was talking about the 509th. Within days the whole island seemed to know that they were over here to win the war. How they were supposed to do *that* was anybody's guess, but they were certainly different from everyone else. Even their planes were different. They looked like B-29s but they had some very odd features. For instance, they were almost entirely unarmed—their only protection was a tail gunner. They had unique bomb doors that were pneumatically driven, opening and shutting in the blink of an eye. And they could taxi *backward*! They had reversible pitch propellers that nobody else had, and they sometimes used them to reverse into parking bays like sports cars rather than swing around in a great big lumbering arc like ordinary mortals. Their bomb hooks were strange too, British Type G attachments that were only ever used on British Lancasters carrying very big bombs. And their bombs were even stranger: huge, swollen, ellipsoidal things weighing five tons.

As for their security, it was something else. The parking area for their B-29s was in an isolated corner of the base. It was very heavily restricted. The guards there had strict orders to shoot anybody who attempted to get too close. One man had already tried. General John "Skippy" Davies was the commander of the 313th Wing, which meant he was also technically responsible for the 509th. But the moment he approached one of their B-29s he was immediately challenged by a sentry. The general asked if the sentry knew who he was. The sentry replied that he did, but he would still have to shoot the general if he put so much as one foot nearer that plane. That was as close as "Skippy" Davies got to any of the 509th's B-29s.

Of course the real irony was that the rumors spinning around

the island were nothing compared to the gossip spinning inside the 509th. Bob Caron was not the only one wondering what he was doing here. So were all the rest of his crew. So were all the other fourteen B-29 crews in the group. So were hundreds of its ground personnel. None of them knew exactly what it was they had spent so long training for. There was only one man who did know: their commander, Colonel Paul Warfield Tibbets. And he was keeping his mouth shut.

NINE

Wednesday, July 18
Operations Office, 509th Compound, Tinian Island

H E WAS GOOD at keeping his mouth shut. That was one of the reasons why he was chosen for the job. That, and the fact that he was also one of the best B-29 pilots in the air force. Bob Caron once said Tibbets could talk to airplanes the way some people talked to animals. He was a squat, square-faced, blue-eyed man with thick black eyebrows and a pugnacious chin, a man who used words sparingly but to great effect. Some of the men worshipped him and some loathed him, but one look at that face and you knew he was not a man to cross. Nobody ever called him Paul. He was always the colonel.

Even the two men sitting next to him in the 509th's operations room would never have called him Paul, and they knew him better than anyone. Tom Ferebee was his group bombardier, a dashing, poker-playing, lady-killing Errol Flynn look-alike with sixty-three combat missions behind him. He had served with Tibbets on B-17s over Nazi-occupied Europe and North Africa. Dutch Van Kirk was his group navigator, a brilliant chemistry major whose baby-faced appearance belied his fifty-seven missions at the age of twenty-

four. He too had served with Tibbets over Europe. Again and again, these three men had flown across the North Sea in their freezing Flying Fortresses to face some of the most dangerous fighting of the war. And they had survived. They were as close-knit a team as anyone in the group. Tibbets had chosen them especially because he knew they were outstanding aviators. Yet even to them he was still the colonel, the chief, the boss with the hard-assed stare who demanded 110 percent from everybody under his command—including himself.

Together these three men sat in the operations hut near the heavily guarded entrance of the 509th compound. This was a large rectangular area, filled with neat, symmetrical rows of metal Quonset huts and tropical flower beds and trim coral paths gleaming in the sunshine. It was perfect for Tibbets's needs: comfortable, close enough to the air base, above all isolated. From the air Tinian looked a little like Manhattan, and in a fit of homesickness the construction battalions had named the roads they built after New York City streets. There was a Broadway, unlike the real thing, a dead-straight six-mile highway, a Forty-second Street and a Wall Street, even a livestock reserve in the middle of the island called Central Park. The 509th compound was up on 112th Street and Eighth Avenue. Back home that was Columbia University territory, one of the key institutions where research on the atomic bomb had first begun. Tibbets had chosen his headquarters well. In a very real sense, the Manhattan Project had finally returned to Manhattan.

The table in front of the men was littered with reconnaissance photographs and maps. But these were not photographs and maps of obscure volcanic islands in the Pacific Ocean. They were targets in Japan. They were oil refineries and marshaling yards, industrial and manufacturing plants, steel and aluminum factories. Tibbets fully understood the realities of the schedule to which General Groves was now working. He had only just missed the Trinity test, but he was aware of its outstanding success. He knew the last pieces of Groves's jigsaw puzzle were finally coming together. The time for

his crews to practice dropping 500-pound general purpose bombs on tiny, barely defended rocks was over. In just two days, on July 20, the 509th would direct their focus to the enemy's homeland for the first time. The training was about to shift into its highest gear.

The targets and routes were laid down with very specific goals in mind. The navigators would learn to fly them until they could do it almost blindfolded. The radio operators would learn to listen on the correct frequencies until they could do it automatically. The radar operators would get their first feel for the enemy's radar environment. The pilots would learn to fly those crazy sixty-degree turns over enemy territory, and possibly under enemy fire. The bombardiers would learn to drop those strangely shaped bulbous bombs on real targets. And the Japanese would become used to the sight of single high-flying American bombers, which only ever dropped one bomb.

Of course the bombs would be real bombs. They were called "pumpkins" because of their swollen shape, and they were filled with 6,300 pounds of a very powerful high explosive. Each one cost as much as a brand-new Cadillac. In the jargon of the time, they were highly effective "blockbusters," and if the rumor mills suggested that these were the bombs with which the 509th were going to win the war, then Tibbets was not about to disabuse them. After all, he was one of very few men in the group who knew the real story. He was aware that these bombs were ballistic models for other bombs that would contain something rather more powerful than high explosive. Not even Tom Ferebee and Dutch Van Kirk knew that.

In the course of the day the planning was completed. The first mission would depart in forty-eight hours. Ten bombers were earmarked to fly. Bob Caron and his crew would not be among them. They still needed to complete their induction training. Nor would Tibbets be going. He was expressly forbidden to fly over enemy territory by order of General Henry "Hap" Arnold, chief of the army air force. He was too dangerous to lose. He knew far too much.

IN TRUTH, he was born to drop bombs. He was only twelve when he went up for his first airplane ride with a barnstormer pilot named Doug Davis. Davis worked for the Curtiss Candy Company, and he gave Tibbets the job of dropping cartons of Baby Ruth candy bars over Miami Beach out of the backseat of his tiny red-and-white Waco biplane. The candy bars had little parachutes attached to them and Tibbets spent one of the happiest hours of his life chucking them over the side of the cockpit. Many of them fell directly on top of the Hialeah racetrack grandstand. His aim, he liked to say later in life, was excellent. The experience no doubt stood him in good stead for the mission that was to make him famous—or infamous—throughout the world. It also provided his first taste of the unholy alliance between airplanes and bombs. For the rest of his life he would remain a confirmed believer in both.

He had been handpicked for this job. One day in the summer of 1944, General Hap Arnold was presented with a short list of the best three bomber pilots in the air force. One of them would go on to lead the atomic missions. Tibbets's name was on the list. He had many of the right qualities. At twenty-nine he was young, but not too young. He had plenty of combat experience in Europe and North Africa. He was probably the most experienced B-29 test pilot in the air force. Flying sixteen hours a day, six days a week, he virtually wrote the book on how to handle the plane against enemy fighters. He was tough, flexible when necessary, a man who could be all granite authority one minute and break rules the next, brave, self-willed, unorthodox, ruthless, egotistical, utterly single-minded in his pursuit of perfection. Above all, he was a man who got results. Of the three names on General Arnold's short list, he was the obvious choice to lead the world's first atomic mission. There was only one outstanding question: could he be trusted with the biggest secret of the war?

For several weeks in that summer of 1944, General Groves's agents snooped around the dusty corners of Tibbets's life. They

spoke to so many of his friends and family that his own father called him up to ask if he was in some sort of trouble. "Not that I know of," said Tibbets. Then one September day he was ordered up to Colorado Springs, to meet the commander of the Second Air Force, General Uzal Ent. No sooner had he arrived when a security officer took him into the men's room and began asking a series of highly personal questions. He seemed to know more about Tibbets than Tibbets himself. His last question was very direct. Had he ever been arrested? Tibbets thought about that one. Ten years ago the police had picked him up for having sex in the backseat of a car on a Florida beach. The security officer waited. Everything depended on Tibbets's answer. Would he lie?

Tibbets's decision to tell the truth effectively sealed his place in history. Within minutes, he was back in General Ent's office, where he was introduced to two men. One of them was a youthful-looking scientist, Norman Ramsey. The other was Deak Parsons, the naval officer who would one day witness the Trinity test from the cockpit of a B-29. Ramsey told him about the atomic bomb. It was, he said, the most destructive weapon in history. By next summer it would be ready. And Tibbets had just been chosen as the man who would drop it. General Ent added the last word. "If you succeed you'll be a hero," he said. "But if you fail, you'll go to prison."

Typically, Tibbets did not waste time. His brief, as he later put it with characteristic concision, was to wage atomic war. Almost immediately he was sent to Los Alamos to be indoctrinated into the mysteries of the atom. Everything he saw there astonished him. Here were people talking about a single bomb equivalent to the punch of two thousand fully loaded bombers—it was beyond belief! He met Oppenheimer, who told him that Captain Parsons would be flying the first atomic mission with him. Tibbets smiled at Parsons. "Good," he said, "then if anything goes wrong I can blame you." Parsons did not smile back. "If anything goes wrong, Colonel," he said, "neither of us will be around to be blamed."

Within days, Tibbets had requisitioned a base for training oper-

ations and a squadron to train. The base was at Wendover, out in the empty salt flats 120 miles west of Salt Lake City, a place so remote and forlorn and windswept that one of the more desperate occupants attempted to put a sign over the gate saying WELCOME TO ALCATRAZ. Jake Beser, an electronics countermeasures officer who would one day fly both atomic missions to Japan, summed it up succinctly: "If the North American Continent ever needed an enema," he wrote, "the tube would be inserted here at Wendover."

He spoke for many. Life on the base was not exactly well appointed. The bachelor officers quarters was a desolate collection of ill-heated barrack huts rattling in the winds that howled off the desert flats. Outside the barbed-wire perimeter was the town of Wendover itself, a grim one-street huddle of ramshackle buildings with a population of 103. Almost the only remarkable thing about Wendover was the fact that this one street straddled the state line between Utah and Nevada. In fact the border went right down the lobby of the State Line Hotel, which meant that the inmates of the air base could enjoy a nonalcoholic meal in Utah before stepping five feet across the lobby into Nevada to get riotously drunk and gamble. That was pretty much it for entertainment in Wendover. Bob Hope once essayed a short visit and won the enduring affection of the men stationed there when he called it "Leftover Field." Unlike them, however, he was able to get out.

Everybody hated Wendover except Tibbets, who loved it. Here he could build and prepare his team in total secrecy. The place was so far from anywhere that no one would be tempted to stray. Everyone could concentrate on his job, away from prying eyes. Almost as soon as Tibbets made the decision to move in, the all-powerful wheels of the Manhattan Project began turning. General Groves had ensured that Tibbets would have the highest priority for anything he needed in the air force. He had only to utter the magic word *silverplate*—the unique code word chosen for this program— and the gates of the kingdom would open.

Officers who far outranked the squat colonel with the steely face

would capitulate when the word was uttered. He wanted Wendover? He got Wendover, and he got it very quickly. He wanted a squadron? He got the 393rd Bombardment Squadron, a nucleus of highly experienced airmen who were on the point of shipping out to the Pacific until they suddenly found themselves dumped in Utah instead. He wanted specialized personnel? He got them all, including his old combat partners Tom Ferebee and Dutch Van Kirk, as well as Bob Caron and Bob Lewis and a cheery cigar-smoking Irish-American pilot called Chuck Sweeney, all of whom had worked with Tibbets on the B-29 testing program.

Silverplate gave Tibbets unholy powers. Over the next months the core bombardment squadron mushroomed into a sizable empire. There was an Air Engineering Squadron, an Air Service Group, a Military Police Company, an Air Materiel Squadron, a Special Ordnance Squadron, and a Troop Carrier Squadron. The whole ensemble made up the 509th Composite Group, activated in December 1944 directly under Tibbets's command. By then he had so many airplanes out in Wendover, his men called it Tibbets's Private Air Force. He even had his own airline, dubbed the Green Hornets after a popular radio show of the day, and he used the planes to fly anywhere he wanted, anytime he needed. He had all the latest equipment, including big four-engined C-54s like the one the president used for his personal transport, and of course the special stripped-down B-29s that would later excite envious stares in Tinian. By the time his crews had worn out the first batch of specially modified B-29s in March 1945, they simply ordered another batch, with even further refinements. In no time they got these too, including the one with no name that Bob Lewis hedgehopped all the way back to Wendover.

Tibbets whipped them on like a slave driver. Day after day they flew out to the ranges at Alamogordo or Salton Sea, dropping their practice bombs from six miles up. High-altitude bombing was a black art in 1944, and for the first few weeks almost everyone kept missing the target rings marked out on the desert floor. So Tibbets

sent them back until they began to achieve results, consistently hitting the target within 200 feet. Even then he was not satisfied. The order of the day, as he later put it, was to drill, drill, and further drill his crews, until the best of them could hit the ground within just twenty-five feet of the bull's-eye. In the very top league, perhaps not surprisingly, was Tom Ferebee, an ace baseball player who had nearly played for the St. Louis Cardinals until the war got in the way. An equal talent was Kermit Beahan, another veteran from the European front, a cool, dab-handed Texan whose bombing skills were so phenomenally accurate that his admiring crew named their B-29 bomber after him: *The Great Artiste.*

Nobody dared question why they were dropping bombs from halfway up into the stratosphere. Or why they kept practicing those crazy steep turns immediately after the drop. The technique was to throw the B-29 into a sixty-degree diving turn for exactly twenty-eight seconds, building up the speed to well over 350 miles per hour. This was not the sort of maneuver for which such a big plane was ever designed. The whole ship would scream and shudder on the very edge of the stall, every rivet groaning and bucking under an extreme form of aerodynamic torture. Get it wrong by a few degrees, pull just a little too hard on the controls, and the wings would rip off before you could blink. Tibbets never got it wrong. "That was better than the quarter ride on the Coney Island Cyclone, Colonel," a breathless Caron would call Tibbets from the tail. And Tibbets would laugh and tell Caron he owed him twenty-five cents.

Of course what Tibbets did not tell Caron—or anyone else—was why they were up there doing aerial acrobatics in a heavy bomber in the first place. But Tibbets knew. On that very first visit to Los Alamos, Oppenheimer had told him bluntly that he could not guarantee his survival. Even bombing from extreme altitude would not necessarily protect him or his crew. The bomb's shockwave might crush the B-29 like a giant's hand swatting an ant. Doubtless Tibbets was prepared to take that risk for his country, but he also had no particular wish to die. In an article written after

the war with the disarming title "How to Drop an Atom Bomb," he revealed the secret behind the steep turns. The key was to get out of the lethal zone ahead of the explosion, turn away as steeply as possible, and outrun the supersonic shockwave before it hit the fleeing bomber. It was an entirely unorthodox maneuver. Tibbets made his crews practice it again and again because nobody knew just how many bombs there would be when the time came, and every one of his fifteen crews might have to drop one. Never once did Tibbets tell them that their lives depended on getting it right.

In the end, secrecy was everything. Half the buildings in Wendover were plastered with signs reminding everyone to keep his mouth shut. One of them was at the exit. WHAT YOU HEAR HERE, WHAT YOU SEE HERE, WHEN YOU LEAVE HERE, LET IT STAY HERE, it declared in bold black letters, and the message was taken very seriously. As well as his own private air force, Tibbets had his own private gestapo—the term is his own—and its thirty-odd agents prowled around the windy air base, eavesdropping on conversations and scrutinizing the most inadvertent slips of the tongue. Several failed the test. Within hours these unfortunates were packed off to sit out the war in places like northern Alaska where, as Tibbets later wrote, they could "talk to their heart's content to any polar bear or walrus they found willing to listen." His gestapo kept detailed psychological and personal profiles on every member of the 509th. Tibbets knew all there was to know about them: their drinking habits, their sex lives, their friends, their families, their politics, their temptations. It was all there in the files. He judged every man as he judged himself: was he competent and could he keep his mouth shut? Nothing else mattered. He tolerated all kinds of peccadilloes where more straitlaced commanders would have balked. He turned a blind eye to the bootleg whiskey, the irate fathers of unmarried daughters, the flood of police complaints about bar brawls and inebriated drivers, even the antics one notorious night in a Salt Lake City hotel when a naked redhead was observed running down a corridor pursued by a bunch of his

drunken pilots. As long as they did not talk and did their jobs, Tibbets would protect them.

It was a philosophy he practiced across the board. Within the 509th he employed a convicted murderer, three men who were guilty of manslaughter, and several felons. All of them had escaped from prison and had since enlisted under false names. Now they were working usefully at Wendover as technicians. None of them was aware Tibbets knew their real identities until the day he called them in and told them that if they did their jobs properly, he would give them their files after the war and a box of matches to burn them with. What counted was not their criminal record but their skills. The morality of the case did not concern him. The bedrock of his thinking was utilitarian, as it would be when the time came to drop an atomic bomb. It is partly what made him so effective. Yet the strain must have been tremendous: to be the only man among nearly two thousand who knew the secret. It put a terrible burden on his marriage to Lucie, his pretty, sociable Georgia-born wife. The marriage would finally buckle after the war, perhaps in its own way another casualty of the atom bomb.

But the truth is that the secret held. At about the time the 509th began shipping out to Tinian, the Japanese Imperial Staff compiled a detailed estimate of every American military unit in and out of the country. Dated May 8, the report says: "One other unit is available but its identity has not been ascertained as yet." That unit was the 509th. Right up to the end, the Japanese had no idea what was about to hit them.

ON THAT SAME Wednesday, July 18, as Tibbets planned his unit's first mission to Japan, President Truman called on Joseph Stalin in his villa across the lake in Babelsberg. It was their second meeting. The day before, Stalin had paid a social visit to Truman at the Little White House. The Soviet leader had worn his brand-new fawn uniform with the red epaulets, having recently promoted himself from

marshal to generalissimo. Truman had persuaded him to stay to lunch, where they ate a good hearty American meal of fried liver and bacon washed down with a bottle of California wine. Stalin had been especially diplomatic about the wine. Truman quickly summed him up. Uncle Joe, he thought, was clearly "honest—but smart as hell." He also thought that at five foot five he was astonishingly small. The absolute ruler of 180 million people was actually "a little bit of a squirt."

Today it was Stalin's turn to play host. Truman had already enjoyed a busy morning inspecting the Scots Guards and lunching with Churchill. There the two allies had agreed to delay any mention of the bomb to the Soviets. By three o'clock Truman was in Stalin's villa facing the first of innumerable Russian toasts. He was especially amused to note that the "Man of Steel" kept surreptitiously substituting white wine for vodka in his glass.

"I must tell you the news," said Stalin, as they stood by the window overlooking the lake. He waved a piece of paper in front of the president. It was a copy of the letter from the Japanese emperor with its urgent request that the Soviets receive the imperial envoy, Prince Konoye, as soon as possible—the very letter that Naotake Sato had presented to Lozovsky at the Kremlin five days ago. Truman glanced at it. Nothing in his face betrayed the fact that he already knew its contents, not to mention the whole story of Japan's peace feelers to the Russians. He was not about to enlighten the Soviet dictator about the translations his code breakers were sending him every day.

Stalin prodded him: should he answer this communication? Truman replied guardedly that he had "no respect for the good faith of the Japanese." Perhaps, said Stalin, the best thing would be to offer "a general and unspecific answer" to the cable. He could instruct his government to say that the imperial envoy's mission required further clarification. Perhaps, in the end, it might be desirable "to lull the Japanese to sleep."

To lull the Japanese to sleep. It suited both men perfectly. Stalin

could gain a little extra time moving his millions of men and tanks up to the Manchurian border. Only yesterday, over the fried liver and bacon, he had told Truman that he would join the war by mid-August. That was now three weeks away. As for Truman, the last thing in the world he wanted was a Soviet-mediated peace. Hundreds of thousands of young Americans had not paid the ultimate price for *that*. The peace would be agreed on American terms: *unconditional* surrender, the very surrender Japan's foreign minister explicitly rejected in all those secret cables to his ambassador in Moscow. Stalin's offer to lull the Japanese to sleep was perfect. It gave Truman just the time he needed to prepare his new bomb. Then he could enforce his ultimatum demanding unconditional surrender. The weight of atomic attack would quickly destroy Japan's will to fight, and the war would be over before a single Russian foot stepped across the Manchurian border. And so the president nodded and told Stalin that his proposal was "satisfactory."

There is a photograph of the two men standing on the balcony immediately after this meeting. They are both smiling broadly, especially Truman, who appears the very image of avuncular charm and confidence. He had plenty to smile about. With Trinity behind him, the war was as good as won. He wrote as much that night in his diary: "Believe Japs will fold up before Russia comes in. I am sure they will when Manhattan appears over their homeland."

The Japanese could send out all the peace feelers to the Russians they liked. But nobody out there was listening.

TEN

Friday, July 20, Morning
Imperial Palace, Tokyo

Within the moated sanctuary of his palace, the Emperor Hirohito waited for news from Russia. For the past week his ambassador in Moscow had repeatedly tried and failed to interest the Soviets in any kind of peace mediation. They had "postponed" any decision to allow the imperial envoy, Prince Konoye, to fly to the USSR. They had demonstrated an absolute unwillingness to enter into negotiations with a nation they clearly regarded as already beaten. And yet Hirohito still clung to the hope that all this might change. Perhaps Konoye would yet be permitted within the walls of the Kremlin. Perhaps some kind of negotiated settlement with the Americans might yet be possible, before they ran out of cities to bomb.

Every day, the pains in his stomach were growing worse. He was finding it almost impossible to sleep at night. Occasionally he would seek refuge in his beloved pursuits, butterfly collecting and marine biology, which had so distinguished him in his earlier, happier years. Most of the time he wandered aimlessly through the gilded halls of his palace in old clothes and carpet slippers. The few aides admitted to his presence saw a man who had become quite in-

different to his appearance. Even his servant would sometimes find him in his bathroom, a toothbrush in one hand, staring vacantly at the mirror and mumbling to himself. His right cheek twitched uncontrollably. In these twilight days, the emperor's conviction of his own mortality had a practical basis in fact. His tragedy, perhaps, is that he felt that mortality most when it truly hurt.

He knew the gamble he was taking with the Russians. He also knew that the gamble could quite possibly cost him his life. He was aware there were fanatics who would kill even him—the emperor—to preserve their nation's honor. It had almost happened once before, in 1936, when a group of army officers had staged an attempted coup. Hundreds of rebels had streamed through the streets of Tokyo in an orgy of killing. One of them had actually penetrated the inner chamber of the palace and threatened the emperor's life. He had survived only by sheer dint of his authority, boldly standing up to the man and daring him to disturb the imperial presence. Instead of killing him, the soldier prostrated himself and fell on his own sword. Now the stakes were far higher. This time the emperor had dared to confront the fanatics in his own war council. In the end, they might not be so ready to fall on their swords.

The step he had taken was unprecedented. His role as emperor was not to decide but merely to acknowledge the decisions of his government. As a proclaimed divinity, he sat high above the sordid machinations of men and politics. So when, six weeks ago on June 8, the Supreme Council for the Direction of the War offered him their blueprint for continuing the struggle, he simply did what he had always done, and accepted it. The blueprint had a name. It was called the "Basic Policy for the Future Conduct of the War," and the basic policy it finally boiled down to was uncompromising, fanatical resistance to the bitter end. The policy openly advocated the use of women and children as human shields. It advocated the metamorphosis of Japan into a giant fortress, and every Japanese citizen into a soldier. The entire might of the nation would strike the enemy at its heart, 70 million men, women, and children armed

with gasoline bombs, rifles, bows and arrows, and bamboo spears to fight the greatest fight of all. The Americans and the British would never be able to resist. Japan had not lost a war since the sixteenth century. The situation was still favorable! Victory was just around the corner! To achieve it, every honorable Japanese should be willing to die for the emperor.

The only problem was that the emperor did not wish the people to die for him. Just four days after he had rubber-stamped the "Basic Policy," he met one of his key naval advisors, Admiral Kiyoshi Hasegawa, at the palace. In stark terms, the admiral outlined Japan's desperate plight. The facts spoke for themselves. The nation, he said, no longer possessed the equipment to fight a modern war. The only war industry that was actually growing was the production of bamboo spears. There was nothing left to fight with. The necessary consequence of the "Basic Policy" was national suicide. There was even a joke, albeit quietly spoken, doing the rounds: if the Supreme Command were driven to the top of Mount Fuji, they would still say the situation was favorable.

And so the emperor spoke out at last. On June 22, he made the astonishing declaration to his war council that the "Basic Policy" was to be reversed. The search for peace must be pursued instead. In just thirty-five minutes, the emperor had overturned the deepest traditions of his office. The god had descended from the heavens and into the world of men. It was a revolutionary step. He did it because he knew there was no alternative. He did it because he knew there were those on the council—his foreign minister Togo, his naval minister Admiral Misumasa Yonai, possibly his prime minister Kantaro Suzuki—who privately agreed with him. He did it, even though his decision might cost all of them their lives.

In these last weeks of the war, death stalked the men who talked too openly about peace. Togo's telegrams to his ambassador in Moscow betrayed very real fears. In this climate, his explicit rejection of unconditional surrender was inevitable. To embrace it was almost certainly a death sentence. His pacifist leanings already

made him an object of loathing and suspicion to the army fanatics. He had to tread very carefully, to hint and suggest at possibilities of peace, to deal in shadows and double meaning and innuendo, rather than speak openly and plainly. Perhaps the tragedy is that nobody on the other side was either able or willing to read the signs. Not even Henry Stimson, in the end.

And so the emperor toyed with his butterflies, and stared at the bathroom mirror, and waited in vain for the peace that would never come. The latest statistics from the air front made grim reading. Only last night the Americans had dropped another 4,280 tons of bombs on cities across Japan. Most of them were incendiary clusters, designed to light up the wooden cities from end to end. Japan was, quite literally, burning to the ground. It was happening in front of the emperor's eyes. A bomb had even been dropped on the Imperial Gardens early this morning. It was only one bomb, a rather unusual occurrence these days. Fortunately it missed the palace and the emperor lying sleepless on his bed inside.

THE BOMB was no ordinary bomb. It was a "pumpkin," and its 6,300 pounds of high explosive made a very big hole in the Imperial Gardens. The man who dropped it was Captain Claude "Buck" Eatherly, one of the 509th's most colorful characters, and he did it with the deliberate intention of pulling off the greatest stunt of the war. It was a classic Eatherly gesture: a spectacular coup in which the emperor himself would die and history would ever afterward remember Buck Eatherly as the man who saved the world. That was the plan, at any rate. Events turned out rather differently.

The weather was against them from the start. Scattered clouds hung low over Tinian as Eatherly gunned his B-29 down the long runway at North Field in the early hours of July 20. Within forty-five minutes, nine other B-29s were also in the air. These were the bombers Tibbets had slated for the 509th's first mission to the Japanese mainland. Each one carried 7,000 gallons of gas and a

pumpkin bomb in the forward bomb bay. The bombers brushed through the clouds at 250 miles per hour, hugging the sea to conserve fuel, heading north to the Empire. On board *The Great Artiste*, radio operator Abe Spitzer jotted a note in his diary about the "piss-poor weather." He also confessed his fear. "The mind," he wrote, "can certainly cover a lot of territory in a very short time." Like most of the ninety-odd men flying that night, he was flying his first combat mission of the war. The time for bombing barely defended islets was over.

The target assigned to Eatherly's crew was the marshaling yards at Koriyama, an industrial town 120 miles north of Tokyo. The route had been carefully planned: a seven-hour hike up the Pacific via the island of Iwo Jima. Despite the men's anxieties, it was an unrelentingly monotonous trip. Some of the nine-man crew passed the time playing poker. Eatherly put the bomber on autopilot and joined in. He always brought a pack of cards when he flew.

Everybody on board loved the crazy twenty-seven-year-old Texan pilot with his cowboy boots and his little-kid grin. He was one of the boys. Handsome, and six feet tall, he was passionate about drinking, driving, gambling, girls, and flying. His address book was filled with scores of telephone numbers from girlfriends across the United States, and he was always happy to oblige less successful crew members with a date if they needed one. "He loved broads," one recalled, "and they loved him." His whoring and gambling were legendary. At the State Line Hotel in Wendover he regularly shot dice at one hundred dollars a throw, and one of his favorite occupations was racing down the two-lane highway to Salt Lake City at eighty miles per hour, passing whiskey bottles through the window to his crewmates in another car. Better still was doing it at night.

Even Tibbets's gestapo could not keep up with Eatherly's antics. By the time he departed the United States for Tinian in early June, he left behind a battery of speeding tickets, a string of despondent girlfriends, and fifteen times the number of liquor permits allowed per person in the state of Utah. Tibbets's head of security, Major

William "Bud" Uanna, described him as "a psycho," but Tibbets kept him on because he was an outstanding pilot and that was what mattered. Nobody, least of all Tibbets himself, would forget the day the number one prop on Eatherly's B-29 suddenly whipped into reverse on final approach and his plane tipped on its wingtip just a few feet above the runway. Somehow, incredibly, Eatherly got her safely down. Flying skills like that did not come cheap, whatever the demons driving him on.

He would need those skills today. By the time he had reached the marshaling yards at Koriyama, the weather had further deteriorated. A thick layer of altostratus clouds clawed up into the sky to 19,000 feet, hiding any trace of the ground. For an hour or more, the big B-29 turned in aimless circles in the clear blue skies above Japan. Her official call sign was Victor 85 but everybody in the 509th knew her as *Straight Flush*. On her silver nose was a cartoon of Uncle Sam flushing a Japanese soldier down a toilet. With the exception of *Big Stink*, it was probably the least happily named B-29 in the 509th fleet. The idea was not Eatherly's but his assistant engineer's, a nineteen-year-old former child radio star called Jack Bivans. Bivans had played a fearless villain in the hit NBC show *Captain Midnight*, but he spent most of this mission thinking the name might not have been such a great idea after all. "If we get shot down," he told the radar operator, "they're gonna cut our balls off." He was not necessarily wrong. Just a few weeks earlier, on June 30, eight downed American airmen had been publicly beheaded in Fukuoka. Now Bivans had a sudden brainwave: why not stop stooging around looking for a gap in the clouds and bomb the Imperial Palace instead? Maybe they could kill the emperor and win the war. It did not take Eatherly long to say yes to *that* one.

There was thick cloud over Tokyo too, so the bombardier had to make a radar drop. The pneumatic bomb bay doors snapped open, releasing the five-ton pumpkin into the freezing stratosphere. As it tumbled away, Eatherly swung the big bomber into the tight sixty-degree banked turn they had practiced over and over again in Utah.

Down went the bomb, accelerating toward the undercast, until it was finally swallowed up in the clouds. Eatherly and his crew whooped and hollered as they turned for home. Of course they had no idea whether they had actually hit their target. Had they done so, the consequences might have been catastrophic. Killing the emperor with an American bomb was not part of Truman's plan for winning the war. Nor was it part of Tibbets's. Which is why he chewed Eatherly's hide from one end of North Field to the other when *Straight Flush* finally made it back to Tinian.

It was a disastrous opening for such a supposedly crack outfit. The thick cloud had affected everybody. Of the ten B-29s that set out early that morning, seven reported "unobserved" bombing results, one reported "poor" and another "very poor." The only crew that did not report anything was *The Great Artiste,* and that was because they aborted the mission altogether. Thanks to an engine failure six minutes from the Japanese coast, they were forced to jettison their hugely expensive bomb directly into the Pacific Ocean.

Little wonder that Tibbets was frustrated. By any yardstick, the first missions were an absolute failure. Night after night, other B-29s on Tinian were knocking out the cities of Japan with ruthless efficiency. Meanwhile the squadron that had spent the last ten months training for the biggest mission of the war was unable to achieve a single positive result in their first outing to the enemy. Already the joke was halfway around Tinian Island. Even the enemy were confused. That night, Radio Tokyo referred explicitly to Eatherly's antics over the capital. "The tactics of the raiding enemy planes," said the announcer, "have become so complicated that they cannot be anticipated either from experience or common sense." It was bad enough having other crews on the island making snide remarks about the 509th. It was much worse when the Japanese started doing the same thing.

The lessons were clear. His men would have to go out again. And they would keep going out until the call came to do the job for real. Time was running out. As the group's commander, Tibbets bore

final responsibility for his crews' success or failure. He perfectly recalled General Uzal Ent's threat when he took on that responsibility ten months ago. He had no intention of going to prison.

IN CHICAGO, time was also running out for Leo Szilard. Sixty-nine scientists had signed his petition urging the president not to drop the atomic bomb on Japan "without seriously considering the moral responsibilities involved." The question was how to get Truman to see it. The urgency of the case decided Szilard. Rather than transmit the petition through White House channels—where it might be dangerously delayed en route to Potsdam—he passed it to Arthur Compton, a key Manhattan scientist and a close colleague of Oppenheimer's. Enclosed was a covering letter asking Compton to submit the petition in a sealed envelope for immediate dispatch to Truman. Szilard also included another six copies, which, as he wrote Compton, "you may wish to communicate to others who ought in your opinion to be informed of the text." It reached Compton on the day Eatherly dropped his bomb on the Imperial Palace.

Compton was probably the worst choice Szilard could have made. A tough, bullnecked authoritarian, he had little time for Szilard's moral scruples. Like Oppenheimer, he was a member of the scientific panel that had recommended "direct military use" of the bomb to the Interim Committee. Unlike Szilard, he did not believe the bomb should be demonstrated on some barren island, and he did not believe the Japanese should be warned in advance of what would hit them if they failed to surrender. In one respect, however, he followed Szilard's request to the letter. He did communicate the text of the petition to others who in his opinion ought to be informed. He communicated it to General Groves.

Groves told Compton to forward the petition to his deputy, Lieutenant Colonel Kenneth Nichols. Compton took his time about doing it—another five days, in fact. Nichols did not receive the petition until July 24. In turn he passed it on to Groves with the

additional suggestion that the scientists who had signed it should be encouraged to "confine their activities to proper channels where security for the project will not be jeopardized." By now nearly a week had passed since Szilard had first sent off the petition. It had got no nearer Truman. Nor would it for some considerable time yet. Groves simply put the whole assemblage of papers into a drawer and left it there. The man who had invented the bomb was quite powerless to stop it.

ELEVEN

THE USS *Indianapolis* raced across the international date line just before noon on a brilliant summer's day. Speed was the only imperative. Captain McVay was following his secret orders to the letter. The heavy cruiser had already traveled the 2,405 miles from San Francisco to Pearl Harbor in just 74.5 hours, setting a record that has never been broken. At Pearl her crew were forbidden to disembark. In just five hours she was refueled, restocked, and on her way. Everything was sacrificed to speed. All hands were required to shower in salt water because her eight White Forster boilers drank all the fresh water on board. The whole ship shook with the roar of her engines. At twenty-nine knots she rode the waves like a motorboat, her fifteen-foot screws spinning a wake as wide as an eight-lane highway behind her.

Belowdecks, James Nolan lay sweating on his bunk in the flag lieutenant's cabin next to his padlocked, lead-lined bucket. He was horribly seasick. The rocking and rolling of the cruiser as it sped through the ocean had left him pale and utterly miserable. Since leaving Pearl he had barely been able to get up, and his uniform

with the fake upside-down artillery insignia lay crumpled over a chair. He was a radiologist, not a sailor. In normal times he worked at Los Alamos in the laboratory's hospital, where his specialty was X-ray therapy. He understood Geiger counters, not ships.

At any rate, it was wiser to remain belowdecks. Unlike his colleague Major Robert Furman—an army engineer in real life— Nolan had no military experience at all, and it was beginning to show. Many of the crewmen had stared at him a little too curiously, especially when he was invited to witness a gunnery exercise. After all, he was supposed to be an artillery officer and the *Indianapolis* was positively bristling with artillery, 20mm and 40mm cannon for close-in firing, not to mention those massive five- and eight-inch guns whose recoil could literally turn the ship on its side if they were all fired at once. When one of the navy officers asked Nolan about the size of the guns he had operated in the army, he was completely stumped. There was a dreadful pause. Then he held up his hands like a man measuring a fish and said, "Oh, about this size." After that it seemed a better idea to remain for the rest of the trip in his cabin.

The two couriers kept a twenty-four-hour watch, in shifts, on their cargo. The lead-lined bucket never left their sight. From time to time they checked its radioactivity with their Geiger counter. Up on the hangar deck, armed guards sealed off the big wooden crate with its six-foot cannon inside. Despite the stares and the rumors, Nolan and Furman followed their orders just as efficiently as Captain McVay on his bridge. They did an excellent job. General Groves knew the caliber of his men. As always, he had told them just as much as they needed to know about their cargo—and no more. The doctor and the engineer were not privy to the ultimate secret: how the weapon they called *Little Boy* actually worked.

In truth, *Little Boy* was a very different bomb from the *Gadget,* tested so spectacularly at Trinity. It employed a different fissionable material: not plutonium this time, but an extremely rare isotope of uranium called U235, refined in yet another of Groves's vast and

highly secret processing plants, at Oak Ridge, Tennessee. The high-velocity cannon now hiding in its wooden crate was designed to be used just once. Its bullet was more than a foot long, a hollow cylinder made of U235. Its target was a piston, also made of U235, designed to fit snugly inside the cylinder on the single occasion the two were united. The target was fixed to the end of the muzzle. It was a closed system. This gun could never miss.

Once fired, the cylindrical uranium bullet would rip down the gun's barrel at the speed of sound until it reached the piston target. The piston would ram into the hollow cylinder, one subcritical mass of U235 cleaving into the other in an unholy, almost instantaneous embrace that brought them over the edge of criticality. Less than a millionth of a second later, the bomb would blow up.

That, at least, was the theory. Unlike the plutonium bomb, *Little Boy* had never been tested. For one thing, there was at present only enough uranium 235 in the world for a single bomb. For another, the physics of the uranium bomb were simpler: the chances were reasonably high that it would succeed. The plutonium bomb—nicknamed *Fat Man* after Winston Churchill—was a far more complex affair. Until the Trinity test there was no guarantee it would work.

Together, both types of bombs would seal the effectiveness of America's nuclear arsenal. More immediately, both could be used against Japan. The production schedules determined the order in which the two types of weapon would be used. Right now the huge plutonium processing plants in Hanford, Washington, were working around the clock to produce enough material for *Fat Man*'s core. *Little Boy*, with most of its U235 in place, was ready to go first.

Inside the lead-lined bucket that Furman and Nolan were guarding was the U235 bullet for this bomb. For millions of years, the uranium ore from which it derived had lain deep under the earth in the part of Africa that would one day become the Belgian Congo. In the last few months, it had been treated, separated, purified, and enriched at Oak Ridge. A few days ago, it had arrived in Los Alamos, as weapons-grade uranium. Now it sat in its bucket

welded to a cabin deck, forming one half of *Little Boy*'s nuclear core, awaiting its destiny. Meanwhile the ship in which it sailed raced on, alone and in radio silence, across the ocean.

As the *Indianapolis* slipped across the international date line on that Saturday, an eight-page document landed on Henry Stimson's desk in Potsdam. The document had arrived straight from the airport. It had been personally couriered across the Atlantic on a C-54 transport plane all the way from Washington. Its contents were far too secret to cable in code. For here, in these carefully typed pages, was General Groves's first fully detailed account of the Trinity test, delivered five days after the event. Its contents had all the impact of a sledgehammer.

Groves was not the only author of the report. Part of it was written by his deputy, General Farrell, the man who had felt the bomb's plutonium in his rubber gloves. The two men had sat up half Wednesday night to get it finished in direct response to the secretary of war's request. Truman's appetite had been whetted. After the first cable confirming the test's success, he wanted details. More than ever he wanted to gauge the real power of the weapon that he, and he alone, now possessed. Groves was more than happy to oblige.

In his Foggy Bottom office the two generals had worked on the report. Groves's secretary sat with her sandwiches and an assistant, typing and retyping the pages as they arrived. A thirty-five-year-old widow, Jean O'Leary was the only member of the War Department typing pool who had dared stand up to Groves. She simply refused to speak to him whenever he was rude to her. The result was that he employed her permanently. She had been with him since 1941 and was now so much a part of his work that she was often known as Major O'Leary. He trusted her, respected her, needed her. By the summer of 1945 the former typing pool secretary knew more about the atomic bomb program than anyone else except himself, and far more than either Oppenheimer or the secretary of war or the president of the United States.

The report was finished at 2 A.M. on the Thursday. Matters had been slightly delayed when General Farrell, warming to a poetic theme, decided he wanted a particular biblical quotation to capture the feelings of doubt in the last moments before the shot. But he could not remember the words. Nor could anyone else in the office. Groves called his daughter, but she had no idea. In the end one of his aides called his sister, a Sunday school teacher at Washington's Temple Baptist Church. Five minutes later she found the verse, Mark 9:24: "Lord, I believe; help Thou my unbelief." O'Leary quickly typed it in, clipped the pages together, and rushed the report off to the airport where an airplane was being held for the long flight to Berlin and the secretary of war's villa.

Stimson read it before lunch. It was, he wrote in his diary that night, "an immensely powerful document." The full impact of the event pierced every line. Stimson could be proud. For the past three years he had overseen the bomb's development. He had nursed it, watched it grow, and jealously guarded its secrets. When Truman became president back in April, Stimson had been the first to tell him he was in possession of the greatest weapon in history. Of course he could be proud. As he finished the report he put aside all his own doubts and fears, perhaps forgot all those sleepless nights worrying about Frankenstein's monster, and strode around the lake to read the report all over again, this time to his master.

Unfortunately, the president was otherwise occupied. He was busy shopping. An aide had brought him a list of gifts to send back home, and for the next half hour he mused over it, making selections, while Stimson sat outside his office clutching his report on the biggest bomb in the world. Finally, after three o'clock, Stimson was allowed in. Truman put his gifts aside and smilingly welcomed his secretary of war. Smiling with him was Jimmy Byrnes, his secretary of state. Four days earlier, Stimson had tried to persuade Byrnes to accept his passionately held belief that the Japanese would surrender if they were allowed to keep their emperor. He had read Togo's telegrams: unconditional surrender was surely the only obstacle to peace. But Byrnes had disagreed. He was not interested

in what he regarded as appeasement. Nor did he trust the Japanese. He was interested in winning the war, and winning it before the Russians got in. He suffered from none of Stimson's faltering doubts, and he had none of his broken nights. His thinking was clear, direct, unambiguous. The bomb was the best thing going for America right now. It would end the war, and it would make the Russians—as he had once put it to Leo Szilard—"more manageable." Those dapper smiles were deceptive. Byrnes was the toughest American voice in Potsdam. And what was more, he had the president's ear.

Together the three men sat down in the president's sunroom overlooking Lake Griebnitz. The afternoon sun slanted through the windows over the mismatched furniture, over the French and Chippendale tables and chairs requisitioned just days before from German homes. Stimson began to read the report. His excitement was palpable. Quite untypically, he stuttered and stumbled over the words. Truman and Byrnes listened in wondering silence. The president's shopping was quite forgotten. The terrible reality of the bomb was implicit in every word Stimson spoke. "Lord, I believe; help Thou my unbelief." General Farrell had judged the mood perfectly. It was all there in Mrs. O'Leary's carefully typed pages: the strange mix of religious awe and human triumph, the seductive blend of horror and beauty and unimaginable power realized in those few shattering seconds in the New Mexico desert. And now all this power lay in the hands of the man sitting opposite Henry Stimson. That initial cable from Washington announcing the test's success was nothing compared to this. This time the president did not tell an old Kansas joke. There was nothing to joke about. The reaction from Truman and Byrnes was unalloyed joy. "They were immensely pleased," wrote Stimson in his diary later that evening. "The President was tremendously pepped up by it and spoke to me of it again and again. He said it gave him an entirely new feeling of confidence." Stimson's language was rarely this unbuttoned. For the aristocratic product of Andover, Yale, and Harvard Law School,

these were meaty words. All his fears were temporarily submerged in the moment of shared triumph. There was no discussion this time about the Japanese keeping their emperor.

Stimson left the Little White House for a massage and dinner. Truman and Byrnes drove off to the Cecilienhof for the evening's plenary session. The agenda was the Polish Question. From the start Truman dominated the discussion. In amazement Churchill watched as he launched directly into the offensive against Stalin. Gone was the diffident ex–vice president, Roosevelt's apologetic understudy who so recently felt cowed in the presence of the great British and Russian leaders. This was a whole new man: vigorous, confident, stubborn, unbending, very definitely in charge. "He told the Russians just where they got on and off and generally bossed the whole meeting," said Churchill the next day. And little wonder. By then Churchill had seen Groves's report himself. It electrified him as well. "What was gunpowder?" he boomed at Stimson. "Trivial. What was electricity? Meaningless. This atomic bomb is the Second Coming in Wrath." The bomb's power drowned every other consideration. It was highly infectious. Stimson's assistant secretary of war, John McCloy, observed the effect with clinical precision. "The bomb," he wrote, "has stiffened both the Prime Minister and the President. After getting Groves's report they went to the next meeting like little boys with a big red apple secreted on their persons."

PRESUMABLY the biblical metaphor was not lost on McCloy. Or on Stimson, who was a regular churchgoer. The bomb was extremely tempting. For that very reason it was also dangerous. With each day, Stimson felt the push and pull of that temptation more acutely. Part of him recoiled in horror: forbidden knowledge brought terrible and lasting consequences for mankind. Part of him felt the necessity to use the bomb quickly and decisively exactly as his own Interim Committee had recommended to the president on May 31, seven weeks ago: without demonstration and without

prior warning. Day and night—especially night—the tired, aging secretary of war wrestled with his demons. He was tortured by doubt, and his only solution was a kind of bizarre moral double-think. His conscience simply dislocated itself from reality when reality proved too unpleasant. Perhaps it was the only recourse for this decent, yet fragile man. It made the unbearable somehow bearable. But it also left him ineffectual against individuals like Byrnes and Truman who had fewer qualms about using the bomb. The pity of it is that the one man who might just possibly have been able to save the bomb from being used could hardly save himself.

And now there was little time left. That very evening, as Truman was busy bossing Stalin in the conference chamber, two more cables reached Stimson from General Groves in Washington. As always, they were routed via Stimson's special assistant, George Harrison—a cover to avoid suspiciously direct communications between the secretary of war and the head of the Manhattan Project. One of the cables concerned Kyoto, the beautiful former Japanese capital that Groves had earlier earmarked as the number one target for the atomic bomb. Stimson hated the idea of bombing Kyoto. He and his wife, Mabel, had visited the city twice, once in 1926 and again in 1929, and he was enraptured by its temples and architectural glories. Even more, he recognized that the city was the spiritual and cultural center of Japan. Far from forcing the Japanese to capitulate, its destruction might ensure the exact opposite, stiffening the nation's resolve to fight the American barbarians to the last man, woman, and child. Groves disagreed. He was not interested in temples or spiritual centers; the city, he said, made a good bomb signature. With its population of one million, it was "large enough in area for us to gain complete knowledge of the effects of an atomic bomb." If all those antiquities meant anything to Groves, they meant simply this: that Kyoto was an intellectual center whose people were "more highly intelligent and hence better able to appreciate the significance of the weapon." Hence this latest cable:

SHOCKWAVE **115**

TERMINAL
Number: WAR 35987
Secretary of War Eyes Only from Harrison.

*All your local military advisors engaged in preparation defi-
nitely favor your pet city and would like to feel free to use it as the
first choice if those on the ride select it out of 4 possible spots.*

Stimson immediately shot back:

From: TERMINAL
To: War Department
TOP SECRET EYES ONLY

*Aware of no factors to change my decision. On the contrary new
factors here tend to confirm it.*

Stimson would not be bullied. He would be just as tough and
stubborn and immovable as Groves. In the end, Kyoto's salvation
was entirely fortuitous. Had the secretary of war and his wife not
happened to spend a few delightful days visiting its shrines and
temples back in the 1920s, those shrines and temples would just as
surely have been reduced to rubble, along with the rest of the city.

The second cable from Washington was even more pertinent. It
was the latest update from Groves:

TERMINAL
Number: WAR 35988
Secretary of War Eyes Only from Harrison.

*Patient progressing rapidly and will be ready for final operation
in first good break in August. Complicated preparations for use are
proceeding so fast we should know not later than July 25 if any
change in plans.*

Groves was pushing for confirmation. Everything was moving ahead. The test bomb had worked. The *Indianapolis* was across the international date line. The 509th were in the final stages of training. Earlier this afternoon the president had heard from his secretary of war's own lips what the new weapon could do. Now Groves had given them a date. Truman would almost certainly issue his ultimatum to Japan immediately after the twenty-fifth—just four days from now. If Stimson was hoping to persuade him to include a guarantee to the emperor, he would have to do it very soon. Time was slipping away: for Stimson, for the president, for the Japanese. They were all at the mercy of Groves's schedule.

TWELVE

Sunday, July 22
509th Compound, Tinian Island

In the shimmering heat of the day, Bob Caron sat down to write a letter to his wife.

> *My Dearest Kay,*
> *Hi Honey, how're you feeling today? I feel swell because when we landed yesterday afternoon there were three letters from you . . . I'm glad Judy's christening came along nice. I'd give anything to have been there . . . We all would like it if you could send me Reader's Digest because we can't buy any reading material over here. Give 'lil Judy a big kiss from her Daddy and heap a million or so on yourself. Keep writing to me, Sweetie, 'cause I live for your letters. Bye now.*
> *All my love,*
> *Bob*

Like everybody else, Bob Caron had ripped the legs off his khaki pants. None of the enlisted men bothered to wear formal uniforms out here. All the guys slopped around in what they called "Tinian

shorts" and T-shirts, and even then the sweat rolled off their skin, stinging their eyes and soaking their clothes. The heat was relentless. Day after day, the thermometer just stuck there at ninety degrees Fahrenheit, and even the rains that arrived like clockwork every afternoon did little to relieve the discomfort. The humidity ate into everything. Sometimes Caron would catch a movie at the Pumpkin Playhouse, the 509th's open-air theater, but he always took his poncho with him because right in the middle of the movie it would always rain. The rain was like nothing else. It burst from the sky as if somebody up there had just turned on a tap, a hot, heavy, battering shower that rapidly turned the 509th compound into a quagmire. The mosquitoes loved the rain. So did the rats. They had already eaten their way through most of the chocolate Caron kept in his duffel bag. Some of the guys in the hut had fitted up a net on the tin ceiling where they stuffed all their extra rations just to keep the rats away.

And yet—the absence of *Reader's Digest*s apart—life was not entirely bad. As army barracks went, the 509th compound was very comfortable. The huts had proper toilets and showers, they had pretty flower beds outside, and there was even a rumor they all would be getting *air mattresses* to help them sleep better! They each had twenty-four bottles of beer a month and seven packs of cigarettes a week. They had their own softball field out back. They had a jazz band and that movie theater. Their caterer, William Perry, still kept coming up with amazing rations, and the bootleg whiskey that some of the crews had flown over was being put to good use. Nobody ever quite worked out how he did it, but in no time Perry had built up a network of semi-licit connections with all the food barons on the island. The result was fresh eggs and fresh milk and steaks for breakfast almost every day. Perry's boast that a private in the 509th "eats better than a general" was perfectly true. When the boys finally got around to flying that top secret mission, they would be flying it well-fed.

It was a strange way to fight a war. Compared to all the other outfits on the island, the 509th were having a very easy time. No

one was shooting at them. So far they had only flown that one milk run to Japan, and everybody had come home unscathed. Little wonder the other outfits were beginning to resent them. Night after night they risked their hides flying massed formation bombing runs on the Empire. They did not fly at 30,000 feet like the 509th. They went in low, at 5,000, where they were sitting ducks to the Japanese defenses. Many were shot out of the sky. Others limped the 1,500 miles home with their engines smoking, their controls shot to pieces, their crewmen wounded or dying or dead.

Sometimes in the early morning Bob Caron got up to watch them coming back. It was quite a sight. The hundreds of planes were stepped up in the skies like a huge flock of geese, headlights winking in the dawn light as each one took its turn to land. Some would fire colored flares that meant there were wounded aboard. A few would crash while landing. A B-29 was no place to be when that happened. They burned quickly and furiously and they were notoriously difficult to escape from. It was even worse when they crashed on takeoff. That happened quite often, the way they were loaded to the gills with incendiary bombs and jellied gasoline. Not many got out alive. The bulldozers would go right in after the ambulances and the fire engines to shovel whatever bits of twisted aluminum and flesh were still left off the runway. Nothing was allowed to hold up the waiting bombers.

It was hardly surprising, then, that the 509th were beginning to be loathed and mocked with equal intensity. People called them all kinds of names. They were the Glory Boys, a bunch of "pampered dandies" who did no fighting. Occasionally other crews would chuck rocks onto their Quonsets at night on their way to the air base. The rocks would clatter over the tin roofs, waking up the men inside. Before long copies of an anonymous poem started doing the rounds on the island. It spoke for a whole mood:

> Into the air the secret rose
> Where they're going, nobody knows.
> Tomorrow they'll return again,

But we'll never know where they've been.
Don't ask us about results or such,
Unless you want to get in Dutch.
But take it from one who is sure of the score,
The 509th is winning the war.

The men of the 509th themselves were heartily sick of the whole business. They were keen to show their teeth. Tibbets had slated a second pumpkin mission to Japan for July 24, and two additional missions after that, but it was still an embarrassment. How much longer would they have to keep hauling their practice bombs up the Pacific? How many more rocks would they have to endure being chucked onto their roofs? All this waiting was driving everybody stir-crazy. Some of the guys were spending far too much time drinking, gambling, skirt chasing, or playing madcap pranks.

Even the colonel was not immune. Only the other night he and Dutch Van Kirk and Tom Ferebee had gone down to the beach, where they found an empty jeep parked in an isolated spot. A couple of nonflying officers from the unit were fooling around somewhere nearby with their girls. They had left their uniforms in the jeep. Tibbets decided it might be amusing to steal the uniforms and remove the rotor from the jeep's distributor. The two officers ended up walking the several miles back to their quarters stark naked. Every time a car came along the road they leaped into the bushes. Their feet were cut to shreds on the sharp coral. Nobody ever found out how their girls made it back, but Tibbets and his boys thought it was all a terrific joke.

Leading the stir-crazy pack was Claude Eatherly, the pilot of *Straight Flush*, with no less than *five* nurses in tow. His crew were in seventh heaven. "We came, we saw, and we conquered," said his engineer, Eugene Grennan, but in truth his bravado was misplaced. Perhaps a more honest appraisal came from Abe Spitzer, diarist and radio operator on *The Great Artiste*. We are, he wrote, "just another outfit waiting to do a job nobody seems to think will ever happen."

But others on the island were not waiting. They were working at a feverish pace, day and night, to complete the final preparations for the world's most secret weapon. And on the day Bob Caron wrote his letter to Kay, they had just two weeks left in which to do it.

THERE WAS NOTHING outwardly unusual about the vehicle that pulled up outside the steel-framed building overlooking the ocean. It was clearly designed to transport a heavy piece of hardware, but that was hardly abnormal on Tinian these days. Nor was there anything especially unusual about the building. From the outside it looked like a warehouse or perhaps a hangar, a nondescript prefabricated structure 100 feet long and 70 feet wide. A casual observer would barely have given it a second glance—except that any casual observer who had made it this far would almost certainly have been shot. For this ordinary-looking building, standing on an isolated bluff on Tinian's northwestern coast, was protected by no fewer than five machine-gun emplacements. All its access points were manned by checkpoints bristling with armed military police. Nowhere on the island was as heavily guarded or as tightly patrolled.

There were a few clues to the building's importance. One was the earthen blast walls that surrounded it on three sides. They were extremely thick and deep, clearly put there to withstand a massive accidental explosion. Another was the hoist under which the transport driver now carefully positioned his vehicle. It stood immediately outside the building's sliding steel doors. A double-ended chain hung from its beam with a single hook on the end, easily sturdy enough to lift a very substantial weight. But perhaps the biggest clue was the sound, a ceaseless, low electrical hum that appeared to come from a small hut to the side. It was an air-conditioning unit, an astonishing rarity on the island. Whatever was inside the building clearly needed to be kept at a constant temperature and humidity.

When the doors finally slid open, a group of men were revealed fussing around a ten-foot-long, gunmetal-gray object that looked,

as one observer put it, like a giant trash can. But the illusion stopped there. For one thing, the men were all wearing special nail-less shoes. The tools they worked with were made out of extremely expensive nonsparking beryllium. The floor they stood on was rubberized, and its spotless surface gleamed in the sun. They worked quickly but carefully. The object was hooked to the hoist and lifted onto the waiting vehicle. As it swung into place, its high-alloy steel nose flashed in the light. Unlike the rest of the trash can, it had been polished until it shone like a mirror.

The date was July 23, a Monday. Six thousand miles away in Potsdam, Churchill was planning a dinner that night for Stalin and Truman. To the massed band of the Royal Air Force playing "Carry Me Back to Green Pastures," the guests would dine on cold ham specially flown in from England. A farther 5,000 miles away in Los Alamos, Oppenheimer was finalizing fuse settings for the first combat atomic bomb. On the basis of the latest experimental records from Trinity, the burst height was provisionally fixed at 1,850 feet. "The figures," he wrote, "are appropriate for the maximum demolition of light structures." Just half a mile down the road on Tinian, Bob Caron and the crew members of Victor 82 were having the day off. Tomorrow they would fly their first pumpkin mission against the Empire.

But here, in this secret location by the sea, a different drama was being played out. The humming, steel-ribbed warehouse was a bomb assembly building—one of three on the island—and the gunmetal trash can was a bomb. In almost every respect it was an exact replica of *Little Boy*, the weapon that would shortly be released over Japan. Its official designation was L1, the first of four practice units scheduled to be test-dropped before the real thing. Only one major element was missing: the uranium 235 that would transform it into an atomic bomb.

Cradled on its motorized dolly, hidden from prying eyes under a tarpaulin, the bomb was driven down a road toward the air base. After a quarter of a mile the road suddenly opened up into a heart-

shaped concrete apron, about the size of a football field. To the south were the massive runways and taxiways of North Field. Armed guards blocked the exits to the base. On either side of the apron were two pits, like small empty water tanks dug into the ground. The transport parked by the westernmost one, and the tarpaulin was removed. A hydraulic hoist then slowly lowered the bomb into the pit. The operation was conducted with extreme care. Some of the planning was several months old. Nothing was left to chance. L1, like its siblings L2, L5, and L6, would prepare the ground for L11. L11 was what they called the "hot" unit: *Little Boy* itself, the bomb they would drop on a city.

Parked ahead of the pit was a B-29 with its bomb doors hanging open, exposing the huge double-section bomb bay inside. Very slowly, under the watchful eye of the technicians, a tug began pushing the big aircraft backwards until its bomb bay rested directly over the pit. The bomb was then raised into the aircraft's guts, fitting snugly inside. L1 was now ready for its test. The B-29 designated to carry it was normally flown by Lieutenant Colonel Tom Classen, one of the 509th's most experienced pilots. But Classen would not be flying her today. Tibbets would. As the man who intended to lead the first atomic mission, he needed all the experience he could get.

THEY HAD BEEN preparing for months—almost since Tinian had originally been selected as the base for the atomic strikes back in February. Those three steel-ribbed bomb assembly buildings strung out on the island's remote northwestern coast were the end point of a major industrial enterprise, the forward assembly area for the bombs that the 509th's B-29s would soon be carrying to Japan. The flying was only one half of the equation. The other half were the bombs themselves, the priceless passengers with their one-way tickets. As the various parts were shipped or flown out from the States, they needed to be finally assembled, to be checked and tested and loaded for deployment. By the time Tibbets took L1 into the air, a won-

drously sophisticated organization existed on Tinian to do just that: in effect a bomb assembly production line. The business of building and delivering atomic weapons was rapidly turning into an operation as straightforward as making cars or sewing machines.

The scale of that operation was truly impressive. The bomb assembly buildings were only part of the story. Just a quarter of a mile down the road was yet another compound, an anonymous enclosure of windowless huts and barbed wire known—to those privileged to know anything at all—as the Tech Area. A patrolled, double-fenced area nestled inside the Tech Area like a holy of holies. Here were the vital organs for the atomic bomb assembly line: the buildings that contained the fusing, firing, pit, and observation teams. This was where the initial stage of assembly took place, where the guts of the bombs were first put together. The final stage was inside the air-conditioned bomb-assembly buildings themselves. Which is why they were the most secret, most isolated, and most guarded places on the island.

It had taken just four months to build this machine. The man who did it was Colonel Elmer Kirkpatrick, another of Groves's discoveries, a tough, no-nonsense, plainspoken army engineer who could cut though bureaucracy like a knife through butter. Since April, when he first broke ground in the Tech Area, Kirkpatrick had proved a worthy tool of his master. He wheedled and bullied and threatened and cajoled whenever and wherever he could. But he got results. His task was not made any easier by the fact that everything was so secret. Memoranda would be sent to the construction battalions that went like this: *"Deliver X bags of cement. This is a project of which you have not been informed and will not be informed."* The Seabees delivered, and they kept quiet.

Somehow, and with incredible speed, the buildings began going up. All through that broiling summer, Kirkpatrick sweated in his wooden hut while the endless cables flew back and forth across the Pacific. The files are thick with them: pink and green triplicate pages filled with requests for everything from refrigerators to Westing-

house electric ranges to Quonset huts to screwdrivers to entire atomic bomb kits. It was an astonishing organizational achievement, a supply system that crossed half the planet with relentless efficiency—and even more astonishing was that it was happening at exactly the same time as the preparations for Trinity were reaching their climax. This was Groves's administrative genius at its most effective. Everybody in on the secret could see it. And not just those in on the secret. Even the Japanese fugitives still hiding up in the caves on Mount Lasso watched and wondered at the new development on the cliffs. To them it looked like an enormous prison compound.

As the buildings went up, so the men arrived from Los Alamos to work in them. Their official title was the First Technical Services Detachment, but in the code-ridden world of Manhattan they had another name: Project Alberta. Some of them had been here since May. More were now arriving after Trinity. One was Deak Parsons, bringing with him a 16mm movie of the test. Another was Philip Morrison, the man who had carried the bomb's core from Los Alamos to the McDonald ranch on the backseat of a car. A third was Henry Linschitz, the detonator expert who had watched the Trinity maelstrom in appalled fascination: this, he kept thinking, was the weapon they intended to drop on a city. There were others too, a total of fifty-one in all, some to assemble *Little Boy,* others to assemble *Fat Man,* the plutonium bomb based on Trinity's *Gadget.* Almost every day they came, alongside the crates of screwdrivers and refrigerators and bomb kits: physicists, chemists, engineers, radar specialists, high-explosive experts, men who barely had time to pack their bags after Trinity before being given a buttock's worth of jabs and sent 6,000 miles across the Pacific to Tinian. In the frantic schedule that General Groves had put together, there was no time to lose. They were still arriving when Tibbets took *Big Stink* up to 30,000 feet with L1 on board exactly thirteen days before he did the same thing for real, over Hiroshima.

FROM HIS OFFICE on the fifth floor of the New War Building on Washington's Virginia Avenue, Groves worked his eighteen-hour days. Every morning he was up by 5:30, often only tumbling back into bed well after midnight. Occasionally his wife would leave little plaintive notes for him on the hall table: "Where Is My Mate?" ran one. Her mate was otherwise occupied. While his aide Captain Fred Rhodes ensured the chocolate bars never ran out, Groves stuck it out with demonic energy. At forty-eight years old he left all his younger staff miles behind. He even found time for the odd round of tennis—a game at which, despite his weight, he was surprisingly skilled. Then it was back to his desk, chairing meetings, composing reports, wearing out the telephone. His secretary, Jean O'Leary, tabulated the daily tally of calls. They never stop. The list is almost endless, one call after another, from early morning until late at night, from one end of the United States to the other, an inexhaustible and exhausting record of pressure on every last far-flung outpost of the Manhattan empire. By now he no longer bothered with a handset. He had special headphones with a microphone attached into which he bawled and barked and drove his troops to work harder, better, faster—above all, faster.

This was truly power. But it was not power exercised out of coarse megalomania. Groves was utterly committed to his bomb program. It ran through every last fiber of his being. In the end it was everything to him, perhaps as much as the wife who left him all those little notes on the hall table. He believed in the bomb as a patriot, as an engineer, above all as a father. The bomb was his baby and he would ensure its survival. For Groves, this was not about one or two bombs loosed on a couple of Japanese cities. This was about a massive national investment of brains, money, industrial might, military endeavor. He clearly understood that the government expected rather more from its $2 billion investment than one giant firecracker in the New Mexico desert. He was in for the long haul. On the day Tibbets flew the first *Little Boy* test, he prepared an estimate of future bomb deliveries. The numbers are instructive:

three bombs over the next four weeks, a further three in September, increasing by increments to seven bombs *a month* by December—a total of *twenty-three* bombs by the end of the year. This is production-line bomb making with a vengeance. The baby would not only survive, it would multiply. As far as Groves was concerned, the Americans would keep raining down atomic bombs on Japan just as long as the Japanese kept holding out.

Now, as he sat at his desk on that hot, humid Washington Monday, he began to draft a new memorandum for the secretary of war in Potsdam, perhaps the most important of all the memoranda he ever wrote. It was called a *directive*, and in its innocuous language it offered the closest thing to a written authorization for the use of the atomic bombs. Its ostensible recipient was the newly appointed commander of the Strategic Air Forces in the Pacific, Carl Spaatz. But its real recipient was Stimson, and beyond him, the president:

To: *General Carl Spaatz, CG, USASAF*

1. *The 509 Composite Group, 20th Air Force, will deliver its first special bomb as soon as weather will permit visual bombing after about August 3rd 1945 on one of the targets: Hiroshima, Kokura, Niigata and Nagasaki. . . .*

2. *Additional bombs will be delivered on the above targets as soon as made ready by the project staff . . .*

3. *Dissemination of any and all information concerning the use of the weapon against Japan is reserved to the Secretary of War and the President of the United States . . .*

4. *The foregoing directive is issued to you by direction and with the approval of the Secretary of War and of the Chief of Staff, USA . . .*

Four cities, four targets. Stimson had already fought Groves over Kyoto. At a single stroke of the secretary's pen, the ancient capital of Japan, along with its one million inhabitants, its beautiful shrines

and famous temples, was spared the horror of atomic destruction. But as Kyoto was taken off the list, the next city moved up to take its place. The number one target for the atomic bomb was far less famous than Kyoto. For all the wrong reasons it was about to become far more so.

THIRTEEN

Tuesday, July 24
Hiroshima City

LIKE EVERY OTHER schoolgirl her age in Hiroshima, Taeko Naka-mae no longer went to school. She had not been to school since that morning in March when her teacher had gathered their entire class in the playground and told them that from that day on they would all begin working to help win the war. Taeko was sent to the city's telephone exchange. Six days a week, from early morning till late at night, she operated the switchboard, fulfilling her duty to her country and her emperor. By April, her family had been evacuated to her uncle's farm in the mountains west of the city, and she faced a long commute to and from the exchange every day. Her school-books were left unread in her bedroom. There was no time for any-thing except work. Then, two months ago, her father had been drafted into the army. On the day he left, he asked Taeko to look after her younger sister, Emiko, and her four brothers. The war had transformed her into an adult. She was fourteen years old.

She had no doubts about the final victory. The struggle would be long and arduous, but the Americans would be destroyed in the end. Every poster on every wall she saw on her daily commute to

Hiroshima assured her of the fact. So did every headline. On July 16, the *Chugoku Shimbun,* Hiroshima's local newspaper, had blared the truth in a double-page banner: "Victory Is Definitely with Us! Our Sacred Country Will Repel the Hated Enemy!" Several column inches followed, detailing all the reasons why the hated enemy would be repelled. Of course, the writer did not know what was happening on the same day half a world away in the New Mexico desert. He did not know about that bomb exploding with the heat of several suns. Or that the next one was destined for his own city.

If she thought about it at all, Taeko accepted the truths of Japan's ultimate victory in the same way everybody accepted them: as certain as night following day. She probably did not even bother to read the newspaper at all. Far more useful was to burn it as fuel. It was well known that four pages of the *Chugoku Shimbun* would boil a kettle for ten minutes at a time. After all, there was so little fuel about these days. There was so little of anything, especially food. The Americans had effectively blockaded the entire country. Their bombers and ships had mined every port, including Hiroshima's. Taeko was not to know it, but the Japanese cabinet had already secretly predicted that the country's rice requirements would fall short by fourteen million tons in midsummer. It was past midsummer now. Japan was on the brink of starvation.

In Hiroshima, a city of more than 300,000, people were beginning to grow very hungry. Two years ago there had been more than 2,000 food shops in the city center. Now there were fewer than 150. And their shelves were often bare. People were falling back on their own resources, merely to survive. They ate whatever they could find or kill or grow. They ate bramble shoots and grubs and worms and beetles. They even ate grass. The *Chugoku Shimbun* wrote lyrically about the grass. "Every day the good children of Hiroshima go up into the mountains to collect grass for food. The grass is dried and either made into powder or chopped and mixed into other food." The paper offered excellent advice on the best way to cook it. On the same page, it also offered a plethora of advertisements for stomach pills and cures for dysentery.

It was dysentery that killed Taeko's little brother Fumio in the end. He was always so hungry. Two weeks ago, on July 12, he had gone out into the countryside to search for food. Taeko and her twelve-year-old sister, Emiko, had already left for work in the city. With five of his friends, Fumio ran off into the woods. There they found some delicious-looking loquat fruit hanging from some trees. They climbed the trees and grabbed handfuls of it. But the fruit was dangerously unripe. By evening, all six boys were seriously ill with dysentery. Taeko and her family did everything they could for Fumio. Two of the boys' families had a little spare rice that they were able to exchange for medicines. Those boys survived. But Taeko's mother had no spare rice for Fumio. She was not able to give him any medicine at all. He lay in his cot while the family took turns at his bedside. After ten days he died. He was only five years old.

He died the day before General Groves drafted his directive to the secretary of war to release an atom bomb over Hiroshima. The following night, he was placed in a wooden coffin and carried on the shoulders of the villagers up the mountainside. Taeko went too. The villagers lit a fire and cremated the body. In the morning, Taeko and her sister picked out the bones of their brother with chopsticks and placed them in the family urn. In these last weeks before *Little Boy* was dropped on its target, Fumio's tragedy seemed to be the very worst that life could offer. When the people of Hiroshima died, they died of hunger. Their city had barely been touched by bombs. In fact, it was the least bombed city in Japan.

IT WAS ALSO beautiful. Not perhaps as beautiful as Henry Stimson's beloved Kyoto, not magnificent or grand or especially antique, but still beautiful with a quiet, provincial charm. Part of that beauty was its setting, surrounded on three sides by mountains, on the fourth by the ocean. And then there were its rivers: seven of them in all, opening like fingers into the wide blue bay of the Inland Sea, offering havens of peace even in these times of war. The willows for which the city was famous fringed many of these rivers,

and the walks beneath them were still a favorite haunt of lovers. Sunao Tsuboi and Reiko, the young couple who spent most of that summer of 1945 together, often strolled under those willows, cooling off in the evening breeze, talking of all the many things they would do when the war was over. Sometimes it was just possible to forget that there was any war at all, to ignore the hunger and the slogans and the substitute soap that brought people's skin out in such terrible rashes and the dull rumble of American B-29s daily traversing the skies.

Nobody could quite understand it, but the bombers never seemed to attack Hiroshima. Or almost never. There had been one minor low-level strike by navy fighter planes back in March. Then on April 30, a single B-29—the shiny silver bombers were now so familiar everybody called them *B San*, or *Mr. B*—had dropped a few 500-pound bombs on the Otemachi district, killing eleven people. After that—nothing. In the grounds of Hiroshima's sixteenth-century castle was a civil defense bunker manned almost entirely by school-girls the same age as Taeko Nakamae. They ran continuous shifts monitoring the reports of massed formations of *B Sans* heading toward the Japanese coast. But the bombers always went somewhere else. The sirens would wail, just in case. The more conscientious citizens would take to the shelters. But the majority would often not bother to look up. Life was too short. The bombers never struck. In any case there were far more important things to worry about, like the next meal.

By late July 1945, *Mr. B* had practically obliterated almost every major Japanese city except Hiroshima—and it was the country's seventh largest. It was also a major military center. There were 43,000 troops stationed there, many of them now preparing for the country's last-ditch defense against the American invaders. Since April, Marshal Shunroku Hata, commander of the Imperial Second Army, had set up his headquarters in the city. His sacred task was to defend the western half of the country against the Americans when they finally landed. There were troops everywhere: in the western

and eastern barracks, in the moated castle compound with its ammunition and supply departments, its infantry training school, and its bunkers full of fourteen-year-old schoolgirls waiting for the bombers that never arrived.

There was also a port, albeit much emptier than in earlier years. Ujina was a massive expanse of jetties and piers and warehouses, jutting out into the Inland Sea. Very few ships ever sailed from there now. Gone were the days when the "Ever Victorious Fifth Army" left these docks to the ecstatic cheers of thousands, on their way to capture Singapore and so many other prized enemy possessions. Ujina was now a twilight backwater. Half the jetties were given over to vegetable patches. The huge *Gaisenkan*, the Hall of Triumphant Return, stood unvisited and silent. There were no cheering crowds to welcome the troops home after their victorious conquests abroad. By July 1945, there was nothing to cheer about.

Yet for all its ghosts this was still a port, and a port in a major city. Hiroshima was a manufacturing base too. This was not an industrial center, but it made its contribution toward the war effort. Most of the work was concentrated in very small cottage units, basement workshops employing perhaps ten or twenty people, often schoolchildren. They made everything, from tinned beef and alcoholic drinks for the army, to tire tracks for tanks, to booby traps and gasoline bombs for use against the expected enemy invaders. The city teemed with activity, widely dispersed across its seven rivers and forty-nine bridges, blurring the distinction between civilian and military, schoolgirl and soldier, noncombatant and combatant.

In these final hot weeks of July, many of Hiroshima's inhabitants began to wonder why the bombers had not yet struck. Anticipating the worst, the mayor, Senkichi Awaya, had reluctantly given the order to create three massive firebreaks east to west across the city's heart. Ninety percent of Hiroshima's buildings were made of wood, perfect fuel for the jellied bombs and incendiaries the American *B San*s unloaded from the sky. The city center was effectively one thirteen-square-mile tinderbox, with an average of 26,000 people crammed

into each one of those square miles. Her firefighting equipment was antiquated, with only sixteen fire trucks to serve the entire area. Along with her seven rivers, the firebreaks would be the city's only defense against the tempest of flames whipped up by American bombs. The order was therefore given, and for the past two months the streets had resounded to the crash of buildings collapsing to the ground. Cafés, offices, shops, public edifices, people's homes— whatever stood in the way of the fire lanes was demolished without distinction. By the time little Fumio died from his unripe loquat fruit, some 70,000 buildings had been destroyed.

Eight thousand schoolchildren were daily involved in this ritual self-mutilation of their hometown. Teams of them tied ropes around each building's beams before literally pulling it to the ground. The thick dust hung like a question mark over the city. Would it survive an attack? Was it enough? Certainly the mayor himself believed so. It was the hardest order Senkichi Awaya ever gave. And yet he was confident enough in this last week of July to bring his baby granddaughter to stay with him in Hiroshima, be- cause he believed the city was so safe.

And so it seemed. Perhaps, after all, Hiroshima and her famous willow trees would see out the war. There was even a rumor going around explaining why the B-29s had not paid a visit. Apparently President Truman's own mother was actually a prisoner in the city. She was living among them right now, under armed guard, in the strictest secrecy. That was why the city was never bombed, and never would be bombed. The order to spare it had come from the President of the United States himself.

IN FACT, Hiroshima had been specially selected for a different fate. Since the beginning of July the city had been deliberately reserved for atomic destruction. No American bomber was allowed to touch it. Even the pumpkin missions flown by Tibbets's own B-29s were or- dered never to bomb it. It was forbidden territory. The city's rumor

mills were spinning in vain: President Truman's mother was not there at all. She was living 7,000 miles away in Grandview, Missouri.

Choosing a target for the atomic bomb had been difficult. Part of the problem was that there was precious little left to be bombed. A target selection committee had been convened by General Groves as far back as April 27—more than three months before the bomb would be ready. Brigadier General Lauris Norstad, chief of staff of the 20th Air Force, spelled out the latest brutal statistics to a mix of Manhattan scientists, weather forecasters, and senior air force officers. Within just six weeks of the destruction of Tokyo on March 9, some 178 square miles of Japan's cities had been razed to the ground. Twenty-two million of her people were now homeless, almost a third of her entire population. An estimated 900,000 people had so far died in the bombings, considerably more than the 780,000 *combatant* Japanese who had died in the Pacific battles. This was truly total war. The world had never seen anything like it, not even in Hamburg or Dresden. General Curtis "Iron Ass" Le May's low-level incendiary attacks were daily demonstrating the unassailable power of the American war machine. That machine was now oiled, tuned, and pitched to perfection. The problem for the men sitting around the table on that late spring morning was frankly to find anywhere left to bomb.

They did find one, however. Buried under section 14 (c) paragraph (i) of the minutes is the dry account that sealed a city's destruction:

> *Hiroshima is the largest untouched target not on the 21st Bomber Command priority list. Consideration should be given to this city.*

Consideration was given to the city. Just two weeks later, on May 10, the Target Selection Committee met again, this time in Oppenheimer's office on Site Y in Los Alamos. In the chair was Groves's ever-faithful deputy, General Farrell. Five cities were earmarked for discussion: Kyoto, Hiroshima, Yokohama, Kokura Ar-

senal, and Niigata. All five were, as the minutes record, "targets which the Air Forces would be willing to reserve for our use." Top of the list was Kyoto, Groves's personal favorite. Right behind it was Hiroshima.

The city satisfied every criterion. It was sufficiently military, with its army depot and port, to salve any consciences about the possible impact of an atomic bomb on a population of 300,000 human beings. Far better to describe Hiroshima as "an urban industrial area," the sort of place the air force were nightly reducing to smoldering heaps of ashes and rubble. But the city had other advantages too, and in spelling these out the minutes betray the deeper "considerations" behind Hiroshima's selection. For one thing, its proportions were just about perfect for an atomic bomb, of such a size that it "could be extensively damaged." For another, it had "adjacent hills which are likely to produce a focusing effect which could considerably increase the blast damage." The same mountains that gave Hiroshima its idyllic setting would also help destroy it.

And there was more. Everybody in that room understood the prime purpose of this weapon: its shock value. Paragraph 7 of the committee's minutes bluntly made the point in case anybody might have missed it. Headlined "Psychological Factors in Target Selection," the argument is spelled out:

> It was agreed that psychological factors in the target selection were of great importance. Two aspects of this are (1) obtaining the greatest psychological effect against Japan and (2) making the initial use sufficiently spectacular for the importance of the weapon to be internationally recognized when publicity on it is released.

Hiroshima's pristine condition virtually guaranteed the weapon's initial use would be spectacular. That was the best reason for bombing it. Apart from Kyoto, no other city was so well preserved. Here then was modern warfare at its cynical worst: to make the most

spectacular blast in history, and then publicize it. From the very beginning, public relations and the bomb went hand in hand.

Nothing could be allowed to diminish the bomb's spectacular effect. At one point in the meeting, the discussion turned on whether to follow the atomic blast immediately with a full-scale incendiary raid. There were very strong reasons urged. One of them was "that the enemies' fire fighting ability will probably be paralyzed by the gadget so that a very serious conflagration should be capable of being started." All that was true—very true in Hiroshima's case given the paucity of its firefighting equipment—but it missed the fundamental point. The bomb needed to be a solo affair. Muddy its effects with an incendiary raid and nobody (least of all the Japanese) would be able to tell which was which. The enemy had to know that the weapon that had just destroyed one of their cities was different from anything they, or the world, had ever seen.

But the discussion is revealing in another sense. The fact that the double shock of an atomic bomb and an incendiary attack was even *contemplated* speaks volumes about the mentality of the men sitting in that room. As ever, the minutes are bare in the detail. The words are guarded. Terms like *gadget* or *coordinated incendiary raid* mask the realities behind them: the horror of thousands of tons of firebombs falling on a city minutes after its atomic obliteration. The prospect is unthinkable and inhuman. Yet these were not in any sense inhuman men. They were competent, conscientious, intelligent professionals, fulfilling a duty. They would not have regarded themselves as unduly cynical or brutal. They simply wanted the war to end. In that respect they mirrored the American people of which they were a part. Four years of war had deadened the senses. The Japanese were objects of loathing or fear or disgust or contempt; rarely were they just human beings.

Almost every day the press and newsreels blasted the same message across the nation: that the Japanese were different, alien, *other*, merciless and fanatical torturers who behaved more like monkeys or gorillas than humans. There was even a lapel button on sale: "Jap

Hunting License—Open Season—No Limit." This was a climate in which Admiral William Halsey, commander of the South Pacific Force, could urge his men to "kill Japs, kill Japs, kill more Japs." "The only good Jap," he once declared, "is a Jap who's been dead six months." Nobody had forgotten Pearl Harbor, that "Day of Infamy" on which Japan had ruthlessly stabbed America in the back. And now, in these last weeks of the war, stories were beginning to emerge of the hideous treatment of Allied prisoners in Japanese camps. The reaction of many decent Americans was a kind of animal vengeance. It crossed every level of society. General Joseph Stilwell wrote to his wife: "When I think of how these bowlegged cockroaches have ruined our calm lives it makes me want to wrap Jap guts around every lamppost in Asia." The demonization of an entire people is concentrated in that one sentence. Cockroaches do not merit human sympathy. They get killed instead.

FOURTEEN

Tuesday, July 24
Little White House, Babelsberg, Near Potsdam, Germany

IT WAS TWENTY past nine on a fine summer's morning when Henry Stimson presented himself at the Little White House for an appointment with the president. In his briefcase he carried the latest cable from Washington: General Groves's final timetable for the bomb. As he waited at the front door of the president's yellow-stuccoed villa, Stimson knew that the first bomb would be ready on August 1, a week from now. He also knew today was his final chance to persuade the president to consider the one alternative to using the bomb: that the Japanese should be allowed to keep their beloved emperor in the Allied ultimatum demanding their surrender.

Truman welcomed Stimson in his office. The president was in a good mood. Things had been going well for him in Potsdam, especially since the moment his secretary of war had read that sensational report about Trinity three days ago. His confidence had grown by leaps and bounds. More than ever he looked like the world leader that, in a very material sense, he now was. His energy was apparently limitless. He was up early every morning, dressed and ready for his regular constitutional around the lake. Despite his

flat feet, he walked fast—up to 120 paces a minute—and his aides had a hard time keeping up with him. The world was going his way. Even the conference here in Potsdam was rapidly moving toward the finish line. With luck the whole thing could be wrapped up by the weekend and he could be on his way home.

As the two men sat in that office on that sunny morning, the contrast between them was palpable. The robust, dynamic, confident president on the one side; his frail, exhausted secretary of war on the other. Like Truman, Stimson was also up early every morning, but not because he was full of energy. His insomnia tortured him, so much so that a good night's sleep earned a special mention in his diary. There had been very few such mentions in recent weeks. Instead there were many entries about badly needed rests or those disturbing pains he kept experiencing in his chest. He was longing to go home. He missed his wife, Mabel, and the long, tranquil summer evenings under the cedar trees at Highhold, their beautiful Long Island estate. He was a tired old man—"over age and overweight," as he put it—and the stress of the past few weeks was making him feel even older and more tired.

His exhaustion undid him in the end. Rightly or wrongly, he believed—as he wrote that same night in his diary—that the emperor's guarantee "might be just the thing that would make or mar" Japan's acceptance of the ultimatum. But somehow, somewhere during that meeting with the president he lost the stomach for the fight. He barely defended his case. He simply accepted, regretfully and with a pained resignation, that the ultimatum would now go out without the guarantee to the emperor. Truman—like his secretary of state Jimmy Byrnes—was too strong for him. He had none of the quibblings of conscience that kept Stimson awake half the night. He was not interested in concessions. He was interested in winning the war, quickly, decisively, and preferably before the Russians stepped in. The world had moved on in the forty-four years since Stimson was first secretary of war. The old, stiff-necked Victorian gentleman belonged to a different era. It was time he went

home to Mabel and the cedar trees and let the president get on with the war. The Japanese would surrender unconditionally or they would die, and they would continue to die in awesome numbers until they did surrender.

In those brief few minutes on that Tuesday morning in Babelsberg, perhaps one of the last possibilities for peace without using the bomb slipped away. It is tempting to consider that had things been different, had Stimson been tougher or younger or more persuasive, the course of history might just have changed. A signal from the Allies might have acted on those "liberal" elements Stimson recognized in the Japanese government—men like the foreign minister Shigenori Togo—prodding them into action against the army leaders bent on Armageddon and national suicide. The emperor himself might have stepped in to prevent further bloodshed. And the bombs might never have been dropped. But that was not what happened. The demand for unconditional surrender could only ever lead to one result. Like actors in a Greek tragedy, the key figures played out their roles to the bitter end. Truman smiled indulgently at his faithful, uncertain, overconscientious old secretary of war, and sent him on his way.

Events now unraveled with rapid inevitability. At 7:15 that same evening, after the day's session in the conference hall, Truman gathered his papers, rose from his chair, and ambled over to Stalin. Stalin was standing with his interpreter. "I was perhaps five yards away," said Churchill, "and I watched with the closest attention. I knew what the President was going to do." Byrnes was watching too. He also knew what the president was going to do. The two men had discussed it that very day, almost as soon as Henry Stimson had left the room. "I casually mentioned to Stalin," said Truman, "that we had a new weapon of unusual destructive force. The Russian Premier showed no special interest. All he said was that he was glad to hear it and hoped we would make good use of it against the Japanese." "That," wrote Oppenheimer later, "was carrying casualness rather far."

Churchill was waiting expectantly for Truman outside. "How did it go?" he asked. "He never asked a question," replied Truman. The two men left the conference hall like a couple of schoolboys who had just pulled off a brilliant prank, quite convinced Stalin had no clue about the nature of the weapon to be unleashed on Japan. They could not have been more wrong. The old fox had duped them to the last. Klaus Fuchs, the waltz-loving, bespectacled Los Alamos spy who had witnessed the Trinity fireball from Compania Hill, had been feeding the Russians information for years. At that very moment, miners were digging out vast deposits of uranium ore in the hills of Soviet Central Asia. Soviet agents had already removed two tons of uranium oxide from the Kaiser Wilhelm Institute in the ruins of Berlin, along with a number of leading German scientists. On the site of an abandoned farm at Podolsk, near Moscow, a top-secret atomic center had rapidly sprung up, an isolated Los Alamos–style laboratory complete with its own testing grounds, airfield, and a uranium diffusion plant based on Klaus Fuchs's specifications. There was even a Russian Oppenheimer, a brilliant nuclear physicist called Igor Kurchatov. The Soviet atomic machine was accelerating with each passing day. Now the Soviet leader prepared to shift it into the highest gear. Less than one hour after Truman's disclosure, Stalin was closeted with his foreign minister, Molotov. He told him what Truman had said. "We'll have to talk it over with Kurchatov," said Molotov, "and get him to speed things up." The nuclear arms race was on. Leo Szilard had warned the president as much. But his warning was locked away in General Groves's office.

HENRY STIMSON did not witness the encounter between his president and Stalin. Before he sat down to supper, Groves's draft directive authorizing the use of the atomic bomb was radioed to his office. He wasted little time replying. There was no longer anything to discuss. Everything had now been decided. Shortly after midnight, he cabled his answer back to Washington.

TOP SECRET

URGENT
From: TERMINAL
To: War Department
Number: Victory 281
25 July 1945

> *Reference your WAR 37683 of July 24, Secretary of War approves Groves Directive.*
> *End*

The time was now 12:35 A.M. in Potsdam. In Washington it was 6:35 P.M., a beautiful midsummer's evening. Groves had his answer. In a single sentence, the secretary of war had effectively signed the order to drop the bomb—and any subsequent bombs, should they be necessary. Control of the weapon had passed from the politicians to the generals—which for all practical purposes meant Groves. Only one thing now stood between the Japanese and nuclear destruction: their response to the ultimatum demanding their unconditional surrender, scheduled for delivery just thirty-six hours from now. As for Stimson, he left for a badly needed holiday in the Brenner Pass, where he caught a trout.

OF COURSE, the decision was always inevitable. So inevitable, perhaps, that it could hardly be called a decision. Everything conspired to that end. There were so many urgent reasons to drop the bomb. Together they made an irresistible cocktail. It would have been far more remarkable had it *not* been dropped. Yet there were dissenting voices. Stimson was not the only senior figure who believed—albeit by no means consistently—that the bomb might not have to be used. There were others: Eisenhower, the supreme Allied commander, felt a moral repugnance to the very idea of the bomb. "I hated to see our country be the first to use such a weapon," he

later wrote. Admiral William Leahy, the White House chief of staff, was also opposed, distinctly on the grounds that Americans had more honorable things to do than destroy innocent women and children in their beds. "I was not taught to make war in that fashion," he said. Others were opposed on purely practical grounds. General Curtis "Iron Ass" Le May was hardly worried about the women and children—his incendiaries were destroying them every night—but he could not see the purpose of the bomb. Surely his own crews were rendering it unnecessary. Another few weeks and there would be no Japanese cities left—Hiroshima, it should be added, among them. Japan would surrender and the war would be over without a single radioactive isotope to poison the air.

But all this missed the point. However horrific, the nightly bombing raids on Japan were nothing new. They were only bigger than anything that had gone before. The atomic bomb, on the other hand, was very new. Its shock value was incalculable. The Trinity test had vividly demonstrated what a single bomb could do. It could turn the desert into glass. It could make blind women see the light. There was something almost demonic—or divine, depending on your point of view—in the power of atomic retribution. That power was the key to Japanese surrender: to break Japanese morale with a form of destruction different, as well as deadlier, than anything the world had ever seen. The Japanese, as General Marshall once said, needed to be *shocked* into surrender. That was the only way to stop the war and save American lives. They needed to be awed, cowed, broken, unutterably crushed into defeat. The bomb was the only weapon in the American arsenal big enough to do that.

Nor was it only the Japanese who would be shocked. Central to Truman's strategy was his fear of the Soviets now massing on the Manchurian frontier. The mistakes the Allies had committed in Europe would not be allowed to recur. This time, there would be no iron curtain to worry about. The Russians would not have time to raise one. The bomb's blast would—metaphorically if not liter-

ally—blow them back across their border. Meanwhile Stalin would be taught an invaluable lesson about American power. His cities would now be just as vulnerable as Japan's, and just as easily obliterated in a single, monumental blast of fire. The point was not lost on General Groves. "You realize of course," he told the British scientist James Chadwick over dinner one night, "that all this effort is really intended to subdue the Russkies." What neither Groves nor Truman knew was that the Russkies had already taken the lesson fully to heart.

For any president of the United States, power like this was heady stuff. The world's game was his, to play almost as he liked. To resist that, somehow to turn back the clock and stop the bomb, would have been either impossible or the apparent act of a madman. By the time Truman arrived in Potsdam, the Manhattan machine was an accelerating roller coaster. More than 100,000 men and women were involved in the development and construction of the bombs. Two billion dollars of taxpayers' money had been spent in total secrecy. Virtually the entire silver deposits of the United States Treasury had been melted down to help giant electromagnetic separation plants produce weapons-grade uranium. Over the past three years, major national reserves had been diverted to the one purpose of building this bomb. How could anyone, how could even the president himself, possibly slam on the brakes? Again, Groves understood this perhaps better than anyone. Truman could no more stop the bomb, he said, than a boy tearing down a hillside on a toboggan could stop the toboggan. The ride was wild, exciting, fearful, even unpredictable, no doubt. But it was unstoppable.

And Truman himself had no wish to stop it. Not once—not then or later—did he ever suggest otherwise. He never seriously questioned the bomb's deployment since the moment Stimson first informed him of its existence immediately after he became president in April. He approved the Interim Committee's recommendations on May 31 to use the bomb against Japan without prior demonstration and without warning. He may have done so "reluc-

tantly"—but he did it nevertheless. "The atomic bomb was no 'great decision,'" he later wrote. "Not any decision you had to worry about." The bomb, he always maintained, "was a weapon of war" and nothing more. As an ex–artillery officer from the First World War, he had no qualms about treating it as such. The Americans had not invited the Japanese to attack Pearl Harbor. Their treachery had started this war. Now they refused to give up. The bomb was the only answer. In the end, its moral dimension could be reduced to simple arithmetic. "It occurred to me," Truman later wrote, "that a quarter of a million of the flower of our young manhood were worth a couple of Japanese cities."

But the moral dimension could not be entirely ignored. On the night Stimson approved Groves's directive, Truman wrote in his diary:

> We have discovered the most terrible bomb in the history of the world. It may be the fire destruction prophesied in the Euphrates Valley Era, after Noah and his fabulous Ark . . .
>
> This weapon is to be used between now and August 10th. I have told the Secretary of War, Mr. Stimson, to use it so that military objectives and soldiers and sailors are the target and not women and children. Even if the Japs are savages, ruthless, merciless and fanatic, we as the leader of the world for the common welfare cannot drop this terrible bomb on the old capital or the new . . . It certainly is a good thing that Hitler's crowd or Stalin's did not discover this atomic bomb. It seems to be the most terrible thing ever discovered.

The whole of Truman's mind is laid bare in these words: his apocalyptic vision of the bomb's destructive power, his instinctual horror of using it the only way it ever could be used—as a weapon of mass destruction. It was illusory talking about military objectives, as every member of the Target Selection Committee already understood. Truman understood it too, but even now, in this fourth year of war, with all its horrors and holocausts and unimaginable

indecencies behind him, perhaps he could not face the final reality of what he was about to do. Like any human being he had to find recourse in his own humanity. It was, he said, no great decision. But there were those who remembered the crushing headaches from which he also suffered, when he took that decision and made it flesh.

FIFTEEN

IT WAS STILL early in the morning when the USS *Indianapolis* hoved into Tinian's waters and dropped anchor half a mile offshore. The ship had performed flawlessly. It was less than ten days since she had eased under the Golden Gate Bridge to begin her journey across the Pacific. Her thirteen-year-old engines had never missed a beat. Now her crew stared through their binoculars at the flat coral island with its treeless plains. As they watched, a flotilla of small boats left the busy port and approached the heavy cruiser.

Within moments the boats surrounded her. Some of the crew noticed they were carrying unusually high-ranking officers, yet another curiosity in this very curious mission. Then the big wooden crate that had attracted so much attention was removed from the hangar deck. A crane on board carefully let it down over the ship's side to one of the boats below. Whatever it contained—Rita Hayworth's underwear or General MacArthur's toilet paper or bacteriological weapons—the ship's crew were glad to be rid of it. Now, at last, they could get on with the war.

At the same time, and almost entirely unnoticed, another motor launch closed toward the ship's stern. On board was Dick Ashworth, a tall, lean naval aviator and Guadalcanal veteran who now worked for General Groves. Ashworth waited patiently as one of the ship's crewmen attached a bucket-shaped object to the davit. He knew what was in the bucket. Here, at last, was what he, and the rest of the scientists on Tinian, had been waiting for: the uranium 235 projectile for *Little Boy*, the first combat atomic bomb.

As the launch bobbed up and down on the light swell, the davit's operator slowly lowered the bucket over the side. Suddenly the line slipped. To Ashworth's horror, the 300-pound lead-lined bucket instantly went into freefall, crashing onto the deck beside him. For one shocking moment, Ashworth thought its priceless contents had smashed right through the hull to the bottom of the sea. Somehow, incredibly, the deck held. Gingerly, Ashworth righted the bucket. The boat sped back to the port where a flatbed truck was waiting on the quay. Quickly, the bucket and the wooden crate were lashed on board and a tarpaulin thrown over them. As always, their secrets would remain hidden from curious eyes.

Under armed escort, the truck drove up Eighth Avenue to the Tech Area, the sealed-off bomb-making compound with its gray windowless buildings up on the island's isolated northwestern coast. The two couriers, Nolan and Furman, rode with it, still wearing their fake upside-down artillery insignia, no doubt relieved to be back on solid ground. Their task was nearly complete. For thousands of miles they had watched over their precious cargo, traveling by car, by air, and by sea. Their trek had taken them all the way from Los Alamos in the mountains of New Mexico to this bare, sultry island in the middle of nowhere. They had just one more job to do.

The truck passed through the compound's gates and into the Tech Area. The wooden crate was removed, followed by the bucket. Nolan and Furman then presented a typewritten sheet of paper to General Farrell. He had recently arrived on Tinian to act as Groves's deputy. Now he carefully examined the typewritten document. It

was a receipt for half the uranium 235 that would be exploded over Hiroshima fewer than ten days from now.

> Date: 26 July 1945
> To: Brigadier General Farrell.
> Re: Receipt of Material.
>
> Original to be signed personally by the recipient and returned to the sender.
> Duplicate to be retained by the recipient.
> Triplicate retained by sender for suspense file.
> Description: Projectile unit containing [blanked out] kilograms of enriched tubealloy at an average concentration of [blanked out].
> PLEASE SIGN AND RETURN THE ORIGINAL RECEIPT IMMEDIATELY.

The formal procedures of transfer were now complete. The uranium 235—"tubealloy" was its code name—was now effectively owned by the army, ready for use as soon as the bomb was assembled. The relevant documents were copied and filed. When *Little Boy* was finally dropped, nobody would be able to complain that the paperwork was not in order.

Exactly twelve days after leaving Los Alamos, half the active fissionable core of the bomb was safely on Tinian. Now the scientists waited for the other half.

THE AIRPORT STAFF at Kirtland Field, Albuquerque, had never seen anything like it. The big Douglas C-54 transport planes were in huge demand these days. Everybody was screaming for them. When they flew, they always flew full. The C-54 was the largest transport in the army air force, capable of carrying up to eighty-six passengers. But here were three C-54s warming their engines on Kirtland's apron, with just a single passenger and a single piece of

cargo apiece. The passengers were peculiar enough. Each of them was armed to the teeth. As for the cargo, it was just a steel bucket two feet high and one foot wide. Three passengers, three buckets, three planes. Not even Eisenhower got that sort of treatment.

At 9:10 A.M. the first plane roared down the runway bound for Hamilton Field in San Francisco, 1,200 miles to the west. Sitting in the back was Lieutenant Colonel Peer de Silva, a clean-cut twenty-eight-year-old ex–West Pointer whom General Groves had appointed his head of security in Los Alamos. De Silva's orders were to deliver all three buckets halfway across the world to Tinian Island. Each bucket contained two specially cast rings of uranium 235. Their combined weight was just fifty-six pounds. Their value probably exceeded several hundred million dollars. They had been divided among the three aircraft in case one crashed. But each bucket still had its own parachute.

The three buckets had arrived earlier that morning from Los Alamos in a closed black truck guarded by fifteen intelligence officers armed with .38 caliber pistols, tommy guns, shotguns, and carbines. Groves and his security teams were taking no chances. For here, separated into these buckets, was the other half of *Little Boy*'s fissionable core. The *Indianapolis* had just delivered the uranium 235 projectile. The C-54s would now set off to deliver its uranium 235 target. Once on Tinian, the two halves would finally be assembled to complete the bomb.

Groves was taking a calculated risk. He had guaranteed the president that *Little Boy* would be operational by August 1, six days from now. General Spaatz was already on his way to the Pacific carrying his directive authorizing the use of the atomic bomb. The president's ultimatum to Japan was being checked by Japanese-language experts before being broadcast to the world. It was imperative that the three C-54s with their three buckets reach Tinian on time. If the buckets failed to arrive, *Little Boy* could not be assembled. On Peer de Silva's young shoulders effectively rested the responsibility for shortening or lengthening the war.

Forty-five minutes out of San Francisco, on the second leg of the journey, de Silva's plane suffered an engine failure. The C-54 was already well out over the Pacific Ocean. Despite Groves's strict orders that all three aircraft stick together, the other two continued on to their next stop, Honolulu. De Silva's plane was alone. The pilot feathered the windmilling propeller, swung the aircraft around, lost height, and started the long descent back to the coast. De Silva tightened his harness and held on to his bucket. The crew sighted Hamilton Field, declared an emergency, dropped flaps, and slowed for the approach. Fire engines screamed toward the runway. The aircraft's tires screeched onto the concrete and rolled to a stop. The bucket and its courier were safe. But it took several hours before the engine was replaced and the C-54 could resume its journey.

And several hours, at this stage of the war, was a very long time.

DE SILVA'S THREE C-54s were not the only transport planes leaving for Tinian that day. There were two others, carrying a very different cargo. The immediate pressure on Groves was to prepare *Little Boy* for operational use. But right behind *Little Boy* was *Fat Man*, the bulbous ellipsoidal plutonium bomb modeled on the *Gadget* that had lit up the New Mexico sky ten days earlier. The men responsible for assembling *Fat Man* were also waiting in their windowless huts on Tinian. And they were also racing a deadline.

Strapped to his seat inside one of the Douglas transports was Raemer Schreiber, a young Los Alamos physicist. Next to him was a small suitcase, very like the one Philip Morrison had carried on the backseat of his army sedan from Los Alamos to the Trinity test site. It contained the same two hemispheres of gold-wrapped plutonium. The hemispheres would remain separated in their suitcase for the entire trip to Tinian. Once there, they would be joined with infinite care exactly as they had been in George McDonald's ranch house living room, to form the active, fissionable spherical core of the world's second combat atomic bomb. If *Little Boy* failed to make the Japanese surrender, *Fat Man* would hit them next.

The two C-54s—cargo and spare—took off from Kirtland Field shortly after the first three aircraft departed with their uranium buckets. Five big four-engined transport planes were now in the air, bound for the Pacific. Between all five they carried just sixty-nine pounds of the world's two most valuable metals—about the same as a single airline passenger's baggage allowance today.

For hour after hour Raemer Schreiber sat with his suitcase as the big plane droned westward across the endless Pacific. Somewhere out over the ocean they ran into a tropical storm. The plane heaved and bucked and dipped all over the sky. One of the guards came up to Schreiber. "Sir," he said, "your box is bouncing around back there and we're scared to touch it." Schreiber grabbed a piece of rope and tied the suitcase to one of the cots on board the plane. The guard kept what he believed was a safe distance. A safer distance would have been several miles. Lashed to its cot, the suitcase with its tennis ball–sized plutonium core crossed the Pacific. Two days after leaving Kirtland it reached Tinian. Less than two weeks later it would explode over Nagasaki, killing 70,000 people.

SIX HOURS AFTER depositing her cargo safely on Tinian, Captain Charles McVay ordered the USS *Indianapolis* to lift anchor. Her secret mission was accomplished. Now her captain had new orders: to join Task Force 95.6, the huge fleet assembling on Leyte in the Philippines for Operation Olympic, the invasion of southern Japan—scheduled for November 1. By mid-afternoon, the cruiser slipped quietly out to sea for Guam, 120 miles to the south. From Guam she continued, alone and unescorted, for the island of Leyte, a further 1,300 miles west across the Philippine Sea.

She never got there. Just before midnight, on Sunday, July 29, she was spotted by a Japanese submarine, I–58. The submarine's commander could not believe his luck. The huge American warship was alone. Immediately he descended to periscope depth, then fired six torpedoes at the *Indianapolis* from a distance of 1,500 yards. Each torpedo carried enough explosive to destroy a city block. They

raced fanwise at fifty miles per hour toward the American vessel. On board, hundreds of men were sleeping out in the open to escape the fierce heat belowdecks. In one of the starboard forward cabins a party was just ending. In the library the ship's Catholic priest was hearing confession. On the bridge the midnight watch were about to replace the previous shift. Twenty officers and men looked out over a black and empty sea. Their ship carried no sonar gear. They saw and heard nothing.

Sixty seconds after launch, the torpedoes tore open the *Indianapolis's* bow and destroyed her power center. Almost immediately she rolled over to her starboard side, rapidly filling with water. Explosions ripped through her decks. Within moments her insides were a teeming cauldron of fire and black choking smoke. Eight hundred fifty men leaped or were thrown overboard. Some were chopped to pieces by the still-spinning number three screw. Others watched in horror as the ship's stern rose a hundred feet into the sky. Many of the survivors heard the screams of trapped sailors inside the hull before the ship plunged into the depths of the sea. It took less than fourteen minutes for the *Indianapolis* to sink. By then 350 of her crew were already dead. Many of them had never even woken up.

For the men who were left, the nightmare was just beginning. Over the next three and a half days they trod water in their kapok life jackets as exhaustion, injuries, hunger, cold, shock, and raging thirst took their toll. Some drank seawater and died in agony. Others hallucinated or went insane. A few tried to kill each other. The sun burned relentlessly down, blinding the survivors as they struggled to keep afloat. But the greatest terror were the sharks that came within hours of the attack, swimming up from the depths to circle the survivors and pick them off one by one. The terrified, half-naked men clung together, linking arms, splashing the water or kicking out their legs in panic. It made little difference. Still the sharks kept coming, sometimes twenty or thirty at a time, tearing at the men's flesh, dragging them out of the huddled groups and

down into the sea. Most frightening of all were the nights, when the waters were too black to see the sharks lurking below. And there were four nights.

Eighty-four hours after I–58 had sent the *Indianapolis* to the bottom of the ocean, a navy plane on a routine patrol spotted the survivors. There were only 318 left. More than 500 men had died in the water after abandoning ship. Of the ship's total complement of 1,196 men, 878 had been lost. It was the United States Navy's greatest disaster at sea. It was also a terrible price to pay for the delivery of eighty-five pounds of highly enriched weapons-grade uranium. Rescue ships would still be collecting the floating corpses when *Little Boy* exploded over Hiroshima, four days later.

SIXTEEN

Thursday, July 26, to Friday, July 27

ON THE SAME day the five Douglas transport planes left Kirtland airport with their nuclear bomb cores, President Truman's ultimatum was delivered to the Japanese people. At 1 P.M. Washington time, as the American aircraft were refueling at Hamilton Field, copies of the Potsdam Declaration were handed out to reporters. Five hours later, at 6 P.M., it was broadcast in Japanese from San Francisco. The first Japanese station to pick it up was in Chofu, a suburb of Tokyo. The first man to hear it was Seiichiro Katsuyama, one of the station's operatives on duty that morning. He made six recordings of it, checked it carefully, typed it out, jumped on his motorcycle, and sped off into the city to the foreign office. It was, he always remembered afterward, a beautiful day, and the potato fields glistened in the hot, early morning sun.

In Japan, the time was 7 A.M., Friday, July 27. In Germany, it was still the evening of the previous day. In his Babelsberg villa, President Truman stood on the back porch in the cool breeze listening to his buglers playing "Colors." The music seemed to touch him deeply, and he turned to one of his staff: "That isn't easy to play, you know," he said. On Tinian, the 509th crews were settling

down to another excellent breakfast. Like Bob Caron, many of them were looking forward to tonight's show in the Pumpkin Playhouse. Movie stars Eddie Bracken and Peggy Ryan were flying in to entertain the boys. There were all kinds of rumors running around about the gorgeous girls who were coming too. It promised to be quite a night.

Minutes after Seiichiro Katsuyama reached the foreign office with his typed text of the Potsdam Declaration, it was in the hands of the minister, Shigenori Togo. Togo quickly scanned Katsuyama's Japanese translation:

> Following are our terms. We will not deviate from them. There are no alternatives. We shall brook no delay.

There were thirteen clauses in all. Not one of them explicitly guaranteed the status of the emperor. The demand for unconditional surrender was left till last. It was direct and uncompromising:

> We call upon the government of Japan to proclaim now that unconditional surrender of all Japanese armed forces, and to provide proper and adequate assurances of their good faith in such action. The alternative for Japan is prompt and utter destruction.

The message was clear. Japan must surrender or she would be destroyed. There was only one point omitted: the actual means of that destruction.

TOGO'S IMMEDIATE reaction was to play for time. The one slender hope to which he clung was the absence of Stalin's signature on the declaration. Truman, Churchill, and the Chinese leader Chiang Kai-shek had all approved the ultimatum. But Stalin was not technically at war with Japan, and to the sixty-three-year-old veteran foreign minister sitting in his office on that hot summer's morning

in the smashed city of Tokyo, there was even yet a possibility, just a glimmer of chance, that the Russians might broker a better deal.

Throughout that day, the Supreme Council for the Direction of the War—the Big Six, as they were known—met to discuss the declaration. The instinct of the two army leaders, Generals Anami and Umezu, was to reject it outright. They wanted to fight, not surrender. They were still pressing for the Armageddon from which they were convinced Japan could emerge victorious, with her honor and integrity intact. The declaration held no possibilities for these men. Their training, their culture, their deepest, most ingrained beliefs were threatened by the very idea of unconditional surrender. Their vision was simple and, to themselves, glorious: victory or martyrdom. No other alternative existed.

Togo pressed his case for time. Earlier that morning he had persuaded the emperor that the Russians would very soon come around. The best recourse was to treat the declaration with "the utmost caution." Now he fought the same case with the Big Six. He urged his fellow ministers to delay a decision until Stalin was back from Potsdam. Right at this very moment his ambassador in Moscow was pleading with the Soviet Foreign Office to step in and mediate the peace. It was only a matter of days before the Russians agreed to meet the emperor's appointed envoy. Until then, he argued, the answer to the Allied ultimatum was neither to accept nor to reject it. Perhaps if Togo had known the truth he might have acted differently. The Russians already had a million men on the Manchurian border. They were not about to mediate any kind of peace. They were about to invade.

The army generals were unconvinced. They loathed the dapper little foreign minister with his eccentric un-Japanese habits, with his foreign German wife, his disdain for geishas and community drinking bouts, his love of Goethe and Schiller and decadent Western ways. They saw him as the betrayal of everything he had been born into: the product of a distinguished aristocratic samurai family who now wore a wing collar, a tie, and a matching pocket handkerchief.

They hated him, as they hated every man who ever thought, felt, or acted like him. For exactly the same reasons they were equally suspicious of the prime minister, Admiral Kantaro Suzuki, a man whom their disciples had tried to assassinate more than once. Japan would never allow these men to sabotage her honor. Not now, not ever.

Perhaps in the end the power of the generals prevailed. Perhaps the fear of assassination lingered in the memory of the prime minister. He always said he could feel the mark of the gun that an army fanatic had pressed into his neck nine years earlier. Did he feel it now, as he stepped before the press at four o'clock on the following afternoon, to deliver his government's verdict on the Allied ultimatum?

There he stood, one of Japan's greatest war heroes, a veteran campaigner of the 1905 battles with Russia, the bravest— if also the most seasick—sailor in the Japanese navy. But those were ancient battles, and now he was a tired old man, seventy-eight years old, and the world outside the windows was smashed and scorched and broken. As he stood before the press on that Saturday afternoon in Tokyo, Suzuki looked oddly vulnerable, with his big cauliflower ears and graying walrus mustache and trembling hands and the memory of that gun barrel on his neck. A Japanese reporter asked for his opinion about the Potsdam Declaration. The prime minister duly answered: "The government does not see much value in it." And then he added a curious phrase: "The government will *mokusatsu* it."

Mokusatsu: the word was dangerously ambiguous. *Mokusatsu* spanned a range of possible interpretations. It could mean to ignore. It could mean to withhold comment. It could also mean to kill with silent contempt. Was this very ambiguity Suzuki's solution to his dilemma: a man who instinctively wanted to stop the war but was also afraid to die? Was the phrase deliberately misleading, equally a signal to the army fanatics that the Allied demand was unacceptable and a signal to the Allies themselves that it might yet be acceptable? The Japanese had a term for this sort of ambiguity. It was called *haragei*, literally "to talk out of both sides of your

mouth." Suzuki was a past master of the art. Perhaps now he felt it served him well, the perfect means to walk the tightrope between two entirely different points of view, and still survive. But *haragei* meant nothing to the Allies, who were waiting for the Japanese response to their ultimatum. There were no tongue-twisting double meanings in *mokusatsu* for Truman and Churchill. There was only rejection. The Japanese prime minister had turned them down. In a single ambiguous phrase Suzuki had sealed the fate of his nation. Now his people would learn the true meaning of "prompt and utter destruction."

THAT AFTERNOON the B-29s came to Hiroshima, as they came to so many other Japanese cities. But they did not bring bombs. They brought leaflets, tens of thousands of them, each one carrying the Japanese text of the Potsdam Declaration. The leaflets fell from the silver planes, floating down in the summer skies over the old city. In the great gray Red Cross hospital, the nurses and patients gazed up at the pieces of paper twisting and turning in the wind, catching the eaves of the wooden buildings. One of them was Naoe Takeshima, a young seventeen-year-old student nurse. She had no idea what they were. Nobody was allowed to keep them. But ever afterward she would remember the leaflets tumbling down like a shower of confetti, shining and sparkling in the light. The American planes had passed over the city so many times, but they never dropped anything. Now at last they had, and it was the most beautiful sight the young nurse had ever seen.

ACT III

DELIVERY

THE FINAL HOURS
AUGUST 4-6, 1945

The whole mission was perfect, it was a picture-perfect mission. You couldn't have wanted a better mission.

DUTCH VAN KIRK, navigator of the *Enola Gay*,
interviewed by the author, May 2004

I knew what the Japs were in for, but I felt no particular emotion about it.

CAPTAIN DEAK PARSONS, *Enola Gay*'s weaponeer,
interviewed immediately after the attack, August 6, 1945

SEVENTEEN

Saturday, August 4, 4 P.M.
Operations Briefing Room, 509th Compound, Tinian Island

COLONEL PAUL TIBBETS mounted the platform and turned to face the eighty-odd men in the room. Their hushed murmurs instantly died to silence. They stared back at him expectantly. Behind him were two large blackboards. Both of them were draped in cloths. To one side was a portable movie screen. A projector stood on a table opposite. All the windows were curtained off, cutting off the bright afternoon sunshine outside. The silence hung thick and heavy in the room. Everybody's attention was fixed on their commander. Then he spoke. "The moment," he said, "has arrived. This is what we have all been working towards. Very recently the weapon we are about to deliver was successfully tested in the States. We have received orders to drop it on the enemy."

Nobody breathed a sound. The tension in the room was electric. For almost eleven months these men had been training for this moment. Since that first mission on July 20, two weeks ago, they had carried their pumpkin bombs three further times to Japan. Over the past couple of days the strain had been building to breaking point. All kinds of rumors were shooting around every corner

of the base. By lunchtime they had reached fever pitch. Then, out of nowhere, the call had come for this special 1600 hours briefing. Seven crews had been summoned. One of them was Bob Caron and the men from Victor 82. They had only just finished flying a check ride with the colonel that afternoon. That was an unusual event in itself. Normally Bob Lewis skippered their ship, but today he sat in the copilot's seat. Tibbets had flown them up to Rota Island. At Rota they had dropped a practice bomb, slammed into one of those jaw-clenching sixty-degree banked turns, and returned to Tinian. Tibbets had taxied Victor 82 straight up to one of the fenced-off bomb-loading pits—again, very unusual. Caron was saying nothing, but it was obvious something big was up. Then he arrived at this briefing where the security was tighter than he had ever seen. Armed MPs stood out in the hot sun, rigorously checking and rechecking every man's pass. Inside, the room was filled with all kinds of strange faces. There were navy personnel, there was a high-ranking general, there was a British flyer and a bunch of those "long-hair" scientists who always kept to themselves. And of course there were those two big blackboards with the cloths hanging over them.

Tibbets motioned to two of his intelligence officers, Hazen Payette and Joseph Buscher. Quickly they drew the cloths off the blackboards to reveal the maps of three cities: Hiroshima, Kokura, Nagasaki. These, Tibbets said, were their targets. In order of priority: Hiroshima was the primary, Kokura the first alternate, Nagasaki the second alternate. One of these three cities would be hit with the new weapon. For the past three days air force meteorologists had reported typhoons battering southern Japan. The latest forecast predicted a break in the weather by late tomorrow night. The time of the attack had provisionally been set for the morning of August 6, less than forty hours from now.

"A chill went through me," wrote Abe Spitzer, *The Great Artiste*'s thirty-five-year-old radio operator and diarist. "The make-believe was over." Every man in the room strained his eyes on the three city maps pinned to the blackboards. Tibbets continued the briefing.

Seven B-29s would fly the mission. Three would act as weather crews. Their job would be to fly one hour in advance of the strike force and radio back conditions over each of the three cities. The weather was critical: this bomb was too valuable and too special to lose by radar bombing through cloud. It *had* to be dropped visually. The bombardier must be able to see his target. If Hiroshima was overcast, then one of the other two cities would be bombed. If all of them were socked in, the bomb would be disarmed on board, flown all the way home, and landed—an option on which Tibbets did not choose to elaborate. The weather would determine the mission. Hence the three advance crews: *Jabit III*, skippered by Major John Wilson, would fly to Kokura. Major Ralph Taylor's *Full House* would go to Nagasaki. Claude "Buck" Eatherly, the hell-raising, skirt-chasing, poker-playing captain of *Straight Flush*, would fly to Hiroshima. Eatherly had spent most of last night carousing with his handpicked harem of nurses, but his assistant engineer, Jack Bivans, could see his skipper was devastated. He had long been fantasizing about dropping the bomb himself. Now all he got was this lousy weather-watching deal. Maybe Tibbets was punishing him for that fracas over the emperor's palace.

Next Tibbets delineated the other crews. Charles McKnight would take *Top Secret* to Iwo Jima, almost halfway along the route to Japan, and remain there as a spare. The final three B-29s would make up the strike force: George Marquardt in Victor 91—later renamed *Necessary Evil*—to carry photographic instruments; Chuck Sweeney, Abe Spitzer's Irish-American cigar-smoking captain in *The Great Artiste*, to carry scientists and blast-measuring instruments. Tibbets himself would command Bob Caron's crew in Victor 82. His job would be to drop the bomb.

Tibbets then introduced a tall, soft-spoken, balding naval officer who was sitting near the front. This was Deak Parsons, the ordnance expert who had watched the Trinity blast from the cockpit of a B-29. Groves had nominated him to babysit *Little Boy* all the way to its Japanese target. Abe Spitzer observed him closely. He noticed

Parsons was sweating, although whether it was nerves or the high humidity he could not tell. Parsons came straight to the point. "The bomb you are going to drop," he said, "is something new in the history of warfare. It is the most destructive weapon ever produced. We think it will knock out everything within a three-mile area."

"The men," wrote Tibbets later, "sat there in shocked disbelief." Parsons elaborated: the size of the blast, he said, was equivalent to 20,000 tons of TNT. It would require *two thousand* fully loaded B-29s to deliver the same punch. It was incomprehensible, impossible, "unbelievable," as Spitzer wrote later that day, "a weird dream conceived by one with too vivid an imagination." Parsons went on to explain how the weapon had been tested in New Mexico, three weeks ago. Now he was going to show some actual footage of the test. He nodded to the projectionist, who switched on the machine. The film spluttered through the gate, then suddenly caught on a sprocket, jammed, and chewed itself into pieces. So much for modern technology. Parsons would have to improvise.

And he did. While his audience listened in stunned silence, he described exactly what the bomb could do. It could knock a man down at 10,000 yards. It could be heard a hundred miles away. Its light was ten times more brilliant than the sun and ten thousand times hotter than its surface. "I can only say," he added, "that it is the brightest and hottest thing on this earth since Creation." It was so bright, so dazzlingly brilliant, that it was essential all crews wear special American Optical Company tinted welder's goggles, which he now proceeded to demonstrate. The knob on the nose bridge must be adjusted to its highest setting, otherwise the wearer might go blind. He did not tell his audience about the memorandum he had received from two of the Trinity scientists the day after the test. They too had been dazzled by the light, so much so that they argued it should be exploited to make the bomb even more effective. "It is our feeling," they wrote, "that nobody within a radius of five miles could look directly at the gadget and retain his eyesight." They recommended that "super-powerful" sirens be dropped at the

same time as the bomb so that the populace below would look up, and be instantly blinded. "It is certain," they concluded, "to have a tremendous morale effect on the troops." As if being scorched and blasted were not enough. Parsons dismissed the idea.

While the two intelligence officers handed around the goggles, Parsons made his final, telling point. "No one," he said, "knows what will happen when the bomb is dropped from the air." He took a piece of chalk and drew a mushroom cloud on the blackboard. The cloud, he said, might look something like this. It should climb rapidly up to 60,000 feet into the sky, right up into the stratosphere. He warned the crews to stay well clear of it. But he did not specify why. He did not explain that the mushroom cloud would be composed of millions of tons of broiling radioactive dust. Not once did he or Tibbets ever mention the words *radioactive* or *nuclear* or *atomic*. Even now, in these last few hours, it was considered too dangerous to reveal the final secret in the chain.

Parsons stepped down from the platform, leaving a numbed silence in the room. An outstanding technocrat, he had performed his part well. Nobody who knew him would have expected any less. But he was not a technocrat only. A few days earlier, just before shipping out for Tinian, he had visited his much younger half-brother Bob at San Diego's naval hospital. Bob had been badly wounded in the terrible fighting for Iwo Jima back in March, along with 21,000 other American soldiers. As he was advancing along a sunken road, a Japanese mortar had exploded inches from his head, slamming red-hot shrapnel into his flesh. His jaw was ripped open, and he had lost his right eye. He was only nineteen years old. He had now been in the hospital for four months. Parsons was under appalling pressure with his Manhattan commitments, but he still made time to see his brother. What he saw must have shaken him. The boy was so young. His face was all smashed up. He wore a patch where his eye had been. Parsons was never a man to display outward emotion, but the experience left its own scars. He would remember them, no doubt, when the time came to drop the bomb.

Tibbets closed the briefing. Years afterward, the men sitting on the rows of wooden benches in that clammy, confined room would remember the force behind his final words. He spoke for all of them. He said that everything he or any of them had done up till then was small potatoes compared to what they were about to do. He was proud to be associated with them and proud of what they had achieved. He was personally honored to be taking part in this raid, and he was sure every man there felt as he did. The bomb, he said, would shorten the war by six months and save countless Allied lives. Then the men filed out of the room. Don Albury, copilot on *The Great Artiste,* never forgot their mood that afternoon. They were quiet, very quiet, quieter than he had ever seen.

LESS THAN HALF a mile from the 509th's briefing room, in one of the three dust-free, air-conditioned bomb assembly buildings, *Little Boy* sat waiting on its cradle. At a first glance, it looked exactly like the test bomb Tibbets had dropped into the sea twelve days earlier. It had the same box fin, the same oversized trash can shape, the same dull gunmetal coat. On its left side, crudely painted in white, was the designation L11. To those who knew, the number provided a crucial clue. L11 was not a test unit. It was the "hot" bomb, the active, fully operational atomic weapon that would shortly be dropped on a Japanese city.

Over the past ten days, the Project Alberta scientists had been working at a frantic pace to finish assembling it. Things had been so hectic that at one point Parsons wrote to all personnel warning of the dangers of overcrowding in the assembly buildings. The risk of an accident was very real. Meanwhile, the drop tests continued apace: L1 on July 23 was followed in short order by L2 and L5. The final test, L6, was flown four days ago on July 31. It was a full dress rehearsal. Tibbets led a formation of three B-29s 600 miles up to Iwo Jima, landed, unloaded and reloaded the bomb, flew back to Tinian, and dropped it from 31,000 feet into the sea. The bomb

was identical to the real thing except in one respect: it contained no uranium 235. Everything functioned exactly as it was supposed to: fusing, firing mechanisms, ballistics, accuracy, timings. The test worked perfectly. There would be no more rehearsals. The next drop would be for real.

By August 1, the day after Tibbets's final test, the live unit was fully assembled and ready. While the men of the USS *Indianapolis* were dying in the Philippine Sea, the uranium 235 projectile they had delivered was carefully installed inside the bomb. The uranium 235 target couriered by Peer de Silva and his two cohorts on the big Douglas transport planes was also installed. The guts of the bomb were now complete: the 6.5-inch smooth bore Type B gun that ran down the bomb's length, the fusing system, the battery, and the firing lines. The inside of the bomb was polished until it shone like a mirror. One of the last acts was to screw the massive two-and-a-half-ton steel target casing to the gun's muzzle. This particular casing had already been used four times in firing tests in Los Alamos before being shipped across the Pacific to Tinian. It had survived each test unscathed. It was so tough and unbreakable, the scientists had given it a name. They called it "Old Faithful." Everybody prayed Old Faithful would perform as efficiently one last time.

Unit L11, the live *Little Boy,* was now ready. Over those first four days of August, it sat inert in its cool bomb-assembly building, while the air-conditioning unit hummed away and the guards sweated outside under the fierce sun in their machine-gun emplacements overlooking the bluffs and the sea. On August 2, General Farrell cabled Groves in Washington. There is, he wrote, "nothing left undone there or here which is delaying initiation of first *Little Boy* operation. Waiting only for weather."

EIGHTEEN

Sunday, August 5, Dawn
Hiroshima City

IN FACT, the weathermen had got it wrong. The typhoons had by-passed Japan entirely, tracking west over the empty Pacific before twisting northward to Korea. While the bomb makers, the scientists, the president, and the aviators waited, all three target cities were basking in calm, sunny skies. Without their realizing it, the meteorologists had granted more than 100,000 people a few extra days of life.

On this Sunday morning, most of them went to work as they did every other day of the week. The authorities had recently earmarked yet another batch of homes for destruction: 2,500 of them, entire city blocks and streets to be cleared away for the fire lanes. Like the student nurse Naoe Takeshima, everyone had witnessed the shower of leaflets that tumbled from the skies, carrying the text of the Potsdam Declaration. At any moment the American bombers could strike. The demolition work had to continue. In this morning's edition of the *Chugoku Shimbun*, the mayor, Senkichi Awaya, thanked the citizens "from the bottom of my heart" for their cooperation in reducing great swaths of their own city to rubble. "There are no words," he said, "to express the depths of my gratitude. I can only say to you: this is for Victory."

Up in the hills near Itsukaichi, twenty kilometers west of Hiroshima, Taeko Nakamae woke yet again to the sunshine pouring through the windows of her uncle's farmhouse where she and her family were living as evacuees. Next to her, shivering feverishly in bed, was her twelve-year-old sister, Emiko. For several months Emiko had worked with the rest of her classmates on the demolition teams, dragging down the old wooden houses with their ropes. But over the weekend she had fallen ill, and the village doctor had ordered her to stay at home. It was only two weeks since dysentery had killed her brother Fumio. Perhaps the doctor had decided not to take any chances with Emiko.

Everyone was so tired and sick these days. Even Taeko's mother was thin and wan with exhaustion. She had never fully recovered since that day in March when the whole family had left their home in Hiroshima to come to this farmhouse up in the hills. Of course it was much safer out here. But something in her spirit had died in that long, slow journey out of the city, with a lifetime's belongings and her six children piled on the cart, and her husband away in the army, and the locked front door of their home receding behind them. Every day since, she had grown thinner and weaker. Her world was collapsing in on itself. And then her little boy had walked out into the woods one morning and eaten the loquat fruit.

Taeko and Emiko made the best of it. Despite their two-year age difference, they were very close. They were also almost exactly the same height, and they often swapped dresses. They slept together in the same room, and night after night they would whisper to each other under the sheets, telling stories and sharing dreams. Taeko always believed Emiko was cleverer and prettier than she was. She was so delicate, and she studied so hard over her schoolbooks, even though neither of them had any sort of school to go to anymore. Emiko was also more ambitious. She wanted to become a nurse in the army, and in those whispered nighttime conversations she would paint her future tending to the wounded in the great battles against the enemy. Like millions of Japanese schoolchildren, both

sisters had an unshakable sense of duty. They saw themselves as soldiers, just like troops on the battlefield, equally dedicated to the fight against the emperor's enemies. But Emiko's dedication was perhaps the stronger, and when the doctor saw her sweating and shivering in bed and ordered her not to work, she privately told her sister she would stay at home only until tomorrow. Nothing, not even illness, would stop her from going down to the city then.

In his boardinghouse near the city center, Sunao Tsuboi also woke to the sunshine. Ahead of him was another day in the university's engineering department, where he worked seven days a week helping to design aeronautical parts. The job was long and there were very few rewards, apart from the fact that he was twenty years old and still alive. That was an increasing rarity these days. Sunao knew it could not last. He had already received his call-up papers. Within the next month he would be in the army. After that his life was statistically over. He had already waved off two of his brothers from Hiroshima's port in Ujina. Both of them had been killed, one in China, the other in Java. Now everyone was waiting for the Americans to invade. The slaughter on both sides would be terrific. Sunao was certain he would be dead before the year was out.

There was one gift, one compensation, that made up for all the losses in his young life, and that was Reiko. Despite the hardships and the hunger, despite the endless bayonet practice and the inedible grass and the constant fear of death, the whole of that summer had passed in a kind of dream for Sunao. Afterward, he would remember Reiko as a tiny flower blossoming in a barren field, a streak of color in a world of gray. The metaphors struggle to capture the living reality: a beautiful girl sitting on a bridge with her friends, smiling, chatting, laughing, her movements alive with grace. That was how he had first seen her and how he had fallen for her. At the beginning he had been very shy, but the moment they talked his shyness had melted away. They had soon become inseparable, picnicking in the countryside, walking in the hills, visiting shrines. But they were always careful not to be seen together in public—neither

of their parents ever knew. They never once kissed. They never even touched. Still, he loved her and he believed she loved him, and as he dressed for the day's work he prayed they would see each other again tonight. She did not know he had been called up to the army. He would have to tell her soon. Perhaps he would tell her this very evening. After all, time was so short.

As soon as Tibbets saw the latest forecast that Sunday morning, he knew the mission was on. This time the weathermen were not mistaken. The synoptic charts all told the same story. A ridge of high pressure was moving up from the southeast pushing away the putative typhoons. High pressure meant stable, clear, bombing skies. Back in April, the Target Selection Committee had run a check on the August weather in Japan over the past eleven years. They discovered there were just five days in the month when the weather was clear: sufficiently clear, that is, to drop an atomic bomb in the kind of visual conditions necessary to achieve maximum impact. Judging by the weather charts on Tibbets's desk, tomorrow was going to be one of those days.

At 1000 hours, Tibbets sat down with the major players on the bomb project to approve the go-ahead. These were effectively the leaders on-site, the men who now wielded the power and made the decisions. They dubbed themselves the Tinian Joint Chiefs of Staff. The name was entirely unofficial and entirely accurate. Apart from Tibbets, they included—among others—Admiral William Purnell, the navy's representative in the operation; General Farrell, Groves's deputy on the island; Norman Ramsey, the scientist who had interviewed Tibbets for his job the previous September; and Deak Parsons. In the sultry heat of the morning, as the temperature rapidly soared up into the nineties, the Tinian Joint Chiefs made the decision that stared up at them from the weather charts on the table. Within minutes, that decision was relayed by teleprinter to General Curtis Le May on Guam, 120 miles to the south. As Gen-

eral Carl Spaatz's chief of staff, Le May's official approval was required to confirm the mission. The word *official* is key. Everybody in the top echelons of command knew that the man effectively in charge of the operation was Groves. Le May was merely the mouthpiece. He fulfilled his role appropriately. By 1400 the teleprinters on Tinian were clattering out his confirmation of the mission. The takeoff time was scheduled for 0245, early the following morning. The message was immediately sent across the world to General Groves in Washington. In less than thirteen hours, the bombers would be on their way.

BEHIND THE sealed doors of the bomb assembly building, the project scientists gathered to make their final checks on the bomb. Geiger counters clicked away, monitoring the radioactivity of the two subcritical slugs of uranium 235. Whip aerials and pull-out wires were fixed in place. The casing joins were examined for any heat-induced cracks; none was found. A few technicians scratched their signatures on Old Faithful's casing. In all essentials the bomb was now complete. The only element still missing was its radar antennas, and for a very simple reason: they were one of the bomb's biggest secrets.

The antennas did not look like much, just three simple aerials, one of them bent in an inverted U shape. Hardly the sort of thing to attract much attention, if any, compared to the bomb to which they were finally attached. In fact, their function was absolutely critical. They formed the final link in the most revolutionary and sophisticated fusing system ever devised, the product of years of development by some of the cleverest minds in Los Alamos. Essentially the system was a chain, a relay of fuses, designed to ensure that the bomb detonated at exactly 1,850 feet—the height Oppenheimer had predicted would cause the maximum demolition of light structures in the target area. It worked like this: the moment the bomb dropped, pull-out wires on its back instantly shifted power to its in-

ternal circuits, starting a bank of eight spring-wound clocks—the first step in the chain. As the clocks ticked past fifteen seconds—putting the bomb a safe distance beneath the bomber—the firing signal automatically passed to the second step, a barometric pressure switch designed to close *only* when the bomb reached 7,000 feet. By now *Little Boy* would be hurtling toward the ground at 1,100 feet per second, more than 700 miles per hour, almost at the speed of sound, the baffle plates in its tail making it scream and shriek and rattle as it tore through the ever-denser air. At 7,000 feet the firing signal would shift to step three, the final link in the chain, a series of four radar units called Archies. Specially adapted from APS-13 tail-warning radar devices, they worked on exactly the same principle, except their antennas radiated directly *downward*, the signals bouncing back to give a continuous readout of the bomb's height above the ground. The moment *two* of the Archies agreed the bomb had reached 1,850 feet—the system effectively had its own fail-safe mechanism—the final switch would close, instantly sending the firing signal to the bomb's internal gun. The gun would fire. Exactly forty-four seconds after release, the bomb would explode.

It was a brilliant piece of engineering, unlike anything ever built. This bomb had its own brain. It had its own logic circuits. It was *smart*. But it was also vulnerable, which is why those antennas had been left off until last. Their shape and size gave vital clues about their frequencies. If anybody had the frequencies, he could signal the bomb to explode. Joining Victor 82's crew tonight was Lieutenant Jacob Beser, a young radar technician from Baltimore. His official job title was electronics countermeasures officer. It meant he would sit next to the plane's toilet doing virtually nothing but monitor Japanese radar frequencies all the way to the target. Later he would be given the correct frequencies for all four radar units. They were written on rice paper. His orders were to eat it in the event of capture.

There was one further secret about these radar antennas. Their inventor was not American, but Japanese. His name was Hidetsugu Yagi, and he had designed them in the 1930s. Perhaps the final twist

in the many ironies of this story is that the very last link in the chain that would cause the atomic bomb to explode over a Japanese city would be a Japanese invention.

LIKE WELL-OILED cogs everybody now followed the routines they had been practicing for months. But one outstanding issue was bothering Deak Parsons. The bombers on North Field were still frequently crashing on takeoff. In the early hours of this morning Parsons had watched in horror as it happened yet again. And not just once—*four* times. Overloaded with tons of incendiaries, 100-octane aviation gasoline and incendiary bombs, these B-29s were simply too heavy to get airborne before 8,500 feet of runway and their luck finally ran out. The result was always the same: the sickening screech of metal as the bomber swerved off the runway, the heart-stopping pause, the slaughterhouse of scorching flame and black smoke from which almost nobody escaped. Throughout the morning the charred remains of the four bombers littered North Field's runways.

This was Parsons's nightmare. *Little Boy* weighed a massive 9,700 pounds. Along with the gasoline required to get to Japan and back, Tibbets's B-29 would be dangerously overweight. And he would not be carrying a few tons of incendiaries. He would be carrying a fully armed atomic bomb. A crash on takeoff would not simply destroy his aircraft; the resulting cocktail of flames and burning gasoline could easily detonate the bomb. The consequences could be catastrophic. Most of Tinian Island, along with its hundreds of bombers, its several thousands of servicemen, its Manhattan Project scientists, its 509th crews, not to mention the plutonium core for the next atomic bomb, could simply be wiped off the map. The prospect was appalling. It was also very real.

There was only one solution. Parsons would have to arm the bomb himself, on board the B-29, once it was actually *in the air.* A procedure already existed for this. It was called a double-plug assembly, developed by one of the gun experts, Francis Birch. Parsons

had originally opposed the procedure. Now he recommended it. The only problem was that he had never practiced it before.

The prospect was daunting. Once the bomber was in the air, Parsons would have to leave the aircraft's cabin, crawl down into the bomb bay, edge along the catwalk, crouch behind the bomb, unscrew a series of back plates, remove the double-plug assembly, insert the bomb's four detonation charges one by one—and then put the whole thing back together again. To do it on the ground, inside the controlled, air-conditioned sanctuary of the bomb-assembly building, was delicate and difficult enough. To do it in the air was a more alarming proposition altogether. With its extreme noise, its bone-jarring vibration and sickening turbulence, the bomb bay was hardly the ideal environment in which to arm an atomic bomb. But Parsons could see no alternative. Before the morning was out, he urged General Farrell to let him do it.

"Have you ever assembled a bomb like this before?" Farrell asked.

"No," Parsons replied. "But I've got all day to try."

Farrell paused. Everything depended on his response. Was it better to risk the mission or risk the island? Every day they delayed lengthened the war by just that much. Parsons was an outstanding ordnance expert. He had practically *designed* the bomb. He knew its guts inside out. If anybody could pull this off, he could.

"OK," Farrell said at last, "go ahead and try."

On board the USS *Augusta*, eleven hours behind Tinian time, President Truman settled down in his cabin for a third night at sea. The Potsdam Conference was over, and he was finally on his way home. Two days before, on August 2, he had left Berlin aboard his special plane—nicknamed the *Sacred Cow*—for the short journey to Plymouth where the *Augusta* was waiting. At Plymouth he had lunched on HMS *Renown* with King George VI. Truman minutely recorded the details in his diary. They had soup, fish, peas, potatoes, finishing off with ice cream and chocolate sauce. The king, he

wrote, was "very pleasant" and asked Truman for three autographs, one each for his wife and the two princesses. They also privately discussed the atomic bomb. The king was "very much interested." He then showed the president a sword that had been presented to Sir Francis Drake by Queen Elizabeth I. The sword was a powerful weapon, said the king, but it was not properly balanced.

At 3:49 P.M., the 10,000-ton *Augusta* slipped anchor in Plymouth Roads and set sail for the United States. Truman urged her skipper, Captain James Foskett, to heap on the coals: he wanted to get home quickly. By the night of August 4, the American cruiser was well over a thousand miles out into the Atlantic. Truman went to bed, tired. He had spent the day working on his presidential statement to be released to the world after the bomb exploded. Bill Laurence, the *New York Times* reporter, had prepared the first draft as far back as two months ago, well before anybody knew the weapon would even work. Others had also had a hand, including the head of public relations at AT&T. It was now nearly complete, except for one key component: the name of the city attacked. That would have to wait a few more hours.

NINETEEN

Sunday, August 5, Afternoon
Konoura Training Camp,
Etajima, Hiroshima Bay

ON A DAY like today the view across the Inland Sea toward Hiroshima was glorious. Standing on the wide sweep of beach on Konoura, Private Isao Wada could see right across the bay to the city shimmering five miles away in the haze. The sea was studded with little islands, perfectly formed pyramids rising up dramatically from the blue waters of the bay. Some of them were also shrines, isolated, secret, mysterious places like Ninoshima, thickly covered with trees. In happier times, the ferries used to leave Hiroshima's port at Ujina crowded with visitors to these islands: pilgrims, tourists, lovers, families, soldiers on leave, people who simply wanted to escape for an afternoon or perhaps a day, to admire the sparkling panorama and breathe the salt breeze whipping off the sea. But the ferries rarely ran now. There were still a few ships anchored in the bay, even the odd battleship, but none of them ever moved. There was no longer any fuel left to move them. Almost the only boats still scurrying around the bay between Konoura and Hiroshima were little green wooden ones, like the kind Private Isao

Wada had been training on for the past two months: the ones with 250 kilograms of explosives on the back.

The city might be shimmering across the bay but Wada had little time to admire the view. Along with his fellow trainees, he was too busy doing what he did almost every day: digging holes in the ground. The holes were there to hide the wooden boats. American reconnaissance aircraft had been flying over the area for weeks. It was only a matter of time before they returned with bombs. It was essential that the boats survived. They were one of the keys to Japan's victory. That was why Isao Wada had volunteered to die in them.

He was just nineteen years old. Less than a year ago, he had been working in Hiroshima on the railways, checking the passenger cars before they left the station. He loved the city. Despite the war, the streets were still filled with Kabuki theaters, cinemas, mah-jongg parlors, even gambling houses where Isao could play pool all night with his friends. Then in February he had joined the army, and things had become more serious. The basic training was very tough. If you left a single grain of rice in your bowl you were severely thrashed. Discipline was everything; above all discipline in battle. The lesson was rammed home over and over again: for a Japanese soldier, surrender did not exist. If you were captured, you committed suicide.

Isao took the mantra to heart. By early summer he had volunteered for the *Toko*, the Special Attack Forces, which also supplied kamikaze pilots to the air force. He could not fly a plane but he could steer a boat, which is how he ended up in Konoura, the training base across the bay from Hiroshima. The concept was very simple. Ride the boat toward the enemy ship, slow the engine to idle, silently approach the hull, pull a lever to your left that released the 250-kilogram barrel-shaped bomb, instantly blowing the ship—and yourself—into oblivion. It was a glorious way to die. To Isao Wada, it represented an affirmation of his very masculinity, a form of attack that marked him out as somehow special and distinctive, a soldier who was prepared to seek death, rather than allow death to seek him.

That, at any rate, was the dream. More often the reality was doing what Isao did today: digging holes to protect the few boats that still actually worked. Most of them ran on old Nissan or Toyota truck engines. The engines kept breaking down, and parts were increasingly scarce. Just occasionally, they went out in one of the working boats and dropped a single bomb into the sea. The explosion threw up shoals of dead fish. It was a good way to find free sushi but it brought them no closer to the enemy. That would have to wait until the mainland battle, when the Americans finally invaded. A thousand soldiers from the class above Isao's had already died in the fighting at Okinawa in June. Only a hundred had survived. Now it was up to Isao and his fellow trainees to prove they were equally worthy when they carried their barrel-shaped bombs against the hated enemy and won the war. But today, there were those holes to dig.

OUT ON THE baking apron, the ground crews swarmed over the big silver bombers like minnows around a shark. By lunchtime each aircraft was a hive of activity. Armorers sat in the tails, fitting 1,000 rounds of .50 caliber bullets into each gun. Mechanics stood on the wings, checking and rechecking every last bolt of every Wright R–3350 eighteen-cylinder engine: each engine was so massive it was assigned two mechanics. Fueling trucks stood parked on the hardstands, pumping 7,400 gallons of high-octane aviation gasoline through their rubber hoses into the twenty-two separate fuel tanks in each bomber. Engineers and radio specialists hunkered inside the cabins, checklists in hand, testing and calibrating every item of equipment. Fitters perched on stepladders polishing every inch of Plexiglas. MPs armed with submachine guns patrolled every ramp and hardstand, ready to deter potential intruders. Tibbets was taking no chances. Last night he had even ordered the huge tails of the bombers repainted to confuse the enemy once the mission was under way. Out went the black arrows, to be replaced by a big black

circle with the letter *R* in the middle. The paint was so new it gleamed in the midday sun.

While the ground crews crawled over the ships, the scientists hurried to complete their own specialized tasks for tonight's mission. Inside Victor 91, the photographic airplane, former physics professor Bernard Waldman rapidly assembled his Fastax camera, a state-of-the-art slow-motion movie camera that ran at an astonishing 10,000 frames per second—each second of real time lasting almost *seven minutes* on the screen. His film would record every last detail of the atomic explosion. Across the tarmac, three more scientists—Luis Alvarez, Larry Johnston, and Harold Agnew—fried inside *The Great Artiste*'s fuselage as they frantically installed a jumble of electronic boxes, oscilloscopes, ammeters, plugs, and cables. The racks of equipment piled up from floor to ceiling inside the cramped space of the center-section cabin. All three scientists would be flying tonight. Their job would be to record the bomb's yield—literally, the size of the blast—using three uniquely designed aluminum canisters that looked like oversized oxygen cylinders. Each canister contained a cluster of microphones and transmitters, intended to be dropped by parachute over the target at the precise second *Little Boy* was also released. The moment the bomb exploded, the microphones would record its blast wave, sending the signal back to the scientists hunched over their oscilloscopes in *The Great Artiste* above. The bomb would write a perfect electronic signature at the very instant of a city's annihilation.

Two hundred yards north of the 509th apron, B-29 serial number 44–86292, call sign Victor 82, waited on the steaming asphalt beside one of the two loading pits, exactly where Tibbets had parked her after yesterday's check flight. Her starboard main wheels rested on the five-foot-diameter turntable anchored into the ground. Her forward bomb bay doors hung open, revealing the huge gaping womb of her bomb bay. At the moment it was empty. By late afternoon all that would change.

FROM HIS OFFICE in the 509th operations area, Tibbets ran over the details of the mission for the hundredth time. The last few days had been hectic. There was so much to organize in so little time. He had barely slept, at best managing to snatch a few hours in his cot before tumbling back to work. Despite the trim, razor-pressed uniform, exhaustion traced the lines of his face, in his deeply furrowed brow, his taut mouth, the creases around his eyes. And he still had a twelve-hour mission to fly.

With his group navigator, Dutch Van Kirk, and his group bombardier, Tom Ferebee, Tibbets now rehearsed the final operational details: routes, waypoints, altitudes, call signs, weather, bombing speeds, targets. As always, the three men made an effective team. Tonight they would fly together just as they had done so many times over Europe. They presented an interesting physical contrast: Tibbets, squat, tough, bull-faced; Van Kirk, slender, perhaps a little pale—for the past few days he had been suffering from a mysterious skin rash that might or might not have been an uncharacteristic case of pre-combat nerves; Ferebee, tall, impossibly handsome, a young Errol Flynn with his rakish mustache and his bedroom eyes, a playboy whose sexual conquests were something of a legend in the 509th—superseding even those of Claude Eatherly, the wild skipper of *Straight Flush*. People either loved Ferebee or they hated him— one of the senior veterans in the squadron thought Ferebee was a "miserable sonofabitch," and he was not alone—but everyone agreed he was a brilliant bombardier who could do things with a Norden bombsight almost nobody could do. Tibbets once said he was "the best damn bombardier in the air force." He would have the opportunity to prove it very soon.

It was Ferebee who had picked Hiroshima's aiming point. Three days before, he and Tibbets had flown down to General Curtis Le May's headquarters on Guam. Le May had shown them the latest reconnaissance photos of Hiroshima: glossy, thirty-inch-square black-and-white prints of the city and its surrounding area taken

from six miles up. The city showed up well, just as it would do very soon through the eyepiece of Ferebee's bombsight: the seven rivers dividing a crammed conurbation of monochrome streets, houses, factories, barracks; the scalloped ridges of dark gray mountains enclosing the city on three of its sides; the port of Ujina clearly discernible to the south; beyond it the flat blackness of the sea where Private Isao Wada was training to blow himself up in his little bomb-carrying boat. It was even possible to see the three fire lanes crossing east to west across the city center, thick chalk-white gashes that showed up quite distinctly, a testament to the labors of twelve-year-old Emiko Nakamae and 8,000 other Hiroshima schoolchildren.

Le May asked Ferebee to select the aiming point for the bomb. Ferebee ran his finger across the photo until it reached a distinctive T-shaped bridge just at the point where the Ota River branches into two. It stood out from every other bridge in the city, an unmissable man-made feature right in the very center. "There," he said. The others immediately agreed. It was, said Tibbets, "the most perfect Aiming Point I've seen in the whole damn war." Its official designation was *063096, Reference: XXI BomCom Litho-Mosaic Hiroshima Area No. 90.30—Urban*. In Hiroshima it was known as the Aioi Bridge.

At ONE O'CLOCK in the afternoon, 100 meters from the Aioi Bridge, in his home above the liquor store where he had lived all his life, Toshiaki Tanaka sat down for lunch with his family. Today was his day off. As a lowly ranking corporal based in the port at Ujina, he worked in the signal corps six days a week. But Sunday was usually free, and by midday Toshiaki was making his way north to his home in Saikumachi, a crowded shopping street in the commercial heart of the city. His wife, Setsuko, greeted him at the door as she always did. Their marriage had been arranged by their parents in 1942, but they were happy together, and just last year Setsuko had given birth to a little girl. They called her Toshiko, and Toshiaki

could hear her now, crying upstairs on the second floor where they lived. His parents also lived there. Unlike thousands of others in the city, Toshiaki's family had not been evacuated to the countryside. They were less fortunate. They had no relatives to take them in.

Everybody in Saikumachi knew the family liquor store. It was locally famous. Toshiaki's grandfather had opened it more than half a century before, passing it on to Toshiaki's father, whose dream was to pass it on one day to Toshiaki himself. The store stood plumb in the middle of a row of others: a printing shop, a greengrocers, a furniture store, even a place that sold artificial limbs. The old wooden frontages jostled cheek by jowl down the street, a colorful hodgepodge of shops, houses, and neighbors who all seemed to know one another. The people were proud of their district. They had two temples, they had an inn, they even had Dr. Kaoru Shima's medical clinic, a fifty-bed private hospital that supplied the midwife who brought Toshiaki's daughter into the world.

Almost all Toshiaki's earliest memories were bound up with the store: a dusky, cavernous warren with its shelves of sake and beer stretching from floor to ceiling. They did not sell only liquor. They sold bean paste for miso soup, they sold paper and eggs, they even sold ice cream. Toshiaki's mother had dreamed up the ice cream. She was convinced it would make the family fortune. Only two or three shops in the whole of Hiroshima sold it back in the twenties. Very soon little Toshiaki was eating ice cream almost every day, the envy of all his friends. As a small boy, he used to load it on a cart and deliver it to Dr. Shima's clinic, a few meters up the street. The patients loved the ice cream too. Dr. Shima was one of their best clients.

The clinic was still there, but the liquor store was now closed. Toshiaki's mother had finally shut it down a year previously when the bean paste and the eggs and the liquor ran out. There was nothing left to sell. But the family still had their connections, which is how Setsuko was able to cook such an excellent lunch when her husband came home. Today they were having egg rolls, a real luxury. Everybody sat together on the tatami mats, Toshiaki and his

wife, his mother and father, his baby Toshiko with her big black eyes and tiny little fingers like a beautiful doll. The egg rolls were delicious. Apart from them there was nothing especially memorable or unusual about the lunch, not until the moment Toshiaki's mother suddenly said something that he never afterward forgot. She said the Japanese were going to lose the war.

Toshiaki was shocked. *Lose the war?* It was impossible! Everybody knew Japan's victory was imminent. He tried to argue but his mother was unconvinced. Her life had been destroyed. The shop was shut, the family fortunes were finished, very soon perhaps the American bombers would drop their bombs. It was only a matter of time before they lost everything. The argument died into silence. There was nothing Toshiaki could say either to convince or to comfort his mother. By mid-afternoon he stood up to go. He was late for the barracks.

He said good-bye to his parents, to his wife, and to little Toshiko. She was growing bigger every day. But he did not kiss her, as he did not kiss any of them. He was a Japanese soldier; such expressions of intimacy were frowned upon as unmanly. Almost his last words were that he looked forward to seeing them all again the following Sunday. Then he left the room.

AT 1400 HOURS, unit L11 was wheeled backward out of its air-conditioned bomb-assembly building into the blinding sunshine. Over the next thirty minutes, while project cameras recorded every move, the dull-gray metal trash can, ten and a half feet long, twenty-nine inches wide, was carefully hoisted into position on its special trailer, just like its four test-unit predecessors in dress rehearsals. Once again a tarpaulin cover was thrown over the bomb to hide it from prying eyes. Once again, flanked by jeeploads of military police, a tractor slowly pulled the trailer past the bluffs overlooking the sea, then down the long narrow coral track toward the loading pits where Victor 82 was waiting in the afternoon sun.

At 1430 the loading began. The routine was followed to the letter.

A hydraulic lift carefully lowered the bomb into the thirteen-by-sixteen-foot loading pit where it rested patiently on a cradle, still under the tarpaulin. Very slowly, a tug pushed the big bomber backwards, the sun flashing on its silver tail as it pivoted on its turntable, until it crouched like some great metallic monster directly over the pit. The heat was almost unbearable. Stripped to their waists, two technicians stepped into the pit and pulled off the tarpaulin, exposing the bomb. Among the signatures scrawled in chalk on its back some witnesses would remember a single line: "A present for the souls of the *Indianapolis*." At this very moment, less than a thousand miles away, several hundred corpses of those souls were still being retrieved from the sea.

Now came the most delicate part of the loading procedure. A single hook snaked down from the bomb bay's guts. Carefully the technical crews lined up the bomb's lug with the hook, clamped it home, then slowly raised the bomb on its hydraulic lift, inch by inch, into the bomb bay. Everybody's eyes were glued on the bomb. A fire truck stood by, ready to move in at an instant. At exactly this point, on a practice loading just three weeks ago on July 12, a pumpkin had fallen off its cradle and crashed to the ground. If the same thing happened now, *Little Boy* could—to use the physicists' phrase—*self-assemble*. The word is a euphemism. What it meant was that the uranium projectile could suddenly unseat itself and slip down the gun barrel toward its uranium target, instantaneously creating a seething supercritical mass of splitting neutrons. At best, the result could be a radioactive cook-off making North Field uninhabitable for some time to come. At worst, it could be a full-scale nuclear explosion.

The bomb locked home. Now held in place only by its single hook, *Little Boy* rested in its womb. It was a tight fit. Military policemen began posting red warning signs around the bomber: NO SMOKING WITHIN 100 FEET. The time was now 1545. The four-engined bomber shone in the heat blazing off the crushed coral, waiting for takeoff exactly eleven hours from now.

INSIDE VICTOR 82's forward compartment, Second Lieutenant Morris Jeppson knelt on a cushion, completing the installation of a thirty-inch-high console crammed with ammeters, warning lights, and switches. From its rear, four thick cables snaked across the cockpit floor, down to the bomb bay and into the back of the bomb. A tall, blond twenty-three-year-old Mormon born in Logan, Utah, Jeppson would monitor the bomb's health all the way to the target. Throughout the 1,500-mile, six-hour haul up the Pacific, he would watch every light, every dial, and every needle for the slightest indication of a fault. The options then were limited: to continue, to jettison, or to abort.

As Jeppson knelt by his console flicking switches and checking warning lights, his immediate superior, Deak Parsons, climbed aboard. Parsons opened a transparent circular hatch in the forward cabin, rather like a washing machine door, and squeezed down into the bomb bay. He carried a flashlight and an aluminum toolbox. In front of him, the black hulk of *Little Boy* loomed in the semidarkness. Parsons had spent half the day in the Tech Area familiarizing himself with Birch's double-plug assembly. Now it was time to practice arming the real thing.

TIME HUNG HEAVY for many of the seventy men who were flying that night. For them there was nothing to do but wait. Some sat out in the hot sun or listened to the music station from Radio Saipan; others tried to read or write letters or snatch a little sleep on their brand-new air mattresses. Bob Caron joined four of his fellow crew members from Victor 82—radio operator Richard Nelson, flight engineer Wyatt Duzenbury, assistant engineer Robert Shumard, radar operator Joseph Stiborik—for a quiet game of softball. The guys kept ribbing him about his new haircut. In a moment of insanity he had let Duzenbury cut it for him a couple of days back, but Duze had clearly been drinking too much navy torpedo juice,

because the result, as somebody said, was a cross between a Black-foot Indian and a patch of sprouting prairie. Duzenbury might be a great engineer but he was a lousy barber. Even Caron's beloved Brooklyn Dodgers cap could not hide the worst of it.

Somewhere in the middle of the softball and the ribbing, a summons came from Tibbets's office. A photographer was standing by with his Speed Graphic to take a picture of the crew. Their usual skipper Bob Lewis was there, his 200-pound frame sweating under his shirt in the tropical heat. He made a little joke about being famous. Van Kirk turned up in tow with Ferebee. Lewis and Ferebee did not get on, not least because Ferebee was a much better poker player and Lewis usually ended up owing him money—on one notorious occasion in Wendover he owed him almost half a month's salary. Perhaps Lewis was a little jealous of Ferebee too. The antipathy was mutual. Ferebee disliked the way Lewis was always trying to impress everyone. Sometimes he enjoyed getting Lewis drunk just for the hell of it. Three drinks and he was gone. It made Ferebee laugh.

Right now Lewis was sober as a judge but he was also angry—not with Ferebee this time, but with Tibbets. He always felt Victor 82 was his ship, its crew his crew. It was he who had collected her that day back in March from the factory in Omaha, hedgehopping at zero feet across the flat prairie all the way to Wendover. He had flown her 6,000 miles across the Pacific. He had captained her on three separate pumpkin missions to Japan over the past couple of weeks. But Tibbets had hijacked this mission. He had demoted Lewis to copilot, bringing along his best buddies Van Kirk and Ferebee to boot. If the war ended tomorrow, Tibbets would take all the glory. Lewis was just a number two, an also-ran. It was enough to make anyone mad.

The photographer snapped the picture: Van Kirk, Ferebee, Lewis, and Tibbets standing at the back, the four officers in formal long pants and shirts; the five enlisted men—Caron refusing to take off his Brooklyn Dodgers cap—squatting at the front in T-shirts and ripped Tinian shorts. Nine men squinting in the sunshine.

Three others were missing. One of them was Jake Beser, the electronics countermeasures officer. Although Beser was flying tonight, he was not technically part of the crew. The other two were missing for a different reason. They were too busy. One was Morris Jeppson, still checking his bomb console. The other was Deak Parsons.

BY LATE AFTERNOON, the temperature inside Victor 82's bomb bay had reached well over 100 degrees, but not for one moment did Parsons stop working. Crouched precariously on a narrow shelf, armed with an assortment of tools and his single flashlight, he practiced the techniques required to arm an atomic bomb in flight.

The huge black tail fin stared back at him, just inches from his face, as he picked up the tools in turn, each one neatly placed on a black rubber pad beside him. The bomb took up almost all the space. There was barely room to move. But the heat was the worst of it, a fierce, airless, searing heat that punched his eyes and pummeled his breath. The sweat poured off him, soaking his neck and his back, his hands slipping as he twisted screwdrivers, nuts, washers and bolts, in the dim light. From time to time he pointed his flashlight at a checklist that he followed precisely to the letter, over and over, until he could do it blindfolded. Eleven steps to arm an atomic bomb:

1. *Check that green plugs are installed.*
2. *Remove rear plate.*
3. *Remove armor plate.*
4. *Insert breech wrench in breech plug.*
5. *Unscrew breech plug, place on rubber pad.*
6. *Insert charge, 4 sections, red ends to breech.*
7. *Insert breech plug and tighten home.*
8. *Connect firing line.*
9. *Install armor plate.*
10. *Install rear plate.*
11. *Remove and secure catwalk and tools.*

Parsons was a perfectionist. His obsession with order and procedure was legendary. Everybody knew that about him: his wife, Martha, his two teenage daughters, Groves, Oppenheimer, all the project scientists who had worked under him to devise and build *Little Boy*. His creed was always to test, test, and retest until absolutely nothing was left to chance. It amounted almost to an addiction; in every sense a quiet, unassuming, unshowy man, he worked brutal, punishing schedules to get results—and never more so than now. For hour after hour he crouched inside the blistering metal coffin of the bomb bay, meticulously rehearsing each one of those eleven steps. By the end of the afternoon his hands were bleeding and lacerated, cut to ribbons from the sharp-edged tools. And still he continued. He had so little time. He *had* to get it right. General Farrell was horrified. "For God's sake, man," he said, "let me loan you a pair of pigskin gloves." "I wouldn't dare," replied Parsons. "I've got to feel the touch."

IN THE LAST hours of daylight, Tibbets gave his plane the name that it would carry into history. In a quiet moment, his thoughts turned to his red-haired mother on the other side of the world back home in Florida. Ten years earlier he had given up medical school to become a pilot. That first love affair with the tiny red Waco biplane as a small boy had never died. He wanted to fly. His father had vehemently opposed his decision. But his mother had supported him. Her faith in his choice was unflinching, and her confidence won the day. She said, "I know you will be all right, son." He remembered those words now.

He wrote her name on a slip of paper, dragged a sign painter from a softball game, and told him to "paint that on the strike ship, nice and big." The painter did just that. As the shadows lengthened under the great bomber's wings, he balanced on his stepladder, carefully painting the eight letters just below the cockpit on the side Tibbets would fly her later: each letter a foot high, square-brushed

in black, angled at thirty degrees. When Bob Lewis saw it he was furious. "What the hell is *that* doing on *my* plane?" he yelled. But it was too late. This was Tibbets's plane now. The name was there to stay, for now and forever. It was a curiously touching, even sentimental gesture for such a man. But Tibbets never regretted it. His mother was the great love of his life and he immortalized her in a way neither of them could ever have imagined. Tonight he would carry her name into battle: *Enola Gay.*

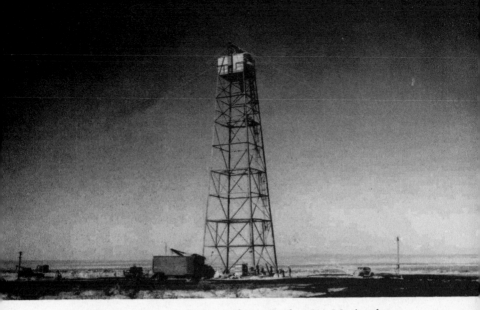

The Trinity test tower at Ground Zero in the New Mexico desert.

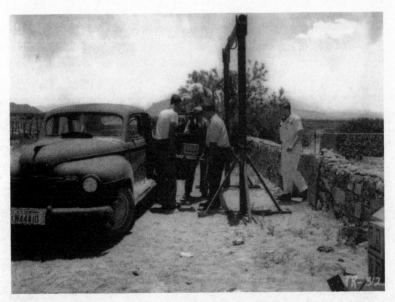

July 14, 1945, 3:00 P.M. The bomb's assembled plutonium core is carried in its ventilated box from the McDonald ranch to a waiting car. From here it will be driven to the tower.

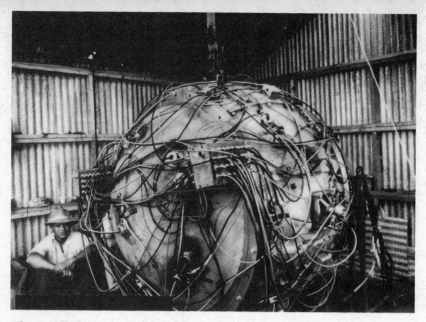

The world's first atomic bomb in its corrugated iron shack at the top of the tower. This is where Don Hornig read his paperback in the storm.
(Los Alamos National Laboratory Archives)

Ground Zero, July 16, 1945, 5:29 A.M.—.04 seconds after detonation. The steel tower has already been vaporized.
(Los Alamos National Laboratory Archives)

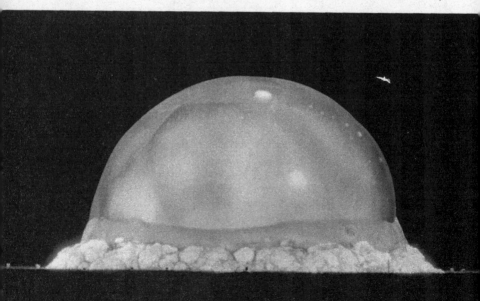

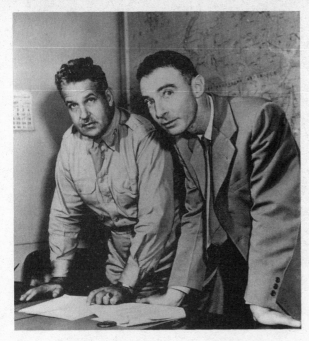

The odd couple: Major General Leslie R. Groves and Dr. J. Robert Oppenheimer, caught on camera.

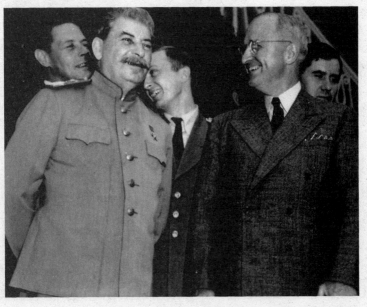

Joseph Stalin and Harry Truman share smiles at Potsdam.

North Field, Tinian Island. In August 1945 this was the biggest air base in the world. Each of the four runways is more than one and a half miles long. (Leon Smith)

Approaching North Field from the cockpit of a B-29. Sitting in the nose, the bombardier has the best view in the house. (Leon Smith)

The headquarters of the 509th Composite Group, on Tinian—the finest accomodations on the island. (LEON SMITH)

Aerial view of the 509th bomber apron on North Field. The three isolated structures at the top of the picture are the air-conditioned bomb-assembly buildings, the most secret site on Tinian. (LEON SMITH)

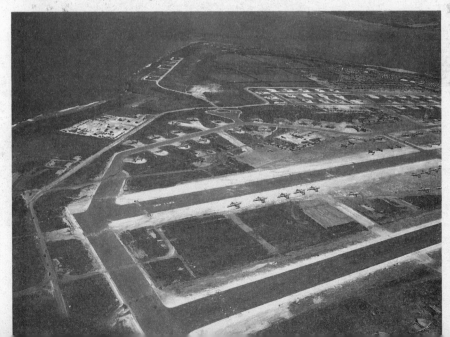

Tail gunner Bob Caron aboard the *Enola Gay*. From this turret he photographed the mushroom cloud. (KENNETH EIDNES)

Claude Eatherly's *Straight Flush*, the aircraft that bombed the Imperial Palace, bearing the cartoon that had assistant engineer Jack Bivans worried all the way to Japan. (LEON SMITH)

August 4, 1945, 4:00 P.M. Deak Parsons *(standing, left)* and Paul Tibbets *(right)* brief the crews that will fly to Hiroshima. The projector chewed up the film of the Trinity test before it could be screened. (NATIONAL ARCHIVES)

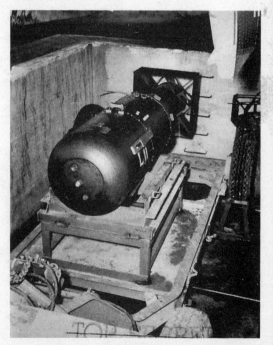

Little Boy in the loading pit, beneath *Enola Gay*'s bomb bay. The bomb's top-secret radar antennas have yet to be attached.

(NATIONAL ARCHIVES)

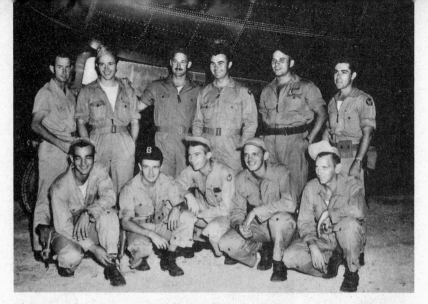

The crew of *Enola Gay* just before engine start. Bob Caron *(front row, second from left)* in his Brooklyn Dodgers cap. Bombardier Tom Ferebee, with the Errol Flynn mustache, stands behind, his hand on Dutch Van Kirk's shoulder. (NATIONAL ARCHIVES)

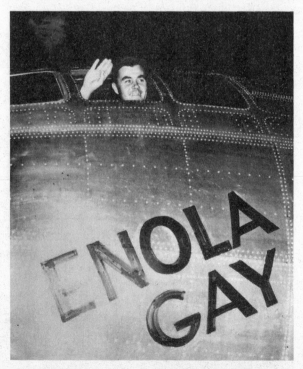

August 6, 1945, 2:27 A.M. Tibbets waves good-bye from the cockpit. At this point the target is one of three possible cities. (NATIONAL ARCHIVES)

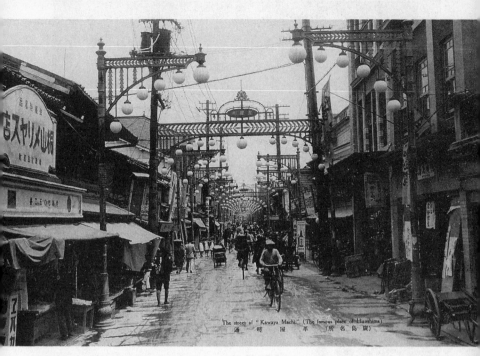

The street of "Kawaya Machi." (The famous place of Hiroshima)
通 町 屋 革 （所 名 島 廣）

Prewar Hiroshima. Hondori Street, 500 meters (0.3 miles) from the hypocenter. Toshiaki Tanaka's liquor store was located on a street similar to the one pictured here.
(SHIGEMI HAMAMOTO, HIROSHIMA PEACE MEMORIAL MUSEUM)

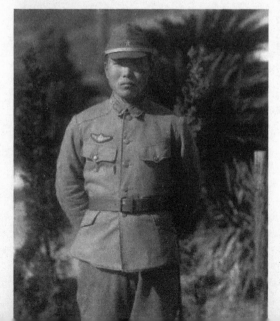

Isao Wada after volunteering for the suicide boats. (ISAO WADA)

The weapon the Japanese hoped would win the war:
one of the plywood boats on which Isao Wada
trained to attack enemy ships. (ISAO WADA)

Taeko Nakamae, 1947. The eyepatch
covers her missing left eye.

(TAEKO NAKAMAE)

Dr. Shuntaro Hida in uniform. His
anti-military sympathies made
him subject to investigation by the
Japanese secret police.

(SHUNTARO HIDA)

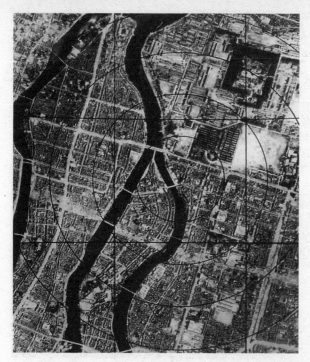

U.S. reconnaissance photo of Hiroshima before the bomb. Ferebee's target, the T-shaped Aioi Bridge, stands out very distinctly just to the northwest of the hypocenter *(marked by a cross)*.
(NATIONAL ARCHIVES)

The same view, after the bomb.
(NATIONAL ARCHIVES)

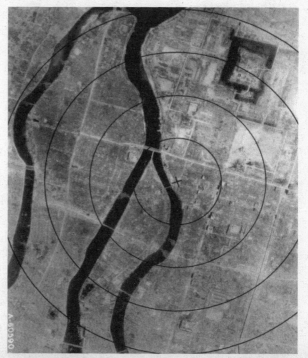

The mushroom cloud, as photographed by Bob Caron through his turret window. At this point the cloud is more than six miles high.

(JOSEPH PAPALIA)

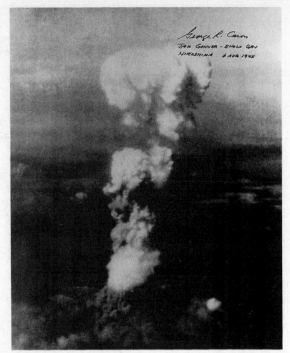

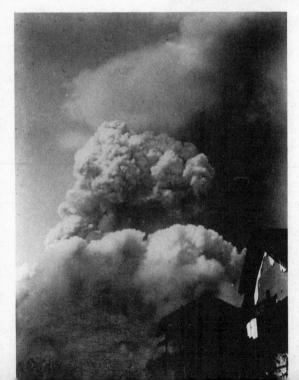

The same cloud from the ground two minutes after the explosion. The photographer is 8 kilometers (5 miles) from the hypocenter.

(MITSUO MATSUSHIGE, HIROSHIMA PEACE MEMORIAL MUSEUM)

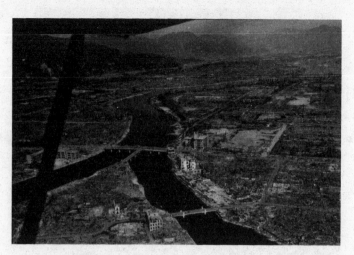

A closer aerial view of the Aioi Bridge, 200 meters (0.12 miles) from the hypocenter. Almost nothing is standing, apart from a few buildings made of reinforced concrete. Miraculously, the bridge itself survived. (HIROSHIMA PEACE MEMORIAL MUSEUM)

Yoshito Matsushige's first photograph on the Miyuki Bridge. He hesitated at least fifteen minutes before taking it. Sunao Tsuboi *(circled)* can be glimpsed in the group of injured people to the left.
(YOSHITO MATSUSHIGE)

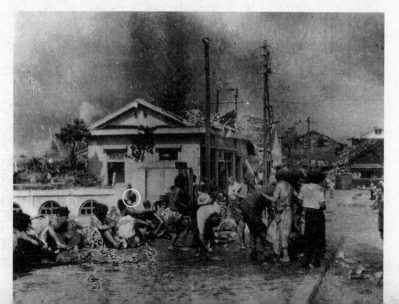

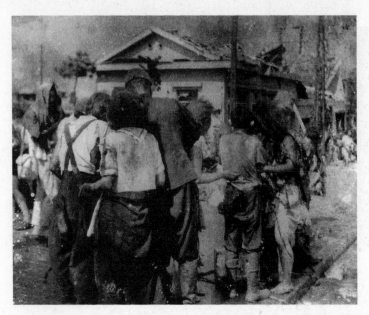

Matsushige's second photograph on the bridge. The policeman is handing out cooking oil for the burns.

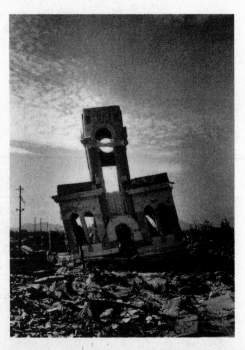

The Shimomura Watch Store, 700 meters (0.43 miles) from the hypocenter. A striking example of the bomb's shockwave effect.

Tibbets, receiving congratulations and the
Distinguished Service Cross minutes after landing.
The stem of his pipe may be seen in his left hand.
(Los Alamos National Laboratory Archives)

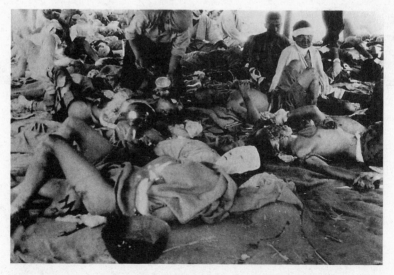

An emergency aid center on the Honkawa riverside, one day after
the bomb. Taeko Nakamae and Sunao Tsuboi were each brought to
similar centers while still unconscious.
(Yotsugi Kawahara, Hiroshima Peace Memorial Museum)

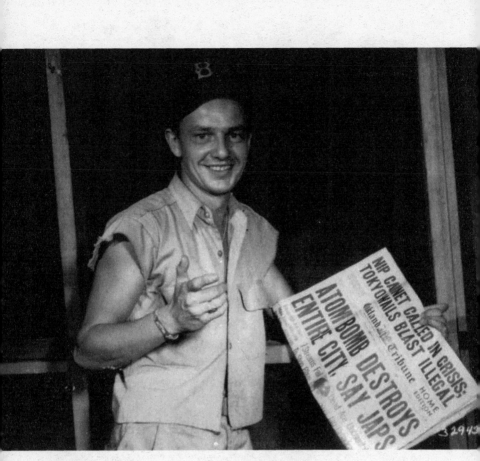

Bob Caron with the headline that changed the world.

TWENTY

IN NORMAL circumstances the X-ray room in the Hiroshima Military Hospital was not the most suitable place in which to get drunk, but Lieutenant Shuntaro Hida had long stopped worrying. By mid-evening, he had downed far too many glasses of sake than were good for him, albeit not so many as the four army doctors he was supposed to be entertaining. But then he was only following orders. His commanding officer had summoned him earlier this evening, asking him to look after the four men. They were all just back from the Manchurian front and on their way up to Tokyo. They had nowhere to stay in the city. So Dr. Hida had brought them down to the X-ray department, and very soon the five of them were sitting down to dinner in the white-tiled room with its X-ray machines and its blackout curtains and its acid stench of antiseptic. That was when the drinking began.

After that it never stopped. Shuntaro Hida did not even try to keep up. And anyway he was too exhausted. It was only a few hours since he had returned from Hesaka, the village six kilometers north

195

of the city where they had just finished building the new hospital. Three hundred diggers had been working on it under Hida's supervision for the last seven weeks. Today was their very last day. It was an impressive achievement in such a short time: a series of big eighty-square-meter rooms tunneled out of the caves behind the elementary school, with enough space for an operating theater and several wards. Some of the school's classrooms had also been converted into extra wards. When the commander of the Fifth Army Divisional HQ had come to inspect it last week, he had been delighted. Casualties were bound to be appalling in the mainland battle. Hiroshima itself might very soon be destroyed by American bombs. Shuntaro Hida's splendid new hospital fulfilled a critical need. Out here in the country, in this little village of three hundred houses nestling on the slopes of Nakayama, the operations and the treatment of the wounded could continue in safety.

Shuntaro Hida was proud of his achievement. At a time when the world was bent on destruction, there was something almost beautiful in the simple act of creation. Before he trained as a doctor he had studied to be an architect and in the past weeks those skills had come in very handy. The work had been unexpectedly satisfying. But he had loved the nights best: sitting under the lantern in the quiet of the old farmhouse, carefully drawing up his building plans on white sheets of paper in India ink. Those were the moments when he could forget the war.

Unlike Paul Tibbets, Hida had passionately wanted to be a doctor—ever since the age of twelve when he first read the adventures of Albert Schweitzer, the famous physician who had worked among the tribes of Africa. He was made for the job: intelligent, soft-spoken, naturally sensitive, curious, always sympathetic. He had strong but oddly feminine hands; a kind, open face; a gentle bedside manner. He had joined the army three years earlier in September 1942 but had never seen any fighting. His war was largely spent in medical institutions. Doctors like him were needed too urgently. His specialty was dysentery. While most of his contemporaries were dying in battle, he was busy handling stool samples.

A year ago, at the age of twenty-seven, he had been posted to the Hiroshima Military Hospital—with more than a hundred doctors it was the largest military hospital in Japan—to practice in the dysentery unit. The disease was epidemic, even in the army where the food was slightly better than for civilians. As the months passed, conditions in the hospital became increasingly chaotic and supplies rapidly ran out. Hida had done what he could, working day and night, often seven days a week, but he was exhausted. Every day was a torture to him. He hated this war. He hated the stranglehold of the army, the ruthless, incessant discipline, the brutality, the whole-sale erosion of even the smallest freedoms. He had recently grown more outspoken in his opinions, so much so that the Kempei—the dreaded secret police—had even paid him a visit in the hospital. But his superiors had protected him because they needed his skills. They also needed him to go up into the hills to Hesaka, to build his new hospital in the caves.

And now the hospital was finished. This afternoon, before he finally left Hesaka with his three hundred diggers, he had made his last rounds of the village. He had said his good-byes to the village headman, to the schoolmaster and the Buddhist priest. All the villagers had gathered outside and waved as the party marched away down the hill. Some were crying. Hida had been very moved. He waved back, then descended with the others toward the city. By nightfall he was sitting in the X-ray room with the four army doctors from Manchuria, drinking himself into oblivion. For the next few hours at least, the war did not exist.

AT EXACTLY MIDNIGHT, the three strike crews filed into the 509th combat crew lounge for the final briefing: pilots, navigators, engineers, radio operators, bombardiers, radar scanners, tail gunners, scientists, observers; thirty-four men in all, blinking under the harsh electric light. There was very little chatter. The weatherman made a joke as they took their seats. It fell flat. All day the tension had been building. By nightfall the men were coiled tight as a

spring. Bob Caron had spent most of the evening on his bunk staring at the curved white ceiling, thinking of his wife, Kay, and their baby, Judy, back home in the States. In a neighboring cot Richard Nelson, *Enola Gay*'s radioman, carelessly flicked through the pages of *Reader's Digest*. Robert Shumard, the assistant flight engineer, tried to sleep, his knees hugging his chest like a small child. Others also tried. Some gave up the struggle. Dutch Van Kirk took two sleeping pills and spent half the evening lying wide awake in bed. Finally he got up to join Tibbets and Ferebee for a concentrated game of blackjack. Ferebee, as always, was on top of his form. They were still playing when the call came to go to the briefing.

Others found different ways to kill time. Chuck Sweeney, captain of *The Great Artiste,* wandered down to the flight line for no particular reason except to look at his plane. There was nothing more to be done. In the silence of the evening he simply stood and stared at the bomber that would shortly carry him, his crew, and his three scientists to Japan. Harold Agnew, one of those scientists, slipped off to the Tech Area to squirrel away a 16mm movie camera and some film from the labs. He was hoping to snatch an unofficial record of the blast. While in the lab he also grabbed a badly needed case of soap. His colleague Luis Alvarez went to the Pumpkin Playhouse to catch a movie. He would never afterward remember its name.

The hours of darkness passed slowly. Jake Beser, *Enola Gay*'s electronics countermeasures officer, was dropping from lack of sleep—by now he had been up twenty hours—but instead he ended up in the officers' bar with Bill Laurence, the *New York Times* reporter who had witnessed the Trinity test. Laurence had only just arrived that afternoon on a C-54 transport from the States. He had been delayed three days and was desperate to join tonight's mission. But it was too late. Tibbets had no space. Instead Tibbets asked—or rather ordered—the exhausted Beser to entertain the excitable science reporter until the midnight briefing. Beser did his best but it must have been hard going, not least because he had to endure several hours' worth of Laurence's enthusiasms for the peacetime wonders of atomic energy, all delivered in a thick Slavic accent.

Out on the ramp, Deak Parsons finally emerged from *Enola Gay*'s bomb bay with his torn, bleeding hands. In the few hours left before the briefing he closeted himself with Morris Jeppson, running over and over again through the arming checklist exactly as he had practiced it all afternoon. In the vibration of the bomb bay, Parsons would not be able to arm the bomb and hold the flashlight. That would be Jeppson's job. He would also confirm that each of the eleven steps was properly completed. Parsons could not afford to make a mistake. No one was taking any chances.

Tibbets opened the briefing. He was short and to the point. Quickly he ran over the essentials. By now the men knew the routine well; this was what they had rehearsed in all those pumpkin missions to the Empire. First the route: from Tinian to Iwo Jima, 600 miles to the north, then direct to the Japanese coast at Shikoku, a farther 800 miles. Fourteen hundred miles each way. Total flying time, twelve hours. Time of takeoff, 0245. Approximately one hour before the strike force made landfall the three weather planes would transmit their reports: *Jabit III* from Kokura, *Full House* from Nagasaki, *Straight Flush*—skippered by Buck Eatherly—from the primary, Hiroshima. At that point Tibbets would decide which city to attack. Tibbets rammed the point home in case anyone had missed it: weather would choose the target. The weather crews would depart at 0145, exactly one hour ahead of the strike force. They had already had their briefing. Right now they were finishing their preflight breakfasts.

The men rapidly scribbled the key points down—on notepads, on scraps of paper, on their hands. Altitudes: 5,000 feet from here to Iwo, then a slow climb in stages to the bombing height of 31,000 feet—six miles straight up. Bombing speeds: 200 mph calibrated, 260 mph true. Frequencies: 7,310 kilocycles for weather reports. Channel G for interplane communication. Channel 7 for any aborts using the single word *aborting*. Air/sea rescue: the navy, said Tibbets, were putting on a huge show. A string of submarines and aircraft would stretch all the way from Tinian to the coast of Japan ready to move in should anyone have to ditch—but Tibbets did not

explain that any seawater seeping into *Little Boy*'s casing was very likely to set it off. Operational forecast: scattered clouds and moderate winds en route to the target; six-tenths stratocumulus over the primary—Hiroshima—three-tenths altocumulus at 18,000 feet. Enough to see Tom Ferebee's T-shaped bridge. A huge zone of high pressure was now sitting over Japan. It was more than adequate bombing weather.

Next Tibbets ran through the bomb run: from the initial point east of the primary direct to the aiming point in the city center. *Enola Gay* would lead, *The Great Artiste* following approximately 300 feet behind. At the instant of release, the two aircraft should execute their steep breakaway turns: *Enola Gay* to the right, the *Artiste* to the left. Victor 91—the photographic plane—should hold off several miles to the south while Bernard Waldman's ultra–slow motion Fastax camera was trained on the city, waiting for the blast. For the last time Tibbets reminded everybody to wear his welder's goggles, and at the highest setting. This bomb was going to be brighter than a supersized sun. Again the word *atomic* was never mentioned.

Time was running short. Tibbets ticked off the final points. For security reasons he had decided to change the radio call signs. Out went the familiar Victor to be replaced by the deceptively cozy Dimples. Tonight's operation was called Centerboard. It had another name too, one that some of the crews were not so happy about: Special Mission Number 13. At least it was not happening on a Friday.

Watches were now synchronized. The time was just coming up to 1215. Two hours and thirty minutes to go. Tibbets's briefing ended on a concise note: "Do your jobs," he said. "Obey your orders. Don't cut corners or take chances." He stepped down from the platform. The chaplain, William Downey, then stood up, glanced at some words scrawled on the back of an envelope, and began speaking in his rich, melodious voice. "Almighty Father," he said, "we pray Thee to be with those who brave the heights of Thy heaven and who carry the battle to our enemies. Guard and protect them, we pray, as they fly their appointed rounds. May they, as well as we, know

Thy strength and power, and armed with Thy might may they bring this war to a rapid end . . ." Joe Stiborik, the *Enola Gay*'s radar scanner, had asked his priest for absolution earlier in the day. At the very least it would provide "a bit of insurance." Chuck Sweeney, a committed Catholic, had gone to confession the night before. Unfortunately, security restrictions had made it impossible for him to confess exactly why he was confessing.

The men quietly filed out of the room. All of them had already given their personal possessions to a nonflying designated man in their huts. Their only identification now was their dog tags. In small knots they went down to the mess hall for their pre-mission breakfast. Charles Perry, the 509th's five-star caterer, had gone all out for the special occasion. Paper pumpkins—shaped just like the practice bombs the crews had carried—hung from every wall. Menus were drawn up with pictures and little jokey descriptions. The food was better than ever: sausages, real eggs ("How da ya want them?"), apple butter ("Looks like axle grease!"), thick pancakes drowning in maple syrup, even the pineapple fritters that Tibbets loved. Ferebee hated those pineapple fritters. He and Van Kirk watched Tibbets scoop them up. They attempted a little small talk and drank several cups of black coffee. Van Kirk was reminded of the condemned man's breakfast. But in truth neither he nor anyone else eating breakfast in that room was the man condemned.

DESPITE THE SHORT ages and the blackout and the prowling police, there were still many ways to entertain oneself in Hiroshima on the last night before its destruction. Even a few theaters managed to stay open. This evening a comedy act was playing at the Takarazuka and a pirate movie was showing at the Imperial. At the Kotobuki theater people lined up to watch the film *Four Weddings,* a romantic comedy about four sisters, a matchmaker, and a young single man. It was extremely popular. For less legitimate pursuits there was always the red-light district in Dobashi. Some-

how—nobody was quite sure how—the prostitutes were still able to deck themselves in vividly colored costumes, although a second glance revealed the drawn faces under layers of makeup and the thin arms poking like sticks through sleeves. Most of the clients were soldiers: the only people with enough money or cigarettes or food to barter for the girls. With 43,000 soldiers now packed into the city, all expecting to die in the Allied invasion, there was never any shortage of customers.

For the majority without money or food to spare—or any food at all—there was always the radio. Not that it was especially inspiring. Japanese fables were a regular diet, almost all of them turning on the glories of self-sacrifice for the national good. Victory in the face of overwhelming odds was another favorite. Occasionally the mix was leavened with other ingredients: music perhaps, or the odd lecture on how to use the abacus, or a traditional poetry recital or a running series at 6 P.M. each evening entitled *This Week's Battle*. Tonight it was fronted by General Takada, a navy leader. It is not recorded which of the week's battles he described—except that it was unlikely to be one that was lost.

Most people went to bed early as they did every night. The blackout was rigidly enforced. After dusk the city was a warren of dark streets and shadows. Soldiers who were restricted to barracks had early curfews. Toshiaki Tanaka was one of them, in his bunk soon after sunset, still puzzling over his mother's strange outburst over the egg rolls. Another was Isao Wada, in his training camp five miles across the bay at Konoura. All day he had done nothing but dig holes for the suicide boats. After a quick supper he fell gratefully into bed, exhausted. By 9 P.M. he was asleep. On Tinian, Bob Caron was staring at the ceiling, thinking of his wife and baby daughter.

Outside the city, in the darkness of the hills, Taeko Nakamae and her twelve-year-old sister, Emiko, were also asleep in their farmhouse bedroom. Emiko was still feeling a little unwell. But nothing would shake her determination to go to work tomorrow. She would have to be up early. The demolition teams started at nine o'clock.

Taeko would have to be up earlier—her long day's shift at the telephone exchange began at eight. Sometimes the two sisters were able to travel together on the tiny commuter train that wound down the mountain toward the city. But not tomorrow.

In the stillness of the Shukkeien Garden, a few hundred meters east of Hiroshima's ancient castle, Sunao Tsuboi and his lover, Reiko, lay side by side on the grass. They had entered the garden at dusk. The cool dark lake spread before them, crisscrossed by its tiny wooden bridges and miniature teahouses. The thick scent of flowers carried on the night air, like the perfume of the letters she sometimes sent him. Occasionally they heard the splash of carp or the turtles for which the lake was famous. Or perhaps the old heron had woken. Once or twice the sirens went off as American formations swept high over the city on their way to somewhere else. Sunao told Reiko about the army and how he would have to fight very soon and she had cried, but after that they had not spoken much. Somehow they were beyond words. It was much more perfect to lie like this together for hours on the still-warm grass, their fingers barely brushing for the very first time. She had such beautiful fingers, thin and white and delicate. For the rest of his life Sunao would always remember their touch, just as he would remember the stars shining out of the clearest, widest, emptiest sky.

At 0137, one hour ahead of the strike force, the three weather planes took off from North Field's parallel runways, hugging low over the ocean as they wheeled slowly north toward Japan. Twenty-seven men were now airborne and headed for their three respective cities. Aboard *Straight Flush* Buck Eatherly watched the compass gradually swing around to 338 degrees—north-northwest—before leveling the huge bomber's wings. In less than seven hours he should be over Hiroshima for the final weather check—if all went well. Plenty of time on this trip for a game of poker. Ninety feet behind him Gillon Truett Nicely, his twenty-one-year-old tail

gunner, said a prayer as Tinian slipped behind in the darkness. He asked God to be as kind to him and the crew as He had always been over the past two and a half years. In the waist section, Jack Bivans, the assistant engineer, was not thinking about God or poker at all. He was thinking about the extraordinary scene they had just witnessed on the taxi to the runways. An entire battery of floodlights and arc lights and klieg lights and every other kind of light were blazing down on the hardstand where *Enola Gay* was parked, like some kind of Hollywood premiere. There were motion picture cameramen, there were photographers and popping flashbulbs, and a crowd of people standing around, and right in the middle of it all the great silver shining movie-star bomber dazzling under the lights with her freshly painted name on the side. Bivans caught only a glimpse through the window as they taxied past, but it was enough to make him stare in wonder. He had never seen anything like it.

The circus had caught everyone by surprise. As the *Enola Gay* crew raced toward the hardstands in their jeeps, they also saw the lights and the movie cameras and the photographers waiting to pounce on them. And pounce they did. Barely had the men jumped off the trucks before the horde descended en masse. Suddenly flashbulbs were banging off right in their faces, people were yelling at them to look this way, look that way, turn around, *do this, do that*, an endless baying, frenzied cacophony under the hot blinding lights. All that was missing was a red carpet. "I expected to see MGM's lion walk to the apron or Warner's logo to light up the sky," said Tibbets later. "It was crazy."

It was also extremely dangerous. The Japanese hiding up on Mount Lasso would have a grandstand view of the spectacle. It required only one of them to have a transmitter and the mission was ruined. Tibbets had spent the last ten months telling everyone to keep his mouth shut but this was now out of his hands. This went all the way up to General Groves, 6,000 miles away in Washington. The bomb was almost as much a PR exercise as a weapon of war— at $2 billion of taxpayers' money it *had* to be—and Groves was de-

termined to make the most of it. *Enola Gay* was a star, her crew were stars, and the bomb she was carrying was the biggest star of all. By tomorrow night the story would be around the world. Groves had worked it all out. If everything went to plan, the men flying tonight's mission would be heroes. They would go down in history as twelve men of outstanding courage who had almost single-handedly won the war. It was essential to record every last detail. Hence the crowds of photographers and the movie cameramen. Groves had even ordered a wire recorder—essentially a primitive tape machine—on board *Enola Gay* to ensure every word its crew spoke was captured for posterity.

As Tom Ferebee watched the photographers poking and prowling around the bomber, he thanked God he had ordered it to be thoroughly cleaned out earlier that day. The ground crews had discovered six boxes of condoms and three pairs of silk panties on board: hardly the most appropriate image moments before America's finest went off to win the war. One or two of the men, like Bob Lewis, clearly basked in the attention. Lewis had already accepted a request from the *New York Times* reporter Bill Laurence to write a log of the flight for the newspapers. No money was discussed but it was obvious to Lewis there would be "a few dollars" in it. (In fact there would be a small fortune one day.) Now Lewis seemed to be spending rather too much time delivering a pep talk to the crew directly in front of the cameras, as if *he* were actually the captain on this mission. Deak Parsons liked the attention least of all. He loathed publicity of any kind, especially an unseemly scrum like this, and it did not help when one of the photographers abruptly shoved him against *Enola Gay*'s main wheels yelling: "You're gonna be famous—*so smile!*"

For three-quarters of an hour it went on like this. By now the crew's nerves were keyed up, stretched and tightened and fueled with black coffee: they were ready to go. Finally Tibbets called a halt to the proceedings. The crew lined up for one last photograph, almost a repeat of this afternoon's, officers at the back, the five en-

listed men at the front—this time Jake Beser was included, but Jeppson and Parsons were once again out of the frame. The ten men pose by *Enola Gay*'s nosewheel, frozen in a moment of history: Van Kirk stands with his flight suit casually unzipped to the waist, his hands in his pockets as if this were a Sunday outing to the park; next to him is a somber-looking Ferebee, his right hand affectionately resting on Van Kirk's shoulder; Lewis, also smiling, conspicuously the most heavyset member of the crew; Tibbets looking relaxed and rested—it was hard to believe that by now he had been awake for more than twenty-four hours; the five enlisted men once again squatting on the floor. It might have been a moment of history but all Bob Caron could feel was Van Kirk's boot in his backside. Once again he refused to take off his Brooklyn Dodgers cap—posterity would never get to see that haircut. The photographers snapped away. "Give us one last good-bye look," one of them said. "Good-bye, hell," Jake Beser replied. "We're coming back."

It was 0220. One by one the men began climbing aboard, up the ladders into the nose or the waist, each man loaded with yellow flotation vests, chest parachutes, emergency rations, water purification tablets, even fishhooks and lines—hardly adequate protection in the shark-infested waters of the Pacific. Some of the crowd began handing the enlisted men trinkets, something special to carry on board and bring back home. In this moment of history perhaps they too wanted a piece of the magic, a touch of the aura for themselves. As Caron waited his turn at the foot of the steps, the 509th's photographic officer, Jerome Ossip, thrust a K–20 stills camera into his hands. He knew Caron's station in the tail would give him a panoramic view of the bomb as it exploded. It was too valuable an opportunity to lose. Ossip quickly showed Caron how the camera worked. "Pull the trigger on the shutter like this," he said. "Don't change the aperture. And shoot anything you see." Caron grabbed the camera and disappeared into the plane.

A few of the crew carried lucky charms. Robert Shumard, the assistant flight engineer, took the little rag doll he would never fly a

mission without. Caron had his cap—back in April he had asked for it in a letter to the Brooklyn team's legendary manager, Branch Rickey. "I'm a deep-rooted Dodger fan," he had written, "having lived within walking distance of the Ebbets Field bleachers all my life." Rickey had sent him the cap on the day Germany surrendered, adding the hope that "someday you wear it down the main street of Tokyo." Caron also carried a medal of the Virgin Mary and his hand-tinted photographs of Kay and Judy. Tibbets had his battered cigarette case, along with an elaborate collection of cigars, pipes, pipe tobacco, and lighters. He would spend a large portion of this flight, as he did every flight, cocooned in a thick nicotine haze. Also concealed in his flight suit pocket was a matchbox. It was filled with cyanide capsules. There were twelve of them, one for each member of the crew. They had been given to Tibbets earlier that evening by Don Young, the 509th's flight surgeon. Young understood the realities of this mission. If *Enola Gay* were shot down, the consequences for any of her surviving crew could be hideous: interrogation, protracted torture, a slow and terrible death. The capsules offered a quick way out. "He assured me," wrote Tibbets afterward, "that with cyanide there would be no pain." Only Parsons was aware that Tibbets had the capsules. None of the others knew.

0227. At his engineer's panel, Technical Sergeant Wyatt Duzenbury, at thirty-two the oldest member of the crew, ran through the engine prestart procedure, his blue eyes rapidly scanning a sea of dials, switches, and levers: fuel gauges, propeller pitch controls, intercooler shutters, inverter switches, fuel valves. A former tree surgeon from Lansing, Michigan, Duzenbury thought that the bomb looked "like a tree trunk." Up and down the ninety-nine-foot bare metal fuselage, the rest of the crew went through their own separate checklists. In the tail turret, Caron tipped down his flip-up seat, closed the pressure seal door behind him, settled the K–20 camera on the floor, checked the turret latches, lamps, and fuses, checked the oxygen pressure gauge, took a test breath into his oxygen mask—he could feel the cool air on his face like a soft breeze—

fastened his harness, and clipped the photos of Kay and Judy to his chart. Duzenbury flicked his interphone to INTER and called up. They were ready to start. Tibbets unlatched the side panel window and waved to the waiting crowd below. There is a photograph of the moment: his eyes slightly straining in the dazzling klieg lights as he waves good-bye. Directly beneath him, its letters flaring in the glare, is the name of his mother. He asked for the lights to be switched off. The apron suddenly plunged into darkness as Duzenbury hit the number-three-engine magnetos. A thin scream cut the air as the starter-motor engaged. Then the massive four-bladed propeller kicked into life with a roar like a hundred thousand drums.

Duzenbury's eyes were glued to his dials: rpm at 1,000, cylinder head temperatures below 248 degrees centigrade, oil below 95 degrees, fuel pressures normal. The aircraft shook with the vibration. Duze watched the needles like a hawk. "Give him an engine fire and he becomes rock steady," Tibbets once said of his engineer. "Give him two and he becomes even steadier."

"Ready to start number four," Duzenbury called.

"Clear on number four," responded Tibbets.

In quick succession the other three engines were started, each one shooting alarming jets of flames and black smoke fifty feet behind the wings. The noise was terrific, inside and outside the aircraft. The men on the ground clamped their hands to their ears. In an instant the great silver bomber had been transformed from an inert machine into the thing she had been built for: a vibrant, living, powerful monster, carrying the most lethal weapon in the world.

Tibbets leaned out of the window, pointing his left thumb forward. The ground crew pulled the chocks away, absurdly tiny slivers of wood wedged against the huge tires. Lewis released the brakes. Very slowly, the plane trundled forward over the asphalt. A jeep drove in front, its lights flashing as it led the way past the crowd of waving photographers and scientists and well-wishers toward the runway. Taking their cue from *Enola Gay,* the other two B-29s of the strike force started their engines, then followed behind: Chuck Sweeney at the controls of *The Great Artiste,* George Marquardt and

his crew in Dimples 91, the aircraft they later called *Necessary Evil*.

Tibbets carefully steered the bomber behind the jeep. At his bombardier's station in the great glass nose, Ferebee went through his bombsight checks. Behind him, Van Kirk laid out his pencils, protractors, and charts. His job was to navigate *Enola Gay* 3,000 miles to Japan and back. His one prayer was that he would not "screw up." A single error, a chance mathematical slip, and the mission was dead. The first time Ferebee and Van Kirk had met was in the nose of a B-17 Flying Fortress three years ago. "I hope you manage to hit the target," Van Kirk had said. "I hope you manage to find it," replied Ferebee. Opposite Van Kirk, radio operator Richard Nelson tuned his radios to the frequencies he had scribbled down in the briefing. A half-read paperback lay beside the Morse key. Kneeling on a cushion by his bomb-monitoring console was Morris Jeppson. He was following every quiver of every needle on its dials, minutely checking for the slightest sign of a problem with the bomb. Deak Parsons sat next to him, his eyes also glued to the console, leaning against the pressure-sealed washing-machine door that led into the bomb bay. His back was only a few inches away from the bomb's blunt nose. His hands were still cut to shreds. Shortly after takeoff he would open the door and start his work. But first they had to get through the takeoff itself.

Tibbets gunned the bomber onto Runway A for Able. On the two parallel runways, Baker and Charlie, *The Great Artiste* and Dimples 91 did the same. Inside *Enola Gay*, Duzenbury performed the final engine run-ups. The last items were checked. Flaps set twenty-five degrees for takeoff. Trim tabs neutral. Bomb-bay doors closed. Lewis pressed the transmit button on his control wheel. "Dimples 82 to North Tinian Tower ready for takeoff."

A voice in the tower crackled back.

"Tower to Dimples 82. Clear for takeoff."

It was a dark, moonless night. Tibbets stared through the Plexiglas down the mile and a half of runway stretching ahead of him. Beyond lay a fifty-foot drop to a perimeter track; beyond that the sea. He noticed his palms were sweating. The smashed remnants of the

four bombers whose crashes Parsons had witnessed less than twenty-four hours before were still there, shoveled to one side. With its big bomb and its 7,000 gallons of gas, *Enola Gay* was already 15,000 pounds—almost seven tons—overweight. She would need every inch of that runway. Fire trucks and ambulances were lined up at intervals down its length. The bomb was unarmed, but it was still an atomic bomb. "That weapon was completely unsafe," said Harold Agnew, one of the scientists aboard *The Great Artiste*. "If the plane had to stop in a hurry, that slug would have gone right in." For a moment Tibbets wondered if all those photographers and movie cameramen back there were about to record the world's first nuclear accident. Then he heard Lewis calling off the seconds. Fifteen to go. Ten. Five. Get ready. Tibbets glanced at his watch. It was 0245.

His left hand slipped to the throttles. The engines roared to an earsplitting crescendo as he eased them forward. The brakes released with a hiss. The wheels inched forward, slowly at first, then painfully gathering speed, faster and faster, until the spinning tires began eating up the coral. Tibbets's eyes danced between the runway and the instruments: manifold pressure, revolutions per minute, most critically airspeed. Normal takeoff was at 123 mph, but Tibbets knew he had to build up much more speed for those wings to lift all that weight up into the rarefied tropical air. One by one the edge lights flashed by, and still he kept her on the ground. The engines were screaming now: a massive 8,800 horsepower pushing the bomber down the packed coral, each of those enormous propellers turning at 2,800 rpm, almost fifty revolutions *a second*. Lewis glanced at him anxiously—they were rapidly running out of runway. Instinctively his own hands began to close on the control wheel. He desperately fought the urge to take over, to pull back and lift this brute off the ground before it was too late. But at that moment the wheels eased into the air. With just 100 feet of runway to go, she started flying.

General Farrell watched from the tower, holding his breath. "We were almost trying to lift it on our prayers and our hopes," he said. *Enola Gay* clawed up into the night sky, swinging out over the sea.

Within four minutes the other two aircraft were also in the air, climbing hard behind. Farrell watched as their tail lights were gradually swallowed into the night. The sound of their engines faded. Immediately he dispatched a cable to General Groves, halfway across the world. Decoded it read:

> *Little Boy mission left Tinian at 051645 (1245 EWT) with Parsons and Tibbets in charge. Everything normal. Two observing B-29s accompanied with Alvarez, Agnew and Johnston in first and Waldman in second. Three B-29s for weather left one hour earlier to check at 3 targets.*

Special Mission Number 13 was on its way. Its destination was one of three cities—but which city, nobody knew yet. Without their realizing it, the lives of hundreds of thousands of now sleeping men, women, and children depended on what the weather was like when they woke up tomorrow morning.

SOMETIME IN THE middle of the night, Dr. Shuntaro Hida was woken from his drunken haze by a soldier. One of the farmers he had known in the village of Hesaka was desperate for help. His granddaughter had a heart condition and she was now very ill. The old farmer begged Hida to come back to the village to treat her. He was terrified she might die. Hida immediately got up, leaving the four Manchurian doctors still sleeping in the white-tiled X-ray room. He walked out of the hospital and climbed on the back of the farmer's bicycle. He was still a little light-headed. The old man carefully secured Hida to the saddle with a belt because he was afraid he might fall off. Then the two of them rattled off through the deserted, blacked-out streets, and out into the countryside. It was the last time Hida saw Hiroshima intact. His final memory of the city was the stars reflected in the Ota River, glittering like diamonds in the black waters.

TWENTY-ONE

SIX HOURS BEFORE ZERO

Sunday, August 5, Early Afternoon
Room 5120, New War Building, Washington, D.C.

FIVE FLOORS ABOVE the New War Building's lobby with its fifty-foot-wide mural of *America the Mighty*, General Groves waited for General Farrell's takeoff message from Tinian. This morning he had arrived even earlier than usual, driving his apple-green Dodge sedan through the city's deserted Sunday streets from his home in Cleveland Park. His wife and daughter were still in bed when he left. There was no reason for them to suppose that today was different from any other day—Groves always worked long hours, and they never asked questions. Whatever it was he did all day, they were used to it by now, just as they were used to spending most of their Sundays without him.

Groves sat in his office with its leather sofa, its oak conference table, and its safe filled with top-secret files and chocolate bars, and continued to wait. A few secretaries and army officers worked quietly at their steel-gray desks outside. The general also worked, or perhaps tried to work, while the minutes ticked past. Yesterday Farrell had sent him the mission's estimated takeoff time of 0245.

Tinian was fourteen hours ahead of Washington. It was now almost 2 P.M. here—the strike force should have left the ground more than an hour ago—and still he had heard nothing. He had no knowledge whether the takeoff was successful, whether it was delayed, or whether something had gone disastrously wrong. He knew nothing. He was effectively blind. Much later he learned that the message had gone astray, for unknown reasons routing through an army channel in Manila where it got stuck. The result was that the head of the Manhattan Project, the man responsible for the largest and most expensive weapons program in history, sat at his desk on this sultry Sunday lunchtime without the faintest clue what was going on.

EXACTLY TEN MINUTES after takeoff *Enola Gay* passed over the northern tip of Saipan, the island immediately adjacent to Tinian. Van Kirk made the first note in his navigator's log: altitude 4,700 feet, airspeed 213 knots, temperature plus twenty-two degrees centigrade. The bomber was now heading north-northwest, following behind the weather planes that had left an hour earlier. Brilliant blue flames trailed from the exhausts as Saipan slipped behind her wings. Somewhere outside in the darkness, *The Great Artiste* and Dimples 91 pursued the same course. None of the strike aircraft would see one another until they reached their next landfall, Iwo Jima, soon after dawn. Before that lay 622 miles of empty ocean. On board the *Artiste,* radio operator Abe Spitzer jotted a line in his diary. "The start of another mission. How I wished to be ten hours older and on the way back."

At 0300—just five minutes after passing Saipan—Deak Parsons tapped Tibbets on the shoulder and said, "We're starting." Tibbets nodded and pressed the transmit button on his control column: "Judge going to work," he said. Judge was Parsons's code name. On Tinian, General Farrell heard the message. A knot of senior scientists clustered around him in the communications hut, straining to hear every word as the distance between them and *Enola Gay* in-

creased with each passing second. The first obstacle had been cleared. Tibbets had pulled the bomber safely off the ground. Now Parsons had to arm the bomb.

Jeppson went into the bomb bay first, opening the washing-machine door and crawling inside. He carried his flashlight and Parsons's checklist—the same checklist the two men had pored over together in the final hours before takeoff. Parsons followed close behind. The noise inside the bomb bay was deafening, a shattering, skull-splitting roar that made conversation almost impossible. Cautiously the two men edged their way along the narrow catwalk toward the back of the bomb. There was no guardrail and they wore no parachutes. Nothing but the bomb-bay doors separated them from nearly a mile of thin air. The bomb trembled lightly from its single hook, its black bulk filling up almost every inch of space. The air was a little rough too. The scattered cumulus clouds at the height they were flying sometimes bounced the big plane around the sky. But at least it was cool, a welcome relief after the terrific heat of the day.

Parsons knelt on his platform opposite the tail fin, opened his toolbox, and placed the rubber pad beside him. Jeppson plugged an intercom lead into the socket. While Parsons worked he would relay each step of the arming procedure's eleven steps to Tibbets—who would pass it in turn to the men waiting on Tinian. Jeppson's flashlight ran down the initial items, beginning with the three wood-handled green plugs that blocked the firing signal between the fuse and the bomb:

1. *Check that green plugs are installed.*
2. *Remove rear plate.*
3. *Remove armor plate.*

It was filthy work. The black graphite lubricant stained Parsons's hands as one by one he removed the various steel plates from the rear of the bomb. Later he would say his principal worry was flying

all the way to Japan with "a pair of dirty and greasy hands and no good place to wash them." It is a classic Parsons remark: pragmatic, unhistrionic, deliberately self-effacing. But the truth was that the success or failure of the mission was now entirely in those hands—hands that were not only dirty but painfully scored with cuts. A wrench dropped, an electrical lead misconnected, and it might not be possible to arm the bomb. His performance had to be perfect. Attention to detail was everything. As a thirteen-year-old boy, Parsons had narrowly failed to win the New Mexico spelling bee championship by missing the *e* out of *potatoes*. It was a useful lesson, most especially now, as he crouched in *Enola Gay*'s vibrating bomb bay opposite *Little Boy*'s black tail.

He worked quickly, just as he had practiced all afternoon. Once the rear plates were removed, he inserted the wrench into the breech plug, rotating it sixteen times to unscrew the plug. Carefully he laid it down on his rubber pad. Steps four and five were complete. Approximately five minutes had passed. Jeppson flashed his torch over his checklist and called off step six: *insert charge, 4 sections, red ends to breech.* This was the most delicate part of the operation. One by one Parsons had to insert four cylindrical silk bags of cordite—a form of gunpowder—into the breech plug. The red ends were igniter patches: the instant they detonated, the bomb's gun would fire, slamming the uranium 235 projectile down its bore to the uranium 235 target at the other end. Very carefully, Parsons lifted the first bag of cordite packed with its highly explosive spaghetti-like granules. Jeppson beamed the torch over his shoulder, watching every move. From time to time, the big plane lurched in the turbulent sky. The engines hammered at the bomb bay's thin walls. Not once did Parsons lose his concentration. All his focus was narrowed to one purpose. "Just being around that man gave you confidence," Jeppson said later. "He was that good." Despite the vibration, Parsons's hands remained steady as he slowly inserted the first cordite bag into the breech plug. *Little Boy* trembled inches from his face. He moved on to the second bag. Outside the bomb

bay, the rest of the crew hung on Jeppson's next report. So did the men waiting 100 miles behind on Tinian. "That worried me more than anything else," Van Kirk said later, "loading all that ██████dam gunpowder while we were on the airplane, for Christ's sake." But Parsons was never more completely in his element. Guns were his life. An early photograph exists of him holding a .22 rifle, snake hunting in the empty flats of Fort Sumner as a boy. His best work in the navy was with guns—designing them, improving them, testing them. It had always been his greatest ambition to command his own ship. Somehow fate had led him here instead.

The final cordite bag was pushed home: step six completed. Parsons screwed the breech back inside the bomb, tightening it another sixteen times with his domestic wrench. Step seven. Next he connected the firing line—step eight—the electrical link between the fuse and the bomb. "All it needed was a little skill and a steady hand," he said later. "Only a suicidal maniac could have made it dangerous." Perhaps so; but in reality he was handling high explosives very close to nuclear subassemblies. And he was doing it with a set of household tools in the darkened, cramped confines of the bomb bay a mile above the Pacific.

By 0315 it was finished. All that remained was to reinstall the rear plates and secure the tools. Jeppson relayed the message to Tibbets in the cockpit. Just fifteen minutes after they had started the two men emerged from the bomb bay. As they climbed back through the hatch, Dutch Van Kirk's first thought was "Hallelujah!" From his copilot's seat, Bob Lewis scrawled an entry into the log Bill Laurence had asked him to write. It was addressed to his parents 6,000 miles away in Ridgefield, New Jersey. "Dear Mom and Dad," it began, "items 1–11 were completed satisf. by Capt. Parson's." The language might be ungrammatical, the words bald, but the relief they underscored was very real for everybody on board. Parsons and Jeppson had not put a foot wrong. Just one further task remained. Before *Enola Gay* climbed to her final bombing altitude in four hours' time, the three green plugs blocking the

firing signal would have to be replaced by three red plugs—which unblocked it. Only then would *Little Boy* be fully armed.

From the cockpit Tibbets relayed the result to the scientists and General Farrell on Tinian. But they never heard it. By the time Parsons reached step eight—*connect firing line*—Tibbets's voice had begun to fade over the airwaves. By step nine—*install armor plate*—his voice had disappeared into static. Several times Farrell attempted to make contact with Tibbets. There was no response. At that point nobody on the ground could be perfectly certain whether Parsons had succeeded, or blown himself and *Enola Gay* out of the sky.

ON BOARD the USS *Augusta*, President Truman went to the ship's chapel that Sunday morning. Jimmy Byrnes, his secretary of state, joined him. The cruiser was now more than halfway across the Atlantic, steaming at twenty-six knots toward Newport News, Virginia. The president spent much of the afternoon closeted with Byrnes in his cabin, studying the latest moves in the ongoing Soviet-Chinese negotiations. Merriman Smith, a reporter from the United Press, remembered the hours as extremely tense. Two days earlier, Truman had invited the ship's press corps to a private conference in his cabin. There, in the strictest secrecy, he had told them for the first time about the atom bomb. He had said the bomb would very shortly be employed against Japan. His tones had been measured, but to Smith his emotions had seemed divided—he was happy the bomb would quickly end the war, but he understood it was also a "monstrous weapon of destruction." The president said he had prepared a special statement which he would release to the press the moment the weapon was used. "Here was the greatest news story since the invention of gunpowder," Smith said afterward. "And what could we do about it? Nothing. Just sit and wait."

They were still sitting and waiting throughout that Sunday afternoon, pretending to talk about anything but the one thing that was on all their minds. "The secret was so big and terrifying," said

Smith, "that we could not discuss it with each other." As for the president, the United Press reporter summed up his mood in one word: *worried.*

ENOLA GAY cruised through the night as a late moon rose in the east. At 0420 Bob Lewis made another note in his log: "The colonel, better known as 'Old Bull' shows signs of a tough day. With all he had to do to get this mission off he is deserving of a few winks. So I'll have a bite to eat and look after George, the autopilot." Tibbets was not the only one to snatch a quick nap. Half the crew were now asleep, exhausted by the tension of the last twenty hours. Others rested at their stations, lulled by the rhythm of the engines. Richard Nelson, the radio operator, dozed over his paperback, *Watch Out for Willy Carter,* a novel about a young boxer. Tom Ferebee sat quietly behind the pilots: "Methinks he is mentally back in the mid-west part of the old US," wrote Lewis. Morris Jeppson perched up in the astrodome, the clear bubble above the fuselage, staring out at the stars and the moonlit cumulus clouds floating past. As a child he had always wanted to be an astronomer. "It was," he remembered, "a beautiful night." In the narrow, thirty-foot pressurized tunnel that separated the nose and the waist compartments, Jake Beser lay stretched out, his first chance to sleep in twenty-seven hours. Bob Caron, assistant engineer Robert Shumard, and radar operator Joe Stiborik took turns rolling oranges down the tunnel toward him. Finally one bounced on Beser's head, waking him up. There was no more sleep after that.

Earlier Caron had tested the twin .50-caliber machine guns that were *Enola Gay*'s only defense against enemy air attack. They checked out perfectly. Then he clambered out of the tail, back to the comfort and companionship of the waist with its photo of "Wendover Mary," a naked Utah belle, stuck to the hatch. He brought with him the green canvas canteen he always used to uri-nate in. A standard joke among his crewmates was switching that

canteen for the one with drinking water. They were ribbing Caron about it now when Tibbets crawled through the tunnel toward them. For a few moments he stopped and chatted. Then he suddenly asked if they had worked out what type of bomb they were carrying. "It's OK now," he said. "We're on our way. You can guess anything you like."

"Is it a chemist's nightmare?" asked Caron.

"No, not exactly," replied Tibbets.

"Is it a physicist's nightmare?"

Tibbets stared at his tail gunner. "You might call it that," he said. He began to crawl back down the tunnel toward the cockpit. Caron tugged his foot. "Colonel," he said, "are we splitting atoms today?"

Tibbets gave him a strange look.

"That's about it," he said.

It was a lucky guess; at least that is how Caron always remembered it. But the rumors had been flying around for weeks now. Everybody had been so conditioned to silence that the real story was suppressed. They all remembered those abrupt exiles to Alaska. It was far too dangerous to speculate—until now. Within minutes of returning to his seat, Tibbets switched on the interphone and called the crew to attention. He told them he was going to give them the last piece of the puzzle. They already knew from the briefing how big this bomb was. Now he told them its name: it was called an atomic bomb.

HENRY STIMSON spent that Sunday with friends in Long Island. Late on Friday night he and Mabel had flown from Washington's National Airport to their estate at Highhold on the North Shore. The views from the big wooden framed house were stunning: especially this weekend, with the sea sparkling in the summer sunshine and the emerald Connecticut coast beyond the Sound. After the stresses of Potsdam it was wonderful to be home again. Yesterday he had received word from the Pentagon that the mission to Japan would

leave today. Like General Groves, he had been given the takeoff time. Since then there had been no news. He and Mabel decided to visit friends over in Port Washington. As always, Stimson noted the details in his diary. "We had," he recorded, "a very pleasant afternoon."

Back in Washington, the Japanese-language translators worked feverishly on the latest secret communication from Naotake Sato, Japan's ambassador in Moscow. The ten-page typed document—number 1228 of the "Magic" Diplomatic Summaries—would be on Stimson's desk by tomorrow. It contained Sato's final plea to his foreign minister in Tokyo. The message was extraordinarily blunt. It was useless, Sato declared, to expect the Russians to mediate a better peace. They would never oppose the Western Allies. Japan must surrender now. Her days were numbered. "If the Government and the Military dilly-dally, then all Japan will be reduced to ashes." The emperor himself must intervene before it was too late. Then he added a rider: "I feel," he wrote, "very deeply the pressure of time." It was a typically prescient remark, rather more so than Sato could ever have imagined.

DAWN CAME quickly at the latitudes the bombers were flying. As the stars faded, a brilliant red fire rimmed the eastern horizon. The sun rose quickly, burning the scattered clouds through which they were flying a molten gold. The big four-engined B-29 was glinting in the early-morning light, moving serenely into history through a Technicolor skyscape. "That sunrise," said Van Kirk, "was one of the most beautiful I had ever seen." At the time Bob Lewis was more businesslike: "0500. The first signs of dawn," he wrote in his log. "A nice sight after having spent the previous thirty minutes dodging large cumulus clouds. It looks like we will have clear sailing for a long spell."

The bomber sped into brilliant daylight. Ahead lay the island of Iwo Jima, the volcanic rock that was their designated rendezvous point with the other two strike force aircraft—and a key marker en

route to Japan. A new alertness gripped the crew. The time for sleeping was over. In the cockpit Bob Lewis slowly took the bomber up to 9,200 feet, the first step in the long climb to its final bombing altitude. Tibbets monitored the altimeters, the needles winding through 500 feet every minute. The thick aroma of tobacco from his pipe filled the cockpit. Behind him Wyatt Duzenbury watched the maze of instruments, gauging the health of the engines as the bomber climbed: temperatures, pressures, revolutions, the glass dials trembling slightly with the vibration. Beside the bomb bay hatch, Jeppson and Parsons knelt on their parachutes scanning the banks of lights on their bomb console. At the moment they were all green. Van Kirk left his charts to observe them: "What happens if all those green lights go out and the red ones come on?" he asked. "We're in a lot of trouble," said Jeppson.

At 0552, Iwo Jima emerged dead ahead over the horizon. Joe Stiborik saw it coming up on his radarscope, its pork-chop shape instantly identifiable on the screen. Van Kirk's navigation had been perfect: his timings split-second accurate after more than three hours' flying over the featureless sea. The sky was now crystal clear. Twelve pairs of eyes scanned every inch of it looking for *The Great Artiste* and Dimples 91. Razor-sharp rays of sunlight slid across the cockpit as Tibbets banked *Enola Gay* into a gentle left-handed orbit over Iwo's extinct volcano, Mount Suribachi. The 556-foot-high mountain slowly revolved beneath them. The crew knew all about Suribachi. For four terrible days back in February the marines had fought some of the bloodiest and most vicious engagements of the war to capture it. Step by step, foot by foot, they had slogged past land mines, booby traps, pillboxes, grenades, shells, shrapnel, and murderous machine-gun fire to reach its summit. The Japanese had fought with extraordinary tenacity. Their general, Tadamichi Kuribayashi, had sworn his troops to kill at least ten of the enemy before dying. The fighting was brutal, often intimately so: men killing each other with bayonets, knives, rifle butts, even fists. The marines had taken more than a thousand casualties. The volcano quickly earned

its nickname: the Hot Rock, its capture immortalized in Joe Rosenthal's photograph of battle-hardened marines raising the Stars and Stripes on its summit. But the fighting did not end there. It took another three weeks to capture the other eight square miles of the island. By then some 7,000 Americans and 19,000 Japanese were dead, their bodies entombed in the soft volcanic ash over which *Enola Gay* now circled. For many of her crew, Iwo Jima was not simply a convenient waypoint en route to Japan. It was the reason they were there. Tibbets had already told them the bomb they were carrying would shorten the war. It might even end it. Every man on board felt that way. But one of them felt so perhaps even more strongly: somewhere down there Deak Parsons's brother had lost part of his face.

Exactly on cue, *The Great Artiste* and Dimples 91 emerged like specks against the sky, rapidly closing toward *Enola Gay* until each aircraft hung just behind her wings. It was a textbook rendezvous. All three navigators had performed without a hitch. The months of training, the endless overwater navigation exercises near Cuba, the practice pumpkin missions to Japan—they had all paid off. For twelve minutes Tibbets circled the island as the formation assembled. Then Van Kirk passed him a new heading: 327 degrees, a 13-degree shift to the left, pointing the formation almost exactly northwest. That heading would take them directly to Shikoku, 650 miles farther on, and their first landfall in Japan. Van Kirk made a careful note of the time: it was 0607½. Just three hours from bombs away. But on which city, no one on board yet knew.

TWENTY-TWO
TWO HOURS BEFORE ZERO

Monday, August 6, 7:15 A.M.
Hiroshima City

B<small>Y</small> S<small>EVEN</small> O'<small>CLOCK</small> in the morning, the temperature in Hiroshima had already reached eighty degrees Fahrenheit, and it was still climbing. The humidity was 80 percent, the wind calm. It was a glorious summer's day. The sun blazed out of a clear blue sky, the visibility so perfect the mountains seemed close enough to touch. Dr. Michihiko Hachiya, director of Hiroshima's Communications Hospital, threw open the windows of his house. "The hour was early," he wrote in his diary. "The morning still, warm and beautiful. Shimmering leaves, reflecting sunlight from a cloudless sky, made a pleasant contrast with shadows in my garden." The city bathed in the sunshine. For a few moments the war suddenly felt far away.

Up in the farmer's house in Hesaka, six kilometers north of Hiroshima, Dr. Shuntaro Hida was still fast asleep. After a hair-raising ride up the hill on the back of the bicycle, he had spent the night tending the old man's granddaughter. The six-year-old girl had a problem with one of her heart valves, and Dr. Hida had finally given her a sedative to sleep. Then he too had fallen asleep, partly

from inebriation, partly from sheer exhaustion. Even the farmer's clattering in the yard failed to wake him up. He lay stretched out on a mat in one of the rooms overlooking the village school while the sun played across the room's whitewashed walls. Next to him lay the sick child. Her mother had left early that morning as she always did, to go to work in Hiroshima.

Across the hills in Itsukaichi, to the west of the city, Taeko Nakamae woke early to get ready for another day at the telephone exchange. She had to be there by eight o'clock. Her sister, Emiko, was awake before she left. Emiko was lucky. She did not have to leave for another hour. She still looked pale and drawn from her illness. She was only twelve years old and Taeko was worried about her. But Emiko was still set on going, and nothing Taeko could say or do would stop her. And she was proud of her younger sister. Both of them were doing their duty. "Even our small bodies," Taeko would say, "are helping our country." She tied her hair back tightly in the approved manner, and said good-bye to Emiko. "I'll try to be back early," she said.

The little country train station at Rakurakuen was thirty minutes away on foot. The sun blazed down as Taeko walked along a straight road through the endless paddy fields. It was already very hot. The landscape slumbered in silence all around her. The fields were almost empty. It was a moment she was to relive many times afterward: the heat, the dazzling sun, the glistening paddy fields, the solitary girl on the arrow-straight road. Then she suddenly found herself at the station, squeezing onto a packed train, holding tight as the engine snorted and lurched down the narrow-gauge track toward the city stretched out across the plains below.

Everywhere Hiroshima was waking up. The city's 123 streetcars and 85 buses—there were only 25 registered private vehicles— clanged across bridges and intersections as the majority of its 300,000 civilian inhabitants rushed to work. In hundreds of cellars dispersed across the city, thousands of schoolchildren settled down once again at communal tables to build parts of tanks or aircraft engines or shells or bombs in readiness for the coming battle. Another

8,000—like Emiko a little later—streamed into the center for another day tearing down the old wooden houses with their ropes. Across the city's forty-seven hospitals, hundreds of nurses, the majority of them teenage students, arrived for the morning shift. They began the day as they always did with bamboo practice, their white headbands—symbols of determination and self-discipline—glistening with sweat as they speared invisible enemies in the hospital yards. The army was also awake. In the huge parade grounds east and west of the Ota River, many of the 43,000 soldiers stationed in the city stood stripped to the waist for the morning's calisthenics, row upon row exercising under the hot sun. Some of them also exercised in the castle compound, not far from the prisons where some twenty-three American POWs—thirteen of them shot down and captured only nine days ago—were waiting in the darkness of their solitary cells.

Despite the shortages of paper, the *Chugoku Shimbun* was once again out on the streets—to be read or used for boiling up water or both. The same headlines shrilled out as they did every day: August 6, 1945, was no different. On the front page this morning was a photograph of elementary schoolchildren drying the ubiquitous edible grass, a reference to last night's B-29 bombing raid on Hokkaido, even a glancing remark about Clement Attlee's Labour victory in Britain's general election. There were the inevitable headlines about the people's martial zeal in preparation for the upcoming battle—"The Fighting Spirit of the People Lives On!"—along with injunctions to deliver old postcards and name cards to the military to help solve the paper shortages and win the war. And of course there was *Today's Broadcast*. Listeners who were interested could hear this week's *School Diary—A Memoir* on the wireless. All they had to do was wait until 12:15 P.M.

ONE HOUR and twenty minutes from the Japanese coast, Morris Jeppson once again opened *Enola Gay's* bomb bay hatch and stepped inside. The time was just before half past seven. In his

pockets Jeppson carried three five-pin arming plugs, each one just over three inches long and colored red. Once again he edged carefully along the catwalk, squeezing past *Little Boy*'s right-hand side. On its upper surface were the three green safety plugs that blocked the firing signal from the fuse. For a moment Jeppson stood beside the trembling bomb holding his three red plugs. He was alone in the bomb bay. Many years later the thought occurred to him: "If I had removed the green safety plugs and then simply tossed the red ones onto the bomb-bay doors, the bomb would have been a dud and there would have been no evidence. I'm willing to believe that a dud would have forced some high-level considerations. Possibly the invasion of Japan would have happened." In a very real sense the power to change history now rested directly with him.

But history kept its course. One by one Jeppson drew out the green plugs. Then he replaced them with the red plugs. Two large pins on the bottom of each one were connected to two smaller pins by a copper jumper wire, closing the firing circuit. Jeppson carefully checked that all three red plugs were properly inserted. He gave the third plug a final twist. "That was a moment," he remembered. Then he made his way out of the bomb bay, closing the hatch behind him. He was the last man to touch the bomb. *Little Boy* was armed. Bob Lewis penciled a note in his log: "We are loaded. The bomb is now alive. It's a funny feeling knowing it's in back of you. Knock wood."

Ten minutes later, at 0741, *Enola Gay* started the long climb to its operational bombing altitude of 31,000 feet. The two other strike force bombers tucked in behind. Inside *The Great Artiste,* the three scientist observers—Lawrence Johnston, Harold Agnew, and Luis Alvarez—thrust their FM receiving aerial out into the 250-mile-per-hour slipstream before Chuck Sweeney pressurized the plane for the climb. The aerial would pick up the blast wave signal from the microphones as they floated down by parachute over the target. Johnston hunched over his equipment calibrating the microphones over and over again—in his growing nervousness it gave him something to do. Inside *Enola Gay,* Bob Caron left his crew-

mates in the midsection and crawled back to his lonely turret in the tail, carefully shutting the pressure-seal door behind him. It was hot in there. The sun glared through the turret's left-side windows. Caron unzipped his coveralls down to his waist, revealing the Miraculous Medal of the Virgin Mary that hung from a chain against his T-shirt. He adjusted his prescription sunglasses, flicked open his Zippo lighter illegally fueled with 100-octane aviation gasoline, and lit up the first in a long chain of Lucky Strikes.

All three aircraft pressurized as they passed 10,000 feet. In the nose, Van Kirk sat over his handheld drift computer calculating the winds every 5,000 feet. It was essential to get them right as they approached the terrific velocities of the jet stream above. A mistake of just a few degrees now could put them miles off course. Despite all his experience—all those murderous flak- and fighter-filled missions over occupied Europe three years ago—Van Kirk could feel the tension beginning to build. Back in the waist, Jake Beser sat by the airplane's toilet and wound up his 300 pounds of hot electronics: APR-4 and S27 receivers, panoramic adaptors and thermal writing spectrum analyzers, a whole array of classified equipment designed to do just one thing—check that the Japanese had not accidentally stumbled on the bomb's secret radar frequencies, thereby signaling it to detonate. A twenty-four-year-old from Baltimore, Beser had left Johns Hopkins University and joined the air corps on December 8, 1941—the day after Pearl Harbor. As he hunkered over his boxes he could already hear radio chatter from U.S. Navy ships of the Fifth Fleet over his headphones. He could also hear communications between air/sea rescue vessels strung out ahead of their path. It was with a slight shock that he realized that those ships down there were waiting for them, if anything should go wrong.

The three silver bombers clawed slowly up into the freezing blue skies. Far beneath them, dazzling cotton-wool clouds tumbled to the horizon. The empty ocean shimmered in the brilliant morning sunshine. "Outside of a high thin cirrus and the low stuff it's a very beautiful day," noted Lewis in his log. The time was approaching

eight o'clock. Two hundred miles ahead of them the three weather planes were approaching their three destinations: Hiroshima, Kokura, and Nagasaki. The next few minutes would decide which of these cities would be the target. "Well, folks," wrote Lewis, "it won't be long now."

TWENTY-THREE
ONE HOUR BEFORE ZERO

Monday, August 6, 8:07 A.M.
Underground Communications Bunker,
District Military Headquarters, Hiroshima

THE RED LIGHT on the big three-meter-by-four-meter wall map had begun blinking just a few minutes ago. Several officers now crowded into the cramped communications room to watch it. The contact was heading north, crossing the island of Shikoku, flying directly toward the city. In the adjoining bunker a group of schoolgirls concentrated on the voices in their headphones. Hastily scribbled notes passed between them and the communications room as further reports came in: from radar stations, from searchlight batteries, from observers on the ground. Only yesterday, the *Chugoku Shimbun* had devoted half of its front page to the girls: "With daily enemy attacks becoming ever harsher, the schoolgirls keep their headphones over their ears. Even if we have to die," said one twelve-year-old, "we shall fulfill our duty. That is our resolve."

The contact continued to head north toward the city. There had been a number of alerts during the night, all of them B-29 formations on their way to—or from—targets elsewhere. But this one was

different: a single B-29, flying unusually high, at 30,000 feet. Perhaps it was a reconnaissance mission. Only photographic aircraft flew that high. The officers stared at the map. Even at this time of the morning it was unpleasantly hot and damp down here. The damp was perennial. The underground communications bunker abutted the moat on the southern perimeter of Hiroshima's castle compound. Outside its thick reinforced concrete walls, the city's famous carp swam in the moat's opaque waters. Inside, the red light kept blinking on the map.

The contact was now less than ten miles away, approaching the outer limits of the city suburbs. The officer-in-charge picked up the telephone that linked directly to the Hiroshima Radio Station one kilometer away. Waiting in the broadcasting booth was Masanobu Furuta, a twenty-eight-year-old announcer. Furuta had one of the most famous voices in the city. His job was to broadcast air raid alerts. Yesterday's article in the *Chugoku Shimbun* had fulsomely praised his talents. "His voice," it reported, "is always quiet and calm, a strong, cool voice, without the hint of a tremor. A voice which calms our anxieties."

The morning's program of martial music was suddenly interrupted as Furuta switched on the microphone. Once again the people of Hiroshima heard the strong, cool voice which calmed their anxieties. A single enemy intruder, he said, was approaching the city from the south. Outside the sirens began to shriek: a series of short piercing blasts that signified a precautionary alert. It was exactly 8:09 A.M. High above the city, a single silver dot crawled across the brilliant blue sky.

JACK BIVANS stared out of the window at the city sliding past *Straight Flush*'s wings 30,200 feet below. The assistant engineer was immediately reminded of his hometown, Chicago: all those rivers and waterways bisecting the streets, glinting in the sunshine. The air was so clear—"as clear," he would remember years afterward, "as

hell." He could see everything, even the green patches that marked the city's parks and gardens and the wooded slopes of the surrounding hills. For a moment Bivans forgot all those fears about his balls being cut off if they were shot down. He just stared at the view.

It had been a routine, almost dull, mission. A 1,500-mile haul up the Hirohito Highway to check the weather over a Japanese city was hardly exciting for this crew—certainly not as exciting as dropping a bomb on the emperor's palace. But then, quite unexpectedly, the weather had begun closing in. By the time they reached Shikoku, thirty minutes from Hiroshima, the scattered clouds had gradually metamorphosed into an almost solid undercast stretching away beneath them, a sheet of low-level stratocumulus as far as the eye could see. Up in the cockpit Buck Eatherly and his copilot Ira Weatherly—the names had been the butt of too many jokes by now—soldiered on just as they had been briefed. But the prospects of a visual run on Hiroshima were beginning to look very doubtful. Despite the gaps here and there, the cloud obscured most of the ground. There was little chance of the strike plane bombing through it. The second weather scout, *Jabit III,* was reporting similar conditions over Kokura. Only *Full House* at Nagasaki was signaling clear skies. Perhaps this was going to be Hiroshima's lucky day.

And then abruptly the cloud had cleared. As Eatherly reached the initial point sixteen miles east of the aiming point, a huge hole had opened up, suddenly exposing the entire city to view. It was at least ten miles across, almost a perfect circle, its circumference mirroring the city's boundaries. Apart from the odd straggling cloud, unfiltered sunlight poured through the gap, revealing every detail from six miles up: streets, city blocks, rivers, the port, even individual buildings. Eatherly immediately swung *Straight Flush* over the top of the hole, heading due west. His navigator, Felix Thornhill, checked the winds aloft: southeasterly at fifteen knots. Easily within bombing limits. His observer, Frank Wey, gazed through the Plexiglas in the bomber's nose. Tom Ferebee's T-shaped bridge drifted lazily past far below. It stood out vividly from all the other bridges,

just as Ferebee had predicted. The hole was perfect. Stripped of its cloud cover, Hiroshima lay naked beneath them. The primary target was open and clear.

One more time Eatherly brought the B-29 bomber back across the city to confirm the findings. There was no flak and there were no fighters. Hiroshima made no attempt to defend itself. *Straight Flush* droned unmolested through the empty skies. Her radio operator, Pasquale Baldasaro, twisted the tuning knob on his transmitter to 7310 kilocycles and consulted his codebook. Then he began to send a message back to *Enola Gay,* less than one hour's flying time behind.

T HE ALERT lasted twenty-two minutes but very few people took to the shelters. In some districts the trains did stop and schoolchildren went underground, but only briefly. Down in the port area, Toshiaki Tanaka—the liquor store owner—and a number of his fellow soldiers in the Akatsuki Corps also huddled in a barrack cellar. But they did not stay long. The short siren blasts indicated a low-level alarm, not a full-scale warning. There were no massed formations of B-29s approaching from the south, only this solitary B-29 crossing the sky. And what possible harm could a single bomber do to a city?

Sunao Tsuboi was on his way to the engineering institute when the sirens began wailing. He barely registered the fact. His mind was elsewhere. He had spent a sleepless night thinking about Reiko. He had even cried in bed—to his own great surprise. Yesterday evening in the Shukkeien Garden had stirred so many conflicting emotions in him: love, despair, pain, happiness, above all, loss. Already he missed Reiko desperately. Perhaps they could see each other once more tonight, he wondered. They might even meet at the garden again. It was almost as much as he could hope for. Time was so short before he was due to leave for the army.

As he continued walking he suddenly felt very hungry. He realized he had not eaten anything since yesterday afternoon. He decided to get some breakfast. There was a place he knew just around the corner from the institute. He headed toward it, walking south

across the city. The streets were crowded with people rushing to work. The trams and buses streamed past the busy intersections, packed with commuters. All over the city the sirens blasted away, unheeded. Sunao crossed a bridge. Six miles above his head the tiny silver dot traversed the sky, turned around, and came back a second time. Sunao hardly bothered to look up.

ENOLA GAY had just passed 29,000 feet, still climbing hard toward her final bombing altitude, when the message came in from *Straight Flush*. It was very brief: a discrete series of letters and numbers. Richard Nelson grabbed a pencil and rapidly scribbled them down as they came through the haze of static over his headphones: Y–3 Q–3 B–2 C–1. He pulled out the scramble sheet and began to decode them. Tibbets stood over his radio operator's shoulder, watching. Quickly Nelson ran his finger down the code list, confirming the combinations one by one. *Watch Out for Willy Carter*, his boxer paperback, lay ignored beside him. He checked over the message. It was all complete. Then he called off the weather report Staff Sergeant Pasquale Baldasaro had sent from somewhere in the skies over Hiroshima:

> *Two-tenths cloud cover lower and middle, two-tenths cloud cover at 15,000 feet.*

> *Advice: Bomb Primary.*

Tibbets switched on his intercom. "It's Hiroshima," he said. Almost on cue, Van Kirk passed him a course correction. *Enola Gay* banked gently fifteen degrees to the right, *The Great Artiste* and Dimples 91 still holding formation behind. A few minutes ahead lay the enemy coast at Shikoku. Bob Lewis returned to his log. "Right now we are twenty-five miles from the Empire," he wrote. "Everyone has a big hopeful look on his face." The time was 0830. In Hiroshima the sirens were just ringing the all-clear.

TWENTY-FOUR
THIRTY MINUTES BEFORE ZERO

August 5, Late Afternoon
Room 5120, New War Building, Washington, D.C.

GENERAL LESLIE GROVES was having a very bad day. All morning he had waited in his office for news of the mission. None had arrived. He had no idea whether the takeoff had been successful or even if the mission had taken place. For several hours he had sat at his desk and done absolutely nothing but wait—an appalling experience for a man like Groves. He lived by controlling events, by keeping a ruthless hand on every aspect of whatever project he happened to be running, above all the Manhattan Project. Control was the watchword of his career, almost the center of his being. And now here he was sitting in his office at by far the most important junction of that career—and he had no power at all. Anything could be happening out there in the Pacific. But for some reason nobody was telling *him*.

Somewhere between Washington and Tinian the lines had got crossed or jammed or misrouted. Groves did not know which. In time, no doubt, they would sort themselves out. Heads would roll if they did not—heads would probably roll even if they did. Mean-

while the general had to find a way to occupy his time. "There was no useful purpose to be served by my sitting there fretting," he wrote afterward. The best thing to do was to work up some sweat. Activity was the solution; intense, heart-busting physical activity. For Groves that meant only one thing: tennis.

Shortly after lunchtime, the overweight general lumbered down to the tennis courts with two staff officers in tow. While he spent the afternoon smashing balls at one of them, the other sat by the net with a telephone, calling back to the office every fifteen minutes to see if any news had arrived. Back and forth went Groves, pounding the court like a man possessed, no doubt unerringly hitting the ball dead center, slamming it like an artillery shell toward his opponent. Meanwhile, every fifteen minutes, his staff officer would pick up the phone, make the call, and shake his head. It went on like that for almost the entire afternoon. They had only been finished an hour or so by the time *Enola Gay* crossed the enemy coast at Shikoku. But Groves was still none the wiser.

Now TIBBETS took control of the *Enola Gay,* switching off the C-1 autopilot for the last time until the bomb run. Behind him Van Kirk logged the height: they were level at 31,000 feet, their final bombing altitude. Outside the bomber's pressurized hull the temperature was minus twenty-four degrees centigrade, as cold as an Arctic winter, only far more inhospitable. Without oxygen a man would last less than two minutes out there. The sun glared through the windows. They were so high that the skies above them were a deep, burning indigo-blue. Far below, between the gaps in the clouds, the enemy coast slipped by: the flat, unwrinkled ocean suddenly giving way to a strip of land, a muddy carpet of parched browns and greens and hills and the occasional town sparkling in a shaft of sunlight. It looked almost peaceful down there.

Inside *Enola Gay*'s waist section, Jake Beser concentrated over his electronic monitoring equipment, intensively searching every

enemy frequency for possible interference with the bomb's radars: the result could be catastrophic. So far there was nothing. The air, he said, was "as clean as a hound's tooth." But Beser could also hear a whine through his headphones, and he knew what that meant. The Japanese early warning radar had locked onto the strike force. They were tracking the American bombers across Shikoku.

On the other side of the thirty-foot pressurized tunnel, Deak Parsons stared at the bomb console. All the green lights were still steady. If the enemy attacked now, he would have to act very quickly. Typically, he had already worked out exactly what needed to be done. He called it "responding to possible abnormal events." "Possible abnormal events" included such things as being shot down, in which case Parsons would somehow have to climb back into the freezing, unpressurized hell of the bomb bay, dismantle the breech plug with his domestic wrench (another sixteen turns) while the aircraft was screaming or shaking or hurtling to the ground, and disarm the bomb. If he failed, the bomb would almost certainly explode. If they were forced to ditch, it would also very likely explode, since tests in Los Alamos had already demonstrated that seawater leaking into *Little Boy*'s casing had an unfortunate tendency to initiate a chain reaction. Parsons had designed as many fail-safes into the bomb as was possible—it could even be dropped if only the pilot and he survived an attack—but in truth there were an infinite number of possible abnormal events, and it was impossible to provide against all of them. In his pocket was a list of coded messages he would shortly use to transmit the result of the drop back to Tinian. There were twenty-eight alternatives on the list. The twenty-fifth was *Returning with unit to indicated place due to damage to aircraft*. If only it were that simple.

Alone in *Enola Gay*'s tail, isolated in his capsule from the rest of the crew, Bob Caron stared out at the sky. Despite his sunglasses the glare burned into his eyes. Beneath his windscreen the two .50-caliber machine guns projected into the slipstream. As they approached the enemy coast he had attempted to struggle into his flak

suit, but the turret was too cramped. His one protection against anti-aircraft fire lay in a heap on the floor. Now he began scanning every inch of the sky for enemy fighters, mentally tearing it into strips and rigorously examining each strip, up and down, left to right, strip by strip, searching for the dot that could suddenly turn into a fighter and kill you. But there were no dots. The only aircraft out there were American: *The Great Artiste* and Dimples 91, hanging off the tail a few hundred feet behind. Otherwise the sky was empty.

Up front, Tibbets also scanned the empty sky. Back in Europe they used to say the antiaircraft fire was so thick you could get out and walk on it. But Shikoku's coastal batteries were silent. No bursts of shrapnel-filled flak greeted them as they crossed the island. The landscape unrolled harmlessly below. Tibbets was convinced that his policy of sending individual or small formations of his bombers to the Empire was paying off. The enemy were simply ignoring them. The three bombers rode the skies undisturbed, the southerly wind pushing them along at 328 mph—well over five miles a minute—toward their target. Van Kirk passed a new estimate to Tibbets. They would reach their initial point—the start of the bomb run—at exactly 0912. "I was trying to hit it exactly," he said. "By this time it was a game for me." Game or not, he suddenly glanced up, looking past the two pilots and through the glass nose. Something glinted on the horizon, a good fifty miles away, beyond Shikoku and across the Inland Sea. He stared in fascination. It was unmistakably a city.

ISAO WADA also saw the glinting city, this time from five miles across the bay, as he sat down to breakfast. But as always he did not pay it much attention. Yet another backbreaking day digging holes stretched ahead. He could see the boats lined up on the beach in the hot sun. Some of his class would be going out on training runs later this morning—but not him. Those holes had to be dug. His only consolation was that the time when he could prove his devotion to his emperor was surely not far off. One day very soon his little

wooden boat with its 250-kilogram ball of explosives would blow him—and an enemy ship—into oblivion. He looked forward to it. Death would be his gift to his nation. Meanwhile there were a few compensations. The food, for instance, was better than for ordinary soldiers, and far better than it was for civilians. At least they did not have to eat grass. Isao Wada remembered that as he lingered for a few precious minutes over his boiled white rice and miso soup. Having elected to die, they were certainly fed very well.

Sunao Tsuboi was also eating breakfast, but it was rather less nutritious than Isao Wada's. He had stopped by a little sidewalk café for a few minutes. Just as he was about to leave, three of his friends from the engineering institute arrived. They asked him to stay. Sunao told them he was already late for work. One of the students smiled and said, "See you at lunchtime." Sunao stepped out into the street and continued toward the institute. It was just coming up to nine o'clock.

Taeko Nakamae had changed trains on the way down the mountain. At Nishi Hiroshima station, she had switched to a local train that took her to Kamiyacho, on the western side of the city. From there she had walked to the telephone exchange, ten minutes farther on. Like all schoolgirls, she carried her first-aid kit on her back. On her right side, near her chest, hung a small strip of cloth with her name on it. It also contained her blood type. She tied her white headband around her head. The trams and buses kicked up the dust from the streets. Her school uniform scratched against her skin. Even at this time of the morning the heat was becoming oppressive.

She reached the exchange on time, took off her shoes, and placed her first-aid kit, as she always did, in one of the ground-floor lockers. Then she went upstairs to her station at the switchboard. On either side her classmates sat in a row. A window looked out over the street. Sunshine poured into the room. The sky, she remembered, was very blue. She could see the Bank of Japan building across the street. She adjusted her headphones, switched on her terminal, and settled down to another day's work. As always, the com-

munications traffic was mostly military, but it was not very busy today. For the first hour Taeko had very little to do. It was turning out to be a quiet morning. About now, she thought, her sister, Emiko, would be just starting her demolition work.

THE PROCEDURE was followed to the letter. In turn Tibbets, Parsons, and Van Kirk formally identified the city. They had seen it so many times already: in charts, in target maps, in reconnaissance photographs. The shape was unmistakable, the ring of mountains, the dense grid of streets, the branching rivers like the fingers of an outstretched hand, the port and the bay. The only difference was that now it was in color, and in the strong sunlight those colors were especially vivid. The sunlight is the keynote of every crewmember's recollection of that moment: a bright, white, brilliant light dancing off the buildings.

Dimples 91 now dropped back to its assigned position south of the city as *The Great Artiste* and *Enola Gay* raced on toward the initial point—a geographical feature sixteen miles east of the city from which the three-minute bomb run would start. On board the *Artiste*, radio operator Abe Spitzer could see *Enola Gay* a few hundred feet in front, and very slightly to the left. Her silver fuselage flashed in the sun, rising and falling on the air currents. "God," he wrote, "how those minutes dragged. That peculiar feeling which crawls around inside began to tickle a little more than usual." Behind him, the three scientists made last-minute adjustments to their instruments. Microphones were calibrated one final time, transmitters finely tuned, oscilloscopes tweaked, batteries rechecked. There would be no second chance to measure the bomb's blast when it fell. Through the bomb-bay hatch, Luis Alvarez could see the three aluminum canisters with their packed parachutes looped over the bomb hooks. They would drop the instant *Little Boy* was released. Sometimes the scientists called them "bangmeters." The name had never seemed more appropriate.

Two minutes to the initial point. Hills, woods, isolated farmhouses, villages, a ship or two in the bay, then the outer suburbs of the city unfolded beneath *Enola Gay*'s nose. In her waist, assistant engineer Robert Shumard stared through the observer's porthole, searching the sky for enemy fighters on the beam: still none came. Beside him Jake Beser focused all his attention on the enemy radar frequencies. The electric motor sweep drive of his tuning unit hummed as it searched up and down the entire spectrum for any signal that might clash with the bomb's own radar fuses. Every ten seconds Beser kept repeating over the intercom: "The air is clear . . . the air is clear . . ." He prayed the air would stay clear. Otherwise they were all dead. Now he reached down to the wire recorder beside him and switched it on for the first time. Tibbets told the crew their words were being recorded for posterity. "Watch your language," he said.

One minute to the initial point. Jeppson began buckling his parachute to his chest, hooking up his oxygen mask to the emergency oxygen bottle. Van Kirk watched him uneasily: "I remember thinking shit, what does he know that I don't know?" In fact, Jeppson was suddenly worried that the bomb's shockwave might shatter the airplane's windows, instantly depressurizing the hull. Parsons kept his eyes riveted to their bomb console. The thick black cables spewed like umbilical cords from its back, down through the bomb bay and into the bomb, hanging snugly in its dark metal cage. *Little Boy* was coming to life. The two scientists could see it on their console: its batteries charging, its Archie radars warming up, its complex circuitry waking into existence. All the needles checked out perfectly, as if painted on their dials. The green lights glowed without a flicker.

Van Kirk calculated the wind for the last time: southerly at eight knots. The initial point came up through the cockpit window. The clouds had thinned to two-tenths just as *Straight Flush* had reported. A few wisps, nothing more. It was perfect bombing weather. Tibbets gently banked *Enola Gay* onto a new heading, 265 degrees, almost due west, for the start of the bomb run. The sun was now

behind them. The target lay just sixteen miles ahead. Tom Ferebee climbed down into the glass nose, settled himself comfortably on his seat, and pressed his left eye to the M–9B Norden bombsight that Tibbets used to say he handled like a magician. For six and a half hours Ferebee had done nothing but wait for this moment. The time was 0912. In three minutes he would drop the bomb.

THREE KILOMETERS south of Taeko Nakamae's telephone exchange, in the district of Midorimachi, Yoshito Matsushige stepped out of the barbershop run by his wife, pulled on his press armband, and climbed onto his bicycle. A thirty-one-year-old photographer with the *Chugoku Shimbun*, Matsushige spent most of his professional life taking the kind of photographs that filled its front pages every day: an unvarying diet of schoolchildren drying grass or pulling down houses or waving off yet more heroic troops to the front. Occasionally he snapped the odd household fire or road accident. Not much else happened in Hiroshima these days.

He had barely slept last night. Most of it was spent sitting up at the district military headquarters, where he was an accredited photographer. Twice a precautionary alert had sounded, but the American bombers had passed harmlessly overhead as they always did. When *Straight Flush* crossed the skies earlier that morning, Matsushige was on his way home to the barbershop for a quick breakfast and a shave. Like most people he had ignored the sirens.

Over breakfast he had carefully checked his camera—the beautiful 6 x 6 Mamiya that was his pride and joy. He had fallen in love with photography ever since the day his parents had given him a Baby Pearl for his birthday as a boy. They had never imagined it would become his career. He did not linger over his breakfast. As soon as he had finished eating he slung the Mamiya over his back and set off back to work on his bicycle, pedaling north, toward the castle compound.

TWENTY-FIVE
THREE MINUTES BEFORE ZERO

August 6, 9:13 A.M.
On Board *Enola Gay*, 31,000 Feet above Hiroshima

LIKE THE atomic bomb, the Norden bombsight was one of America's most secret weapons. After every mission it was removed from the aircraft under armed guard and locked away in a special vault. It was the most advanced bombsight in the world, an extraordinarily complex mesh of gears, clutches, cogs, gyroscopes, and mechanical computers. Its designers often made outrageous claims about its capabilities but in the right hands it could be lethal. Hands like Tom Ferebee's.

Now those hands gently rotated the drift and displacement knobs just below the eyepiece, searching for the elusive angle of correction to compensate for the wind. If Ferebee got it wrong, the bomb would miss the target. He had less than two minutes to get it right. Through the crosshairs he could see the city unraveling beneath him, a living, breathing maze of streets and houses and rivers. His eyesight was legendary. His skills were honed to perfection: this was his sixty-fourth mission. His right hand brushed the furled metal knobs, one degree here, another degree there, his fin-

gers making tiny, almost imperceptible corrections, the same fingers that in years to come would grow such beautiful roses in his Florida garden. Behind him Van Kirk thought this was the longest damn bomb run he had ever known but he still made time to log the eight ships he could see in the harbor below. Then Ferebee suddenly captured the drift: eight degrees left into the southerly wind. He called out the new heading. Tibbets banked the bomber very slightly, its left wing dipping toward the city. At the same time Ferebee saw the feature through his crosshairs that he had studied in a hundred photographs: a bridge at the point where the Ota River branches into two, shaped like a T. His flat North Carolina drawl burst over the intercom: "I've got the bridge," he said. They were exactly ten miles away.

THEY HAD NOT gone unnoticed. At 9:06 A.M., the Matsunaga lookout in the hills east of Hiroshima sighted and reported two high-flying aircraft heading north. Three minutes later the observer corrected his report: another aircraft was following several miles behind. That was Dimples 91, dropping back to wait for the blast. On board, Bernard Waldman sat in the bombardier's seat beside his Fastax slow-motion camera, his finger resting on the start button.

At 9:13, an observer in Saijo, an air-raid warning post nineteen miles east of Hiroshima, also spotted the three aircraft. They were now tracking west toward the city. The observer immediately cranked the field telephone that connected him to the damp air defense bunker deep below the castle compound. One of the schoolgirls in the communications center took the message:

0913. *Chugoku Military District Information. Three large enemy planes spotted, headed west from Saijo. Top alert.*

Carefully she wrote it all down. Then she picked up the telephone linking directly to Hiroshima's radio station and began dictating slowly into the receiver.

YOSHITO MATSUSHIGE had not gone very far on his bicycle before he realized he needed to go to the toilet. The call had come upon him very suddenly. It was a nuisance. For a moment he debated whether to continue to the military headquarters or to return home. He was only a few hundred meters from the barbershop. Reluctantly he turned the front wheel around and pushed off back down the street, weaving in and out of the rush-hour traffic.

NINETY SECONDS before release, Tibbets slid back his seat, took his hands off the yoke, and handed control of the bomber to Ferebee. "It's all yours," he said. Now Ferebee flew the bomber through the automatic pilot on the bombsight. Locked in the center of his crosshairs was the approaching bridge. Tibbets stared out of his window, just above the letters of his mother's name. The city looked very peaceful. A soft, filmy haze now lay over it as people heated up their charcoal braziers for breakfast. But he could not see any people from six miles up. He could see only a target.

Fifty seconds to release. Tibbets warned the crew to remember their goggles. In the tail, Caron fixed the strap over his head in readiness. He picked up the K-20 camera by its pistol grip and checked the settings. The world unrolled backward through his window: the eastern suburbs over which they had just traveled, a few floating puffs of stratocumulus way below, then the mountains and the limitless sky. Still no sign of fighters. *The Great Artiste* hovered just off to the left. The tinted photographs of Kay and Judy dangled from their chain. His ashtray was full.

Thirty seconds. Everything began coming together. Duzenbury scanning the engine instruments for the slightest deviation. Beser still calling the air is clear from his station by the toilet. Van Kirk tightening his harness in anticipation of the violent turn. Tibbets still fascinated by the view, the white, gleaming, people-less buildings sliding below. Parsons with his graphite-stained, shredded hands watching the steady green lights, Jeppson kneeling on a

cushion beside him. Nelson observing them both from his radio operator's chair; ever afterward he would remember the two men staring "as if they were willing all those lights to remain as they were." Shumard and Stiborik lowering their goggles. A few bumps as the bomber hit the thermals in the warming air. Lewis worrying about the turbulence with the bomb back there. Ferebee bent in concentration over the bombsight, and the T-shaped bridge rapidly approaching—the best aiming point in the whole damn war. Then the pneumatically operated bomb bay doors snapped open, flooding the bomb in the bright morning sunlight.

The time was 0915:02. Ferebee flicked a switch. A low-pitched warning tone howled across the airwaves. Everyone heard it over his headphones: on *Enola Gay,* on the *Artiste* and Dimples 91, even on *Straight Flush,* 200 miles to the south, returning home to Tinian. They all knew what it meant. In exactly fifteen seconds *Little Boy* would drop into the freezing skies above Hiroshima. Lewis scrawled a note in his log. "There will be a short intermission," he wrote, "while we bomb our target."

ONE THOUSAND meters from the Aioi Bridge, inside Hiroshima's radio station, Masanobu Furuta was just about to sit down to breakfast. A bowl of rice simmered on the charcoal heater. The air raid announcer had not eaten anything since yesterday. He called out of the window to one of his colleagues, mending a bicycle in the courtyard. Breakfast, he shouted, was ready. "Thanks," said his colleague, "I'll be right there."

At that moment the old school bell in the radio station's alert room began ringing. Furuta immediately turned away from the window. He hurried down a corridor. An engineer passed him the message dictated by the schoolgirl from the air defense bunker. Furuta glanced at it. Then he pushed open the door to the studio while the bell clanged above him.

TWENTY-SIX
FORTY-FIVE SECONDS
BEFORE ZERO

August 6, 9:15 A.M.
Hesaka Village, Six Kilometers North of Hiroshima

As SOON AS he woke up, Dr. Shuntaro Hida knew he had overslept. He could hear the old farmer drawing water from the well outside. The six-year-old girl was still sleeping peacefully next to him. Hida decided to give her another sedative injection. With her bad heart the child needed as much rest as possible. He reached over for his bag and took out a clean syringe. At that moment he was sitting on the front porch of the farmhouse. He had a perfect view of the city bathed in sunshine below. He carefully cut the neck of an ampoule with a pair of scissors. Then something flashed on the edge of his vision. He looked up. A tiny silver speck was moving slowly across the sky, so slowly it looked as if it had stopped there. An American bomber. It was, he remembered, extraordinarily high.

ABRUPTLY the warning tone stopped. The single shackle loosed its clasp on the 9,700-pound deadweight. It tumbled out of the bomb

246

bay into the subzero air. Ferebee could see it behind him, wobbling slightly before beginning its fall, nose down, hurtling toward the city six miles below. "It's clear," he called. Van Kirk noted the time: 0915:15. Freed of its cargo, the bomber instantly shot several hundred feet upward. Tibbets disengaged the autopilot, grabbed the yoke, and did exactly what he had trained so long to do: he slammed the bomber straight into the right-hand diving turn, sixty degrees of bank, the massive bomber almost standing on its wingtip, the g-forces pinning every man to his seat. The city pivoted violently beneath, every bolt and rivet shaking and juddering as the B-29 sought to outrun the coming shockwave. "Now it's in the lap of the gods," Parsons thought. Jeppson threw his goggles over his eyes and started counting backward. Forty-four seconds to detonation.

Behind them *The Great Artiste* dropped its three aluminum blast-gauge canisters, each one spilling out its sixteen-foot-diameter parachutes as soon as it was clear of the bomb bay. Immediately Chuck Sweeney swung the plane into the same hard-diving turn as *Enola Gay*—this time to the left. The two aircraft streaked away to the south, engines screaming at full throttle, their airspeed touching 350 miles per hour. Tibbets chucked his goggles on the floor: he could not see the instrument panel. Caron hung on in the back. The bomber was really turning now, hanging on the edge of a high-speed aerodynamic stall. Any tighter and the wings would snap off.

Jeppson kept counting. Thirty-eight seconds to go. *Little Boy* plummeted through the thickening atmosphere. Its eight on-board spring-wound clocks ticked down toward the end of the first stage of the fusing relay. The rushing air battered and buffeted Old Faithful's tungsten-steel casing with its chalked inscription to the emperor— but the casing held. Hiroshima climbed to meet it. Streetcars trundled over the T-shaped bridge. The willow trees rustled in the late summer breeze. Pedestrians hurried to work. "The target," Truman had written in his diary, "will be a purely military one": but this target had an average of 26,000 people packed inside every square mile, and the bomb was aimed directly at its heart.

Twenty-nine seconds to detonation. The firing signal automatically passed to the second step in the fusing relay, the barometric pressure switch designed to close at 7,000 feet. High above, up in the bright blue sky, the silver blast-gauge canisters swayed gently beneath their parachutes, slowly descending over the city. Thousands on the ground saw them. Toshiaki Tanaka was one, watching from the window of his barrack in Ujina. He wondered what the parachutes could be. Others clapped and cheered. They thought the high-flying American bomber had just been shot down.

Seventeen seconds. In the central telephone exchange, 800 meters from the Aioi Bridge, Taeko Nakamae concentrated on her switchboard. Somewhere nearby, her twelve-year-old sister, Emiko, was busy helping her classmates clear the firebreaks that would make Hiroshima safe from air attack. Sunao Tsuboi was crossing the street toward the engineering institute, wrapped up in thoughts about Reiko. Yoshito Matsushige was sitting on the toilet in his barbershop. Isao Wada was digging holes for his suicide boats across the bay. On the sunny porch of his farmhouse, Dr. Shuntaro Hida was rolling up the little girl's sleeve.

Nine seconds. The bomb tore through 7,000 feet. The firing signal instantly switched to the Archie radars—the final stage in the fusing relay. The Japanese-invented Yagi antennas began bouncing their signals off the rapidly approaching ground. *Enola Gay* and *The Great Artiste* were still hurtling away, the gap between them and the city widening at almost seven miles a minute. Caron thought this was the most thrilling ride of his life. On board the *Artiste* the three scientists hunched over their ammeters, their eyes glued to the zero-centered needles, waiting for them to jump. Nineteen miles to the south, George Marquardt brought Dimples 91 around until Bernard Waldman's ultra-slow-motion Fastax camera was pointing directly at Hiroshima.

Six seconds. The three billowing parachutes floated harmlessly in the summer skies. *Little Boy* was shrieking now, the baffle plates in its tail creating its alarming signature tune: the earsplitting, rat-

tling, roaring howl as it accelerated toward its terminal velocity of 1,138 feet per second, well over 700 miles per hour. For many, this would be the last sound they ever heard.

Three seconds. Jeppson was still counting. Dr. Hida pushed the air out of his syringe and placed the needle against the little girl's arm. The last relay switch closed. The firing signal jumped across the three red arming plugs directly toward the breech primers, detonating Deak Parsons's carefully placed cordite charges, instantly propelling the uranium 235 projectile straight down the gun's six-foot barrel toward its uranium target. The projectile slammed into the target at the speed of sound, the two joining in a single unholy supercritical embrace, holding together just long enough for billions upon billions of splitting neutrons to begin releasing phenomenal amounts of energy in an ever-expanding, uncontrolled, runaway chain reaction.

In the radio studio, Masanobu Furuta pressed the black buzzer to interrupt the normal program, pushed the button on his stopwatch, and began speaking with "the voice that calmed everyone's anxieties" into the microphone: "Chugoku District Army announcement: three large enemy planes proceeding . . ." He never got any further. The entire station suddenly tilted as he was hurled into the air. Exactly 1,903 feet above Dr. Kaoru Shima's clinic in Saiku Street, 200 meters from the Aioi Bridge, *Little Boy* exploded. Before the sirens even had a chance to sound, the sky fell in over Hiroshima.

ACT IV

IMPACT

THE FIRST TWENTY-FOUR HOURS
AUGUST 6–7, 1945

I can assure you of one thing. Nobody in my airplane ever had the least emotional problem or lost a night's sleep over the Hiroshima mission.

COLONEL PAUL TIBBETS,
captain of the *Enola Gay,* interviewed in 1985

This is a human being?
Look how the atom bomb has changed it.
All men and women take one shape.
Flesh swells fearfully.
The voice that trickles from swollen lips
On the festering, charred-black face
Whispers the thin words.
Please help me.
This, this is a human being.
This is the face of a human being.

TAMIKI HARA,
Hiroshima survivor, born 1905, committed suicide 1951

This is the greatest thing in history.

PRESIDENT HARRY TRUMAN,
on being given the news of the Hiroshima bomb, August 6, 1945

TWENTY-SEVEN
ZERO PLUS ONE MINUTE

August 6, 9:17 A.M.
Hiroshima

TOM FEREBEE had missed but it made little difference. The impact was at once immediate and catastrophic. In the first billionth of a second, the temperature at the burst point reached 60 million degrees centigrade, 10,000 times hotter than the sun's surface, the heat almost instantaneously expanding outward across the city in a visible, searing, alien, unimaginably brilliant flash of light. Afterward they gave the flash a name—*pika,* or lightning, the opening act in a terrifying drama—but for many who survived, it was also astonishingly beautiful: a swirling wave of myriad colors, of electrically vivid greens and blues and reds and golds that burned into the retina and seemed to last forever. These witnesses were fortunate: before the flash even ended, thousands of other human beings were already dead, burned beyond recognition by the extreme primal heat, instantly carbonized into little charred smoking bundles where they stood or sat or slept or walked, littering what was left of Hiroshima's streets.

Within a one-kilometer radius of the hypocenter, the thermal energy contained in that single moment's flash was intense enough

to evaporate internal organs, literally boiling off intestines in less than a fraction of a second. Birds ignited in midair, telegraph poles, trees, clothing, thatched roofs, wooden buildings, household pets, and entire streetcars spontaneously combusted, steel-framed buildings liquefied like wax, rubble and bone fused together in a single amorphous mass. Watches and clocks suddenly stopped, their hands permanently burned into their faces, forever recording the precise moment of detonation. Hundreds of fires sprang up simultaneously all across the city, overwhelming the firebreaks so carefully prepared in the months before. Accidents of clothing determined how and whether people died. Black or dark-colored garments absorbed the heat, white or lighter colors reflected it. In some cases individuals were so completely incinerated that nothing remained but their shadows. One man was sitting on the steps outside a bank 260 meters from the hypocenter when the fireball struck. All that was ever left of him was the imprint of his pose, scorched into the stone like a photograph. The heat was visceral and horrifyingly destructive, as if the sun had suddenly descended to earth. And it all happened in the first three seconds.

Within those first seconds, too, came something new in the history of warfare: the invisible flood of gamma rays and neutrons released in the bomb's chain reaction, penetrating exposed skin, damaging and destroying cells, altering the very structure of living tissues. More than 200 radioactive isotopes spewed out of the bomb's core and into the dust cloud, forever identifying Hiroshima as the place destroyed by an altogether *different* kind of weapon. Tens of thousands would die as a result—some now, some in the next few days, others in the months and years to come. The onset of illness and death depended on a number of different factors, most obviously distance from the hypocenter, but within 500 meters the effect was almost universally lethal. American scientists would very shortly have a name for this zone: they called it the *scare radius.*

After the flash came the shockwave. It ripped out from the hypocenter at 7,200 miles per hour—10,000 feet *a second*—rapidly

dropping to the speed of sound, a wall of high pressure that smashed through doors, windows, houses, offices, temples, hospitals, shops, stalls, restaurants, factories, buses, schools, animals, and people. Oppenheimer had already calculated the optimum detonation height for the maximum demolition of light-sized structures in the target area—1,850 feet—but *Little Boy's* performance exceeded all his expectations. The shockwave slammed through the city with an initial force of nearly *seven tons* per square meter, destroying almost 60,000 buildings in its wake, among them the wooden teahouses, the trees, the flowers, the ornamental bridges, and the turtles in the Shukkeien Garden where Sunao Tsuboi and Reiko had held hands less than twelve hours earlier.

It also killed at least another 50,000 people. Some of them were crushed by the blast itself, others by falling debris, beams, bricks, caved-in ceilings, or flying splinters of glass. Even blades of grass were driven into flesh. As it smashed through the city, the shockwave sucked almost all the air out behind it, leaving an area of extreme under-pressure in its wake: in some cases people's eyes or viscera were simply vacuumed out of their bodies. Within 800 meters of the hypocenter every single building was flattened, blown apart or demolished, apart from a few ferroconcrete, earthquake-proof structures, and even these were rendered uninhabitable. There was virtually no protection from the blast. The very flatness of the city center helped seal its destruction. The lack of any warning also contributed: nobody was in the shelters when the bomb exploded. The whole city was taken by surprise. Only freakish accidents of fate ensured survival. Eizo Nomura was one such, a clerk in the Fuel Distribution and Control Cooperative, a concrete building 100 meters from the hypocenter. Moments before the explosion, he had gone down into the basement to retrieve a document his chief had forgotten. Quite possibly he was the closest man to the hypocenter to survive.

Flash and blast, fire and destruction: these are the keynotes of the bomb's impact. Perhaps 80,000 people died in those very first

seconds; the exact figure will never be known. For the survivors the moment is seared into the memory. Sunao Tsuboi was 1,200 meters from the hypocenter near the city hall when he saw the flash—for him an intense reddish-silver light that ripped across his field of vision before the blast hurled him thirty feet across the street. Yoshito Matsushige saw it sitting half-naked on his toilet 2,700 meters from the hypocenter, a brilliant bright white, as if a magnesium flare had suddenly blazed up directly in front of his eyes. He could feel hundreds of needles stabbing his body before the blast punched holes in the walls of his house and tossed him to the ground. His first reaction was that it must be an earthquake. In her telephone exchange, Taeko Nakamae—just 550 meters from the hypocenter—felt rather than saw the flash as a moment when the entire room seemed to melt. Within seconds she heard a sound like a tremendous crash of thunder, the same doomsday roar that had so terrified the Trinity scientists hunkering safely in their bunkers. The Japanese gave this roar a name, too—the *don*, or thunderclap—so that the whole sensation of the bomb in its first moments is summed up by two words, *pika-don*, lightning and thunder. Like thousands of others across the city, Taeko's last thought before losing consciousness was that the building had just received a direct hit.

Six kilometers from the hypocenter, the *pika* struck Dr. Shuntaro Hida directly in the face, boring into his eyeballs with brilliant intensity. A wave of violent heat blew against him. He remembered saying, *"Ah!"* but he could never remember if he actually injected the six-year-old girl. He crawled out to the porch. The sky was still very blue. The trees did not move. Not a leaf stirred. The whole world hung in silence. For a moment he thought he was dreaming. Then he turned his eyes toward Hiroshima.

A giant red ring encircled the city, expanding at terrific speed, spreading up into the hills, over the rice fields, the woods, the farms and houses, rushing like a tidal wave toward him. Suddenly the roof tiles on the village houses were flying into the air like a shower of leaves, the shutters and screens blew up around him, and then the

ceiling disappeared. The blast threw him backward through two rooms until he smashed against the family altar. The mud and dust and what was left of the roof tumbled down over his body. Somewhere nearby the little girl was also lying under the rubble.

The roof crashed in over Toshiaki Tanaka, too, as he sat in an army classroom south of the city in the port of Ujina. Dazed and half in shock, he picked himself off the floor and peered out through the yellow choking dust. The thick walls had shielded him from the worst of the blast. He was lucky. His family were less so. The home above the liquor store where Toshiaki had eaten his wife's delicious egg rolls less than twenty-four hours earlier was just eighty meters from the hypocenter, deep within the "scare center": and his wife and child were inside at the moment of impact.

BOB CARON saw it first. From his turret at the rear of the plane he had a ringside view looking directly back at the city as they dove away. One moment he was peering through his welder's goggles, barely able to see the sun through the darkness; the next he was blinded by a terrific flash. At that moment, *Enola Gay* was eleven and a half miles slant range from the bomb burst. The dazzling light filled the plane. It seemed to come from every direction. Tom Ferebee's back was to the explosion but it "felt like an enormous flashbulb going off" in his face. For several seconds every part of the plane was bathed in the strange, unearthly radiance. Tibbets experienced a peculiar tingling sensation in his teeth—and the distinct taste of lead on his tongue. His fillings, he later learned, were interacting with the bomb's radiation. Nobody spoke. Then Caron suddenly yelled over the intercom, an incoherent animal shout of warning. Through his goggles he watched in astonishment as something that looked like the ring of a distant planet detached itself and came hurtling toward him. Before he could utter another word, the shockwave had caught up with them.

It smashed against the fuselage, tossing the big bomber up in the

air like a scrap of paper. Somebody cried, "*Flak!*" and for Dutch Van Kirk, a combat-hardened veteran, that is exactly what it felt like: "a very, very, very close" antiaircraft shell burst. "My God, the bastards are shooting at us!" was his first thought. To Bob Lewis it was as if a giant had slammed the plane with a telegraph pole. Jake Beser was thrown off his seat. A voice shouted over the intercom in panic. The plane bucked violently under the impact. Tibbets gripped the controls, fighting to keep it under control. On board *The Great Artiste,* the three scientist observers saw the needles on their meters swing sharply all the way across to the right. A pulse on their oscilloscope screens registered the shock as it passed—the green N-shaped wave describing the force that moments before had obliterated a city. Later that force was measured at approximately fifteen kilotons, the equivalent of 15,000 tons of high explosive: more than five times the total tonnage of bombs that destroyed Dresden in February 1945. To achieve it had required slightly less than two pounds of fissioning uranium 235.

Caron yelled again: "Holy Moses, here it comes!" A second shockwave was rising up toward them, a ground reflection of the first, the condensing moisture on its front making it visible as a shimmering ring, just as Dr. Shuntaro Hida had seen it from his farmhouse porch. The impact pitched against the plane—as Bob Lewis remembered it, like a baseball bat hitting a trash can—and then suddenly *Enola Gay* was racing into the clear. A few miles away, the *Artiste* also broke clear. Both planes had survived the shockwave. Cautiously, Tibbets leveled out at 29,000 feet.

At this point, the bomber was still traveling directly away from the city. Only Bob Caron in the tail could see it. He had removed his goggles and was staring through his windscreen in amazement. Boiling up from the ground was a spectacular and terrifying mushroom-shaped cloud, at least a mile wide, with a fiery blood-red core. It was climbing and expanding at an astonishing rate, a monstrous, angry, purple-gray mass of turbulence punching up into the skies at almost ten miles a minute. Beneath it, Hiroshima had completely disappeared. Everything down there was burning. Thick black

smoke covered the entire city, rolling out into the surrounding foothills and into the valleys like lava spilling from a volcano. Fires were springing up everywhere, "like flames," Caron said later, "shooting out of a bed of coals." It was an awesome, terrible sight. He struggled to describe it over the intercom—and for the wire recorder. "Holy Moses, what a mess!" he cried. Tibbets told him to count the fires. "I said, 'Count them'? Hell, I gave up when there were about fifteen, they were coming too fast to count."

He grabbed his K-20 camera and started shooting. The gun sight got in the way. He asked Tibbets to turn the plane five degrees, pointing the lens instead through the escape-hatch window to his right. One after another he snapped images of the mushroom cloud—seven of them, each frozen black-and-white frame capturing those first instants of Hiroshima's destruction. They would stay in his memory forever. "I can still see it," he said years later, "that mushroom and that turbulent mass." It was "a peep into hell."

Tibbets turned the bomber broadside to the dying city. Everybody rushed to the windows. The huge cloud had already reached 25,000 feet—five miles up—and was still rapidly climbing. For a moment nobody spoke. Then they were all shouting at once. "My God," several of the crew remember Bob Lewis saying, "look at that sonofabitch go!" He kept pounding Tibbets's shoulder and yelling: "Look at that! Look at that! Look at that!" Van Kirk stared down at the city he had observed through his window less than three minutes before: all he could see now was something resembling a huge cauldron of boiling black tar. The whole area was smothered in smoke, dust, debris, "anything and everything kicked up by the bomb." The war had to be over, he thought. "Now I could go home." Morris Jeppson's first instinct was relief that the bomb had worked. The red arming plugs had functioned perfectly. Now he seemed visibly shaken by what he saw. Even Deak Parsons— normally sober and collected—appeared awestruck: this was far more spectacular than the Trinity test he had witnessed from the air. It looked like a meteor had struck the city. The bomb had performed flawlessly. Its victims were less his concern. "I knew what the

Japs were in for," he said afterward, "but I felt no particular emotion about it." Then Tibbets's voice came over the intercom. "Fellows," he said, "you have just dropped the first atomic bomb in history."

For three minutes he kept his course southeast of the city. The mushroom raced past their altitude, sparkling with vivid flashes of fire, seething upward to the edge of the stratosphere "like something," said Tibbets, "terribly alive." Nelson broke radio silence to rush an initial strike report back to Tinian. It was brief and unexpansive: the primary target, he transmitted, had been bombed visually with good results, one-tenth cloud cover, no fighter opposition, and no flak. On board the *Artiste* the whole spectacle unraveled in a kind of awed silence. Nothing like this existed outside science fiction. "A strange and unbelievable sight," wrote Abe Spitzer, the radio operator. "This was Buck Rogers come to earth. Fantastic—but real!" Behind him, Harold Agnew pressed the 16mm camera he had borrowed from the Tech Area laboratory against the window, his hands shaking as he tried to film the cloud now reaching 45,000 feet, three miles above them. Its colors kept changing: blue, yellow, green, red, salmon-pink. "It had every color in the world up there," said Don Albury, the *Artiste*'s copilot, "it was beautiful." But Robert Shumard, *Enola Gay*'s assistant engineer, saw no beauty in it. "There was nothing but death in that cloud," he said. "All those Japanese souls ascending to Heaven."

Now it threatened to engulf them too. Caron uttered a warning over the intercom. "Better turn off, Colonel. That mushroom seems to be coming downwind at us." Tibbets abruptly swung *Enola Gay* away, southeast, back toward Shikoku and home. The other two aircraft followed. Parsons took his code sheet over to Nelson at the radio. Together they prepared a more detailed report to send back to Tinian. The dying city slipped behind. A whole world had suddenly vanished into a radioactive ball of dust. Lewis stared back at it. Then he picked up his pencil and turned to his log. "My God," he wrote, "what have we done? If I live for a hundred years, I will never quite get these few minutes out of my mind."

FOR THE MEN waiting on Tinian, it had been a long night. "The hours," wrote Bill Laurence, the *New York Times* reporter, "dragged along on feet of lead." Along with General Farrell and a group of project scientists, he spent those hours in the 509th communications center, waiting for news. The air force had a name for this activity. It was called "sweating out the mission." A few of the scientists tried to snatch some sleep. Others kept themselves awake with black coffee. The questions burned in everyone's mind. Had the bomb worked? Had they been shot down? Had Parsons even succeeded in arming the bomb—without blowing himself and *Enola Gay* out of the sky? By morning the shack was crowded with tired, drawn, tense faces. The minutes ticked down toward the estimated time over target: 0915. Everybody knew Tibbets was punctilious, a perfectionist who would hit his marks exactly. If no message arrived soon, something must have gone very wrong.

At 0919 Nelson's first, very brief, strike report came over the receiver. The relief was overwhelming. Everybody shook hands. A few people cheered. Exactly fourteen minutes later, at 0933, Parsons's longer message arrived. Farrell scanned the once-only code he had worked out with Parsons and Norman Ramsey twenty-four hours earlier. His finger ran down the twenty-eight separate lines describing every conceivable scenario for the bomb. Then he wrote the decode down:

RESULTS CLEAR CUT SUCCESSFUL IN ALL RESPECTS PERIOD VISIBLE EFFECTS GREATER THAN TRINITY TEST PERIOD TARGET HIROSHIMA PERIOD CONDITIONS NORMAL IN AIRPLANE FOLLOWING DELIVERY PROCEEDING TO BASE STOP

It had happened. Farrell whooped with glee. Some of the men clapped one another on the back. "We were transported into the air ourselves," wrote Laurence, "flying back with Colonel Tibbets and his gallant crew." The whole room dissolved into excited discussion.

Farrell immediately fired off a cable to General Groves in Washington. At that point Farrell had no clue that messages were being held up in Manila. "Congratulations from all," he wrote. "Recommend you go all out with release program." The news embargo on America's most secret story was shortly to be lifted. In the next few hours the world would know what had happened over Hiroshima. So would the rest of Japan. Meanwhile, General Farrell and his exhausted colleagues did what they had been desperate to do for a long time. They went to bed.

TWENTY-EIGHT
ZERO PLUS FIFTEEN MINUTES

August 6, Morning
Hesaka Village,
Six Kilometers North of Hiroshima

THE FIRST thing Dr. Shuntaro Hida saw when he groped through
the wreckage was the little girl's blanket. He crawled toward it, push-
ing the fallen beams aside, wiping the dirt and dust from his eyes. His
mouth was full of earth. He lifted up the blanket. The girl's hand was
sticking out of the mud. Beside it were the remnants of her straw bed.
She had been sleeping when the bomb fell. He took her hand and
began pulling her out of the earth with all his strength. Pain swept
through his body, but he did not allow himself to think about it. He
carried the child to the porch, laid her gently on the ground, and
opened her nightdress. His stethoscope was gone, lost somewhere in
that smashed room. He placed his head on her chest. The mud stuck
to his ears but he could feel her heart beating. She was alive.

Outside the villagers were calling to each other. Their cries
sounded lost and remote on the air. A strange yellow haze filtered
through the porch. The sunshine that had filled the room a few mo-
ments ago had disappeared. Hida got to his feet and stepped out.
The sky was almost black, the dim outline of the sun moving swiftly

through the haze. He could see the villagers standing in the road pointing and shouting. He looked over in that direction. A sudden chill ran through him. The most tremendous cloud he had ever seen was swelling up into the sky over Hiroshima.

Unconsciously he dropped to his knees. He stared transfixed at the cloud. It seemed to fill the whole horizon. It was growing with terrific violence and climbing to an enormous height. He feared it would break through the sky itself. It had that shape that afterward gave it its name: *kinoko gumo*, the mushroom cloud. Of Hiroshima there was no sign at all. The entire city seemed to be trampled under the terrible cloud. The dust rolled up into the hills toward the village like a fog. An ominous wind began to stir the leaves. Hida continued to stare at the spectacle. The little girl lay beside him, breathing softly. Then he saw the farmer approaching. Something in his expression, a kind of animal terror, added instantly to Hida's fear. The old man was unhurt—he had been protected from the blast by a thick wall—but his legs suddenly gave way beneath him. He sank to the ground beside his granddaughter. Hida quickly reassured him that the child was safe. He asked if he could borrow his bicycle. He was a doctor. He had to get down to the city.

He cycled fast, toward the cloud. The countryside was deserted. Halfway down the hill—three kilometers from the city—he passed an *ishi-jizo*, a small stone Buddhist statue. The dusty white road stretched ahead, then turned sharply to the left. He followed it. The mushroom cloud loomed over him, blotting out the sky. He was moving very rapidly now, his wheels kicking up the white dust. Just as he turned the corner, an object sprang out into the road. He braked suddenly. The bicycle flew away from him and he was thrown off the saddle face-first into a bush. Despite the shock, he quickly picked himself off the ground. He looked up. The object he had nearly collided with was coming toward him. He held his breath as it came closer.

He could not tell what it was. It did not look like a human being. It looked monstrous. Every part of its body was black, its arms, its

head, its legs, its grotesquely swollen face. Its eyes protruded horribly like golf balls. It had no nose or hair. Its mouth gaped open like a huge hole. Its black lips were half the size of its face. It was naked but Hida did not know if it was a man or a woman. Its hands were stretched out with the palms turned down. Black rags hung from its arms and torso. For a moment Hida thought these were pieces of burned clothing. Then he realized they were burned flesh.

The figure tottered toward him. Hida began to back away in shock. The man's eyes—if it was a man—seemed to find him. He lunged out suddenly, as if using up the very last of his strength. Then he stumbled over the fallen bicycle and collapsed to the ground. His body convulsed, the limbs jerking briefly. He did not move after that.

Hida went up to him. He kept telling himself he was a doctor. He had to be strong. He knelt beside the man but he did not know where to put his hands. He slowly reached out and touched the twisted, charred body, searching for a pulse. But the skin was too burned. He did not know where to look. Droplets of black blood dripped off the man's flesh, seeping into the dust. Shards of glass pierced his back. Hida could not find a pulse anywhere.

For a moment, perhaps for several minutes, Hida did not move. He said a prayer beside the body. He dragged the bicycle away. Then he hauled himself to his feet and looked back down the road in the direction of Hiroshima.

Hundreds of shapes were coming up the hill toward him. Some of them were staggering, others were crawling, a few seemed to lean against each other for support. They all looked like the man lying at his feet. They had the same huge black heads, the same swollen eyes, the same gaping mouths, the same ragged strips of charred flesh. More and more of them streamed up the hill. Hida stared in horror. He wanted to run away but his legs would not move. "My God," he thought, "how many are there?" They seemed to stretch all the way back down the road, a teeming procession of the living dead fleeing the burning city. And always behind them was that huge, rolling, violent cloud mushrooming up into the sky.

TAEKO NAKAMAE did not know how long she remained unconscious in the telephone exchange. From somewhere very distant she heard the voice of her teacher, Mrs. Wakita. She was shouting, telling everybody to get up, to be strong, to remember they were student soldiers. Taeko thought she must be dreaming. She opened her eyes but the room was in darkness. Her legs were pinned under something and she could not move. She could hear some of her classmates crying out in the dark. One of them was calling over and over for her mother. Mrs. Wakita kept shouting at them to get up. Then she came over to Taeko and pulled her free. Together they felt their way past the wreckage of upturned desks and chairs toward the corridor. The room was smoldering. There were bodies of schoolgirls in the rubble.

It was impossible to reach the staircase. Smoke filled the corridor. Taeko turned back to one of the windows. She could see the Bank of Japan burning furiously across the street. Flames shot up from the telegraph poles. Across to the east she could see Hijiyama, a 221-foot-high wooded rise in the city: it seemed to be the only place free of the fire. The window was on the first floor but she climbed out onto the ledge and jumped, barefoot, into the street below. Then she started running.

She could not see out of her left eye. Blood flowed from her arm but she felt no pain. She struck out toward Hijiyama, running as fast as possible, clambering over the burning telegraph poles and smoking debris. The whole city seemed to be on fire. The streets were filled with the same grotesque shapes Dr. Shuntaro Hida had seen coming up the hill: the blackened, swollen, almost-dead, their arms stretched out before them. The bomb had created a terrible equality in the moment of its impact. There was nothing to distinguish one individual from another, the young from the old, a man from a woman. They moved slowly and silently, shuffling through the smoke as if under water, ignoring Taeko as she ran past. She felt like the only living person in the world.

For a moment she stopped. The heat scorched her lungs, and she

could hardly breathe. Beside the road she saw a boy of about ten bending over his little sister. "Mako, Mako," he kept saying, "Mako, Mako, are you dead? Please don't die." The girl did not respond. The boy began crying, calling his sister's name over and over. He picked up her limp body and cradled her in his arms. Nobody paid them any attention. Even Taeko moved on. The flames were closing in. She had to keep running.

YOSHITO MATSUSHIGE stumbled out of the toilet into an unrecognizable world. The street had been pulverized. Opposite his barbershop, the four-story fire department building had completely collapsed. Somehow the barbershop was still standing. All the windows had blown in but the roof was intact. The floor was smothered in broken glass and plaster. One of the walls had partly collapsed into mounds of rubble but the chairs and sinks were undamaged. Miraculously his wife Sumie, several months pregnant, was also unscratched. She had been trying to lift a mirror off the wall when the bomb fell. Even the mirror had survived.

In a daze the two of them stood in the middle of the floor. The shock had been so sudden and overwhelming: they were both beyond fear. Then Yoshito began searching in the rubble for his camera and his uniform. His immediate instinct was to get to the Chugoku military headquarters as quickly as possible. He had to find out what had happened. His shirt was covered in glass splinters but he threw it on. He pulled his camera from the dirt. The lens needed wiping but it seemed to be in one piece. He grabbed two rolls of black-and-white film, 100 ASA, twenty-four exposures in total. Then he went outside.

His bicycle lay smashed on the ground. He began walking. His only thought now was to get to his headquarters. The need pushed him on, a single purpose that drove him forward. The streets he had been cycling down a few minutes earlier had altered beyond recognition. Houses, offices, shops, an entire geography of the familiar had almost disappeared. In places it was barely possible to

follow the road at all. He walked northward, toward the military headquarters. The farther he went the more bodies he saw. The black bundles littered the sides of the roads. People passed him like ghosts, moving with the same numbed, aimless stupor Taeko Nakamae and Dr. Hida had witnessed. He kept walking, continuing through the shattered streets, carrying his camera and his rolls of film. He did not know it yet but he was moving directly toward the epicenter.

SUNAO TSUBOI was already much closer to the epicenter, just over a kilometer away, when *Little Boy* blasted him into unconsciousness. When he came around he was naked. His clothes had been blown or burned off him. He noticed—with a curious kind of detachment— that his hands were very black. Black-red blood dripped down the left side of his body. His skin was peeling. A strange black tubular shape protruded in front of his face. It took him a little time to realize it was his own lips. He coughed and choked. Thick smoke curled around him. He could barely see. The part of his brain that was still working told him a bomb must have fallen very close by. He must be still inside its cloud.

He got to his feet and began to run. The cloud did not disappear. People began emerging from the shadows, branding the unforgettable images on his mind, just as they did for Taeko Nakamae, for Dr. Shuntaro Hida, for Yoshito Matsushige, for everyone who survived. Language stumbles beside the horrors encountered in these first minutes after the bomb exploded. The deadweight of adjectives piles up like so many corpses in the streets. The experiences are so similar and yet so individual, so general and yet so desperately personal. Sunao Tsuboi never forgot them: the woman of about thirty holding in her intestines with both hands as she was running away; the schoolgirl with her right eyeball torn out of its socket and hanging down her cheek; the old man with a piece of wood—probably from a window frame—splintering his abdomen, a part of his lung visibly expanding and contracting as he struggled

to breathe. Above all there was the sense that he could do nothing, that these people were beyond any help he or anybody could give. There was also fear: somewhere out there was Reiko.

He ran and walked and crawled through the debris and the fires. He was weak and the pain from his burns was increasing. He did not know where he was going. His mind was already blurring by the time he found the wooden board on the wall. There he wrote his last message to her, scratching out each letter with a piece of chalk from the rubble. "Sunao Tsuboi is alive," he wrote. "I want to see you again."

IN THAT FIRST half hour after the bomb fell, Hiroshima's identity as a city effectively ceased to exist. The bomb overwhelmed everything and everyone in a single devastating, unparalleled blow. Deak Parsons was right: it was as if a meteor had struck the earth. The members of the United States Strategic Bombing Survey—the teams that went into Hiroshima immediately after the war—dutifully compiled the figures: 109,000 buildings entirely destroyed; 70,000 to 80,000 people killed, an equal number injured (almost certainly an underestimate; a number of historians later revised the figure to 140,000 killed, some dying immediately, others within the next few months from radiation poisoning and other injuries). Thirteen square miles totally reduced to ashes. Ninety percent of the city's doctors dead or injured; 1,654 out of 1,780 registered nurses also dead or injured. Forty-two out of forty-five civilian hospitals destroyed. Eighty percent of the telephone service destroyed, a third of all its employees killed. Sixty-five percent of all streetcars destroyed—100 percent within one and a half kilometers of the hypocenter. Only sixteen pieces of firefighting equipment operational in the entire city—three of these borrowed. Eighty percent of firemen killed or critically injured. Seventy thousand separate pipe breaks in the city, reducing the water pressure in some places to zero, making it impossible for the very few firemen left to extinguish the thousands of fires. The list goes on and on, the crushing weight of num-

bers anatomizing a city's death. "As might be expected," noted the American observers coolly, "the primary reaction to the bomb was fear—uncontrolled terror." That, of course, was part of the point.

ON BOARD *Enola Gay* the floodgates had opened. Everybody began asking the questions they had been conditioned for almost a year not to ask. The intercom was alive with excited chatter. Tibbets and Parsons explained as best they could. The word *atomic* was bandied about with sudden freedom. Lewis believed the Japanese would surely "throw in the sponge" before they even landed: no nation could fight on after a bomb like that. Ferebee wondered— perhaps not uncharacteristically—whether the bomb's radioactivity would make them all sterile. Parsons assured him it would not. As they crossed the coast, the Japanese antiaircraft batteries fired a few rounds at them. They burst harmlessly 15,000 feet below. At 1003 a single Japanese fighter approached them tentatively, then rolled away. After that they were in the clear. Nothing but 1,400 miles of ocean lay between them and Tinian. Tibbets put the airplane into a slow descent and switched on the autopilot. Dimples 91 and *The Great Artiste* followed behind. In less than five hours they would all be home.

The chatter subsided. Some of the crew members went to sleep—for many of them the first time in twenty-four hours. Dick Nelson returned to *Watch Out for Willy Carter,* leaving half an ear open for radio communications. Tibbets lit his pipe. Bob Lewis took up his log for the last time. "Our ship sure had a happy but puzzled crew," he wrote. He signed off as he started, as if this were a letter to his parents back home in New Jersey: "Love to all. 'Bud' R. A. Lewis." In the tail Bob Caron monitored the mushroom cloud on the horizon. One hour and thirty-five minutes after leaving the target area he could still see it. By then it was 417 miles away, considerably farther than the distance from London to Paris. But for the haze and the earth's curvature he would have seen it far longer.

TWENTY-NINE
ZERO PLUS ONE HOUR

Sunday, August 5, 6:45 P.M.
Army-Navy Club, Washington, D.C.

BY EARLY evening General Groves was back in his office at the New War Building, refreshed after his energetic afternoon on the tennis courts. But there was still no news from Tinian: no takeoff message, no cancellation or postponement cable, no strike report, nothing. Matters were frankly becoming embarrassing. His aide Major Jack Derry had already received a call from General Marshall, the Chief of Staff, asking for the latest information. Derry had offered to put Groves on the phone but Marshall was tactful enough to leave matters alone for the moment: "I don't want you to bother General Groves," he said. "He has enough to think about."

He did. But typically he did not show it. Sometime after five o'clock he drove downtown to the Army-Navy Club on Farragut Square for a prearranged dinner with his wife, his daughter Gwen, and George Harrison, the assistant secretary of war. As always, his family knew nothing about his job or his concerns. He and Harrison had to dissimulate. Also at the club was General Thomas Handy, Marshall's deputy. He took Groves aside and asked quietly if there was any news. Again, Groves was obliged to say no.

They all sat down to dinner. At 6:45, Groves was called to the telephone. As he went, he could feel Harrison's and Handy's eyes boring into his back. They had both stopped eating. On the line was Major Derry: he had just received the takeoff message from Tinian, six hours late. The mission had departed safely. There was still no news about the bomb. Groves returned to the table. Thirty minutes later, at 7:15 P.M. Washington time, *Enola Gay* dropped the bomb on Hiroshima. Unaware, Groves was still finishing his meal.

In the car on the way back to the New War Building, he told his wife and daughter he would be staying the night at the office. Never once had he done this before. Neither of them commented on the fact. "Their lifetime in the Army," said Groves later, "had conditioned them well." They left him at the entrance and drove off home to Cleveland Park. He went up to his fifth-floor office, where a dozen of his aides were sitting at their desks. The strike report had still not arrived. He telephoned the chief signal officer, an old friend, to find out yet again what was going on. He was informed everything possible was being done to correct the problem. Meanwhile, there was nothing to do but wait.

He sat down, took off his tie, opened his collar, and rolled up his sleeves—for him a very unusual form of behavior. While he worked on some papers, his secretary, Jean O'Leary, and a few of his staff began a subdued game of poker. "The hours went by," wrote Groves, "more slowly than I ever imagined hours could go by. And still there was no news." Outside, night fell over Washington, the close of another quiet Sunday evening.

WITHIN ONE HOUR of the explosion, Dr. Shuntaro Hida was waist-deep in the Ota River, the same river he had seen glittering from the back of the farmer's bicycle the night before. He had abandoned the bicycle beside the dead man. The press of bodies fleeing the city had made the road impassable. The river was his only route into Hiroshima. The smoke obscured his vision and he

took a wrong branch, entering the city near the suspension bridge at Choju-En. The bridge was in flames. A slow procession of half-naked people crept across it. Some of them tumbled off and fell into the water, too exhausted to continue. On either side, as far as Dr. Hida could see, the riverbanks were crowded with more bodies. It was impossible to tell which were dead and which were alive. They had fled to the river to escape the fires.

He kept going. He knew his own hospital was farther down-stream, near the Kohei Bridge. Only afterward did he learn that it had been totally destroyed, along with the four drunk army doctors and the white-tiled X-ray room. The old farmer's summons in the middle of the night had saved his life. He pushed on through the water. With each step it became more difficult. The hot smoke seared his lungs, tearing at his breath and making him choke. People whose faces had been burned away brushed past him. Corpses bumped against him. Sometimes he could feel them nudging his legs under the water. A dead baby floated past, twisting and turning until it was lost in the current behind. At this point Dr. Hida began to lose his grip on reason. He stopped in the middle of the river, standing up to his waist, not knowing what to do. Then, quite suddenly, a hot wind struck his face. It came out of nowhere, whipping into his eyes and churning up the water with terrific vio-lence. The waves began heaving and crashing against him. The spray blinded his eyes. It was impossible to continue. Hiroshima's firestorm had begun.

OTHER CITIES—Tokyo, Dresden, Hamburg, among many others—knew the phenomenon only too well. As the air became superheated by the fires it rushed rapidly upward, sucking out the oxygen and creating a partial vacuum below. Cold air tore into the space to replace it, a man-made tornado moving at tremendous ve-locities through the devastated city. With it the tornado carried fire: bits of burning wreckage or flaming debris or red-hot splinters

were suddenly hurled through the streets, instantly igniting anything remotely combustible such as flesh or clothing or wood. As in so many Japanese cities, 90 percent of Hiroshima's buildings, and almost all its private dwellings, were made of wood. Those that had not been destroyed in the initial impact were shortly reduced to ashes in the firestorm. With its sixteen pieces of firefighting equipment, its decimated fire teams, its 70,000 pipe breaks in the water supply, its shattered communications, the city could not begin to cope: the flames spread beyond human control. Within a radius of two kilometers of the hypocenter almost everything that had so far managed to survive was burned to the ground. The firestorm was the great leveler. It overwhelmed the firebreaks, it crossed the rivers, it completed the landscape of comprehensive destruction—the dead, limitless, pulverized plains—which is Hiroshima's signature. There was virtually no escape.

It began at 9:45, just thirty minutes after the explosion, at almost exactly the same time General Groves received his telephone call from Major Derry at the Army-Navy Club in Washington. By the time his wife and daughter had dropped him back at the office, it was raging through the city with increasing violence. Its course can be charted fairly precisely. Amazingly, the Hiroshima District Meteorological Observatory, located 3.6 kilometers southwest of the hypocenter, continued to function normally throughout the entire day. The bland summations of its hourly—and sometimes half-hourly—reports offer an extraordinary snapshot of the bomb's impact, a clinical record that underpins the scarred memories of survivors. The firestorm appears to build slowly in strength, reaching its peak by mid-afternoon, with wind speeds of up to 5.5 meters per second observed. For several hours the whirlwinds howled through the ruins. They only slowed by evening. There are other phenomena also logged, noted otherwise fleetingly or impressionistically by survivors. A thunderstorm rolled across the city at 11:07 for forty minutes—less than two hours after the explosion. Lightning flashed continuously in the skies. The bomb had upset nature in the most fundamental sense. It even created rain.

Afterward they called it black rain but in truth it was not really black at all. It was a muddy, dirty sort of color. And for very good reason: it was literally formed from the debris of buildings and bodies blown up into the mushroom cloud. It fell over an oval-shaped area north and northwest of the city and it fell hard, between 50 and 100 millimeters in less than three hours. It left spots and streaks on people's clothes or on walls and it was strangely, unpleasantly sticky. Some people thought the Americans had deliberately dropped oil, perhaps to fan the flames. In fact they had dropped something far worse, even if they had not actually intended to. Forged in the bomb's dust cloud, the rain was extremely radioactive. In the parching heat many people ignored its stickiness and its muddiness and saw it instead as a lifesaver. They opened their mouths to the downpour and drank it, gleefully, willingly, desperately, to quench a terrible thirst.

THE FIRESTORM finally caught up with Taeko Nakamae at the Tsurumi Bridge, in the eastern half of the city. The bridge was her last link to Hijiyama and freedom. But it was engulfed in flames. The hot wind roared through its smashed girders. Her only escape was across the river, but the tide was flowing in fast from the Inland Sea and the currents were treacherous. She collapsed on the riverbank in exhaustion. A few people were already in the water, struggling hopelessly to swim across. She watched them numbly. Someone nearby began screaming: "Kill me, kill me, please kill me," over and over. The wind tore in her face. She was still bleeding. Her left eye would not open. She did not know yet that a glass splinter from the telephone exchange window had ripped it out entirely. Somebody came up to her and crushed a cigarette into her wounds. There was nothing else to staunch the flow of blood.

The fires were coming closer. A voice shouted in her ear, telling her to run. A woman grabbed her hand, pulling her to her feet. She looked up in a daze. Her teacher Mrs. Wakita was standing over her. Her clothes were ripped to shreds. She kept shouting at Taeko to

run. A wall of flames was rapidly advancing toward the riverbank, carried on the whirlwind. The air was full of flying sparks. The heat burned into Taeko's spine. Mrs. Wakita dragged her down to the river, where the waves slapped against the bank. The water slipped over her legs, her stomach, her arms, her head: it felt deliciously cool. Then she was suddenly gasping for breath and fighting the current. Her teacher held on to her hand, pulling her across. She choked and spluttered. She could barely see. The water slammed against her, pummeling her body. She was only fourteen and she was small for her age. Halfway across, her strength ran out. She was sinking. Mrs. Wakita kept supporting her, holding her up. All the time she was shouting: "Be strong, child," she said, "you can't die here!" They were the last words Taeko remembered before she lost consciousness. She would live, but she would never see her teacher again.

THE NEWS got out slowly to the rest of Japan. Telephone communications had been comprehensively destroyed by the bomb. Almost all the lines out of the city were cut. One second after Masanobu Furuta's last words into the microphone, the Tokyo control operator at the Japanese Broadcasting Corporation noticed that the Hiroshima station had gone off the air. He tried several times to raise the studio but there was no response. Twenty minutes later, at 9:35, engineers in Tokyo's railroad signal center realized that the main-line telegraph had suddenly stopped working: there seemed to be a break just north of Hiroshima. Several times in the course of the morning Tokyo's General Headquarters tried to make contact with the communications bunker in Hiroshima's castle compound. Again all the lines were dead. By eleven o'clock, at approximately the time Bob Caron saw the mushroom cloud finally disappearing into the haze, the Tokyo-based editor of the *Asahi* newspaper received a phone call at home from his office. There were strange reports coming out of Hiroshima. The city, he was told, had "almost completely collapsed."

Just after midday, with *Enola Gay* still three hours away from Tinian, a reporter for the Domei News Agency—the official mouthpiece of the government—reached the small local broadcasting studio at Hara, five kilometers north of Hiroshima. Satoshi Nakamura was a thirty-seven-year-old journalist who lived on the second floor of a house 300 meters from the hypocenter. The only reason he was not dead was because he was not there. He had spent the previous evening at a colleague's home out of town, waiting for a shirt to dry. The bomb had exploded while he was eating breakfast the next morning. He jumped onto his bicycle and pedaled into the city. His journey took him directly through the worst of the destruction. It also took him into the black rain. The downpour was so heavy that he had to stop and take shelter. The wind was too fierce for him to control the bicycle. He walked the rest of the way, carrying his notebook.

At Hara only one telephone line was functioning. It connected the studio with a sister station in Okayama, the nearest sizable town. Somebody in a kimono was shouting into the handset: Nakamura saw he was injured. He asked permission to use the telephone for just five minutes. He spoke to the man at the other end of the line: "Please relay the message I will now give you to Domei's Okayama office immediately." The time was 12:20. He began dictating into the mouthpiece, perhaps one of the most important newsflashes ever sent: "At approximately 0816 [Japan time] one or two enemy planes flew over Hiroshima and dropped a special bomb. Hiroshima is completely destroyed. Casualties estimated at 170,000."

It was a guess. At that point neither Nakamura nor anyone else had any idea of the casualty figures. He simply took what he believed to be the city's population and halved it. As he roved with his notebook through the obliterated streets, it did not seem unlikely that half the entire populace was either dead or seriously injured. In fact the figure was almost identical to the one later published by the United States Strategic Bombing Survey—between 70,000 and 80,000 dead, an equivalent number wounded—itself almost cer-

tainly an underestimate. Later Nakamura filed a second, far more detailed report. A shorthand secretary stood by. The Domei bureau chief in Okayama challenged him over the telephone. His original estimate, he said, could not possibly be true. It was inconceivable that Hiroshima had been destroyed by a single bomb. He ordered Nakamura to correct his previous story. The army would never accept it. Nakamura exploded down the telephone: "You tell those bastards in the army they are the world's biggest fools!" he yelled. He then proceeded to dictate his second report, spelling out each detail exactly as he had recorded it, unaware that the tears were streaming down his face and over his notebook.

O N T I N I A N, preparations were in full swing for a huge celebration. The news of *Enola Gay*'s success had raced around the 509th compound like a bushfire. By late morning, the entire base was aware that something extraordinary had happened. The mess officer, Charles Perry, set out to throw the party of a lifetime. By the time Nakamura filed his first report down the telephone line, Perry's cooks were preparing hundreds of pies for a pie-eating contest. They were also making thousands of hot dogs, beef and salami sandwiches, and potato and fruit salads. Crates of beer and lemonade were pulled out of storage and stacked on ice. Perry sat down at his typewriter and began to compose the afternoon's program:

509TH

FREE BEER PARTY TODAY 2 P.M.

TODAY TODAY TODAY TODAY

PLACE 509TH BALL DIAMOND

FOR ALL MEN OF THE 509TH COMPOSITE GROUP

FOUR (4) BOTTLES OF BEER PER MAN

NO RATION CARD NEEDED

LEMONADE FOR THOSE WHO DO NOT CARE FOR BEER

ALL STAR SOFTBALL GAME 2 P.M.

JITTER BUG CONTEST

HOT MUSIC

NOVELTY ACTS

SURPRISE CONTEST—YOU'LL FIND OUT

EXTRA ADDED ATTRACTION, BLONDE, VIVACIOUS,
CURVACEOUS, STARLET DIRECT FROM ???????

PRIZES—GOOD ONES TOO

AND RATION FREE BEER

FOOD GALORE BY PERRY & CO. CATERERS

SPECIAL MOVIE WILL FOLLOW AT 19:30, "IT'S A PLEASURE"

IN TECHNICOLOR WITH

SONJA HENIE AND MICHAEL O'SHEA

All morning the 509th kitchens were a hive of activity. Perry drove his staff like a battle-hardened general. There was not much time. The strike planes were due back by mid-afternoon. From then on it was going to be one big nonstop party.

THIRTY
ZERO PLUS THREE HOURS

August 6, Midday
Miyuki Bridge, Hiroshima

For more than two hours that morning Yoshito Matsushige had carried his camera into the heart of Hiroshima, but he had not taken a single picture. He walked around the shattered streets—within 200 meters of the hypocenter—in a kind of shock. The two rolls of film remained unexposed. It seemed impossible, an act of indignity, to take photographs of what he saw. But the decision was not entirely moral: it was also forbidden to publish photographs of corpses. And almost all he saw were corpses.

He never reached the military headquarters or his newspaper offices. The firestorm prevented any access to that part of the city. The only route was through Hirono Street, and by the time he got there the fire was blazing from house to house like a tunnel of flames. He turned back, retracing his steps southeastward, until he reached the Miyuki Bridge, 2.2 kilometers from the hypocenter. The bridge had been turned into a primitive temporary refuge. Hundreds of people—possibly as many as a thousand—lay or squatted along its length. Many of them were junior high school

girls from Hiroshima's Prefectural First Middle School and the Girls' Commercial High School. Like Taeko Nakamae's younger sister, Emiko, they had been busy demolishing buildings for the fire lanes when the bomb exploded. They had been directly exposed to the primal heat rays at the instant of detonation. All of them were burned, some very badly. Many were dying or already dead. There was nothing to treat them with except cooking oil.

Matsushige moved among them, like the living among ghosts, carrying his camera. He saw the girls with blisters on their faces, backs, arms, legs—blisters, he always remembered, the size of tennis balls. They "were starting to burst open and their skin hung down like rags. Some of the children had burns on the soles of their feet. They had lost their shoes and run barefoot through the burning fire." Their clothes were scorched and tattered, their hair filthy and matted. In silence they stared up at him as he passed. He paused, still holding his camera. He could feel their eyes on him. Except for a few glass fragments in his skin, he was unhurt. For as long as fifteen, perhaps twenty minutes, he stood on the bridge, still hesitating. "I couldn't bring myself to press the shutter," he said. "The sight was so pathetic."

Then he took the first picture. A group squats or stands by the police box at the eastern end of the bridge. The shot is wide angle, deliberately detached. It is difficult to make out any detail. Most of the people are turned away from the camera. Their arms are clenched against their knees. Behind them is the police box with its collapsed roof. Other smashed buildings lie beyond. A smudged column of smoke climbs into the air. Debris is scattered in the road. A man, or perhaps it is a woman, bends down to retrieve something while a girl runs behind her. Another group huddles around a policeman. He is identifiable by his boots.

Matsushige moved four or five meters forward. He took a second picture: a closer version of the group with the policeman. The man's back is to the camera. It is unclear what he is doing but in fact he is handing out cooking oil. A boy holds out his arms while a woman

appears to rub oil on them. Again, the faces are turned away. The detail is in the clothes: ripped, sweat-soaked, filthy, scorched. And the hair, thickly clotted with dirt. Matsushige put the camera down. He could no longer see properly. "Even today," he said almost six decades later, "I remember how the viewfinder was blurred with my tears."

He took no more photographs on the bridge. By late afternoon, he had taken just three more elsewhere: one of a policeman issuing emergency rations certificates; one of the view outside his barber-shop window, with the wrecked fire station across the street; and one of the interior of the shop. In the far corner his wife, Sumie, opens a chest of drawers amid the rubble.

Five photographs. For a news photographer, here was the scoop of a lifetime. Matsushige found himself, alive and with a professional camera, in the middle of the greatest man-made destruction in history. And yet he was unable, or chose not, to take advantage of it. The pictures he took are almost anodyne; for that very reason they are powerful. They shock for what they do not show. But they are remarkable for another reason too: with just one exception, they are the only known photographs taken of human beings in Hiroshima on the day the bomb fell.

There is one more detail that strikes the eye. In the first photograph—the wide shot on the bridge—a man can be glimpsed leaning against the wall opposite the police box. His shaven head is turned away from the camera. The back of his skull catches the light. He looks toward the smoke beyond the bridge. He appears unidentifiable but he is not. He is in fact Sunao Tsuboi, Reiko's lover. And he had come to the bridge to die.

SUNAO'S STRENGTH was already ebbing by the time he left his message for Reiko. He was so weak. The pain from his burns increased with each step. They were everywhere: on his back and legs where his clothes had caught fire, on his face and hands. Somehow he kept walking. He had no sense of direction. Time began to dis-

solve in a sequence of disjointed memories; he stumbled through the streets on the edge of consciousness. At some point during that morning he reached his aunt's house, in the south of the city. The house was smashed to the ground but his aunt was still alive. She stood helplessly beside the piles of splintered wood. She stared at Sunao in shock: she barely recognized him. It was the first time he realized how badly burned he was. He must look like all the others.

She had nothing to soothe his burns. He heard people saying something about a rescue center on the Miyuki Bridge. It was only a few hundred meters away; perhaps they would be able to help him. His aunt tried to stop him, but he left. He did not want to die at her house. He pushed himself toward the bridge. He tottered, sometimes he crawled. The pain was unbearable. He never knew how long it took, but sometime before midday he finally reached the bridge. He saw the people heaped against the railings, the burned schoolgirls, the police box with its broken roof. He did not see Matsushige, the photographer. He collapsed on the ground in exhaustion. Nobody came to help him. He could feel his spirit slipping away. He knew he was going to die. He had only one fear left: that nobody would ever know who he was. He would die anonymous, unknown, unidentified. If Reiko survived, she would never discover what had happened to him.

There were a few pieces of stone, like small pebbles, on the ground beside him. With the very last of his strength he picked them up and placed them, one by one, next to his legs, to form the letters of his name: "Here Dies Tsuboi," he wrote. It was all he could manage. Almost as soon as he had finished he slipped into the coma that would last for forty days, not knowing whether the woman he loved was alive or dead.

Toshiaki Tanaka, the son of the liquor store owner, was also on the Miyuki Bridge that morning. One hour after surviving the collapse of his army classroom, he found himself in a truck with eight

fellow soldiers from the Akatsuki Corps, heading north from the port. Their route took them directly into the stream of refugees escaping the city. This was Toshiaki's first experience of the bomb's impact on human beings. He had fought in China in 1938. He had survived three assaults on the enemy's beaches, engaging in some of the bloodiest fighting in that war. Nothing compared to what he saw now. From this moment on, he began seriously to doubt his family's chances of survival.

His first post was at the police box on the eastern end of the Miyuki Bridge, exactly opposite the point where Yoshito Matsushige took his photograph of Sunao Tsuboi. At some point before noon, all three men must have been standing within a few meters of each other. Tanaka's orders were clear. His squad were to requisition trucks crossing the bridge, fill them with the wounded, and send them back to the Akatsuki Corps Hospital in Ujina. But there were too few trucks and too many wounded. The bridge was rapidly overwhelmed. Huge numbers of burned people swarmed toward it, pleading for treatment. The supplies of cooking oil quickly ran out. Still more people kept coming. Tanaka could hear children calling for their mothers. Others were asking for water: *mizu, mizu,* they cried, water, water. But there was no water. It was a hot August day; by 2 P.M. the temperature had climbed to thirty-one degrees centigrade. For the first time the sun now began to burn through the haze. There was no shelter on the bridge. The hundreds of injured and dying sat listlessly in its relentless glare. Like Sunao Tsuboi, most had given up hope. They could go no farther.

Tanaka and his eight soldiers did what they could. Tanaka himself went to the nearby Red Cross hospital—the largest in Hiroshima—to try and find medical supplies. But it was the same story there: 85 percent of the hospital's doctors and nurses had been killed or wounded in the blast. One of the injured was Naoe Takeshima, the young student nurse who had watched the glittering leaflets tumble down over the city a week earlier. Her left leg had been smashed when the roof of the isolation ward collapsed on top of her. The

entire building was virtually a shell. The hospital was almost two kilometers from the hypocenter, but the floor of the pathology examination room had literally sunk fifteen centimeters from the shockwave. Thousands waited patiently outside in the sun just as they did at the Miyuki Bridge, too often with the same result: a slow descent into unconsciousness and death.

Tanaka found a little iodine and took it back to the bridge. It did not last long. Wherever possible, his men loaded the people on the trucks and sent them south to Ujina. Most had to be lifted on board. Some were so burned it was impossible to know where to hold them. It was grim work. But what made it worse for Tanaka was that the Miyuki Bridge, like the Red Cross hospital, was just two kilometers from his family's liquor store. From what he could learn, the center of the destruction was very near his home. He was afraid of the worst. The bomb had wrought terrible damage: the evidence was right in front of his eyes. He was desperate to search for his family but he was forbidden to leave. He was a Japanese soldier. He had his orders, and his orders were to remain at his post.

OTHER RESCUERS began moving in from farther afield. By early afternoon, as *Enola Gay* began her final descent into Tinian, Isao Wada was crossing the bay in a boat with eighty other suicide-attack cadets. They had seen the explosion from their camp in Konoura, five miles across the Inland Sea. They had also heard it, a tremendous crash that rocked the barrack huts. Everyone had rushed out onto the beach and stared at the spectacle across the bay. Within less than three minutes, Hiroshima had disappeared under the huge cloud.

By midmorning, a small group of cadets had taken a boat to Ujina. They tried to enter the city, navigating up one of its seven rivers. But it was impossible. There were too many corpses in the water. They returned with terrible tales. Isao was appalled. He had lived in Hiroshima himself, working on the railroads. He knew and loved the city; he had many friends there. When the next group of

rescue workers were drafted to go across early that afternoon, he joined them.

Before he even stepped out of the boat across the bay at Ujina, at around 3 P.M., Isao saw for himself the first signs of human destruction. All along the length of the pier were straw mats heaped with wounded people. There were hundreds of them, waiting for ferries to take them to the islands. The beautiful wooded shrines that studded the bay were about to be transformed into huge holding centers for the dying. Isao and his fellow cadets threaded their way down the pier. They left the port behind, following the tramlines north from the docks. The smashed streetcars lay across the roads. An occasional truck sped past, heaped with yet more wounded, headed back for the port. Many of these trucks came from the Miyuki Bridge. At some point during that afternoon, Sunao Tsuboi would have been inside one of them, already unconscious.

A temporary shelter had been established at the Dentetsu Tram Company offices—itself half-destroyed—a few hundred meters west of Miyuki. Isao and his squad were ordered to spread out into the area and collect the injured on stretchers. But there were no stretchers. They were forced instead to use anything to hand: mats, planks, sheets of corrugated iron, doors, window frames, pieces of wood torn up in the blast. Everywhere people kept begging them for water. They had strict orders not to give it—their superiors had told them it could kill—but it was impossible to turn away. They refilled their canteens from the burst water pipes, spilling the liquid into people's mouths. They carried the wounded on their makeshift stretchers through the burning streets to the Dentetsu shelter. Then they went back to do it again. The work went on all afternoon. The men who had been training to blow themselves up in their wooden boats suddenly found they had become rescuers.

AT ALMOST exactly the time Isao Wada stepped off the pier in Ujina, *Enola Gay* touched down on Tinian. Dutch Van Kirk penciled the final entry in his navigation log: "Base 14:58." They had been in

the air twelve hours and thirteen minutes, covering a distance of 2,960 miles. They were all exhausted. As the bomber slowly turned off North Field's Runway A for Able, an extraordinary sight greeted them. Hundreds of servicemen were lining the taxiways, cheering and applauding. *Enola Gay* swept past like the conquering heroine, her silver tail with its big black *R* glinting in the brilliant afternoon sun. The men on board stared in amazement at the crowds through the windows. They had never seen anything like this in their lives. The other two strike aircraft, *The Great Artiste* and Dimples 91, landed almost unnoticed. They had deliberately slowed down to allow *Enola Gay* to arrive first.

Tibbets swung the bomber onto the apron and cut the engines. A gathering of at least 200 people—officers, scientists, technicians, enlisted men, photographers, journalists, movie cameramen, at least one admiral, and several army generals—clustered around. The nose hatch opened: Tibbets emerged legs-first, followed by Deak Parsons and Morris Jeppson. The rest exited in quick succession behind. Barely had their feet touched the ground before a voice called out, "Attention to orders!" The crew lined up smartly. General Carl Spaatz, commander of the United States Army Strategic Air Forces, immediately marched up to Tibbets and pinned the Distinguished Service Cross directly onto his sweat-stained flight suit. The two men saluted. The whole episode was filmed and photographed from various angles. Less than five minutes had passed since the engines stopped. Tibbets was so taken by surprise, he was still holding his pipe when the general approached. He had to hide the bowl in his left hand as the medal was fastened to his chest.

The formality then relaxed. Everyone began shaking hands, talking, grinning, slapping backs. Jerome Ossip, the 509th's photographic officer, relieved Bob Caron of his K–20 camera and its roll of exposed film. An intelligence officer collected the disc of the intercom conversation from Jake Beser. Swept along by the crowd, the crew was escorted to the debriefing room. Each man was given a physical check-up and a shot of medicinal whiskey. Eyes were examined especially carefully, especially for those like Tibbets who had

not been wearing their goggles when the bomb exploded. Geiger counters were run over bodies and clothes. They were also run over *Enola Gay*. Once again Ferebee raised his worries about sterility. The doctor reassured him. In every case radioactivity levels were found to be harmless. Unlike the people of Hiroshima, none of the crew had been, or ever would be, affected.

The debriefing lasted two hours. Despite the unusual presence of the air force generals, it was an informal affair. There was food, cigarettes, lemonade, bourbon laid out on the table. The men described in detail what they had witnessed. Bill Laurence, the *New York Times* reporter, took copious notes. He already had access to Bob Lewis's in-flight journal. Later he hoped to write up the greatest scoop of his career—if not of the century. A photographer snapped a few more shots. Bob Caron kept his Brooklyn Dodgers hat on—he was still determined nobody would ever get to see that haircut. Unshaven, sometimes smoking, their eyes rimmed with fatigue, the men sat around the table answering questions, flying the mission all over again. Consulting his log, Dutch Van Kirk said that the bomb had been dropped just seventeen seconds behind schedule, by any account a remarkable piece of precision navigation. "So why were you late?" joked the debriefing officer, at which point the whole room dissolved into laughter. In an almost macabre piece of bookkeeping, Parsons wrote a note on the original receipt for the uranium projectile that had been couriered to Tinian aboard the USS *Indianapolis*: "I certify that the above material was expended to [*sic*] the city of Hiroshima, Japan, at 0915, 6 August. Signed W. S. Parsons." General Spaatz congratulated the crew. Later they were all given Silver Stars.

The session finally ended. One by one, the men stumbled out into the late afternoon sunshine. Some, like Dutch Van Kirk, went straight to bed. A few got quietly drunk. Others went to join the blow-out party Charles Perry and his mess cooks had been preparing all day. But they were too late. By the time they got there, all the beer and the salami sandwiches and the potato salads had gone. They even missed the jitterbug contest.

THIRTY-ONE
ZERO PLUS TWELVE HOURS

Sunday, August 5, 11:30 P.M.
Room 5120, New War Building,
Washington, D.C.

FROM THE Pentagon to the New War Building across the Potomac was a short ride, especially at this hour of the night. Within minutes the army courier had pulled up outside the impressive white frontage on Virginia Avenue. He did not wait around. He rushed through the black marble Art Deco lobby, rode one of the eight elevators up to the fifth floor, hurried down a short corridor, and entered the outer office of General Groves's headquarters. In his hands was the message Groves had been waiting for all evening, now four hours late: General Farrell's strike report from Tinian, exactly as he had received it from Deak Parsons on board *Enola Gay*. Groves scanned its contents: *"Results clearcut, successful in all respects. Visual effects greater than Trinity test . . ."* The bomb had worked, indeed more than worked. It had been a triumph. General Groves was the first man in the United States to know it.

Typically, he did not make a fuss. He made just one telephone call, to Colonel McCarthy, an aide to General Marshall, the Chief of

Staff. McCarthy in turn called Marshall at home. Marshall, perhaps the most powerful man in the United States Army, responded with equal understatement. "Thank you very much for calling me," he said. Then he put the telephone down. Back in Groves's outer office there was much greater excitement, but not for the general himself. He immediately retired to his desk, drafted a report to be delivered to General Marshall first thing in the morning, lay down on a cot that had been specially set up in his office, and went to sleep.

Enola Gay had already landed back at Tinian, and the crews had finished their briefing, when Groves was awakened by a second message from General Farrell. The time in Washington was now 4:30 in the morning. For security reasons the message was addressed to Major O'Leary. The army decoding officer at the Pentagon had added the rank as a guess; he had no idea this was actually Mrs. Jean O'Leary, Groves's secretary, who had spent half the night accumulating a stack of dollar bills at poker while the general slept. The new message was more dramatic, especially in its conclusion. Groves read it out to his staff:

> To: War Department Message Center 060805z
> Apcom 5245
>
> . . . One observer stated it looked as though the whole town was being torn apart with columns of dust rising out of the valleys approaching the town. Due to dust visual observation of structural damage could not be made. Parsons and other observers felt this strike was tremendous and awesome even in comparison with Trinity. Its effects may be attributed by the Japanese to a huge meteor.

Deak Parsons's metaphor had worked its way 6,000 miles across the world. Over a pot of coffee, Groves rewrote his earlier draft, shaved and changed into a new uniform while it was being typed, then crossed the Potomac to the Pentagon—the complex he had

helped to build before he was brought in to build the bomb. He knew General Marshall always arrived in his office punctually at 7 A.M. At 6:58 Groves was waiting outside the door with his report.

The men conferred briefly. They were joined by George Harrison, Groves's dinner guest at the Army-Navy Club the previous night, and by General "Hap" Arnold, chief of the army air force. There was no time to lose. The key now was to get the news of the atomic strike out to the world—and to Japan—as fast as possible. The Japanese had to know what had just hit them, and what would hit them again if they failed to surrender. At 7:45, Marshall called Henry Stimson over the scrambler at his estate on Long Island. The aging secretary of war, still exhausted from his trip to Potsdam, extended his "very warm congratulations." If he felt any ambivalence he showed no hint of it. He urged that the president, on board the USS *Augusta* out in the Atlantic, be informed immediately. He also authorized the release of the president's statement, first drafted by Bill Laurence two months earlier, on the dropping of the bomb. The release was timed for 11 A.M.—in just over two hours.

Marshall suggested they should guard against too much gratification: the Japanese must have suffered huge casualties. Groves was provoked. He said he was thinking less about Japanese casualties and more about Japanese atrocities such as the Bataan Death March—a notorious 100-mile march in 1942 in which American and Philippine prisoners of war were routinely beaten, starved, shot, bayoneted, beheaded, or left to die in the sun. Afterward, out in the hall, General Arnold slapped Groves on the back. "I'm glad you said that," he exclaimed. "It's just the way I feel." Millions of Americans would very soon feel likewise.

PRESIDENT TRUMAN had spent the morning on the *Augusta*'s decks enjoying the ship's band. The cruiser was now south of Newfoundland in calm blue seas. The crew had changed into crisp white uniforms and the sun was shining out of a cloudless sky. Before

noon, local time, the president and his secretary of state, Jimmy Byrnes, descended to the mess to have lunch with the enlisted sailors. They were just starting their meal when Captain Frank Graham, one of the White House staff, rushed into the room. In his hand was a cable from Washington and a map of Japan. The city of Hiroshima had been ringed in red pencil. Quickly Truman read the message:

> To the President
> From the Secretary of War
>
> Big bomb dropped on Hiroshima August 5 at 7.15 P.M. Washington time. First reports indicate complete success which was even more conspicuous than earlier test.

Truman suddenly grabbed Graham by the hand. "This is the greatest thing in history," he said. A few minutes later, a second, more detailed message arrived. According to the ship's logbook, the president then "jumped up from his seat." He tapped a glass with his fork and called for attention. A hush fell over the sailors at their lunch trays. "I have an announcement to make," Truman declared. "We have just dropped a bomb on Japan which has more power than 20,000 tons of TNT. It has been an overwhelming success!" The room dissolved into cheers and applause. Nobody, not least Truman, questioned the figure of 20,000 tons. The bomb had actually been rather less powerful, but the legend of its equivalence with the Trinity yield would live for a long time. Not that it mattered. What mattered was whether it was big enough to end the war. Truman certainly thought so. He dashed out of the sailors' canteen clutching his cables and map, and burst straight into the officers' mess. "We won the gamble!" he said excitedly to the men half-rising in confusion from their seats. Merriman Smith, the United Press reporter, never forgot the president's expression. "He was not actually laughing," he wrote, "but there was a broad smile on his face. In the small dispatch which he waved at the men of the ship, he saw the quick end of the war."

In washington it was 10:50 A.M. A group of journalists were gathered at the White House briefing room. Earlier that morning, the press corps had been told to expect an important announcement from the president's press secretary. The notice did not arouse much interest. Announcements like this had become routine. Few of the star reporters had bothered to turn up in person—most of them had sent their assistants. As the clock struck the hour, the press secretary mounted the podium and faced his audience. He began to read:

> *Sixteen hours ago an American airplane dropped one bomb on Hiroshima, an important Japanese Army base. That bomb had more power than 20,000 tons of TNT.*

Before he reached the third sentence there was pandemonium. The room erupted. Everybody stampeded to the tables stacked with texts of the presidential statement. People jostled and pushed their way out the exits to the phones or their offices. The excitement was electric. Here suddenly was the biggest story of the war—and half the reporters covering it were mere assistants. A heaven-sent opportunity had fallen into their laps. Not one of them stopped to wonder why a bomb that size had been dropped on what had now become "an important Japanese Army base." The refinement had only just been added that morning.

Within minutes, the president's statement was broadcast over the radio. At their home in Cleveland Park, General Groves's wife, Grace, and his daughter, Gwen, sat listening in stunned silence. Groves had telephoned his wife earlier that morning, telling her to switch on the radio just before eleven o'clock. He did not say why. He also told her he was sending one of his public-relations officers directly to the house. Next he contacted the secretarial school where Gwen was enrolled in a typing course. She was asked to go home immediately. Again she was not told why. Both women were duly

sitting in their living room when the announcement was made. The general's name was mentioned in the broadcast. They were flabbergasted. Almost immediately the phone was jammed by reporters calling the house. Not one of them could believe that Groves's own family had not the faintest clue what he had been doing almost every day for the past three years. But it was true. "We were just as surprised as the Japs when Dick's bomb was dropped," his wife said later. She was right on every count.

THE HUGE monitoring station in Saitama prefecture outside Tokyo picked it up first. A bristling compound of aerials and masts, the station was operated by the Domei News Agency. Fifty monitors sat day and night listening to American broadcasts, many of them girls born of Japanese parents in the United States. Just after midnight—fifteen hours after the attack—the station chief, Hideo Kinoshita, was woken up by one of the monitors. He was told the Americans were broadcasting a statement from the president. A device called "an atomic bomb" had been dropped on Hiroshima. Kinoshita had no idea what an atomic bomb was. The president's statement enlightened him:

> *It is a harnessing of the basic power of the universe. The force from which the sun draws its power has been loosed against those who brought war to the Far East.*

Immediately Kinoshita called his foreign news editor, Saiji Hasegawa, also asleep in a nearby hotel. Hasegawa was irritated: it was late, he was tired, he too had never heard of an atomic bomb. Kinoshita quickly explained. Hasegawa got dressed and hurried over to the station. He scanned the transcripts of the president's statement. Then he picked up the telephone and called the chief secretary of the cabinet. The chain of communications was reaching the very top. By the time reporters were besieging General Groves's

house in Washington, the prime minister of Japan, Kantaro Suzuki, knew what had happened to Hiroshima.

In fact, disturbing reports had been coming in all day but the army had suppressed them from the public. Satoshi Nakamura's horrific, detailed eyewitness account from the local radio station at Hara had not been released. Clearly something catastrophic had happened, but it was essential to keep it quiet. The impact on the nation's morale could be disastrous. Within seven hours of the explosion, the editors of Tokyo's five biggest newspapers had been summoned to the office in charge of press and radio censorship. They were ordered summarily to play down any references to the bombing of Hiroshima pending further investigations. The six o'clock news later that evening made the first bare reference to the attack:

> A few B-29s hit Hiroshima city at 8:20 A.M. (Japan time) August 6 and fled after dropping incendiaries and bombs. The extent of the damage is now under survey.

The extent of the damage was still under survey when President Truman's announcement finally hit the airwaves. The prime minister's worst fears were realized. In those early hours of the morning, Suzuki was faced with a stark choice. In case he was in any doubt, the American president had spelled it out for him:

> It was to spare the Japanese people from utter destruction that the ultimatum of July 26 was issued at Potsdam. Their leaders promptly rejected that ultimatum. If they do not now accept our terms they may expect a rain of ruin from the air, the like of which has never been seen on this earth.

Once before the Japanese government had rejected the Allies' demands. Hiroshima's destruction was the direct result. There was only one question left. Would the government reject them a second time?

THIRTY-TWO
ZERO PLUS EIGHTEEN HOURS

August 6, Midday
Site Y, Los Alamos, New Mexico

IN LOS ALAMOS it was now noon. From his office with its sensational views of the Pajarito mountains, Oppenheimer spoke to General Groves for the first time since the strike. The telephone conversation was transcribed. Groves said, "I'm very proud of you and all of your people."

"It went all right?" asked Oppenheimer.

"Apparently it went with a tremendous bang."

"When was this, was it after sundown?"

"No, unfortunately it had to be in the daytime . . ."

"Right," said Oppenheimer. "Everybody is feeling reasonably good about it and I extend my heartiest congratulations. It's been a long road."

"Yes, it has been a long road," replied Groves.

Back in May, at the first Interim Committee meeting in Washington, Oppenheimer had been asked how many people were likely to be killed in an atomic attack on a city. He estimated 20,000—perhaps a seventh of the real figure. His estimate was based on certain assumptions, one of which was that the inhabitants would

have time to get to the shelters. On this Monday lunchtime, five weeks later, neither he nor anyone else outside Japan knew the truth: that there had been no warning and no time. Such qualms as he may have had—perhaps the hint is there in the "*reasonably good*"—were drowned in the sweet savor of success. The bomb had worked. He, J. Robert Oppenheimer, had done it.

An address went out across the laboratory. The announcer had no idea what he was announcing. In mechanical tones he said merely that there had been a "successful combat drop" of one of the laboratory's "units." The reaction from the scientists was immediate: "The place went up like we'd won the Army-Navy game!" said Robert Wilson, a physicist. Everybody gathered at the big theater where the colloquia—the once-weekly assemblies of all the scientists involved in the project—took place. The atmosphere was extraordinarily charged. Normally Oppenheimer arrived at the colloquia punctually; today he was late. With great stage presence, he swept down the aisle toward the podium. Almost the entire theater broke out in spontaneous applause and cheers. People yelled and stamped their feet. Edward Teller, the father of the future hydrogen bomb, recalled a colleague shouting out, "One down!" Another scientist never forgot Oppenheimer's behavior as he mounted the stage: "He entered that meeting like a prizefighter." And like a prizefighter he clasped his hands together over his head in the classic boxer's victory salute.

BY SUNSET up to 4,000 people were dying in the paddy fields and on the roads leading to Hesaka village. Dr. Shuntaro Hida had just himself and three medical staff to treat them. The wife of the village doctor had offered all her husband's supplies of gauze and bandages—he was away at the front—but they had very soon run out. There was nothing else for the burns except a few rags soaked in soybean oil and wet leaves. An emergency kitchen had been set up near the primary school to boil rice, but most of the victims were too burned to eat it. The women of the village boiled the rice

again until it softened into a kind of gruel. Their children helped to pour it into people's mouths. Sometimes the children ran away. The sight of the wounded was too frightening.

Night fell. The dust cloud, the *kinoko gumo*, still hung over the city, blotting out the stars. More people kept streaming up the road toward Hesaka. All of them were injured, some so appallingly it seemed miraculous to Hida they had ever reached the village. Most would not last until the morning. Their wounds had begun to fester as gangrene set in. Others were vomiting or passing bloody stools. Hida thought they were suffering from bacterial dysentery. In reality he was witnessing the first signs of the radiation sickness that would in time claim tens of thousands of lives. A few people had become insane, tearing at their clothes or skin. Hida saw one girl, in her early twenties, stumbling over the dead and wounded. She was naked. An accident of posture or clothing at the instant of the explosion meant that only the upper half of her body was burned. Every time she moved, her white thighs were suddenly, almost indecently, exposed. Somebody tried to wrap a piece of cloth around her. She ripped it off and collapsed to the ground, wailing and hugging the corpses. Hida watched the whole scene, helplessly. There was nothing he could do. He would not allow himself to cry. "If I had cried," he said, "I would have lost my strength to keep going."

He kept going, with his three helpers: an unending round of soaking, binding, wiping, cleansing, cauterizing, amputating. Sometime in the night, he took a candle and walked out among the thousands lying in the paddy fields. Supplies of soybean oil and rice were running out. He had to make choices about whom to treat and who was beyond treatment. He moved silently through the mass of bodies, checking faces by candlelight. Many he saw were already dead. Others still clung hopelessly to life. He could feel their eyes following him, like those of dumb animals, as he moved past with his candle. The moment would return to him again and again in his dreams: the pity and the horror and the dread that he would catch in their eyes when he knew they could not live.

Down in the city, Isao Wada and his squad of suicide cadets also worked through that first night as they would continue to work for the next seven days and nights. They brought as many people as they could to the tram shelter, carrying the wounded on their makeshift stretchers through the ruins. But the task soon began to change from saving lives to disposing of corpses. The corpses were everywhere, and they were beginning to smell. Again and again Wada and his men went out into the city to collect them: from the still-smoldering buildings, from underneath the wreckage, from the bridges, from the rivers, from inside the streetcars. They tried where they could to identify them; in most cases it was hard enough to decide whether they were male or female. They piled them into groups of up to fourteen or fifteen at a time. They dug holes in the sandbanks by the rivers, laid a few pieces of wood over the bodies, and burned them. They stood in a little group around the pyres and put their hands together and prayed for the souls of the men and women they were burning. One of their squad always waited until the very last embers had died away. Then he left a little marker, usually a few stones arranged in a simple pattern, to show where the people had been cremated. They burned hundreds of bodies like that but they never forgot the stones.

Sometimes the bodies would not catch fire easily so they used marine fuel to light them—the same marine fuel that they also used in their wooden suicide boats. The boats were irrelevant now. It was obvious to Wada that the enemy who had done this were far beyond anything he and his fellow cadets could do. Their bombs were too big.

All through that night Toshiaki Tanaka remained by his post on the Miyuki Bridge. The following morning, his superiors finally gave him permission to search for his family. The army had begun to set up checkpoints around the inner ring of destruction. Tanaka

was issued a special armband to allow him access. At eight o'clock he began walking. By the time he reached Takano-bashi, a few hundred meters from his home, he knew his family could not have survived. Almost every building had gone. He entered Saiku Street, the bustling thoroughfare along which he had last walked after his lunch of egg rolls thirty-six hours ago. All the houses and shops had disappeared: the furniture store, the greengrocers, the artificial limb shop, the temples, the old wooden inn. There was nothing left. On every side now was a level, barren plain. For the first time in his life he could see out to the mountains beyond.

Alone, he continued up the street, past the Shima clinic where he used to deliver his mother's ice cream as a child. The brick building was almost entirely obliterated. He did not know it, but he was now standing directly beneath the hypocenter of the bomb: this time yesterday, 1,903 feet above his head, *Little Boy* had exploded. He walked on. The liquor store was just eighty meters from the Shima clinic. It had been in his family for three generations. One day his father had hoped to pass it on to him. There was nothing to pass on now. The smashed remains littered the ground. The rubble was still hot. He remembered what his mother had said about losing the war.

The first body he recognized was his neighbor's: he could tell from the shape of his belt buckle, the only part of him that had somehow survived. He stepped gently past. It was very quiet. There was no sound, no birds, no wind, no insects, nothing. He had to tread carefully in the burning rubble. Then he saw them. Two figures, like charcoal sticks, fused together on the ground, facing what was once the doorway. One of the figures was much smaller than the other, a tiny, shapeless bundle pressed against the other's back, as if somehow clinging to it. He knew immediately this was his wife and baby daughter.

He stood perfectly still, staring at them. Despite the terrible burns, their bones stood out. They were extraordinarily white. He could not understand how it was possible they were so white. He

bent down beside them. Then he picked up the bones, placing them one by one in his handkerchief. He stood up. He left the ashes of the liquor store carrying the handkerchief. He walked out into the street that no longer existed and took the bones of his wife and child all the way back to the barracks in Ujina. There he placed them, still in their handkerchief, on a shelf above his bed in his quarters. It was the only home he had left.

FIFTEEN HUNDRED miles to the south on Tinian, Lieutenant Jerome Ossip, the 509th's photographic officer, stared in frustration at the strip of 70mm negatives taken from the various fixed cameras on the strike planes. One by one he examined the frames through his enlarger. In every case it was the same story. All he saw were bits of sky and earth or crazily tilted horizons as the planes executed their impossibly steep escape turns. None of the negatives showed clearly what he was looking for: the mushroom cloud the crew had described so vividly in the debriefing.

It had been a disastrous night. Earlier, Bernard Waldman's ultra-slow-motion Fastax footage of the blast had been rushed to the labs. Somehow half the emulsion had disappeared during processing. The result was several thousand feet of blank film. An entire aircraft and its crew—Dimples 91—had flown the mission for nothing. Ossip did not know then about Harold Agnew's unofficial 16mm movie of the explosion taken from *The Great Artiste*. Agnew had quietly squirreled the film cartridge away. It would only emerge weeks later.

There was still Bob Caron's camera. Ossip finally turned to the little handheld K-20 he had given Caron just before yesterday's takeoff. In the quiet of the laboratory he examined the first image. There, for the first time in front of his eyes, was the extraordinary cloud. He looked at the next image. There it was again, just as Caron had snapped it though his little turret side window: already growing bigger, now a gray-and-white pillar hurtling up from the ground.

He spooled on through the negatives. Seven times he saw the expanding mushroom cloud: each one a pin-sharp, perfectly exposed record of its progress as it boiled up into the stratosphere high above Dr. Kaoru Shima's brick-built clinic on Saiku Street, eighty meters from Toshiaka Tanaka's liquor store.

The amateur photographer had outdone all the experts. *Enola Gay*'s diminutive, nearsighted tail gunner had captured the definitive icon of the bomb—perhaps of the twentieth century. His pictures would soon be in every newspaper across the United States. They would also illustrate many of the six million leaflets that American bombers would begin dropping over forty-seven selected Japanese cities in the next few hours, each one carrying the stark warning of Hiroshima's example.

A FEW hundred meters from Lieutenant Ossip's photo laboratory, enmeshed in their double-fenced cordon on Tinian's northwestern bluffs, the windowless bomb-assembly buildings hummed away. As always, their air-conditioning units worked ceaselessly. The sentries sat behind their machine-gun emplacements. Behind the doors of one of the buildings, two armored steel ballistic casings sat in giant wooden crates, like fat halves of an enormous egg. They had been brought there overnight under cover of darkness. Close by the crates, crouching on a dolly beneath the bright electric lights, was a fifty-five-inch-wide Dural-plated sphere packed with sixty-four explosive charges. It was an exact replica of the sphere that Don Hornig had squatted beside in his corrugated iron shack on top of the tower amid the rain and thunder of the New Mexico desert. There was only one difference: this sphere was not part of a test.

At the back of another building, sitting alone on a shelf, was a small magnesium suitcase. Armed guards watched over it around the clock. Twenty shock-absorbing rubber bumpers sprouted from its sides for protection. A thermometer projected from its innards. It was strangely warm to the touch, at least five degrees centigrade

higher than the ambient temperature. Nestling inside were two hemispheres of plutonium, separated by a thin gold-foil gasket. Together, they weighed exactly 13.6 pounds. It was more than enough to destroy a city.

The Japanese government had not replied to Truman's ultimatum. On the morning Toshiaki Tanaka discovered the bones of his wife and daughter, twenty-four hours after *Little Boy* exploded above Dr. Shima's clinic, the next bomb was being prepared. Its name was *Fat Man* and its heart were those two hemispheres of plutonium now sitting in their magnesium suitcase. Very soon they would be joined to form a single tennis ball–sized sphere, just like their predecessors in George McDonald's ranch house, before being inserted deep into the secret center of the assembled bomb. Oppenheimer once described them as diamonds in an enormous wad of cotton. The diamonds would rain from the heavens again.

EPILOGUE

AT EXACTLY two minutes past noon on Thursday, August 9, 1945, three days and three hours after the destruction of Hiroshima, the crew of *Bockscar,* captained by Major Chuck Sweeney, released *Fat Man* over the city of Nagasaki. Forty-seven seconds later the bomb exploded over the Urakami industrial valley in the northern suburbs with the force of 22,000 tons of TNT—nearly one and a half times more powerful than *Little Boy.* Its original target had been Kokura, 100 miles to the northeast, but the city had been obscured by thick cloud. The weather, which was Kokura's salvation, sealed Nagasaki's fate. In a curious twist of irony, the war had come full circle: *Fat Man*'s hypocenter was almost directly overhead the Mitsubishi armament factories that had produced the torpedoes used in the attack on Pearl Harbor. The bomb destroyed the factories. It also killed some 70,000 people. As in Hiroshima, there was virtually no warning of the attack. The sirens began wailing seven minutes after the explosion.

In an underground bunker in Tokyo, an emergency session of

the Supreme Council for the Direction of the War—the Big Six—
had only just begun. The night before, the Soviet Union had de-
clared war on Japan. Stalin had finally made good his promises to
Truman and Churchill—just as they had feared he would. Since the
early hours of the morning, millions of Russian troops had been
pouring across the Manchurian border in China. The six members
of the Supreme Council, chaired by the prime minister, Kantaro
Suzuki, gathered around the green baize table in the narrow, unven-
tilated bunker to discuss this latest crisis. Their last hope of a favor-
able, Soviet-brokered peace was gone. American bombers were
raining down millions of leaflets threatening further atomic devas-
tation. The choice facing the six men was stark: whether to continue
the struggle or to accept the Allies' terms and surrender. They were
still arguing when an aide interrupted the meeting with the news
that the second atomic bomb had just exploded over Nagasaki.

The two army leaders, supported by the navy chief of staff, were
still determined to fight. "Would it not be wondrous," said General
Anami, the war minister, "for this whole nation to be destroyed like
a beautiful flower?" Prime Minister Suzuki, backed by his foreign
minister Togo and his navy minister Admiral Yonai, was unim-
pressed. The debate grew bitter and heated. Suzuki argued for the
acceptance of the Allied demands, as long as the emperor might be
retained. The war minister and his two cohorts wanted to gain fur-
ther concessions from the Allies. The hours passed, and nothing
was resolved. The six men were divided equally. Toward eleven
o'clock, in an attempt to break the deadlock, the prime minister
called an imperial conference. In the sweltering, airless bunker,
the emperor listened in silence to the opposing sides. At two in
the morning, he finally stood up, took off his spectacles, and
wiped the moisture from the lenses. "The time has come," he said
very quietly, "when we must bear the unbearable. I swallow my own
tears and give my sanction to the proposal to accept the Allied
Proclamation." A sharp wail of grief ripped across his audience.
The emperor left the room.

It was not a moment too soon. On that same Thursday after-
noon, while the Big Six were arguing over the green baize table,
Lieutenant Colonel Tom Classen, the 509th's deputy commander,
took off from one of Tinian's huge runways on the first leg of a
6,000-mile journey across the Pacific. His orders were to collect the
third atomic bomb. Groves had been pushing his people hard: "Pro-
vided there are no unforeseen difficulties," he reported to General
Marshall the next day, "the bomb should be ready for delivery on
the first suitable weather after August 17th or 18th." The favored
target was now Tokyo itself. But as the first indications of a Japanese
surrender reached the United States, Truman decided to delay fur-
ther atomic bombings. According to Henry Wallace, his secretary of
commerce, the president's conscience had begun to bite: "He said
the thought of wiping out another 100,000 people was too horrible.
He didn't like the idea of killing, as he said, 'all those kids.'"

He did not have to. At ten past six on Tuesday, August 14, the
Swiss chargé d'affaires in Washington arrived at the State Depart-
ment with the final text of the Japanese surrender. Five days had
passed since Hirohito's decision in the bunker. The sticking point
had been the precise status of the emperor. In the end the Allies al-
lowed him to retain his office—just as Henry Stimson had urged
the president before any atomic bombs were dropped.

In Washington, tens of thousands gathered in the summer
evening sunshine to celebrate. A huge conga line formed in
Lafayette Square. Cheering crowds surged against the White House
railings. The party was soon in full swing. By tomorrow, millions
would be celebrating across the free world. Nine days after the sky
collapsed over Hiroshima, the war had finally ended. For many of
the survivors, however, the struggle was just beginning.

TAEKO NAKAMAE did not recover consciousness for several days
after her teacher saved her life. When she came around, she could
not see. Her eyes were covered in bandages. Later she learned she

had been brought to Kawanajima, one of the beautiful islands in the Inland Sea, which had been converted into a vast rescue center. Thousands of victims were taken there. Most of the worst cases, the ones who were not expected to live, were in Taeko's hut.

She lay there, in terrible pain, for five days. On August 11, her father found her. He had been searching the entire city and had almost given up hope. She heard his voice as he passed through her hut and called out to him. He rushed to her side, overwhelmed to find her still alive. He did not tell her then that her twelve-year-old sister, Emiko, had already been dead for four days.

Her father had found Emiko too. She had been demolishing houses in Dobashi, 700 meters from the hypocenter, when the bomb exploded. Most of her classmates died instantly. The rest were taken to an elementary school in Koi. Emiko was alive, though very badly burned. On August 7, the day after the bomb, her father had come to the school. He did not recognize his own daughter. With her black and swollen face she looked like everybody else. But she recognized him. She said, "Daddy, I'm here." She asked him to take her home. He hurried off to find her clothes but by the time he returned she was dead. For the rest of his life he blamed himself for not remaining by his daughter's side. He could not bear to think she died alone.

Taeko married after the war. She has one son. She wears an artificial eye to replace the one she lost. She still lives in Hiroshima. Several years ago she became a *taiken shogensha,* one of the peace witnesses who have recorded their experiences of the bomb. Perhaps because her father hid his pain for so long, she has chosen to reveal her own.

Isao Wada returned to his training camp on August 12, six days after the bomb. In that time he had cremated hundreds of bodies across the city. He never once changed his clothes or washed. He barely slept. Almost as soon as the war was over he started to suffer from dysentery. His hair began falling out. He had been in the center of the radioactive city too long. For several weeks he barely

clung to life. Many of the soldiers who had cremated the bodies with him died. Isao survived.

After the war he married and became a barber. He still lives with his wife in Hiroshima. His home is only a few meters from the Dentetsu tram headquarters where he carried the injured and the dying on the first night after the bomb fell.

Dr. Shuntaro Hida remained in the hospital at Hesaka for two months, until late October. Medical supplies soon began to arrive in quantities but often it was too late. Many of his patients died from radiation sickness. Hida himself survived. In the months after the war, he assisted the United States Strategic Bombing Survey teams in Hiroshima to assess the bomb's impact. He is now eighty-eight years old. He has retired as a doctor but is still an active advocate for the victims of both bombs.

Toshiaki Tanaka kept the bones of his wife and daughter on the shelf above his bed. Shortly afterward he learned that his father had also been killed. He had just left the house to buy food when the bomb exploded. On August 14, the day before the Japanese surrender, his mother died from radiation sickness. In one week Toshiaki had lost his entire family. Of all the people who had sat together at that lunch to eat egg rolls, he was the only survivor.

He was discharged from the army in September. For several months, like so many thousands in Hiroshima, he lived in a tent. There he met his second wife, Mitsue, also an atomic bomb survivor. They married in 1946 and had two children, a girl and a boy, and six grandchildren. Mitsue died in 1997 but Toshiaki is still alive. At the age of eighty-eight he lives by himself. He runs a small liquor shop of his own in Hiroshima, just as his father and grandfather did before him. The remains of his first wife and daughter lie in an urn in the family grave.

Yoshito Matsushige and his wife, Sumie, survived the war. For many years he continued to work for the *Chugoku Shimbun*. He also spoke around the world about the events he had witnessed, including more than once at the United Nations. In the decades since

1945 he made it his mission to photograph Hiroshima's rebirth, as a new city rose up from the ashes of the old. Very little of prewar Hiroshima exists. One of the few buildings that survives is Matsushige's own barbershop. It is still there, exactly as it was sixty years ago. Almost the only object missing is the mirror Sumie was lifting off the wall at the moment *Little Boy* exploded.

Matsushige's five images of Hiroshima on August 6, 1945, have become unforgettable icons of that day. He died in Hiroshima on January 17, 2005, at the age of ninety-two. The last time he ever told his story was to the author of this book.

Forty days passed before Sunao Tsuboi emerged from his coma. Like Taeko Nakamae, he had also been brought to one of the island rescue centers, in his case Ninoshima. It was not until he returned to Hiroshima that he discovered that Reiko had not survived. Ten years later he married and had three children. Now aged eighty, he lives alone, a widower, in Hiroshima. His face is still scarred by the burns he received from the bomb. To this day he does not know how Reiko died.

Not all the bomb's victims were Japanese. There were also approximately 53,000 Koreans living in Hiroshima in August 1945—some of them working in forced-labor programs. The most recent studies suggest that at least 25,000 died—almost a sixth of the total casualties. Other nationalities suffered, too, albeit in much smaller numbers, among them up to several hundred Chinese as well as Japanese Americans who had returned from the United States before the war.

Unknown to the target planners, there were also some twenty-three American prisoners of war in Hiroshima on the morning the bomb fell. At least ten of them died. Some were killed immediately in the blast. Others appear to have been murdered later by enraged survivors. Shoichi Noboru, a twenty-nine-year-old farmer from Nakachi, saw two American prisoners when he entered the city on

August 7. One of them was tied to a tree in the castle compound. He was very weak but he was still alive. The second man was bound with electric cables to a pillar on a bridge. He was dead. His skin was cut to shreds and bleeding. Rocks and roof tiles were scattered around his feet. He had obviously been stoned to death. In a savage twist of fate, he had died on the same bridge Tom Ferebee had selected as the aiming point for the bomb: the Aioi Bridge, whose T shape stood out so clearly from 30,000 feet.

"I SUPPOSE you have seen today's newspapers," wrote Leo Szilard to a close friend on the day Hiroshima was destroyed. "Using atomic bombs against Japan is one of the greatest blunders of history. I went out of my way and very much so to prevent it but as today's papers show without success." He did not then know that Truman had never seen the petition that he and sixty-nine of his fellow scientists had signed. Immediately after the Nagasaki bomb, in a move that directly challenged the current of opinion, Szilard organized a collection for the survivors of both cities. He also requested the University of Chicago's chaplain to say special prayers for the dead. The power of the weapon he had envisioned twelve years earlier on a London street crossing horrified him. In his despair he drafted a new petition to the president in which he called the bombings "a flagrant violation of our own moral standards," pleading that they be stopped. The war ended before the petition was sent. Had it been, it is unlikely it would have made any difference.

Until his death, in December 1972, Truman never regretted his decision to drop the bomb. It was, he once claimed, "not a decision you had to worry about." In the immediate aftermath he received a telegram from the Federal Council of Churches of Christ in America opposing further use of the weapon. His response is telling: "Nobody," he wrote, "is more disturbed over the use of the atomic bomb than I am, but I was greatly disturbed over the unwarranted attack by the Japanese on Pearl Harbor and their murder of our

prisoners of war. The only language they seem to understand is the one we have been using to bombard them. When you have to deal with a beast you have to treat him as a beast." The sentiment caught the dominant mood of the nation and her allies at the time. Truman never swerved from it. In 1958 he wrote a letter to the Hiroshima City Council confirming that he would order the bomb to be dropped again, given similar circumstances. "We'll send it airmail," he is reported to have told his secretary. "Be sure there are enough stamps on it!"

Unlike Truman, Henry Stimson always remained ambivalent about the weapon he had helped to create. The decision to use it, he wrote after the war, was "our least abhorrent choice." Perhaps the fact of its abhorrence weighed more heavily on this frail, sensitive, uncertain secretary of war than it did on his master. Two days after Hiroshima's destruction—and the day before Nagasaki's—he had a heart attack. He recovered, but his days at the center of government were very nearly over. A month later, on his seventy-eighth birthday, he left office. One of his last acts as secretary of war was to write a memorandum to the president urging international controls over nuclear weapons. He recognized the danger of an arms race with the Soviets. Left uncontrolled, he believed Frankenstein's monster would destroy mankind. His vision of a peace-loving international community may have been naïve; if so, there is still perhaps something heroic in his naïveté, the last gasp of the old Victorian who suddenly found himself thrust into a new and frightening world. His proposals were not adopted. In the climate of the new cold war, the monster was too valuable to share.

General Groves, unsurprisingly, remained an outspoken advocate for the bomb. "I have no apologies or excuses for its use," he said in a speech two weeks after the Japanese surrender. "We did not start the war." This was his greatest hour. Over the next few months his star began to wane. He had made too many enemies along the way, and now they turned on him. In 1948, somewhat disillusioned, he left the army to join the Remington-Rand Corporation as a director

of research. It paid well but it was not the Manhattan Project. Despite his narrowing field of influence, his bullish can-do skills never deserted him. In his last years he made a very effective campaigner to found a retirement home for widowed army wives. His lifelong battle against his weight continued until the end. Despite the occasional diets, he never got thinner and his addiction to chocolate never waned. He died in 1970 with his wife by his side, a proud, powerful, difficult, monstrous, but always extraordinary man whose achievement at the head of the world's greatest weapons program undoubtedly changed the world—though for good or ill is another question.

His partner Oppenheimer also lost the esteem he had won at the war's end. In 1945 his face graced the cover of *Time* magazine. His porkpie hat was world-famous. But as with Groves, his moment of glory was short-lived. He too had many enemies; moreover, his doubts about the bomb came to haunt him. The fear he had experienced in those first seconds of the Trinity test never disappeared. In October 1945 he resigned from his post as director of the Los Alamos laboratory. Over the next few years he resolutely opposed the development of the hydrogen bomb, a weapon that when first tested in 1952 was a thousand times more powerful than *Little Boy* or *Fat Man*. "This thing," Oppenheimer said, "is a plague of Thebes." His opposition helped to ruin him. In the McCarthy years he became a victim of a witch hunt. His prewar Communist associations were dragged into the public eye. In 1954, his national security clearance was revoked. The man who had built the bomb was effectively regarded as a potential spy. He did not recover. Over the years he became even thinner and more skeletal. His five-pack-a-day habit finally caught up with him in February 1967, when he died, a broken man, of throat cancer. In all that time he never stopped questioning his creation. Perhaps his most prescient warning came in a speech he made on the day he left Los Alamos. "If atomic bombs are to be added to the arsenals of the warring world," he said, "then the time will come when mankind will curse the name of Los Alamos and Hiroshima."

THE TWO bombs undoubtedly shortened the war. How long the Japanese might have held out had they not been dropped will be a source of endless debate. Clearly the fighting would have claimed other lives, though whether as many as—or more than—the number who actually died in both Japanese cities is an unanswerable question. What is more certain is that the perceived threat of the Soviet Union also played a major part in the thinking behind the bomb's use. The arguments have been well-rehearsed, but there is one document in the National Archives that offers an astonishingly revealing insight into the mood of the day. On September 15, 1945, Groves wrote a memorandum, which he subsequently sent to Brigadier General Lauris Norstad, chief of staff of the Army Strategic Air Force. Enclosed was a top-secret three-page report entitled "Estimated Bomb Requirements for Destruction of Russian Strategic Areas." The document contains three columns. The first is a list of sixty-six principal Soviet cities, beginning with Moscow and ending with Ukhta. The second specifies each city's size in square miles. The third details the number of atomic bombs required to destroy it. Six bombs would be needed for Moscow; a total of 204 bombs to wipe out every city on the list.

The document is undated. An index at the National Archives gives it as August 30, 1945. At the very least it predates mid-September, when Groves enclosed it in his memorandum. The implications in either case are startling. Just one month after the end of the war—and possibly as little as *two weeks*—the eyes of American strategists were already firmly on the USSR. In Hiroshima and Nagasaki, the corpses were still being cremated. Whatever else was achieved, the two Japanese cities provided invaluable evidence for what atomic bombs could do elsewhere. Oppenheimer's curse applied before he even made it.

TODAY, the Trinity site is part of the White Sands Missile Range, a vast testing ground for the military's latest weapons. "If it's a missile," says a brochure on Trinity handed out to tourists, "we fire it." There are not too many tourists now. The 51,500-acre site is opened to the public only once a year. Every visitor is required to complete a short course in weapons recognition: the ground is littered with dangerous explosives. The test site itself is surrounded by a chain-mail fence with black-and-yellow signs warning of radioactivity. The levels are acceptably low, though they still exist, six decades later. The location of the tower where Don Hornig kept his lonely vigil on the night before the test is marked with a stone tablet. It is even possible to find pieces of greenish-glass Trinitite on the ground. It is still faintly radioactive. The authorities do not encourage visitors to take any home.

George McDonald's ranch house two miles southeast also exists. It was restored to precisely its condition on July 12, 1945, when the work of bomb assembly began. The living room where General Farrell felt the plutonium core in his rubber gloves is now pristine. The overriding impression today is silence. The place is eerily quiet. For months at a time it sits alone, unvisited, in one of the emptiest, remotest parts of the United States.

The Los Alamos National Laboratory has also survived, but not as a monument. It is still an operational weapons development facility, and parts of its site are strictly off-limits. It is far larger than it was in 1945. Permanent housing for its staff sprawl over the mesa and beyond. Almost nothing is left of the temporary wooden structures erected during the war. Oppenheimer's office, where Hiroshima was once selected as a target, no longer exists. The pioneer days are long gone. A bustling street of shops and restaurants now crosses the town. The place is nevertheless alive to its past. The Bradbury Museum exhibits artifacts from the nuclear era. Until recently it displayed one of the bombs from the *Little Boy* series, but after the atrocities of September 11, 2001, the bomb was removed

from the museum. The museum's director, John Rhoades, told the author that it was now "under lock and key" in secure storage somewhere on National Laboratory property. Its location is strictly classified. "If I tell you more than that," Mr. Rhoades wrote, "I'll have to shoot you."

THREE WEEKS after the war's end, Paul Tibbets, Dutch Van Kirk, and Tom Ferebee flew in a C-54 transport plane to Nagasaki. They would have landed at Hiroshima, but its airport's runways were too badly damaged. They went in company with Japanese and American observers. The U.S. occupation forces had not yet entered the city. Nobody in Nagasaki knew who they were.

Their initial reaction was amazement at the scale of destruction from a single bomb. That fact, more than any other, appears to have been the dominant impression. "It scares the hell out of you," said Van Kirk sixty years later. They did not see any of the 70,000 casualties of the bomb. There were no bodies anywhere. They stayed in a bamboo hostel—"like a summer camp," said Tibbets—and ate excellent food. They even went souvenir shopping. Tibbets bought several hand-carved rice bowls and saucers that he took back with him to the United States. "We became," he later told one interviewer, "typical American tourists."

Very few of the crews who flew either the Hiroshima or the Nagasaki mission ever expressed guilt for what they had done. Some were more outspoken in this than others—perhaps their leader most of all. "I have absolutely no feeling of guilt," said Tibbets twenty years after the Hiroshima mission. "I was directed to do it. If I were directed to do such a thing today, I've learned in all these years of military service to follow orders, so I'd follow them without question." He has never changed his mind. Now aged ninety, his faith in the rightness of his actions remains undimmed. His belief that the bomb was justified because it saved lives is unquestioned. It has made him both a hero and an object of loathing. In October

1976 he caused an international outrage when he simulated an atom bomb drop in a Texas air show, flying in a restored B-29 bomber. Engineers on the ground created a mushroom-shaped explosion in front of a crowd of 40,000. The mayor of Hiroshima denounced the action as "grotesque." The Japanese foreign minister protested to the United States government. Tibbets could not see what the fuss was about. The bombing of Hiroshima was not something he felt obliged to apologize for. "I've never lost a night's sleep over the fact that I commanded the bombing," he said after the air show. "The gray hairs I've got now came from the pressures of business." It is a sentiment he has echoed more than once down the years.

Tibbets is one of only three surviving crew members of the *Enola Gay*. Dutch Van Kirk, his navigator, lives with his wife near San Francisco. At the age of eighty-four, he too has no regrets about his actions. The bomb, he says, had no impact on his life. "I will not apologize for it," he says, "because I truly, honestly believe it saved a lot of lives." Morris Jeppson, the man who helped Deak Parsons arm the bombs, subscribes to a similar creed. Back in 1960, however, he suggested in an interview that the bomb might have been demonstrated to the Japanese "without the need for destroying a city." In correspondence with the author, he has recently written of his "sorrow" at the "great tragedy" in Hiroshima. Other crew members, now deceased, have also spoken occasionally of their sorrow—though not of their guilt. "You don't brag about wiping out sixty to seventy thousand at one time," admitted Robert Shumard, the assistant flight engineer. Bob Lewis, the copilot who wrote the mission log, believed that the war ended sooner as a result of the bombs. But that view from the window in those first few minutes appears to have haunted him for many years. "I can't get it out of my mind that there were women and children and old people in that mess," he said. Some of his fellow crewmen remained skeptical, not least when Lewis sold his log in 1971 for $37,000. (In 2002, it was auctioned for $350,000.)

One crew member who did explicitly acknowledge remorse was

Bob Caron, *Enola Gay*'s tail gunner, who died in 1995. He once described the effect of seeing photographs or movies of the victims, especially of the burned children. "That is the only time I might have had a partial feeling of guilt," he said. "I wish I hadn't seen them." After the war he became an aviation designer. He had three more children in addition to the baby girl whose picture he carried in his turret to Hiroshima. The specter of a nuclear holocaust increasingly concerned him as he got older. "When I think about the fission and fusion bombs of today," he once said, "I wonder whether we're not getting into God's territory."

PERHAPS A quarter of a million people died as a result of the two atomic bombs dropped by the 509th Composite Group. Not a single member of the 509th itself was killed. Their only casualty of the war was a military policeman who injured his hand disarming an old Japanese shell.

The 509th still holds annual reunions but their ranks are rapidly thinning. Over the course of my researching this book, two members of the crew who dropped the bomb on Nagasaki died, including their captain, Chuck Sweeney. A few veterans, among them Tibbets himself, may return to Tinian Island for the sixtieth anniversary in August 2005. It will almost certainly be for the last time. There will be a simple ceremony by the bomb-loading pits, which have recently been renovated. Almost everything else has long since disappeared. The runway from which *Enola Gay* took off is now a swath of cracked coral, half swallowed in jungle. The bomb assembly buildings, once the most secret place on the island, are now deserted ruins, the weeds growing through the old foundations. The 509th compound where the crews lived, ate, slept, wrote their letters home, and prayed for the end of the war, has also been lost to the jungle. There are no signs or plaques. The foliage is impenetrable. Everybody went home long ago.

TODAY THE Shukkeien Garden is a beautiful oasis of peace in the heart of the modern city of Hiroshima. It was all painstakingly restored after the war. Everything looks almost exactly as it did: the wooden teahouses and the lake, the hidden paths and ornamental rocks, the islets and the turtles and the flowers. The air is filled once again with the scent of fresh pine and the sound of cicadas. For a few moments, perhaps, it is possible to stand on the gray-stone rainbow bridge and believe that everything is just the same as it was sixty years ago, when Sunao Tsuboi held Reiko's hand under the stars on the happiest night of their lives.

ENDNOTES

I have tried to keep these notes to a minimum. The range of sources I have used—interviews, primary and secondary written works—are listed in the bibliography. Unless otherwise specified, all interviews are with the author. In most instances, except where it might be confusing, I have given only the author's name for published works. Full details may be found in the bibliography. Generally, I have given page numbers only for very specific references. For avoidance of repetition, I have not included the year 1945 each time it applies.

Prologue

Sunao Tsuboi's story from interview. Details of the Shukkeien garden from author's visit, July 2004.

Act 1
Chapter One

Don Hornig's experience on the tower are from his (and his wife, Lilli's) interview and subsequent communication with author, supplemented by accounts in Lamont (especially pp. 196ff) and Rhodes (p. 665). Details of the X-unit, sphere assembly, and detonators in Coster-Mullen (probably the most in-depth account that exists of the bomb's mechanics); also interviews

with Los Alamos scientists Henry Linschitz and Benjamin Bederson. George Kistiakowsky in "Trinity—A Reminiscence" (*Bulletin of Atomic Scientists,* June 1980) also describes the X-unit failure from passing atmospheric discharge. Trinity's elaborate scientific instrumentation is in Lamont, Rhodes, Szasz, Goodchild, Hoddeson, and especially Merlan's astonishing technical breakdown.

The background to Truman at Potsdam is from Mee's excellent account (especially pp. 72ff). Also McCullough (pp. 405ff). Truman's own description of the Little White House ("a dirty yellow and red") is in his diary (Ferrell, pp. 50–51). The minutes of the Joint Chiefs' meeting with Truman, June 18 is in *Manhattan Project* (eds. Stoff etc.), including breakdowns of casualty estimates and projected opposition. It is important to remember that the figures apply only to the invasion of Kyushu, not to the later, second invasion on the Tokyo plains. On July 8, the Combined Intelligence Committee estimated that Japanese divisions facing the Americans by the end of 1945 would total 2 million men. The issue of what casualty estimates Truman and his advisers believed at the time remains very controversial. In postwar accounts Truman argued that American troops might have suffered up to 1 million casualties. The question remains whether these were actual figures upon which he based his decision to drop the bomb, or rather postwar justifications for its use.

For Oppenheimer, see Goodchild, Smith, Szasz, Lamont (especially for the account of Greisen's encounter with traffic policeman), and Kurzman. Also Rhodes, especially on experimental failures such as Creutz.

Lilli Hornig waiting on Sandia Peak from interview. Los Alamos accounts from *Los Alamos 1943-1945,* Lamont, Norris, and especially Wilson for a woman's perspective.

Chapter Two

History of Jornada and buildup for Trinity in Szasz, Hoddeson, and Lamont. Rhodes and Laurence's 1946 account for Hanford plutonium plants. Philip Morrison interview for bomb-core assembly, supplemented by author's visit to Ground Zero location, McDonald ranch and base camp site in May 2004. Technical details of radioactivity and chain-reaction principles from Laurence, Rhodes, and author's communication with Los Alamos physicist Henry Linschitz. Coster-Mullen (p. 44) gives an extraordinary account of Slotin's accident; also gives details of core size, explosive assembly arrange-

ment, and the use of Scotch tape and Johnson's Baby Powder. Norris Bradbury memorandum to "personnel concerned," July 9, 1945, for a full breakdown of the Trinity timetable, beginning July 7 and ending July 16 0400 with the single word "BANG!" (Coster-Mullen, p. 253).

Details of storm especially from Szasz; personal recollections ("Eyewitness Reports") from Los Alamos National Laboratory Archives (LANL) and interviews with Don Hornig, Linschitz, and Morrison.

Oppenheimer character and description are from his own correspondence in Smith; Goodchild (also for dementia praecox), Alvarez, Wyden. For Fermi's bets on earth's demise and reactions, Rhodes (p. 664) and Lamont (p. 194). Groves character and relationship with Oppenheimer especially in Norris and Goodchild; also Groves's own account in *Now It Can Be Told*. Even Oppenheimer's driver was spying on him for Groves.

Chapter Three

Truman's encounter with Churchill is in his diary (ed. Ferrell), and own memoirs; also Byrnes's and Churchill's memoirs. Modern sources include Mee, Kurzman, McCullough.

Hubbard's weather dilemmas (and equipment) are in Szasz, altogether an authoritative account of the entire meteorological crisis. Also Lamont for Bainbridge's escape routes and *Wizard of Oz* code names for monitors. Oppenheimer's May 11 memorandum warning of what would be later called black rain is in 4F, M1109, RG 77, National Archives (Nara). The actual progress of the radioactive cloud after the test is given in a memorandum to Groves from Stafford Warren, medical director of the Manhattan Project, dated July 21, 1945 (4b, M1109, RG 77, Nara). He also details radiation monitors placed in key areas. There is, he writes (five days after the test) "still a tremendous quantity of radioactive dust floating in the air."

Chapter Four

Sato's character and description are in Kurzman (including his drinking habits); also Craig, Butow and *Day Man Lost*. The account of Sato's interview with Lozovsky is described in his cable to Togo July 13–14 (in Magic Summary No. 1207, dated July 15, Box 18, RG 257, Nara).

Stimson's description is in Hodgson and Mee; also his own memoirs. Min-

utes of Interim Committee meeting May 31, 1945, by R. Gordon Arneson in Harrison-Bundy File, Folder 100, Manhattan Engineer District, RG77, Nara. Stimson's own notes before meeting in Rhodes (p. 642). (The bomb, he writes, "May [be] *Frankenstein or* means for World Peace.") Togo's cable to Sato on July 12 translated in Magic Summary No. 1205 dated July 13, RG 457, Nara. Bard's June 27 resignation memorandum is in Harrison-Bundy File, Folder 77, Manhattan Engineer District, RG77, Nara. McCloy's quote about heads being examined in Wyden (p. 171).

Leo Szilard's background is in Rhodes (also for the story of conceiving the bomb on a London street in 1933), Wyden, Kurzman. For a less flattering perspective, Compton, and Groves in *Now It Can be Told.* Szilard's petition to the president (and accompanying letter to Groves's deputy, Colonel Kenneth Nichols) in Harrison-Bundy File, Folder 71, RG 77, Nara. Szilard's encounter with Byrnes ("rattling the bomb . . . might make Russia more manageable") and also with Oppenheimer ("the atomic bomb is shit") in Weart and Gertrud Weiss Szilard (pp. 184–85). The Scientific Panel (of which Oppenheimer was one of four members) officially endorsed the Interim Committee's conclusion to use the bomb in *Recommendations on the Immediate Use of Nuclear Weapons,* dated June 16, Harrison-Bundy File, Folder 76, RG 77, Nara.

Chapter Five

Hubbard's 2 A.M. meeting with Groves and Oppenheimer in Goodchild, Rhodes, Szasz, and Lamont. Press releases dated May 14 with various possible Trinity scenarios in 4A 1/2, M1109, RG 77, Nara. Groves's fear about Fort Leavenworth in Norris (pp.174–75).

Laurence's own extraordinary account of Trinity and his involvement in the Manhattan Project in *Dawn Over Zero.* Groves in *Now It Can Be Told* (pp. 325–27) describes his meeting with the managing editor of the *New York Times.* Laurence's article, *The Atom Gives Up,* in *Saturday Evening Post,* September 7, 1940. In their own accounts both Laurence and Groves refer to the investigation of all individuals across the nation who requested a copy. The archivist at the *Saturday Evening Post* confirms that names and addresses of those individuals were supplied to intelligence agencies. Laurence's May 17 memorandum with breakdown of future articles on Manhattan Project in 5A (a), M1109, RG 77, Nara.

Chapter Six

USS *Indianapolis* and loading of *Little Boy* bomb parts in Stanton and New-comb, Richard, *Abandon Ship!: Death of the USS Indianapolis.* (New York: Henry Holt, 1958). Also Wyden, Lamont, Knebel and Bailey (henceforth Knebel). Coster-Mullen for rumors about MacArthur's toilet rolls.

For the final minutes in the concrete bunker at S-10,000, Goodchild, Rhodes, Szasz. Lamont (p. 220) for radio interference from KCBA. This story is also recounted by an unnamed Trinity eyewitness in a radio interview transcript, dated March 25, 1946 (LANL Archives). Interview with Philip Morrison for base camp atmosphere in last minutes. Fermi describes his torn strips of paper in *Observations During the Explosion at Trinity on July 16, 1945* (LANL Archives); his remark to Anderson about the potential yield is in Lamont (p. 224). Laurence in *Dawn Over Zero* for the last moments on Compania Hill. Moss for description of spy Fuchs and information already handed to the Soviets.

B-29 observation aircraft (before and after test) in Alvarez, Christman (especially for Deak Parsons's perspective). Interview with Lawrence Johnston, one of the observers on board (Johnston would be the only observer to witness all of the first three atomic explosions, at Trinity, Hiroshima, and Nagasaki). Details of B-29 operation at Trinity contained in a memorandum from its commander and pilot, Major Clyde Shields, to Norman Ramsey, entitled "Report of 'T' Test Aircraft Operations," dated July 22, 1945. The memorandum also describes the phenomenon of St. Elmo's Fire (Parsons Papers).

Interview with Hornig for his joke to Oppenheimer. Also interviews with Linschitz and Morrison for the last seconds before zero. General Farrell's account at S-10,000 enclosed with Groves's memorandum to Secretary of War Henry Stimson, July 18, in *Manhattan Project* (pp. 190–91). Oppenheimer's last prayer quoted in Rhodes (p. 669). Lamont refers to the mating spadefoot toads and Georgia Green.

Chapter Seven

Description of explosion from various sources including: interviews with Linschitz, Hornig (Don and Lilli), Morrison; eyewitness accounts written shortly after the event by Maurice Shapiro, Otto Frisch, Enrico Fermi, Captain R. A. Larkin, Victor Weisskopf, Ralph Carlisle Smith, Edwin McMillan

(LANL Archives); Laurence and Groves for their recollections in later years; also numerous secondary sources including Rhodes, Lamont, Szasz, Knebel, Wyden, Goodchild, Norris, Hoddeson, Christman. Figures for temperature of fireball and shockwave from personal communication with Coster-Mullen and also LANL report LA-550 *Crossroads Handbook of Explosion Phenomena*. Details of impact beyond the test site in Groves's July 18 memorandum to Stimson (see above); also Szasz (especially pp. 83ff). Groves's words to Farrell about using two bombs, Rabi's *High Noon* account of Oppenheimer, Bainbridge's line ("sons of bitches"), in Rhodes (pp. 675–76).

Truman's tour of Berlin in Mee, Kurzman, McCullough and also Truman's own diary (ed. Ferrell).

Herbert Anderson's experience in the tank at Ground Zero in Laurence and Lamont (pp. 245–46). Lamont states that the frequency Anderson used to radio back his observations was also used by the Carrizozo taxi service.

Harrison cable to Stimson and latter's reply in 5E, M1109, RG 77, Nara.

Act 2

Groves quotation from Norris (pp. 376–77) (originally interview with George Carroll). Truman quotation from Alperovitz (p. 179).

Chapter Eight

Caron's description and character from author's interviews and communication with Kenneth Eidnes, Van Kirk, Classen, Albury, Bivans. Also Caron's own autobiography and Marx. Eidnes supplied details of turret and gun sight mechanism. Details of *Enola Gay* missions from Campbell. The author visited Tinian in July 2004. Today, most of the air base is swallowed up in the undergrowth.

North Field's B-29 operations against Japan from Birdsall (also for specification of the B-29). Coffey's biography of Le May and Le May's own memoirs for the Tokyo raid.

509th headquarters and accommodation from interviews (as above, and also with Agnew, Albury, Morrison, Smith, Jeppson, Linschitz, Ramsey) and Tibbets in *Mission: Hiroshima* (also for story of "Skippy" Davies). Interview with Albury for the five fridges (and washing machines). Harold Agnew recalls the $25,000 dessert in *Time* magazine (July 29, 1985). Smithsonian archives have excellent photographs of the 509th compound, including the

Pumpkin Playhouse and softball field. The best account of specially adapted B-29s is in Campbell.

Chapter Nine

Account of mission planning from interview with Van Kirk, supplemented by official *History of 509th*, August 31, 1945 (LANL Archives), which gives a breakdown of all "pumpkin" missions. Official reports also in Tinian Files, RG 77, Nara.

Tibbets character and background to 509th from interviews with Albury, Ashworth, Bivans, Classen, Mary Anne Ferebee, Jeppson, Ramsey, Van Kirk, and Weatherly. Also published memoirs of 509th crews, including Tibbets himself, Beser, Caron, Olivi and Sweeney. I am indebted to Thomas and Morgan-Witts for their detailed account of the 509th and Jim Petersen at Historic Wendover Airfield for his information on my tour of the area in May 2004. Tibbets's article, "How to Drop an Atom Bomb" from the *Saturday Evening Post*, June 8, 1946. The Japanese Imperial Staff estimate which missed out the 509th is in Craig (pp. 44–45).

Account of Truman's encounter with Stalin in his diary (ed. Ferrell), and own memoirs; also Byrnes's memoirs. Modern sources include Mee, Kurzman, McCullough and, for a Russian perspective, Sebag Montefiore. The substance, though not the text, of the Imperial letter is described in Sato's cable to Togo recounting his meeting with Lozovsky on July 13 (Magic Summary No. 1207, July 15, Box 18, RG 257, Nara).

Chapter Ten

Hirohito's physical condition in July 1945, details of the "Basic Policy" and June 22 meeting in Kurzman, Craig, Butow and *Day Man Lost*.

Eatherly's attempted bombing of the Imperial Palace described to author by crew member Bivans. Added aspects of Eatherly's character and behavior in interview with his commander, Classen. Supplementary details in Huie and Thomas and Morgan-Witts. Eatherly's career after the war was controversial and checkered: he attempted a number of robberies (with a toy pistol) and spent some years in a psychiatric institution. Some have argued that he was affected by guilt over the Hiroshima bombing, others that his innate instability tragically overcame him.

Details of first four pumpkin (known as "Special") missions on July 20 in

Tinian Files, RG77, Nara, and *History of 509th* (LANL Archives). Spitzer Diary is reproduced on the Children of the Manhattan Project website. Knebel (p. 106) quotes the Radio Tokyo report about confused enemy tactics.

The fate of Szilard's petition in Kurzman (p. 392). Compton's covering letter to Nichols (dated July 24) in Harrison-Bundy File, Manhattan Engineer District, Folder 71, RG77, Nara. In a poll commissioned by Groves of 150 MetLab scientists only 15 percent voted for "use of weapons in a manner that is from the military point of view most effective in bringing about prompt Japanese surrender at minimum human cost to our armed forces." (Memorandum from Farrington Daniels to Compton, July 13, in *Manhattan Project*, p. 173). One of the best studies of the scientists' dilemma is Alice Kimball Smith, *A Peril and a Hope: The Scientists' Movement in America: 1945–1947* (University of Chicago Press, 1965).

Chapter Eleven

USS *Indianapolis* speed record and Nolan's predicament in Stanton. Description of *Little Boy* mechanism and principle in Coster-Mullen, supplemented by author's interview with Ramsey.

The race to complete Groves's July 18 report on Trinity is from his own account in *Now It Can Be Told*. Knebel (p. 89) supplies the detail about the biblical quote. The report itself is quoted in *Manhattan Project* (pp. 190–91). Kurzman and Mee describe Truman's shopping while Stimson waits. Stimson's reaction to the report and Truman's response are from Stimson's Diary for July 21, and also Hodgson. Kurzman (p. 383) quotes Churchill's observation of Truman bossing the Potsdam session.

Both Groves's cables and Stimson's reply in 5E, M1109, RG 77, Nara. The argument over Kyoto is detailed in Wyden. Groves's quote about Kyoto's people appreciating the bomb's significance is in Norris (p. 384).

Chapter Twelve

Caron's letter from his autobiography. Other sources for life on Tinian, including Perry's breakfasts and the poem about the 509th, in Thomas and Morgan-Witts, Knebel, Tibbets, Sweeney, as well as interviews with Eidnes, Classen, Van Kirk; also Spitzer Diary. Author's interview with Morrison, in which he describes the crashes on North Field.

Details of *Little Boy* tests in Ramsey's *History of Project A*, supplemented by interview with author. The foundations of one of the three bomb-assembly buildings are still visible today, albeit deep in the undergrowth and almost inaccessible. Coster-Mullen provides written and photographic documentary evidence for the building layout (including flooring and air-conditioning). Other published sources include Campbell (test-drop missions listed with date, crew, and aircraft) and Russ (a Project Alberta scientist), for details of loading procedure (p. 47).

The account of the top-secret bomb-assembly areas and their development is based on author's interviews with Ashworth and Ramsey. Ashworth's papers provide transcripts of numerous telephone conversations between himself and Parsons concerning equipment transports to Tinian. He also supplies the quotation about "X bags of cement." A June 1, 1945, telecon from Kirkpatrick to Major Derry (Groves's assistant in Washington) lists equipment to be shipped to Tinian including, among other things, "6 family-size refrigerators" and an office stapler! (Tinian Files, Box 17, RG77, Nara). The files contain extensive such lists, and Kirkpatrick's heroic efforts to chase orders, throughout April to August 1945.

The note from Groves's wife in Groves's Papers, RG 200, Nara. Jean O'Leary's diary of Groves's telephone calls from the same source. Groves's July 23 bomb-production estimates in Harrison's cable to Stimson (WAR 37350) in 5E, M1109, RG 77, Nara. The same file contains Groves's Directive, as finally sent by radio to Stimson in Potsdam. By the time it was sent, Nagasaki had replaced Kyoto as a target. A map of Japan, torn from a copy of *National Geographic*, was delivered separately by courier.

Chapter Thirteen

Most of the first section of this chapter is based on interviews with Taeko Nakamae as well as with all Japanese witnesses listed in the bibliography. Sources also from the *Chugoku Shimbun*, published Japanese accounts by Suzuko Numata and Dr. Shuntaro Hida, unpublished diaries of Sakamoto, Shikoku, and Umekita (all in the Hiroshima Peace Memorial Museum); also various secondary sources, including *Day Man Lost*, Knebel (who refers to the famous willow trees and the rumor about Truman's mother), Rhodes, Kurzman, and Wyden.

Population figures (including troop levels) in *Hiroshima and Nagasaki:*

The Physical, Medical, and Social Effects of the Atomic Bombings (p. 352 [henceforth *Hiroshima and Nagasaki*]). According to Rhodes (p. 714), this is the most authoritative study of the Hiroshima bombing.

Target Selection Committee minutes for April 27 and May 9–10, in 3D, 2 (a) and (b), M1109, RG 77, Nara.

The exhortation to "kill Japs" was on a billboard commissioned by Admiral Halsey on Tulagi Island in the Solomons. It continued: "You will help to kill the yellow bastards if you do your job well." According to one of his biographers, John F. Kennedy would have seen the billboard when he disembarked at Tulagi as a young naval officer (see Robert J. Donovan, *PT-109: John F. Kennedy in World War II* [New York: McGraw-Hill, 1961]). In the context of attitudes at the time toward the Japanese, a photo-essay, "A Jap Burns," in *Life* magazine, August 13, 1945, is also very revealing. Six photographs portray in graphic detail the death of a Japanese soldier in Borneo from an American flamethrower, with such captions as: "Blind and still burning, he makes agonized reach for support." On the opposite page is a full-color advertisement for Campbell's Mushroom Soup ("mushrooms fresh from the hothouse").

Chapter Fourteen

Sources for Stimson's meeting with Truman in Hodgson, McCullough, Wyden, Mee. Also for Truman's mention of the bomb to Stalin, with additional material from memoirs of Truman, Churchill, Byrnes. Oppenheimer's quote about Truman's casualness in Rhodes (p. 690). Details of Soviet nuclear program from Rhodes, Moss, Sebag Montefiore. Molotov's remark about Kurchatov in Mee (pp. 222–23). Its source is Marshal Zhukov, a witness, who describes the moment in his own memoirs. Stimson's cable approving Groves's directive in 5E, M1109, RG 77, Nara. His trout is referred to in his diary entry for July 26.

On the decision to drop the bomb, the following memoirs: Truman, Stimson (also his *Harper's* article, February 1947), Byrnes, Churchill; also secondary sources: Alperovitz, Butow, Coffey, Feis, Fogelman, Hodgson, McCullough, Kurzman, Norris, Rhodes, Wyden. Groves's remark about subduing "the Russkies" is in Norris (p. 331), who gives its original source as Joseph Rotblat, a scientist living with Chadwick. The silver deposits are recounted by Groves in *Now It Can Be Told*. He also refers to the toboggan. Truman's equation of two Japanese cities and a quarter-million Americans is

quoted in McCullough (p. 439). His diary entry for July 26 is in Ferrell. His headaches are in Griese (p. 253).

Chapter Fifteen

USS *Indianapolis* arrival in Tinian harbor from interview with Ashworth, who relates the story of the near-accident with the bucket. Christman, Knebel, Thomas and Morgan-Witts for the receipt, a facsimile of which is in Ashworth's papers.

Details of C-54 uranium and plutonium shipments for both *Little Boy* and *Fat Man* in two memoranda from Groves to General Harold George, dated July 23–24, 3(k) and (l) M1109, RG 77, Nara. Further details in Hoddeson (p. 390) and Coster-Mullen for weights of materials. De Silva's engine failure in Groves, Coster-Mullen, Knebel. Raemer Schreiber tells the story of his flight in an interview with the *Albuquerque Journal,* Special Report, July 1995.

For Nagasaki casualty figures see notes on Epilogue (see p. 341).

For the fate of USS *Indianapolis* the author is indebted to Stanton and Newcomb; also Rhodes.

Chapter Sixteen

Text of Potsdam Declaration in *Manhattan Project* (ed. Stoff) (pp. 215–16). *Day Man Lost* (p. 211) for station operative Katsuyama's actions, and the Declaration reaching Suzuki. Also Rhodes and Mee (especially for Truman and the buglers in Potsdam). Craig, Butow and *Day Man Lost* for Togo's arguments at the July 27 Big Six meeting. Kurzman for Suzuki's background in navy and character. Butow (p. 148), Wyden (p. 233), Thomas and Morgan-Witts (p. 321ff) for Suzuki's July 28 press conference and the varied meanings of *mokusatsu*.

Naoe Takeshima's recollection of the Potsdam Declaration leaflets in her interview with the author. Leaflets were dropped on thirty-five Japanese cities.

Act 3
Chapter Seventeen

Account of August 4 briefing from interviews with Albury, Van Kirk; also Spitzer Diary; Caron, Sweeney, and Tibbets autobiographies. Secondary sources include Christman, Coster-Mullen, Knebel, Kurzman, Thomas and Morgan-Witts, Rhodes. The memorandum to Parsons regarding "super-powerful sirens" is from Bradbury, Kistiakowsky, and Roy, dated July 17, entitled "Proposal for a Modified Tactical Use of the Gadget" (in Parsons's Papers). Parsons's character from interviews with his brother Bob and daughter Clara. Bob Parsons also supplied story of his wounding on Iwo Jima and meeting Deak in the San Diego hospital.

Ramsey's originally classified *History of Project A* for *Little Boy* tests; supplementary information from Campbell and Coster-Mullen (especially p. 23 for "Old Faithful"). Farrell's August 2 cable to Groves in Tinian Files, Box 21, RG77, Nara.

Chapter Eighteen

Actual weather reports for Japan from Hiroshima District Meteorological Observatory, July 31 to August 6. Accounts of Taeko Nakamae and Sunao Tsuboi from author's interviews.

U.S. synoptic chart for August 5 in Tinian Files, RG77, Nara. Norris (p. 382) for Target Selection Committee meteorologists' predictions. Interview with Ramsey for Tinian Joint Chiefs meeting. Details of bomb's fusing system from Beser's autobiography (including the edible rice paper, p. 106) and Coster-Mullen. Parsons's concerns about the crashing bombers in Laurence (Laurence reached Tinian on that Sunday); he also reproduces the dialogue between Parsons and Farrell.

Truman's diary August 5 (ed. Ferrell) for encounter with George VI. Also McCullough. Griese's biography of AT&T PR executive Arthur Page describes Page's draft of the president's statement (p. 253).

Chapter Nineteen

Interview with Isao Wada for his account of August 5. Further details of Konoura training camp from interview with Hiroshi Sugawara, also a suicide-boat volunteer, and author's visit, July 2004.

For afternoon preparations on North Field, interviews with Agnew, Albury, Classen (and subsequent communications), Johnston; autobiographies of Alvarez (especially details of blast canisters), Caron, Tibbets and Sweeney; secondary sources Hoddeson, Knebel, Marx, Thomas and Morgan-Witts. Interview with Van Kirk for final planning, also for Ferebee description (supplementary information from interviews with Mary Anne Ferebee and Albury). Aiming-point decision in Tibbets (p.196) and Thomas and Morgan-Witts (p. 361). USAAF reference for Aioi Bridge in Field Orders for Special Mission No. 13, August 2 (in Tinian Files, RG77, Nara).

Interview with Tanaka for lunch of egg rolls.

Details of *Little Boy* loading from interview with Ramsey, supplemented by photographs and 16mm film in LANL Archives and Nara; also Tibbets autobiography, Rhodes, Thomas and Morgan-Witts. The loading accident took place in a rehearsal at Kirtland air base, Albuquerque: memorandum Bolstad to Larkin, July 13 (Parsons Papers). Crash crew in letter from former Fire Marshal George Sallas (see bibliography). Coster-Mullen notes the line about the *Indianapolis* "reportedly" scrawled on the bomb. Interviews with Jeppson and Leon Smith for bomb monitoring console. Caron's afternoon on softball field from his autobiography. Albury, Classen and Van Kirk supplied assessments of Lewis to the author.

Laurence and Christman describe Parsons's arming practice. The "Check list for loading charge in plane with Special breech plug" is in Parsons Papers. Tibbets confirms Parsons's cut and bleeding hands. Thomas and Morgan-Witts for Farrell's offer of pigskin gloves. Tibbets relates the story of naming the B-29.

Chapter Twenty

Interview with Hida for his account of the night of August 5–6 and also his published account (in bibliography).

Evening and final briefing: interviews with Albury, Jeppson, Ramsey, Van Kirk; Spitzer Diary; facsimile of Downey's prayer (in Manhattan Project Heritage Preservation Association website); Beser, Caron, Sweeney, Tibbets autobiographies; *History of 509th*. Also secondary sources: Campbell, Christman, Coster-Mullen, Knebel, Marx, Thomas and Morgan-Witts; mission details (including routes, frequencies, etc.) in Field Orders for Special Mission No. 13, dated August 2 (in Tinian Files, RG77, Nara). Van Kirk interview, Tibbets, Thomas and Morgan-Witts for pre-mission breakfast.

Description of Hiroshima from *Chugoku Shimbun*; also interviews with Japanese eyewitnesses (listed in bibliography).

For *Straight Flush* and *Enola Gay* takeoffs: interviews with Albury, Bivans, Jeppson, Ramsey, Van Kirk, Weatherly; also Caron (for letters with Dodgers manager), Laurence, Sweeney, Tibbets (for MGM parallel and poison pills). Secondary sources: Christman, Knebel, Marx, Rhodes, Thomas and Morgan-Witts (for Ferebee's discovery of condoms). B-29 start-up procedures from author's communication with Classen and B-29 Flight Manual (see bibliography). Interview with Harold Agnew on the dangers of nuclear accident in a takeoff crash, even without cordite charges loaded into the bomb. Also Christman interview with Francis Birch (inventor of the breech-plug assembly) in which he claims *Little Boy* was vulnerable to nuclear accident in the event of fire, ditching, or a crash (Parsons Papers). Farrell's cable to Groves in Tinian Files, Box 21, RG77, Nara. His prayer in Laurence (p. 210).

Chapter Twenty-one

Groves in *Now It Can Be Told* and Norris for waiting in Washington.

For early hours of flight, interview with Van Kirk and his *Navigator's Log*; also Lewis in-flight log. Interview with Jeppson for bomb arming; Parsons in-flight log; additional material from Christman. Parsons's spelling bee described in Christman's interview with Parsons's sister, Clarissa (p. 3, in Parsons Papers). Additional material: interviews with Bob and Clara Parsons. Details of cordite bags in Coster-Mullen. Laurence describes fears on Tinian when Parsons's voice faded. The account of Truman aboard USS *Augusta*, including Merriman Smith's remarks, is in McCullough.

Caron's discussion with Tibbets about the bomb is described in both Tibbets and Caron (from which the dialogue comes).

Stimson's day in Port Washington from his Diary entry for August 5. Magic summary in RG457, Nara.

For approach to Iwo Jima: interviews with Van Kirk, Jeppson, Albury, Agnew, Johnston; Van Kirk's *Navigator's Log*; Lewis log; Spitzer Diary; Beser, Caron, Tibbets (who describes his in-flight smoking habits), Sweeney. Secondary sources: Christman, Marx, Rhodes, Thomas and Morgan-Witts; Hough for Iwo Jima battles.

Chapter Twenty-two

Hiroshima weather from Hiroshima District Meteorological Observatory (for August 6). Interviews with Hida, Nakamae. Hiroshima statistics from *Hiroshima and Nagasaki* and United States Strategic Bombing Survey (USSBS Pt. II: "The Effects of the Bombings," M1013, Nara). Rhodes (p. 713) for the number of schoolchildren involved in demolition work. Further material from *Chugoku Shimbun*.

The figures of American POWs are from Thomas and Morgan-Witts. Two B-24 Liberators—*Taloa* and *Lonesome Lady*—had been shot down near Hiroshima on July 28 returning from a mission to sink the Japanese battleship *Haruna*. Thirteen of their crew members were prisoners in Hiroshima on August 6. The fourteenth, pilot Thomas Cartwright, was taken to Tokyo for interrogation before the atom bomb was dropped.

The question of American POWs had been raised before the atomic mission. On July 31, General Spaatz sent two cables to Washington stating that Hiroshima was the only one of four targets selected for atomic destruction that had no Allied POW camps. (He specifically identified a POW camp one mile north of Nagasaki city center.) Washington's response (effectively, if not nominally, from Groves) was: "Targets previously assigned ... remain unchanged. However, if you consider your information reliable, Hiroshima should be given first priority." (5D 3 (b) M1109, RG77, Nara). The assumed absence of U.S. POWs in the city was one reason why it was destroyed.

Jeppson's account in the bomb bay is from an interview with Coster-Mullen. Additional material for this part of the flight: interviews Van Kirk, Agnew, Albury, Johnston; *Navigator's Log*; Lewis log; Parsons log; Spitzer Diary; Beser, Caron, Sweeney, Tibbets.

Chapter Twenty-three

Details of air defense bunker from *Chugoku Shimbun* and testimony of Kosuke Shishido, an officer in Hiroshima military headquarters. Secondary sources: *Day Man Lost*, Thomas and Morgan-Witts. Also author's visit to bunker's remains, July 2004. The carp are still in the moat. Testimony of Masanobu Furuta for broadcast of alert (in *On Microphone on the Day of the A-Bomb*, in *On the Microphone* [author's translation from Japanese], ed. Shuichi Fujikura [Japan: 1952]). Wyden (p. 254) for times. Japanese interviews for the indifferent response to alert.

Straight Flush arrival over Hiroshima: interviews Bivans, Weatherly. Weather details from *Special Mission Number 13: Observed Weather* (Tinian Files, RG77, Nara). In the same files, Apcom 5245 (post-mission report from Farrell to Groves), which states: "One-tenth cloud cover with large open hole directly over target."

Tibbets gives weather code and translation; additional material in Parsons log (also for weather reports from Kokura and Nagasaki); Lewis log; *Navigator's Log*.

Chapter Twenty-four

Communication delay and tennis in Groves's own account; also Norris (especially for Groves's tennis skills). In an interview Ramsey gave to Christman, he suggests that the strike report was delayed by General MacArthur under a rule that all such reports had to be announced from his headquarters in Manila and not from Washington. When Ramsey learned to his horror that the message had not reached Washington, he tried to resend it via every available channel: "I think we even tried to send something by Postal Telegraph!" (p. 30, interview Ramsey, Parsons Papers).

Strike force approach Hiroshima: interviews Agnew, Albury, Jeppson, Johnston, Van Kirk; *Navigator's Log*; Lewis log; Spitzer Diary; Alvarez, Beser (for Japanese radar lock and dialogue), Caron, Tibbets, Sweeney. Secondary sources: Christman, Knebel, Marx, Rhodes, Thomas and Morgan-Witts, Wyden. Parsons's codelist of twenty-eight scenarios (*Top Secret Special Table*, Ramsey Papers, Smithsonian) drawn up with Ramsey the day before the mission (interview with Ramsey).

For reaction on the ground, interviews with Wada, Tsuboi, Nakamae, Matsushige.

Chapter Twenty-five

For Norden bombsight operation: *Manual M-Series*. Interview Mary Anne Ferebee for Thomas Ferebee's roses. Tibbets for Ferebee's dialogue. Last ninety seconds: interviews Agnew, Albury, Jeppson, Johnston, Van Kirk; *Navigator's Log*; Lewis log; Spitzer Diary ("I've got my fingers crossed," he writes); Alvarez, Beser, Caron, Sweeney, Tibbets. Secondary sources: Christman, Knebel, Marx, Rhodes, Thomas and Morgan-Witts, Wyden.

Air-raid observation posts: Knebel, Thomas and Morgan-Witts, Wyden, *Day Man Lost*. Furuta's testimony (above) for radio station. Interview Matsushige for bicycle.

Chapter Twenty-six

Bomb drop interviews: Agnew, Albury, Jeppson, Johnston, Van Kirk; in Japan: Hida, Tanaka, Nakamae; Wada; also *Navigator's Log*, Parsons log, Spitzer Diary. Alvarez, Beser, Caron, Sweeney, Tibbets. Secondary sources: Christman, Coster-Mullen (excellent on mechanisms), *Day Man Lost*, Knebel, Marx, Rhodes, Thomas and Morgan-Witts, Wyden. Drop data from records tabulated by Malik. Both Agnew and Jeppson in their interviews recall from earlier drop tests the sound of the bomb as it fell. Testimony of Furuta in radio station (as above).

Act 4

Tibbets quotation in *U.S. News and World Report*, August 5, 1985. Truman's response to the news of the bomb in McCullough (p. 454), whose source is Merriman-Smith.

Chapter Twenty-seven

Details of bomb's impact: immediate temperature at the burst-point confirmed by Coster-Mullen from LANL report LA-550 *Crossroads Handbook of Explosion Phenomena*. The temperature decreased rapidly as the fireball expanded: according to *Hiroshima and Nagasaki* (the report compiled between 1977 and 1979 by thirty-four Japanese specialists), after 0.1 millisecond, the fireball was 15 meters in radius, with a temperature of 300,000 degrees centigrade. Within 0.2 seconds it was 7,700 degrees (approximately equivalent to the temperature of the sun's surface). The heat rays causing thermal burns were largely infrared, emitted in massive amounts in the first 0.2 to 3 seconds after the explosion. The report also classifies thermal burns in five grades. It finds that the most severe Grade 5 burns ("carbonization") occurred within 1 to 1.5 kilometers of the hypocenter. It also finds "evaporation of viscerae" within this area (pp. 120–21), a claim supported, albeit unofficially, by various eyewitness reports. The author is also indebted to Rhodes for his authoritative account.

For radioactive isotopes, author's communication with Linschitz. Sources for radioactivity effects: *Hiroshima and Nagasaki*, U.S. Strategic Bombing Survey (RG243, Nara) and Rhodes. In this context, it is important to clarify that American strategists (notably Groves) intended the bomb's impact to be from heat and blast, not radioactivity. A memorandum from Groves to the Chief of Staff, dated July 30 (a week before the mission) makes this clear. "With respect to the probable effects of the combat bomb," he writes, "no damaging effects are anticipated on the ground from radioactive materials. These effects at New Mexico resulted from the low altitude from which the bomb was set off." (5B(o) M1109, RG77, Nara). The burst height was fixed at 1,850 feet because this was estimated as the most efficient altitude for the destruction of people and buildings through blast and fire, not radioactivity. In fact, however, as the U.S. Strategic Bombing Survey suggested after the war, the numbers of deaths in Hiroshima would have been approximately the same from radioactive contamination without *any* of the effects of heat and blast: "The principle difference would have been in the time of the deaths" (p. 19).

For shockwave velocity and pressures, U.S. Strategic Bombing Survey. This also provides statistics for destruction of buildings from blast. Wyden (p. 254) for Eizo Nomura. Personal accounts from interviews with Hida, Matsushige, Tanaka, Nakamae, Tsuboi.

For reaction (and dialogue) from strike aircraft: interviews Agnew, Albury, Jeppson (and subsequent communication with author), Johnston, Van Kirk; Spitzer Diary; Lewis log; Alvarez, Beser, Caron, Sweeney, Tibbets. Secondary sources: Christman, Knebel, Marx, Rhodes, Thomas and Morgan-Witts, Wyden. Based on blast gauge canister data, Malik estimates *Little Boy*'s yield at the equivalent of 15,000 tons of TNT. According to Taylor, the total tonnage of bombs dropped on Dresden on the night of February 13–14, 1945, was 2,647 tons. The weight of highly enriched uranium (HEU) that actually fissioned to produce the yield is in Coster-Mullen. Given the much larger total amount of HEU in its core, *Little Boy* was an extremely inefficient bomb.

For the reaction to the strike report on Tinian: Laurence (a witness). The two reports from *Enola Gay* are in Box 21, Tinian Files, RG77, Nara. In the author's possession is a copy of the once-only code with its twenty-eight scenarios, given to him by Ramsey. The numbers corresponding to the strike message are ticked, as they came in over the radio.

Chapter Twenty-eight

Interview with Hida for his experiences immediately after the bomb. Likewise, Nakamae, Matsushige, Tsuboi. Statistics for Hiroshima's destruction largely from U.S. Strategic Bombing Survey, including the quotation (p. 20 of Part 2 of the report). Casualty figures are notoriously varied. I have given both the immediate postwar U.S. Strategic Bombing Survey estimates and also the much higher later estimates of Rhodes, one of the most authoritative historians of the bomb. He suggests (p. 734) that deaths up to the end of 1945 reached 140,000; by 1950, they had reached 200,000. Similar figures are also given in *Hiroshima and Nagasaki,* which reaches its conclusion after a detailed assessment of estimates from various sources.

Enola Gay reaction on flight home: interviews Jeppson, Van Kirk. Lewis log, *Navigator's Log,* Parsons log for Japanese fighter and distance of aircraft from mushroom cloud when it finally disappeared. Flak details in Special Mission 13 final report, August 6 (Tinian Files, Nara). Also Beser, Caron, Tibbets.

Chapter Twenty-nine

Groves's own account for dinner and telephone calls. Secondary sources: Norris, Knebel.

Firestorm and black rain: U.S. Strategic Bombing Survey, and Hiroshima District Meteorological Observatory. Also *Hiroshima and Nagasaki.* I am grateful to Taylor for his explanation of the firestorm in *Dresden.* Personal impact of firestorm: interviews with Hida, Nakamae.

For the news of the bomb spreading to the rest of Japan: *Day Man Lost,* Knebel, Wyden. Satoshi Nakamura's story from personal communication with author.

Celebration preparations from Morgan and Thomas-Witts. The invitation reproduced in their book was shown by the author to Van Kirk, who confirmed its validity.

Chapter Thirty

Matsushige interview, for his experience and photographs. Also interviews with Tsuboi and Tanaka. Red Cross hospital damage statistics from U.S. Strategic Bombing Survey. Additional material from interviews with Red Cross student nurses Matsumoto, Oshima, and Takeshima. Interview with

Wada for account of his rescue operation. Supplementary information from interview with Wada's fellow volunteer, Sugawara.

Enola Gay's arrival on Tinian and debriefing: interviews with Jeppson, Ramsey, Van Kirk. *Navigator's Log.* Parsons's signature and words on receipt for "tubealloy" (Ashworth papers). Also Beser, Caron, Laurence, Tibbets. Secondary sources: Christman, Marx, Norris, Thomas and Morgan-Witts.

Chapter Thirty-one

Strike message to Groves and subsequent events in Washington: Groves, Knebel, Norris. Apcom 5245 with latest observations of bombing in Tinian Files, RG77, Nara. According to O'Leary's diary, Groves made eighteen congratulatory calls that day (Groves Papers, RG200, Nara).

Similarly, Stimson's Diary for August 6 details (with typical precision) the ten telephone calls he received at his Highhold estate. He records drily: "It was a rainy day and I didn't miss much by my occupation on the telephone."

For Truman on USS *Augusta*: Truman's memoirs (which quotes the cable from Stimson), and especially McCullough (also for Merriman-Smith remarks). Groves's own account for the Washington press conference; also Wyden. An earlier draft of the president's statement is in M1109, RG77, Nara. It does not contain the line "an important Japanese Army base."

For Groves's family hearing the news and his wife Grace's quotation: Norris (p. 357). Tibbets's parents also heard the news on the radio. Enola Gay was proud of her son. Later she told a reporter: "If that bomb brings the Japs to time it will save the lives of our boys" (Tibbets, pp. 234–35).

For president's statement reaching Japan: Butow, Knebel, Kurzman, Wyden.

Chapter Thirty-two

Groves and Oppenheimer telephone conversation quoted in Rhodes (pp. 734–35). O'Leary also notes the time of the call in her diary. For the reaction in Los Alamos: Goodchild (especially for witness to the boxer salute), Lamont, Rhodes, Smith, Wyden. Rhodes also quotes scientist Otto Frisch: "Somebody opened my door and shouted, 'Hiroshima has been destroyed!'; about a hundred thousand people were thought to have been killed. I still remember the feeling of unease, indeed nausea, when I saw how many of my friends were rushing to the telephone to book tables at the La Fonda Hotel in Santa Fe, in

order to celebrate." The euphoria does not appear to have lasted long. According to one account, as Oppenheimer left a party later that night, he saw a (sober) fellow-scientist vomiting into the bushes. Oppenheimer reportedly turned to a colleague and said: "The reaction has begun" (Smith, p. 292).

Accounts in Hiroshima from interviews with Hida, Wada, Tanaka.

Ossip in the photo lab is from Caron. Hoddeson describes disaster of Waldman's Fastax film. Rhodes gives figures for leaflets translated by Japanese POWs and printed by the Office of War Information on Saipan. There were various versions of the leaflet. One declared: "We have just begun to use this weapon against your homeland. If you still have any doubt, make inquiry as to what happened to Hiroshima" (Laurence, p. 222). A bureaucratic error meant that Nagasaki received its leaflets warning of impending destruction the day after it had already been destroyed by the second atomic bomb.

Preparations for *Fat Man* in Coster-Mullen, Goodchild, Hoddeson, Rhodes, Russ. Also interviews with Ashworth, Bederson, Linschitz, Morrison, Ramsey.

Epilogue

Nagasaki and the final days of war: Butow, Coster-Mullen, Craig (especially for details of conference bunker), Kurzman, Mee, McCullough (for Anami's "beautiful flower"), *Day Man Lost*. For Nagasaki casualties, Rhodes (p. 740) and *Hiroshima and Nagasaki* (p. 113). According to Rhodes the tally of deaths reached 140,000 by 1950. Classen's account of leaving to collect the third atomic bomb is from his interview. Groves's cable to Marshall is in Tinian Files, Box 9, RG77, Nara. Henry Wallace's recollection is in Rhodes (p. 743).

Japanese survivors: interviews with Nakamae, Wada, Hida, Tanaka, Matsushige, Tsuboi.

Figures for Korean victims from *Hiroshima and Nagasaki* and author's communication with Hiroshima Council of Korean A-Bomb Survivors. *Hiroshima and Nagasaki* for numbers of American POWs believed to have died in (or after) the bomb. Interview with Shoichi Noboru for accounts of the two POWs. Hida, in his interview, also saw the POW in the castle compound on August 7. He describes his "boyish face"; in a moment of pity, Hida says, he cut the man's ropes with his knife.

Szilard's letter to Gertrud Weiss (later his wife) is in Rhodes (p. 735). Truman's letter to the Federal Council of Churches is in Wyden (p. 294) as is

also his reported remark about the stamps to his secretary. For Stimson's re-actions to the bomb see Hodgson. Groves's speech (at Oak Ridge on August 29) is in Norris (p. 441). Norris also provides details of Groves's subsequent career and retirement. Oppenheimer's postwar career is charted in Goodchild (who quotes his speech on leaving Los Alamos), Kurzman, Smith, Wyden.

Groves's memorandum to Norstad with the attachment about Russian cities is in 3B M1109, RG77, Nara.

Details of Trinity site, McDonald ranch, and Los Alamos from author's visits, May 2004.

Visit to Nagasaki from interviews with Albury (who was also on the trip) and Van Kirk. Tibbets describes the rice bowls in his autobiography. His stated absence of guilt is quoted in Marx (p. 245). The air show and associ-ated quotation is from the *Washington Post,* October 14, 1976.

Other crewmembers' postwar reactions: interviews with Jeppson and Van Kirk; Marx; fifteenth-anniversary feature in *Coronet,* August 1960 (especially for Caron's "partial feeling of guilt"). Knebel (p. 108) for the 509th's single ca-sualty. Lewis's exact words on board *Enola Gay* will never be known. On ar-rival back at Tinian, Beser handed the disc recording the crew's conversations to an official after which it disappeared, never to be seen or heard of again.

Descriptions of North Field and the Shukkeien Garden as they are today from the author's visits, July 2004.

SOURCES AND BIBLIOGRAPHY

Author's Interviews

The following interviews were conducted between April 2004 and March 2005. Where applicable, the roles described are as they were in August 1945.

United States

Harold Agnew, observer, *The Great Artiste*
Charles D. Albury, pilot, *The Great Artiste*
Frederick Ashworth, weaponeer, *Bockscar*
Benjamin Bederson, Project Alberta
Jack Bivans, assistant engineer, *Straight Flush*
Thomas Classen, deputy commander, 509th composite group
Mary Anne Ferebee, wife of Thomas Ferebee, bombardier, *Enola Gay*
Don Hornig, physicist, Los Alamos
Lilli Hornig, chemist, Los Alamos
Morris Jeppson, weapon test officer, *Enola Gay*
Lawrence Johnston, observer, *The Great Artiste*

Henry Linschitz, physicist, Los Alamos
Roger Meade, Los Alamos National Laboratory Archives
Philip Morrison, Project Alberta
Bob Parsons, private, U.S. Marines, Iwo Jima
Clara Parsons, daughter of Deak Parsons, weaponeer, *Enola Gay*
Jim Petersen, Historic Wendover Airfield, Utah
Norman Ramsey, Project Alberta
Leon Smith, weaponeer, 509th composite group
Dutch Van Kirk, navigator, *Enola Gay*
Ira Weatherly, copilot, *Straight Flush*

Japan

Toshio Fukada, schoolboy, Hiroshima
Bun Hashizume, schoolgirl, Hiroshima
Dr. Shuntaro Hida, army physician, Hiroshima
Takumi Kamio, flight engineer, Ozuki
Hiroto Kuboura, engineer, Japan National Railways, Hiroshima
Chieko Matsumoto, student nurse, Red Cross hospital, Hiroshima
Sumie Matsushige, wife of Yoshito, Hiroshima
Yoshito Matsushige, press photographer, Hiroshima
Keiko Nagai, schoolgirl, Hiroshima
Taeko Nakamae, schoolgirl, Hiroshima
Yasuo Nakamura, transport pilot, Fukuoka
Kikuo Nishida, ordnance specialist, Kure
Shoichi Noboru, farmer, Itsukaichi
Suzuko Numata, telephone communications employee, Hiroshima
Kimie Oshima, student nurse, Red Cross hospital, Hiroshima
Hiroshi Sugawara, volunteer, Special Attack Forces, Etajima
Naoe Takeshima, student nurse, Red Cross hospital, Hiroshima
Toshiaki Tanaka, corporal, Akatsuki Corps, Ujina Port
Keisaburo Toyonaga, schoolboy, Hiroshima
Sunao Tsuboi, engineering student, Hiroshima
Isao Wada, volunteer, Special Attack Forces, Etajima

Primary Sources

Ashworth, Vice-Admiral Frederick. Personal papers, in his possession.

————. *USS Augusta, Her Story.* Unpublished record, dated October 15, 1945, in personal papers.

Boeing B-29 Superfortress, *Flight Manual,* www.flight-manuals-on-cd.com Ltd.

Chugoku Shimbun, July-August 1945. Microfilm, Hiroshima Central City Library, Hiroshima.

Enola Gay, Technical Logs, July-August 1945. Archives, Smithsonian National Air and Space Museum, Washington, D.C.

Franck Report, June 11, 1945, in *The Manhattan Project: A Documentary Introduction to the Atomic Age.* Eds. Michael Stoff, Jonathan Fanton, R. Hal Williams. New York: McGraw Hill, 2000.

Groves, Leslie. Papers. Record Group (RG) 200. National Archives and Records Administration. College Park, Md.

Hiroshima District Meteorological Observatory. Reports July 31–August 6, 1945, Hiroshima Regional Weather Bureau, Hiroshima.

History of 509th Composite Group, 313th Bombardment Wing, Twentieth Air Force, Activation to 15 August 1945. Manuscript drafted at Tinian, August 31, 1945, Los Alamos National Laboratory Archives, Los Alamos, N.M.

Inquiry into Atomic Bomb at Hiroshima. Japanese investigation, September 1945, translated MS in collection of Kikuo Nishida, former ordnance specialist, Kure.

"A Jap Burns." *Life* magazine, August 13, 1945.

Jones, Richard N. *Memoirs of United States Navy, 1941–1945, aboard USS Augusta* unpublished.

Kozu, Lt. Comm. Y. *View of Hiroshima Photographed 24 Hours from Atomic Attack* unpublished. Collection of Kikuo Nishida, former ordnance specialist, Kure.

Kuboura, Hiroto. *The Bomb That Destroyed My Youth* trans. Personal testimony unpublished.

Lewis, Robert A. *Bombing of Hiroshima, August 6, 1945.* Mission log, *Enola Gay.* Archives, Smithsonian National Air and Space Museum, Washington, D.C.

Malik, John. *Hiroshima and Nagasaki Mission Data Summaries.* Los Alamos National Laboratory Archives, Los Alamos, N.M.

National Archives and Records Administration. Records of the Office of the Chief of Engineers, Entry 1, Top Secret Correspondence of the Manhattan Engineer District, 1942–1946, Microfilm M1109, Record Group (RG) 77. College Park, Md.

———. Records of the Office of the Chief of Engineers, Manhattan Engineer District, Entry 3, Tinian Files, April–December 1945, Boxes 17–21, RG 77. College Park, Md.

———. Records of the Office of the Chief of Engineers, Manhattan Engineer District, Entry 20, Harrison-Bundy Files Relating to the Development of the Atomic Bomb, Microfilm M1108, RG 77. College Park, Md.

———. Records of the United States Strategic Bombing Survey, Final Reports 1945–7. Microfilm M1013, Rolls 18 and 24, RG 243. College Park, Md.

———. Records of the National Security Agency, Magic-Diplomatic Summaries. Box 18, RG 457. College Park, Md.

Norden Bombsight, M-Series, Manual. Archives, Historic Wendover Airfield, Utah.

Parsons, Deak. Private papers. Los Alamos Historical Museum, Los Alamos, N.M.

———. *Check List for Loading Charge in Plane with Special Breech Plug*, in Private papers. Los Alamos Historical Museum, Los Alamos, N.M.

———. Log of *Enola Gay's* mission to Hiroshima. In Ramsey Papers, Archives, Smithsonian National Air and Space Museum, Washington, D.C.

Ramsey, Norman F. *History of Project A*. Manuscript, draft 27 September 1945, Doc. 29-6 Los Alamos National Laboratory Archives. Los Alamos, N.M.

———. *Top Secret Special Table:* Code sheet for reporting results of bombing of Hiroshima, August 6, 1945. Archives, Smithsonian National Air and Space Museum, Washington, D.C.

———. Papers. Archives National Air and Space Museum, Washington, D.C.

Sakamoto, Yoshitada. Unpublished diary, Hiroshima, July-August 1945. Hiroshima Peace Memorial Museum, Hiroshima.

Sallas, George M., former fire marshal, North Field, Tinian. Communication to Robert van der Linden, August 6, 1990. Archives Smithsonian National Air and Space Museum, Washington, D. C.

Shikoku, Naoto. Unpublished diary, Hiroshima, July-August 1945. Hiroshima Peace Memorial Museum, Hiroshima.

Spitzer, Abe. Diary July-August 1945. Courtesy of Joan Hinterbichler, Manhattan Project Heritage Preservation Association Inc.

Stimson, Henry L. Microfilm of personal diary. McKeldin Library, University of Maryland, College Park, Md.

———. "The Decision to Use the Atomic Bomb." *Harper's* magazine. February 1947.

Szilard, Leo. "A Petition to the President of the United States," in *The Manhattan Project: A Documentary Introduction to the Atomic Age*. Eds. Michael Stoff, Jonathan Fanton, R. Hal Williams. New York: McGraw Hill, 2000.

Tibbets, Paul. "How to Drop an Atom Bomb." *Saturday Evening Post*, June 8, 1946.

Trinity Test, Eyewitness Reports of Nuclear Explosion. Los Alamos National Laboratory Archives, Los Alamos, N.M.

Truman, Harry S. *Off the Record: The Private Papers of Harry S. Truman*. Ed. Robert Ferrell. New York: Penguin, 1980.

Umekita, Tomiko. Unpublished diary, Hiroshima, July-August 1945. Hiroshima Peace Memorial Museum.

Van Kirk, Dutch. *Navigator's Log, Enola Gay, August 6 1945*. Facsimile, in possession of author.

Secondary Sources

Alvarez, Luis W. *Adventures of a Physicist*. New York: Basic Books Inc, 1987.

Alperovitz, Gar. *Atomic Diplomacy: Hiroshima and Potsdam: The Use of the Atomic Bomb and the American Confrontation with Soviet Power*. New York: Random House, 1965.

Bernstein, Barton, ed. *The Atomic Bomb: The Critical Issues*. Boston: Little, Brown, 1976.

Beser, Jacob. *Hiroshima and Nagasaki Revisited*. Memphis, Tenn.: Global Press, 1988.

Birdsall, Steve. *Saga of the Superfortress: The Dramatic Story of the B-29 and the Twentieth Air Force*. New York: Doubleday & Co., Inc., 1980.

Bruckner, Karl. *The Day of the Bomb*. Princeton, N.J.: D.Van Nostrand Company Inc., 1962.

Byrnes, James F. *All in One Lifetime*. New York: Harper & Brothers, 1958.

Butow, Robert J. C. *Japan's Decision to Surrender*. Palo Alto, Calif.: Stanford University Press, 1954.

Campbell, Richard H. *They Were Called Silverplate: A History of Silverplate B-29s' Deliveries and Operations from 1943 to 1960.* Arizona: Becan Press, 2003.

Caron, George R., and Charlotte E. Meares. *Fire of a Thousand Suns: The George R. "Bob" Caron Story—Tail Gunner of the Enola Gay.* Colorado: Web Publishing Company, 1995.

Chinnock, Frank W. *Nagasaki: The Forgotten Bomb.* New York: The World Publishing Company, 1969.

Church, Fermor S., and Peggy Pond. *When Los Alamos was a Ranch School.* Los Alamos, N.M.: Los Alamos Historical Society, 1998.

Coffey, Thomas M. *Iron Eagle: The Turbulent Life of General Curtis LeMay.* New York: Crown Publishers Inc., 1986.

Committee of Japanese Citizens. *Days to Remember: An Account of the Bombings of Hiroshima and Nagasaki.* Japan: Hiroshima-Nagasaki Publishing Committee, 1981.

Compton, Arthur Holly. *Atomic Quest.* New York: Oxford University Press, 1956.

Coster-Mullen, John. *Atom Bombs: The Top Secret Inside Story of Little Boy and Fat Man.* Self-published, 1996.

Craig, William. *The Fall of Japan.* New York: The Dial Press, 1967.

Christman, Al. *Target Hiroshima: Deak Parsons and the Creation of the Atomic Bomb.* Annapolis, Md.: Naval Institute Press,1998.

Del Tredici, Robert. *At Work in the Fields of the Bomb.* London: Harrap Ltd., 1987.

Farrell, Don A. *Tinian.* Tinian: Micronesian Publications, CNMI, 1992.

Feis, Herbert. *The Atomic Bomb and the End of World War II.* Princeton, N.J.: Princeton University Press, 1966.

Fogelman, Edwin. *Hiroshima, The Decision to Use the A-Bomb.* New York: Scribner Research Anthologies, 1964.

Goodchild, Peter. *J. Robert Oppenheimer: "Shatterer of Worlds."* London: BBC, 1980.

Griese, Noel L. *Arthur W. Page: Publisher, Public Relations Pioneer, Patriot.* Atlanta: Anvil Publishers, Inc., 2001.

Groves, General Leslie M. *Now It Can Be Told: The Story of the Manhattan Project.* New York: Harper, 1962.

Hachiya, Michihiko, M.D. *Hiroshima Diary: The Journal of a Japanese Physician, August 6–September 30, 1945.* Chapel Hill: University of North Carolina Press, 1955.

Hersey, John. *Hiroshima*. London: Penguin Books, 1986.

Hida, Dr. Shuntaro. *The Day Hiroshima Disappeared: Testimony by a Bombed Doctor*. Dr. Hida's collection, no publication details.

Hiroiwa, Chikahiro. *Hiroshima Witness for Peace: Testimony of A-Bomb Survivor Suzuko Numata*. Japan: Soeisha/Books Sanseido, 1993.

Hiroshima Peace Memorial Museum. *The Spirit of Hiroshima: An Introduction to the Atomic Bomb Tragedy*. Hiroshima: Hiroshima Peace Memorial Museum, 1999.

Hoddeson, Lillian; Paul W. Henriksen; Roger A. Meade; Catherine Westfall, eds. *Critical Assembly: A Technical History of Los Alamos during the Oppenheimer years, 1943–1945*. Cambridge: Cambridge University Press, 1993.

Hogan, Michael J., ed. *Hiroshima in History and Memory*. Cambridge: Cambridge University Press, 1996.

Hough, Frank O. *The Island War: The United States Marine Corps in the Pacific*. Philadelphia: J.P. Lippincott Company, 1947.

Huie, William Bradford. *The Hiroshima Pilot*. New York: Pocket Books, 1964.

Ibuse, Masuji. *Black Rain*. Tokyo: Kodansha International Ltd., 1969.

Jenkins, Rupert, ed. *Nagasaki Journey: the Photographs of Yosuke Yamahata, August 10, 1945*. San Francisco: Pomegranate Books, 1995.

Jungk, Robert. *Brighter Than a Thousand Suns*. Harmondworth, Middlesex: Penguin Books, 1956.

Kimball Smith, Alice, and Charles Weiner, eds. *Robert Oppenheimer: Letters and Recollections*. Cambridge, Mass.: Harvard University Press, 1980.

Knebel, Fletcher, and Charles W. Bailey II. *No High Ground: The Complete Eye-Opening True Story of the First Atomic Bomb*. New York: Bantam Books, 1961.

Kurzman, Dan. *Day of the Bomb: Countdown to Hiroshima*. New York: McGraw-Hill, 1986.

Lamont, Lansing. *Day of Trinity*. New York: Atheneum, 1965.

Laurence, William L. *Dawn over Zero: The Story of the Atomic Bomb*. New York: Alfred A. Knopf, 1950.

LeMay, General Curtis E., and Kantor MacKinlay. *Mission with LeMay: My Story*. New York: Doubleday, 1965.

Levine, Mark. *Enola Gay*. Los Angeles: University of California Press, 2000.

Los Alamos National Laboratory. *Los Alamos 1943–1945: The Beginning of an Era*. Los Alamos, N.M.: Los Alamos National Laboratory, 1986.

McCullough, David. *Truman*. New York: Simon & Schuster, 1992.

Marx, Joseph L. *Seven Hours to Zero.* New York: G. P. Putnam's Sons, 1967.

Matsushige, Yoshito, ed. *Atomic Bomb Photo Testament.* Hiroshima: Sasaki Printing Co., 2002.

Merlan, Thomas. *The Trinity Experiments.* WSMR Archaeological Report No. 97-15, 1997.

Moss, Norman. *Klaus Fuchs: A Biography: The Man Who Stole The Atom Bomb.* New York: St. Martin's Press, 1987.

Nagai, Takashi, M.D. *Atomic Bomb Rescue and Relief Report.* Nagasaki: Nagasaki Association for Hibakushas' Medical Care NISHAM, 2000.

Norris, Robert S. *Racing for the Bomb: General Leslie R. Groves, The Manhattan Project's Indispensable Man.* Hanover, N.H.: Steerforth Press, 2002.

Olivi, Fred J., Lt. Col. USAF Ret. *Decision at Nagasaki: The Mission That Almost Failed.* Glenview, Ill.: Handgun Press, 1998.

Ogura, Toyofumi. *Letters from the End of the World: A Firsthand Account of the Bombing of Hiroshima.* Tokyo: Kodansha International, 1997.

Oppenheimer, J. Robert. *The Open Mind.* New York: Simon & Schuster, 1955.

Rhodes, Richard. *The Making of the Atomic Bomb.* New York: Simon & Schuster, 1986.

Roberts, Sam. *The Brother: The Untold Story of the Rosenberg Case.* New York: Random House, 2001.

Rowe, James Les. *Project W-47.* Livermore, Calif.: JA A RO Publishing, 1978.

Russ, Harlow. *Project Alberta: The Preparation of Atomic Bombs for Use in World War II.* Los Alamos, N.M.: Exceptional Books Ltd., 1984.

Sebag Montefiore, Simon. *Stalin: The Court of the Red Tsar.* London: Phoenix, 2003.

Selden, Kyoko, and Mark Selden, eds. *The Atomic Bomb: Voices from Hiroshima and Nagasaki.* New York: M. E. Sharpe, 1989.

Stanton, Doug. *In Harm's Way: The Sinking of the USS Indianapolis and the Extraordinary Story of its Survivors.* New York: Henry Holt, 2001.

Stimson, Henry M., and McGeorge Bundy. *On Active Service in Peace and War.* New York: Harper & Brothers, 1947.

Stoff, Michael B., Jonathan F. Fanton, and R. Hal Williams, eds. *The Manhattan Project: A Documentary Introduction to the Atomic Age.* New York: McGraw-Hill, 2000.

Sweeney, Maj. Gen. Charles W. *War's End: An Eyewitness Account of America's Last Atomic Mission.* New York: Avon Books, 1997.

Szasz, Ferenc Morton. *The Day the Sun Rose Twice: The Story of the Trinity Site Nuclear Explosion, July 16, 1945.* Albuquerque: University of New Mexico Press, 1984.

Takaki, Ronald. *Hiroshima: Why America Dropped the Atomic Bomb.* New York: Little, Brown, 1995.

Taylor, Frederick. *Dresden: Tuesday, February 13, 1945.* New York: Harper-Collins, 2004.

The Committee for the Compilation of Materials on Damage Caused by the Atomic Bombs in Hiroshima and Nagasaki. *Hiroshima and Nagasaki: The Physical, Medical, and Social Effects of the Atomic Bombings.* New York: Basic Books Inc./ Harper & Colophon Books, 1981.

The Pacific War Research Society. *The Day Man Lost: Hiroshima, 6 August 1945.* Tokyo: Kodansha International, 1972.

Thomas, Gordon, and Max Morgan-Witts. *Enola Gay.* New York: Stein & Day, 1977.

——. *Ruin from the Air.* London: Sphere Books Ltd., 1977.

Tibbets, Paul W. *Mission: Hiroshima.* New York: Stein & Day, 1985.

Tibbets, Paul W. *The Tibbets Story.* New York: Stein & Day, 1978.

Trinity Site, July 16, 1945, Official Guide. U.S. Government Printing Office, no date.

Truman, Harry S. *Memoirs by Harry S. Truman: Volume One, Year of Decisions.* New York: Doubleday, 1955.

Trumbull, Robert. *Nine who Survived Hiroshima and Nagasaki.* New York: Dutton, 1957.

Truslow, Edith C. *Manhattan District History: Nonscientific Aspects of Los Alamos Project Y 1942 through 1946.* Los Alamos, N.M.: Los Alamos Historical Society, 1997.

Weart, Spencer R., and Gertrud Weiss Szilard, eds. *Leo Szilard: His Version of the Facts.* Cambridge, Mass.: MIT Press, 1978.

Wilson, Jane S., and Charlotte Serber, eds. *Standing By and Making Do: Women of Wartime Los Alamos.* Los Alamos, N.M.: The Los Alamos Historical Society, 1988.

Wyden, Peter. *Day One: Before Hiroshima and After.* New York: Simon & Schuster, 1984.

PERMISSIONS

The author gratefully wishes to thank Joan Hinterbichler for permission to use extracts from the personal diary of Abe Spitzer, 1945, and the Caron family for use of extracts from Bob Caron's letters. The author gratefully acknowledges the Hiroshima Peace Memorial Museum for the text of the Tamiki Hara poem.

About the author

About the book

Insights,
Interviews
& More...

Read on

Meet Stephen Walker

© Sally George

STEPHEN WALKER grew up in London in a large loving family complete with a dog, a cat, and several goldfish. Apart from one challenging year at a typical British boarding school (where cold baths were the daily norm) he was educated at St. Paul's, a hothouse academic factory famous for former pupils such as the poet John Milton. He went on to study modern history at Oxford, where he spent his time irregularly attending lectures and crashing parties thrown by the likes of Hugh Grant.

Upon graduation from Oxford he won a fellowship to study for a master's degree in the history of science at Harvard. Harvard gave him two wonderful years and engendered a lifelong love affair with the United States. A spell as an intern on a New York City radio station convinced him to pursue a media career, and in 1984 he moved back to London and a job at the BBC.

The BBC trained him as a director, and for the next twelve years he was lucky enough to travel around the globe making documentary films on subjects as diverse as the Vietnam War, Beirut, French Nazis, a history of toys, the troubles in Northern Ireland, apartheid

66 He went on to Oxford, where he spent his time irregularly attending lectures and crashing parties thrown by the likes of Hugh Grant. 99

in South Africa, and a Jewish wedding. In 1998 he directed a film about four obsessive filmmakers in search of fame and glory at the Cannes Film Festival. His first book, *King of Cannes: Madness, Mayhem, and the Movies* (Penguin), records his maddening struggle to complete the documentary.

Walker next made a highly successful film for the hit British series *Faking It.* The episode charts the progress of a punk rocker who must transform himself into a convincing classical music conductor in just four weeks—despite never in his life having listened to a single piece of classical music. In 2003 the film won Europe's most prestigious television prize, the Golden Rose of Montreux.

His most recent film, *Hiroshima: A Day That Shook the World,* won an Emmy Award (the film received three nominations) and became the springboard and inspiration for this book.

Walker lives by the River Thames in London and divides his time between his wife, his teenage daughter, and his tiny plane—a plane in which he manages to terrify himself and his braver friends whenever possible. ∽

Stephen Walker on Nagasaki—the Forgotten Bomb

DON ALBURY stared through the Plexiglas at the runway stretching ahead in the darkness. The roar of the big bomber's four engines hammered through the cockpit walls. Fifteen feet behind him, a huge egg-shaped object, ten feet long, five feet wide, and weighing almost five tons, trembled in the forward bomb bay. Its high-gloss yellow finish was spattered with chalked messages to the Emperor of Japan. Nicknamed *Fat Man* after Winston Churchill, its portly shape barely hinted at the awesome power contained in its guts. For *Fat Man* was an atom bomb, destined—like its predecessor that had leveled Hiroshima just three days earlier—for a Japanese city. That was the intention at any rate. As Albury and Chuck Sweeney, his captain aboard *Bockscar,* gunned the silver B-29 Superfortress down the runway for the start of the fifteen-hundred-mile flight to Japan, neither they nor any of their thirteen-man crew could predict the catalogue of disasters about to befall them.

Sixty years later, Albury, now eighty-five, sits in his neat living room in a tranquil suburb of Orlando, reliving the mission that ended World War II. "It was all screwed up," he says quietly. "Everything got messed up in that mission. Everything that could go wrong, did go wrong. We'd been training for months. We knew our job inside out. Our crew had accompanied *Enola Gay* to Hiroshima as the instrument plane. We saw the bomb drop there, the mushroom cloud, everything. It was perfect, the whole thing was perfect. Then it was our turn."

The date was August 9, 1945. Despite the destruction of Hiroshima and the deaths of

> " Nicknamed *Fat Man* after Winston Churchill, the bomb's portly shape barely hinted at the awesome power contained in its guts. "

at least eighty thousand of its inhabitants, the Japanese showed no signs of surrendering. The fighting and the dying continued. Now the pressure was on to drop a second atom bomb. The strategy was starkly simple: if the Japanese could be led to believe the Americans had an unlimited supply of nuclear weapons they might be persuaded to see the writing on the wall. *Fat Man* was the cornerstone of that strategy, the second act of what General Leslie Groves called "a one-two punch" that would shock the enemy into unconditional surrender. The responsibility for ending the war lay, quite literally, on the shoulders of Don Albury and his crew.

At midnight the men filed into a briefing hut on the tiny island of Tinian in the western Pacific, six hours' flying time south of Japan. All day the mood had been somber. "The feeling in our hearts," *Bockscar*'s assistant engineer Ray Gallagher said later, "was very, very low. At a quarter to twelve we were getting ready to leave our Quonset. As we walked past the last bed, the barracks bag was laying there. When we dropped our wallets inside, truthfully, I never thought I'd pick up mine again." Radio operator Abe Spitzer kept an unauthorized diary of the mission. He spent the evening before the briefing lying on his bunk, counting down the hours to takeoff. "Sleep was out of the question," he wrote. "My thoughts were running wild."

The briefing was short and to the point. The group commander who had piloted *Enola Gay* to Hiroshima, Colonel Paul Tibbets, rapidly outlined the targets. There were just two: the primary, Kokura, a city containing one of Japan's largest weapons arsenals; and the alternate, Nagasaki, a hundred miles southwest of Kokura and a center of armament production. Despite the emphasis on military installations, every man in the room knew the reality of what they were about to do. They had all seen the photos of ▶

> " The responsibility for ending the war lay, quite literally, on the shoulders of Don Albury and his crew. "

Hiroshima. If *Fat Man* performed as efficiently as its predecessor it was not merely factories that would be destroyed in a few hours. It was an entire city.

The mission profile would be an almost exact copy of that for Hiroshima. Two weather planes would fly one hour ahead of the strike force to check conditions over each target. The city to be bombed would be the one with the clearest weather. Tibbets was emphatic: this bomb *had* to be dropped visually. It was far too valuable to lose. If the targets were hidden by clouds the bomb must be brought back and landed at Tinian—itself a potentially hazardous operation. Two other aircraft would accompany *Bockscar: The Great Artiste,* carrying instruments to measure the bomb's blast, and the unfortunately named *Big Stink,* carrying photographic equipment. All three aircraft would rendezvous over Yakoshima, a small island off the coast of southern Japan. Together they would then fly to one of the two designated cities. Tibbets wished them luck. A chaplain said a blessing. Don Albury fingered the Saint Christopher medal he kept in his flight suit pocket. Then the men left for the planes waiting in the darkness.

That was when the first problem hit. Almost as soon as the engines started they were shut down. A warning light had suddenly flickered on the flight engineer's panel. A fuel transfer pump appeared to be malfunctioning. The B-29 carried 7,250 gallons of fuel; 640 of those gallons were now unusable, trapped in tanks in the aft bomb bay. There was still enough fuel left to fly the mission; indeed, the primary purpose of the extra fuel was to correct the imbalance caused by the 10,000-pound bomb in the forward bomb bay. But the odds were tightening before they had even left the ground. A hasty

> 66 If the targets were hidden by clouds the bomb must be brought back and landed at Tinian—itself a potentially hazardous operation. 99

conference was convened between the captain, Chuck Sweeney, and Tibbets. Should they go or should they abort? The weather gave the dilemma extra urgency. Typhoons were forecast for Japan over the next five days. If the mission were cancelled now there was no certainty when it could next be flown. The window of opportunity would close. Men might be killed who would otherwise have lived. "Tibbets said, 'Chuck, it's up to you,'" recalls Albury. "Finally Sweeney said, 'Okay, we'll go.' And we did." It was a decision that would cost them dearly before the mission was over.

At 3:47 in the morning *Bockscar* accelerated down Tinian's 8,500-foot runway, clawing its way into the night sky. The two accompanying aircraft followed behind at one minute intervals. Everyone observed the strictest radio silence. Nothing could be allowed to give away the purpose of the flight to Japanese eavesdropping on their frequencies. Invisible to one another in the darkness, all three aircraft pressed northward over the Pacific. With each mile the weather rapidly deteriorated. To get above it Sweeney climbed to 17,000 feet—much higher than they normally cruised. In practical terms, that meant they were using more fuel—the one commodity of which they were already short. The bomber bucked and dipped in the turbulence. Saint Elmo's Fire enveloped the wings in incandescent blue light, leaving a glowing wake in the sky. The effect was strangely unsettling. Fred Olivi, an Italian American crewmember acting as a third pilot, recorded his impressions in an hour-by-hour log he wrote immediately after the mission: "04:40. Some of these damned cumulus and thunder clouds are rough as hell! God I'm so tired I can barely keep my eyes open. But ▶

66 If the mission were cancelled now there was no certainty when it could next be flown. Men might be killed who would otherwise have lived. 99

66 The bomber bucked and dipped in the turbulence. Saint Elmo's Fire enveloped the wings in incandescent blue light, leaving a glowing wake in the sky. 99

flying through these clouds sure wakes you up in a hurry."

Behind Olivi, a tall thirty-three-year-old man squatted beside a door opening into the bomb bay. Through its window he could see the bomb vibrating with each jolt. He kept a watchful eye. *Fat Man* was his responsibility. Aside from Chuck Sweeney, Commander Dick Ashworth was the most important man aboard. As the mission's officially designated 'weaponeer,' his job was to babysit *Fat Man* on the way to its target. In front of him was a console packed with dials and lights. Its purpose was to monitor the bomb's health: its batteries, fusing systems, and internal circuitry. For the first few hours everything checked out perfectly. Then around 7 A.M. Ashworth's attention was suddenly caught by a steady white light on the panel. According to the manual, that meant the bomb had inadvertently activated its arming system. The circuit between the firing system and the detonator appeared to have closed. The bomb was ready to go off.

Ashworth died on December 3, 2005, but that moment sixty years earlier remained indelibly imprinted on his mind. "That was one light you didn't want to see," he recalled with classic understatement in one of his last interviews. "I reported to Sweeney. I said we may have a bit of a problem here." His assistant Philip Barnes, "took two sides off his box, broke out his blueprints, and went through the wiring." Barnes coolly fiddled with a screwdriver behind the console. For three minutes he worked when the light suddenly flicked out. A switch had been improperly connected. The bomb was safe. But everybody on board looked forward to the moment they could get rid of it over the target.

> The bomb had inadvertently activated its arming system. . . . It was ready to go off.

That would prove more difficult than anticipated. Two hours later *Bockscar* arrived in brilliant morning sunshine over the Yakoshima island rendezvous point to meet the other two aircraft. *The Great Artiste* showed up almost immediately. But of *Big Stink,* captained by Major James Hopkins, there was no sign. Round and round the island Sweeney circled, all on board straining for a glimpse of the camera plane. "We were all looking out the windows," remembers Albury, "but we couldn't see it anywhere. By now things were getting pretty late. Chuck was very angry." Tibbets had earlier ordered Sweeney not to remain longer than fifteen minutes at the rendezvous. But Sweeney continued to orbit the island. For fifty minutes he searched for Hopkins in vain, using up more of their precious fuel. Ashworth went forward to the cockpit and urged Sweeney to continue on to Japan: "I said, 'Let's get out of here, we've got to get on with the mission.' " The Japanese defenses were already picking up the formation on their radar screens. It was too dangerous to wait. Finally Sweeney relented. Olivi noted later in his log: "09:50. Hoppy still hasn't arrived. We can't wait any longer. Our gas is going fast."

The two aircraft turned north toward Kokura, the primary target. Only later did they discover that Hopkins had been at the rendezvous, but flying at 39,000 feet—much higher than *Bockscar.* He too was desperately searching for the others. At some point he broke radio silence to call the base: "Has Sweeney aborted?" he asked. The men waiting back on Tinian heard only the words "Sweeney aborted" over the static. When General Thomas Farrell, the Manhattan Project's base commander, heard the news he threw up his breakfast. Somewhere out there *Bockscar* ▶

66 When General Thomas Farrell, the Manhattan Project's base commander, heard the news he threw up his breakfast. 99

Stephen Walker on Nagasaki—
the Forgotten Bomb *(continued)*

was lumbering about the Pacific with an atom bomb worth several hundred million dollars—and nobody on Tinian had the remotest clue where it was or what was happening to it.

The advance weather report from Kokura had been good, but by the time *Bockscar* got there at 10:40 cloud buildup made it difficult to see the target. Smoke from a recent American bombing raid over nearby Yawata also drifted across the city. Bombardier Kermit Beahan, a cool Texan whose bombing skills were legendary in the squadron, set up his bombsight for the four-minute run to the aiming point. "Target in sight but 7/10 cloud coverage," recalled Olivi in his log. "Bomb must be dropped visually but I don't think our chances are very good."

"I had my fingers crossed," wrote radio operator Abe Spitzer, "praying we wouldn't have to make more than one run."

He prayed in vain. The first run was abandoned. Sweeney decided to go around a second time—a very dangerous decision on any combat mission but especially so on this one. As they turned back toward the target antiaircraft shells began exploding beneath them. The Japanese batteries were bracketing their flight path, trying to nail their height. Over his headphones the radar operator could hear the Japanese controllers directing fighter planes toward them. Beahan again abandoned the bomb run at the last second. "No drop!" he called. Today was his twenty-seventh birthday; it was not his lucky day.

Sweeney brought the plane around for a third pass. By now the fuel situation was becoming critical. They had been over the target almost forty-five minutes. "Everybody was talking back and forth," says Albury. "The tension was really building in there." Assistant

> ❝ By now the fuel situation was becoming critical. Assistant flight engineer Ray Gallagher yelled over the intercom: 'Let's get the hell out of here!' ❞

flight engineer Ray Gallagher yelled over the intercom: "Let's get the hell out of here!" Then, just before the drop, Beahan yet again called off the bomb run. Still he could not see the aiming point. A rapid decision was made to leave Kokura and fly to the secondary target. Olivi wrote: "11:30. Gas damn low! Going on to Nagasaki. It's now or never! Boys getting jittery."

But it was the same story at Nagasaki. There too clouds had built up, making a visual drop impossible. The engineer calculated the latest fuel position: there was just enough for one bomb run. After that he could not guarantee the aircraft would make it to a friendly base. A stark choice faced the crew: either disobey orders and drop the bomb by radar through cloud—a notoriously inaccurate operation—or face the probability of ditching the atom bomb in the sea. As the officer ultimately responsible for the bomb Ashworth now faced an agonizing decision. "We were under strict orders from Washington," he said, "that under no circumstances could we drop that bomb unless we could see the target." Everything was at stake here, not just for Ashworth, or even for the people of Nagasaki, but for the outcome of the whole war. He had very little time to make up his mind before they reached the outskirts of Nagasaki.

"I could see the commander was struggling," wrote Spitzer in his diary. "He was in a tough spot." Ashworth quickly made his decision. "We had to get rid of that weapon," he remembered, "or we were going to ditch in the sea. The only valid choice was to get loose of that bomb on the city of Nagasaki." Chuck Sweeney immediately swung the plane into its one and only bomb run. The navigator set up the radarscope and feverishly passed coordinates to Beahan squatting over his ▶

66 We had to get rid of that weapon, or we were going to ditch in the sea. 99

bombsight. Olivi stared at the clouds below: "11:56. No change in cloud coverage—it's radar all the way so far—still hoping for visual sight of the target." The seconds ticked by as they approached the target. "Lord, no hang-up, not this time," wrote Spitzer.

Twenty seconds before the drop Beahan suddenly caught a glimpse of the ground through gaps in the clouds. "I see it! I see it!" he shouted over the intercom. "You own it," replied Sweeney. But it was not the aiming point east of the harbor that Beahan saw. It was a stadium in the industrial north of the city, 1.3 miles from the intended target. Not that it mattered to him now. The pneumatically operated bomb doors jerked open. After a fifteen-second warning tone, *Fat Man* tumbled out of the bomb bay 29,000 feet over the city and plummeted toward it. "That," declared Beahan in a radio interview a week later, "was my greatest thrill."

"A few things that you do," said Ashworth, "have such an indelible impact on your mind that they stay there forever." The explosion ripped apart the Urakami valley in Nagasaki's northern suburbs with the force of twenty-two thousand tons of TNT—almost nine times the total bomb tonnage that destroyed Dresden in February 1945. A brilliant flash of light brighter than a supersized sun flooded the plane. The mushroom cloud boiled up from the ground, punching into the skies at a terrific rate. "It was whirling," recalled Ashworth, "and there were flames in it, and there were bits of orange color mixed up in this whirling batch of smoke." "It had every color in the rainbow," says Albury, "greens, blues, pinks, everything." Beneath it some seventy thousand people were already dead or dying. Olivi gazed in hypnotic fascination through the windows. "12:01," he wrote. "I've

66 The mushroom cloud 'had every color in the rainbow,' says Albury, 'greens, blues, pinks, everything.' Beneath it some seventy thousand people were already dead or dying. 99

never seen anything like it! Biggest explosion I've ever seen. Those poor Japs. But they asked for it."

The cloud threatened to engulf them too. Sweeney quickly banked *Bockscar* away. They had dropped the bomb. Now they had to get home. Their only hope was Okinawa, the recently captured island three hundred fifty miles south of Japan. Spitzer fired off an anxious message to the base. Decoded, it read: *Bombed Nagasaki visually with no fighter opposition and no flak. Results "technically successful" but other factors involved make conference necessary before taking further steps. Visible effects about equal to Hiroshima. Trouble in airplane following delivery requires us to proceed to Okinawa. Fuel only to get to Okinawa.*

Their chances of reaching it were slim. Nagasaki receded behind them, the mushroom cloud still visible for two hundred miles. Sweeney slowed the plane down to conserve fuel and it gradually lost height over the sea. "Everybody," says Albury, "was getting ready to ditch." Spitzer sent out an urgent stream of SOS messages. None of them knew that Hopkins's earlier misunderstood abort signal meant that every rescue ship and submarine had already been recalled. There was nobody down there to help them.

Miraculously, Okinawa appeared over the horizon. "We started calling them," says Albury, "but they didn't answer. By now our fuel tanks were almost empty. We were practically flying on fumes. We kept calling, sending out Maydays, distress messages, everything, but nobody was answering." The airfield was extremely busy. Planes were taking off and landing in rapid succession.

"13:20. There's heavy traffic," wrote Olivi, "but we're going in—we've got to—we have ▶

❝ At best there was barely enough fuel for one landing attempt. Sweeney ordered every available distress flare to be fired at once. **❞**

Stephen Walker on Nagasaki—
the Forgotten Bomb *(continued)*

no choice." At best there was barely enough fuel for one landing attempt. Sweeney ordered every available distress flare to be fired at once. They burst from the plane in all their colors "like a Fourth of July celebration," wrote Spitzer, each color signaling a different emergency: "wounded aboard"; "heavy damage"; "aircraft on fire." The stench of gunpowder filled the cockpit. As Sweeney brought the plane toward the runway the number two engine suddenly spluttered and died.

The plane hit the runway hard and fast, sixty-odd tons of flesh and metal screeching onto the concrete. It swerved violently to the left towards a row of parked bombers. Both pilots threw their weight onto the brakes and slammed the propellers into reverse. The big bomber gradually slowed. Just before the end of the runway it stopped. Ambulances and fire trucks raced toward the aircraft. The door opened and a man poked his head inside. "Where's the dead and wounded?" he asked. An exhausted Sweeney nodded to the north, toward Nagasaki. "Back there," he answered.

A month after the war Don Albury and other crewmembers from *Bockscar* and *Enola Gay* flew into Nagasaki. They were the first Americans to set foot in the city. What Albury saw shocked him. The scale of destruction was so tremendous. "It was devastated," he says. "The only things standing were a few concrete buildings. We didn't see any bodies, except for in one hospital. They were lying on the ground outside." He pauses for a moment, then turns to look out the window. The silence is almost oppressive. Finally he turns back. "I was just happy the war was over," he very quietly says. "I didn't care how it happened. I just wanted to go home." ∿

Have You Read?
Best of the Bomb Books

The Making of the Atomic Bomb,
by Richard Rhodes
The most authoritative work on the subject
I have read. It possesses astonishing breadth
and a peerless mastery of the subject, and it's
that rare thing: a beautifully written book.
If there is one volume to read on the whole
business of the bomb, this is it.

***Racing for the Bomb: General Leslie R.
Groves, the Manhattan Project's
Indispensable Man,*** **by Robert S. Norris**
A meticulous, beautifully paced, and wholly
engrossing portrait of the man at the center of
the bomb project. Norris is a great read about
a great subject. His General Groves spills off
the pages as the part monster, part miracle
that he was. At times horrifying, fascinating,
and shocking, the book is also written with
great humor and humanity. A very rich source
for my book.

Dawn over Zero, **by William Laurence**
The Holy Grail of atom bomb reportage,
written by the propagandist whose coverage
of the story of the development of the A-bomb
began nearly at its inception. Laurence was
at Trinity, he was on the Nagasaki mission,
and he knew most of the key men—aviators,
engineers, soldiers, as well as scientists—
involved. His book is a riveting narrative
of that experience, brilliantly told. His
account of the Trinity test, a tour de force of
descriptive prose, still shocks today with its
dark and prescient perception of this terrible
new danger about to be unleashed upon
the world.

> ❝ *Dawn over
> Zero* is the
> Holy Grail of
> atom bomb
> reportage. ❞

Day of Trinity, by Lansing Lamont

Published more than forty years ago, this book in some ways provided the model for mine. A countdown itself—this time toward the Trinity test—it is a gripping read from start to finish. There are some wonderful set pieces, especially of the frantic, last-minute preparations before the Gadget is exploded on its tower. Some of the material has since proved to be incorrect—much of what we have access to now was still classified when Lamont was writing—but the sharpness of the storytelling was (and remains) an inspiration to me.

Now It Can Be Told: The Story of the Manhattan Project, by Leslie Groves

This is General Groves's own account of the Manhattan Project and his role in it, and as such needs to be handled with a sturdy pair of tongs. I have chosen it not simply for its debatable historical value (Groves is a master of omission) but much more for its unintended revelations about Groves's own character. Here, on every page, is the man laid bare: his monstrous ego, his fantastic sense of risk, and his epic sense of scale and place in history. The sheer force of his personality takes my breath away. I read it in one sitting in a Mexican restaurant in Las Vegas as a perfect complement to the hottest of chilies.

The Day Hiroshima Disappeared, by Shuntaro Hida

A beautiful, deeply poignant, and in some ways deceptively simple autobiography by one of the doctors who survived the bomb and whose story I tell in my book. I read this after meeting Dr. Hida in Japan. I was profoundly moved after my interview with him, but even more so after I read his book. Its images, some of which I include in my own account, still haunt me now. I will never forget his description of the burned figures stumbling up the road from the blazing city as Hida looks down in horror. Of all the translated Japanese works I have read on the subject, this is the one that touched and appalled me the most.

Don't miss the next book by your favorite author. Sign up now for AuthorTracker by visiting www.AuthorTracker.com.